MANDALAS

MAPPING THE BUDDHIST ART OF TIBET

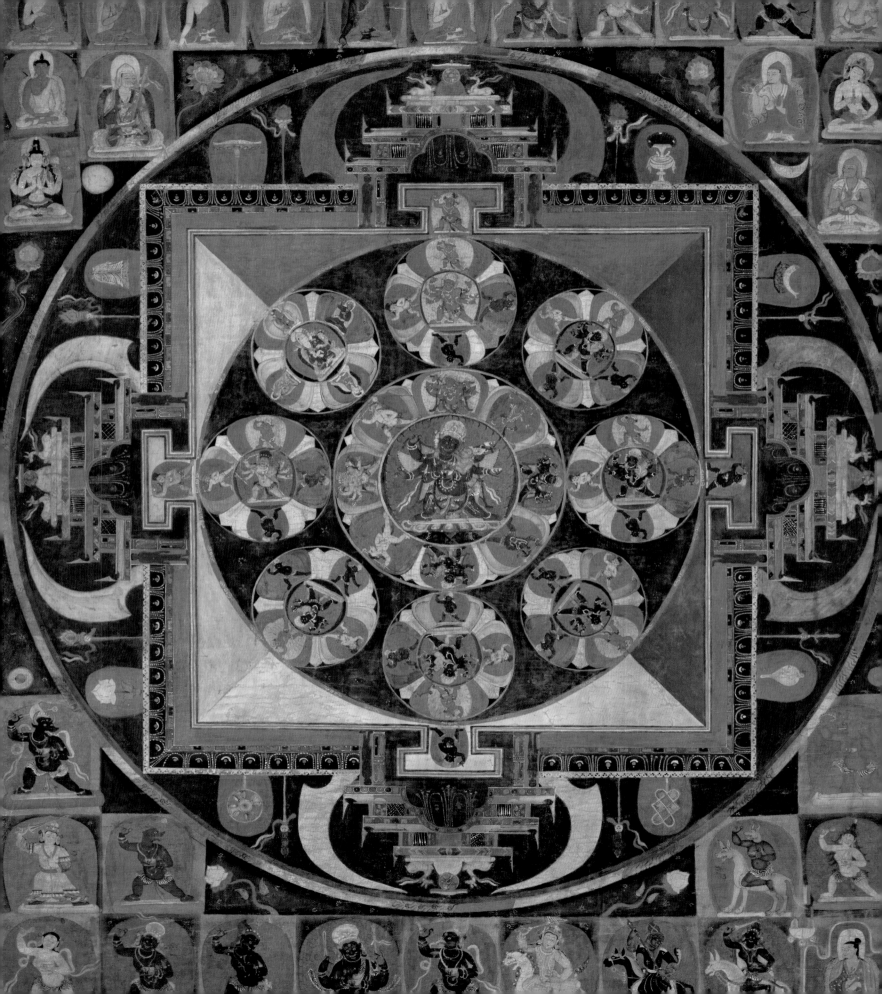

MANDALAS

MAPPING THE BUDDHIST ART OF TIBET

KURT BEHRENDT

With essays by Christian Luczanits and Amy Heller
and an interview with Tenzing Rigdol

The Metropolitan Museum of Art, New York
Distributed by Yale University Press, New Haven and London

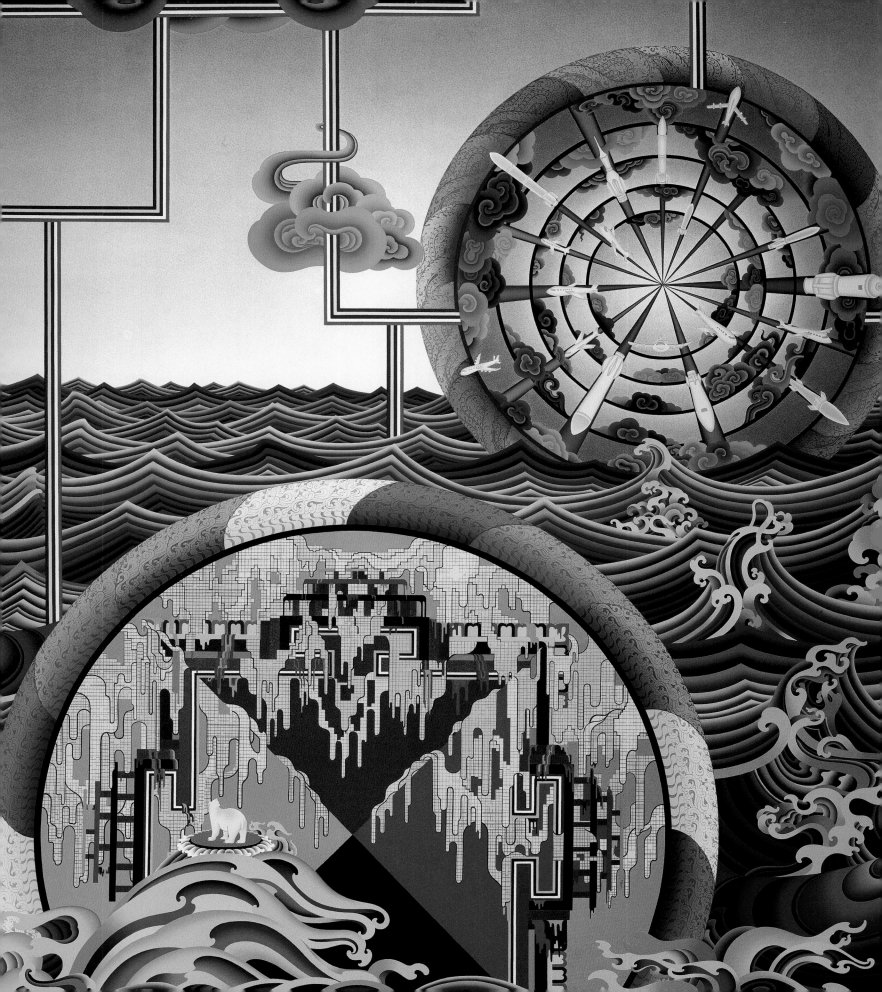

CONTENTS

6 Foreword
8 Acknowledgments
10 Contributors to the Catalogue
11 Lenders to the Exhibition
11 Note to the Reader
12 Map

15
Mandalas: Mapping the Buddhist Art of Tibet
KURT BEHRENDT

31
Teachers and Texts
KURT BEHRENDT

47
Visualizing the Taboo in Esoteric Buddhism
CHRISTIAN LUCZANITS

69
Compassion as Essence: Bodhisattvas as Spiritual Guides
AMY HELLER

89
Biography of a Thought: A Discussion with Tenzing Rigdol
KURT BEHRENDT AND TENZING RIGDOL

99
Plates

224 Checklist of Plates
242 Glossary
244 Notes
245 Bibliography
249 Index

FOREWORD

Tibet, and its art, has long captured people's imaginations in part because this high plateau behind the Himalayas remained relatively unknown until the twentieth century, despite both a geographic and a cultural proximity to Nepal, Bhutan, and India. In recent years, many exhibitions and a wealth of scholarship have sought to shed light on this great artistic tradition, but owing to the complexities of tantric Buddhism—the most prevalent form of Buddhism in Tibet, and the philosophy behind much of its art—it remains largely inaccessible to modern audiences. Hence, a goal of this publication and the landmark exhibition it accompanies is to bring together a stunning array of masterworks that illuminate the key principles of tantric Buddhism, ideas that the artworks themselves embody and which remain central to the Tibetan cultural landscape. By focusing on works from the eleventh to the fifteenth century, it is possible to observe how Buddhist ideas originating from India were visually codified in dramatic and often sublime ways in Tibet, and no more so than in the dazzling imagery encapsulated in the form of the mandala. Ultimately, it is this imagery that crossed linguistic and cultural boundaries to establish Tibet as one of the great Buddhist centers. Complementing this diverse body of work in the present exhibition is a contemporary mandalic installation by the artist Tenzing Rigdol, created specifically for this show and illustrated in spectacular detail in the following pages. Rigdol's work recasts the traditional Tibetan Buddhist visual lexicon to address issues relevant in the present day, including climate change, social inequality, and the elusive impact of technology.

Mandalas: Mapping the Buddhist Art of Tibet is organized by Kurt Behrendt, Associate Curator of South Asian Art at The Met, who has drawn on his deep knowledge of the subject and of these artworks, as well as extensive field research, to develop the exhibition and its catalogue. Taking advantage of the inherently "mandalic" layout of the Robert Lehman Wing, with long galleries surrounding a central atrium, he devised this presentation to highlight the artistic elements that underpin Tibetan Buddhism, which are, in turn, reflected in the central installation by Tenzing Rigdol. We are grateful for Kurt's stewardship of this ambitious project, which was conceived in 2019, on the eve of the Covid-19 pandemic. It was at that moment of great uncertainty, when society collectively turned inward to

reflect on what was important, that he invited Rigdol to create a work for The Met. Rigdol responded by addressing some of these global concerns from an individual's perspective, mirroring the personal path one takes in pursuit of liberation within Buddhism.

Mandalas: Mapping the Buddhist Art of Tibet brings together more than one hundred works of art from fourteen lenders. The project was realized through the extraordinary talents of our staff and is indebted to the individuals and institutions that lent works to the exhibition, all of whom are named, with our thanks, on page 11. We are grateful to them all for their help in bringing these compelling artworks to the attention of a broader public and casting on them the recognition they deserve.

The Met extends its profound gratitude to the Placido Arango Fund and Lilly Endowment Inc. for making this exhibition possible and for recognizing the merits of this ambitious presentation. The beautiful book that you now hold was realized through the support of the Florence and Herbert Irving Fund for Asian Art Publications. It is only through our donors' generosity that we can present important projects such as this one.

Max Hollein
Marina Kellen French Director and CEO,
The Metropolitan Museum of Art, New York

ACKNOWLEDGMENTS

Mandalas: Mapping the Buddhist Art of Tibet is in many ways the outgrowth of more than thirty years of intense scholarly interest in this great tradition, which has allowed me to unpack many of its iconographic and ideological complexities. This exhibition and the catalogue that accompanies it strive to untangle some of the intricacies governing tantric art, so as to make this dynamic visual tradition accessible to a broad audience. It is with this goal in mind that I would first like to acknowledge Tenzing Rigdol and his contributions to this project. During the long stretch of the Covid-19 pandemic, Rigdol and I had many wide-ranging discussions on Tantrism and how artworks stemming from this Buddhist philosophy focus on an individual's realization of their place in the world. His resulting large-scale, site-specific installation, *Biography of a Thought*, reflects his effort to address related topics, which, though inflected through his own personal experience, succeeds in speaking universally about the conditions affecting contemporary humanity.

Equally, this catalogue has benefited from many scholarly voices, foremost among them being those of my two coauthors, Christian Luczanits, David L. Snellgrove Senior Lecturer in Tibetan and Buddhist Art, Department of History of Art and Archaeology, School of Oriental and African Studies, University of London; and Amy Heller, Research Associate, Institute for the Science of Religion, University of Bern; Senior Research Fellow, Margot and Thomas Pritzker Art Collaborative; and Associate Researcher, CNRS–Paris, Centre de Recherche sur les Civilisations de l'Asie Orientale. I thank them for their essays, which serve to clarify the Tibetan Buddhist tradition and, more to the point, explain how artworks of the highest quality served

to make this practice accessible to monastic and lay audiences. I am also grateful to several colleagues from across the Museum who contributed incisive catalogue entries on specific works of art: John Guy, Florence and Herbert Irving Curator of the Arts of South and Southeast Asia, Department of Asian Art; Donald J. La Rocca, Curator Emeritus, Department of Arms and Armor; Clara Ma, Research Associate, Department of Asian Art; Joseph Scheier-Dolberg, Oscar Tang and Agnes Hsu-Tang Curator of Chinese Paintings, Department of Asian Art; and Bradley Strauchen-Scherer, Curator, Department of Musical Instruments. Special thanks are also owed to my research assistant, Ross L. Bernhaut, a PhD candidate in art history at the University of Michigan, who not only wrote many catalogue entries and compiled the glossary, but also offered valuable insight on questions related to the Tibetan and Sanskrit languages.

As important to our effort to showcase the legacy of Tibetan art are the fourteen lenders, named on page 11, that generously granted us access to their finest works. We sincerely thank these museums, collections, and individuals for their trust and confidence and for their shared commitment to promoting the arts and cultural heritage of the Himalayas. Their support has allowed us to explore the vital connections between Tibet, Nepal, and north India in the eleventh to fifteenth century and the lasting impact of these exchanges on the arts of this region, offering a rare window into this era of global history and an opportunity for those who have the privilege of experiencing the exhibition to view these works of art. I thank in particular Jorrit Britschgi, Executive Director of the Rubin Museum of Art, New York, together with Senior Curators Karl Debreczeny

and Elena Pakhoutova; Yasufumi Nakamori, Museum Director and Vice President of Arts and Culture at Asia Society, New York; Linda Corliss Harrison, Director and CEO of the Newark Museum of Art; and Soyoung Lee, Landon and Lavinia Clay Chief Curator of the Harvard Art Museums. Nearly half the objects in the exhibition were drawn from the rich collection of The Met, most prominently that of the Department of Asian Art. For facilitating generous internal loans from their own departmental collections, I thank Jayson Dobney, Frederick P. Rose Curator in Charge, Department of Musical Instruments, and Edward Hunter, Acting Curator and Conservator in Charge, Department of Arms and Armor.

I have many colleagues to thank at The Met, beginning with Max Hollein, Marina Kellen French Director and CEO, for supporting this project from its inception. I am also grateful to Quincy Houghton, Deputy Director for Exhibitions and International Initiatives; Christine McDermott, Senior Exhibitions Project Manager; and Quinn Corte, Exhibitions Project Manager, for making this show a reality. Elsewhere throughout the Museum, I thank Dita Amory, Robert Lehman Curator in Charge of the Robert Lehman Collection; in Design, for all his work envisioning the exhibition, I thank Daniel Kershaw, as well as Maanik Chauhan, Clint Coller, Jourdan Ferguson, Hamilton Guillén, Mortimer Lebigre, Amy Nelson, and Kamomi Solidum; in Asian Art Conservation, Jennifer Perry, Mary and James Wallach Family Conservator of Japanese Art; in Objects Conservation, Warren Bennett, Matthew Cumbie, Andrew Estep, Christina Hagelskamp, Vicki Parry, Frederick Sager, and Marlene Yandrisevits; in Paper Conservation, Marina Ruiz-Molina; in Textile Conservation, Minsun Hwang and Kristine Kamiya; in the Registrar's Office, Aislinn Hyde; in Development, Evie Chabot and Kimberly McCarthy; in the Counsel's Office, Amy Lamberti and Rebecca Noonan Murray; in Merchandising, Alicia Cox, Emily Einhorn, Leanne Graeff, and Stephen Walker; in Buildings, Deepesh Dhingra and Taylor Miller; in Digital, Christopher Alessandrini, Isabella Garces, and Rachel Smith; in Education, Rebecca McGinnis, Mary Jaharis Senior Managing Educator, Accessibility, as well as Francesca D'Alessio, Amy Charleroy, David Freeman, Marianna Siciliano, Elizabeth Perkins, and Sherri Williams; in Imaging, Oi-Cheong Lee, Anna-Marie Kellen, Paul Lachenauer, and Richard Lee; in Communications, Stella Kim; and in Publications and Editorial, Peter Antony, Jennifer Bantz, Mark Polizzotti, and Michael Sittenfeld. For their work in making this catalogue a success, I am profoundly grateful to Marcie M. Muscat, the editor of this volume; Paul Booth, who oversaw production; Jenn Sherman, who managed image acquisitions and permissions; Gina Rossi, who provided its elegant design; Julia Oswald, who edited the notes and bibliography; and Adrian Kitzinger, who drafted the map.

I express my deepest gratitude to all my colleagues within the Department of Asian Art, and especially to Maxwell K. Hearn, Douglas Dillon Chair, for his steadfast support and sage advice. In addition to those individuals already mentioned above, I thank Alison Clark, Mary Hurt, Stephanie Kwai, and our departmental technicians, Imtikar Ally, Djamel Haoues, Sooyoung Jeon, and Beatrice Pinto. This project simply would not have been possible without their help.

We are profoundly grateful to the Placido Arango Fund and Lilly Endowment Inc. for their lead support of *Mandalas: Mapping the Buddhist Art of Tibet*. This publication benefits from the Florence and Herbert Irving Fund for Asian Art Publications, which is owed further recognition.

Finally, I wish to express my appreciation to Janet Hunter and to Ruby and Beatrice Leblanc for their support throughout this endeavor.

Kurt Behrendt
Associate Curator of South Asian Art,
Department of Asian Art,
The Metropolitan Museum of Art, New York

CONTRIBUTORS TO THE CATALOGUE

Kurt Behrendt (KB)
Associate Curator of South Asian Art, Department of Asian Art, The Metropolitan Museum of Art, New York

Ross Lee Bernhaut (RLB)
Doctoral candidate, Department of the History of Art, University of Michigan, Ann Arbor

John Guy (JG)
Florence and Herbert Irving Curator of the Arts of South and Southeast Asia, Department of Asian Art, The Metropolitan Museum of Art, New York

Amy Heller
Research Associate, Institute for the Science of Religion, University of Bern; Senior Research Fellow, Margot and Thomas Pritzker Art Collaborative; and Associate Researcher, CNRS–Paris, Centre de Recherche sur les Civilisations de l'Asie Orientale

Donald J. La Rocca (DLR)
Curator Emeritus, Department of Arms and Armor, The Metropolitan Museum of Art, New York

Christian Luczanits
David L. Snellgrove Senior Lecturer in Tibetan and Buddhist Art, Department of History of Art and Archaeology, School of Oriental and African Studies, University of London

Clara Ma (CM)
Research Associate, Department of Asian Art, The Metropolitan Museum of Art, New York

Tenzing Rigdol
Contemporary artist based in New York and Kathmandu

Joseph Scheier-Dolberg (JSD)
Oscar Tang and Agnes Hsu-Tang Curator of Chinese Paintings, Department of Asian Art, The Metropolitan Museum of Art, New York

Bradley Strauchen-Scherer (BSS)
Curator, Department of Musical Instruments, The Metropolitan Museum of Art, New York

LENDERS TO THE EXHIBITION

NOTE TO THE READER

Asia Society, New York

Robert H. Blumenfield Collection

Mr. and Mrs. Richard L. Chilton

Stephen and Sharon Davies Collection

The John and Berthe Ford Collection at the Walters
 Art Museum, Baltimore

Harvard Art Museums/Arthur M. Sackler Museum

Mr. and Mrs. Gilbert H. Kinney Collection

The Kronos Collections

Michael J. and Beata McCormick Collection

The Newark Museum of Art

Rubin Museum of Art, New York

Somylo Family Collection

Tenzing Rigdol

Zimmerman Family Collection

For consistency, this publication uses Sanskrit terminology when referring to Buddhist concepts and deities. Buddhism originated in India, as did the tantras and many esoteric deities. As Sanskrit has long been used in religious contexts, it is a logical choice, though Tibetan is used in some instances that are specific to this region. In the interest of greater accessibility for the general reader, diacritic marks have been omitted so that the Sanskrit can be read phonetically. Similarly, for greater legibility of the Tibetan, we employed common romanized renderings rather than the Wylie transliteration scheme.

Unless otherwise indicated, dimensions are the maximum, and those given for manuscripts pertain to a single folio. Height precedes width precedes depth; the abbreviations H., W., and D., as well as L. (length) and Diam. (diameter), are sometimes provided for clarity. Every effort was made to obtain high-quality images for reproduction. However, in a few instances when suitable images were unobtainable, lower-quality photographs or those of comparable objects are provided instead.

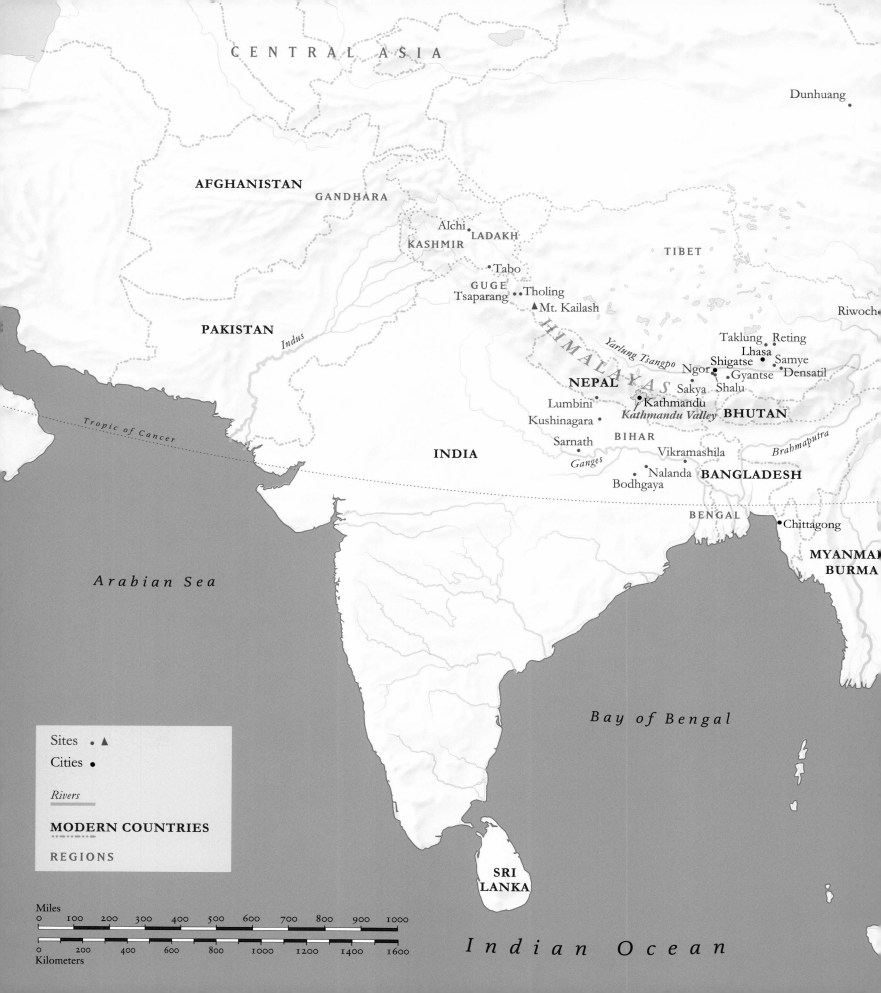

CENTRAL ASIA

Dunhuang

AFGHANISTAN

GANDHARA

Alchi
KASHMIR LADAKH

TIBET

Tabo

GUGE Tholing
Tsaparang

▲ Mt. Kailash

Riwoch

PAKISTAN

Indus

HIMALAYAS

Yarlung Tsangpo

Taklung Reting
Lhasa
Shigatse Samye
Ngor Densatil
Gyantse
NEPAL Sakya Shalu

Lumbini
Kathmandu Valley Kathmandu BHUTAN
Kushinagara

Tropic of Cancer

BIHAR

Sarnath
Ganges
Vikramashila
Brahmaputra

INDIA

Nalanda BANGLADESH
Bodhgaya

BENGAL

Chittagong

MYANMAR
BURMA

Arabian Sea

Bay of Bengal

Sites • ▲

Cities •

Rivers

MODERN COUNTRIES

REGIONS

SRI
LANKA

Indian Ocean

Miles
0 100 200 300 400 500 600 700 800 900 1000

0 200 400 600 800 1000 1200 1400 1600
Kilometers

MONGOLIA

▲Wutaishan

JAPAN

SOUTH
KOREA

Xian •

CHINA

Suzhou •

Derge

Yangtze

Pacific Ocean

VIETNAM

LAOS

SOUTHEAST
ASIA

THAILAND

CAMBODIA

PHILIPPINES

MALAYSIA

Srivijaya

BRUNEI

IDONESIA

INDONESIA

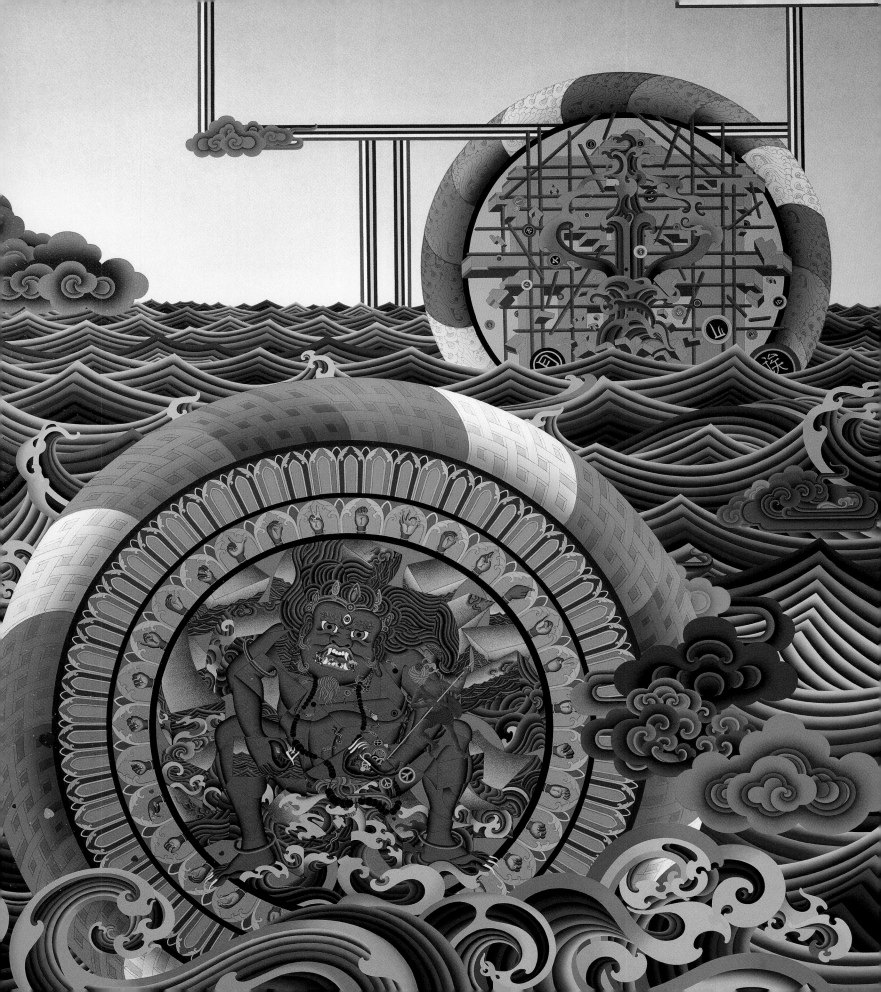

Mandalas: Mapping the Buddhist Art of Tibet

Kurt Behrendt

At the most fundamental level, a mandala is a diagram of the universe—a map of true reality. It can be as simple as a square marking the directions of the rising and the setting sun, often with a circle inscribed within it to reference all the intermediary points of a compass. Buddhist, Hindu, and Jain temples across South Asia have this structure as their conceptual foundation, often positioning a sacred image at the center, a place of purity and perfect balance.[1] In Tibet, mandalas are sometimes painted on cloth, making them portable representations of the true reality embodied by the central deity. Though mandalas have roots in ancient practice, they continue to resonate into the present day, with contemporary practitioners crafting novel applications for their creation and interpretation. Tenzing Rigdol's specially commissioned installation *Biography of a Thought* (2024; pl. 104) follows this tradition to present secular ideas as a personal expression. The viewer is invited into this structured space to consider a personal relationship, not with a deity but, rather, with a range of issues that drive our world today. Just as an ancient mandala confronts the viewer with their own reckoning to absolute reality, so too does Rigdol's mandalic installation. This contemporary work complements the many others illustrated in these pages, some of which date to nearly a thousand years earlier. All of them offer ways to visually unpack and represent the subtle nature of one's place in the world. Perhaps more importantly, this imagery invites us to consider how we might take action to respond to the challenges of our time.

The historical material presented in this catalogue and the exhibition it accompanies is broken into five groups, each addressing a major artistic focus of the Himalayan tradition: teachers and texts; bodhisattvas as spiritual guides; protectors of the Buddhist doctrine; tantric deities as evocations of enlightenment; and mandalas as diagrams of true reality. Artistic exchanges across the barrier of the Himalayas between the eleventh and fifteenth centuries allowed Tibet to develop a uniquely imaginative and authoritative way of visually presenting Buddhist concepts. Stunning artworks inspired the devout, clarified practice, and worked to promote Tibet as a new Buddhist heartland. Critical to this development are the longstanding artistic traditions of Nepal, Kashmir, and the Ganges River basin of India that Tibet

OPPOSITE: Tenzing Rigdol (b. Kathmandu, 1982), *Biography of a Thought*, 2024 (pl. 104, detail)

absorbed and transformed. This was a time of great prosperity, innovation, and artistic creativity, factors that permitted the classical Buddhist imagery of the Indian subcontinent to be recast to serve new Tibetan social and political goals. Key was Tibet's use of spectacular imagery that gave tangible form to Vajrayana ("*vajra*-path") ideology and ritual. The tradition advocates complex rituals involving the use of mandalas, the repetition of mantras, and the visualization of tantric deities. Hence, it is often called tantric Buddhism. Tantric texts had begun to appear in India by the seventh century and with time made their way to Tibet, some of the most important being the *Guhyasamaja Tantra*, the *Chakrasamvara Tantra*, and the *Hevajra Tantra*. By design, Vajrayana is difficult to grasp, but therein lies its mystery and power. Mandalas have always served as key instruments in the explication of Buddhism's more esoteric elements. A compelling mandala of the late twelfth century (pl. 97) effectively functioned like a portable temple, giving a charismatic monk legitimacy to perform rituals for the benefit of ruling elites and, by extension, for the benefit of the common person. In this way, Tibet leveraged visual media to position itself as a new and convincing center of the Buddhist world.

Texts and Teachers

A few words to set the historical stage help elucidate how a group of remote communities of Buddhists on the high Tibetan Plateau was able to claim transregional religious authority. Although tantric Buddhism had been introduced to Tibet in the seventh century, the surviving artworks and architecture largely date to after the eleventh century, when contact with the plains of north India, Kashmir, and Nepal led to a burst of artistic exchange. This was a time when Tibetans traveled to the great monasteries and religious centers of north India seeking teachings and copying Buddhist texts. In India they encountered images like a bejeweled eleventh-century representation of the Buddha (pl. 73), and while stone images such as this one could not travel, the ideas they embodied did and went on to have great significance in Tibet. The convention of adorning the Buddha with elaborate jewelry relates to conceiving this enlightened figure as accessible and living in a celestial, crystalline realm. In turn, donors often had jewelry created to embellish such images and generate merit (see pls. 19–24). The *Yoga Tantra*, a popular Vajrayana text, says that, at the moment of enlightenment, the Buddha Shakyamuni left his physical body and was conducted to the highest heaven in his "mind-made body" (*manomaya kaya*). Buddhas of the ten directions then bestowed upon him the five stages of perfect enlightenment, which is described in terms that relate to a coronation, hence the crown (fig. 1). This text then recounts how Shakyamuni became the celestial Buddha Vairochana and, only after having taught the *Yoga Tantra* to a host of beings on the summit of Mount Meru, at the center of the universe, did he descend

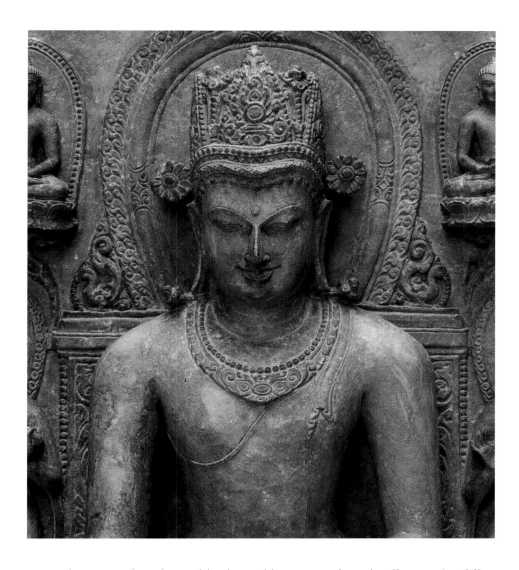

Fig. 1. Crowned Buddha Shakyamuni (pl. 73, detail). India, Bihar or West Bengal, 11th century

to earth, resume his physical body, and begin to relate the dharma (Buddhist teachings) to his followers.[2] This concept of the Buddha residing in a celestial realm as Vairochana resonated with both lay and monastic communities. Note that in this sublimely sculpted image from north India, the Buddha is shown touching the earth to bear witness to his enlightenment, and that he wears a crown as befits his status as Vairochana. Surrounding the Buddha are scenes from his life at locations in north India and the edge of Nepal that had become important pilgrimage centers (more clearly seen in pl. 8). In Tibet, emphasis shifted from the historic Buddha's role to that of enlightened celestial manifestations accessible through ritual. Not surprisingly, dramatic imagery helped both lay and monastic Tibetan communities to access this empowered and devotionally immediate way of understanding the role of the Buddha in a cosmic realm.

This period of translating and absorbing Indian Buddhist texts, teachings, and art effectively came to an end at the beginning of the thirteenth century.

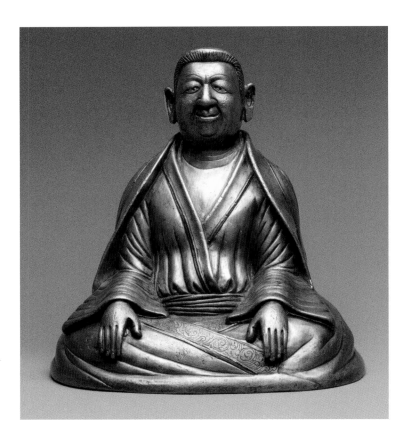

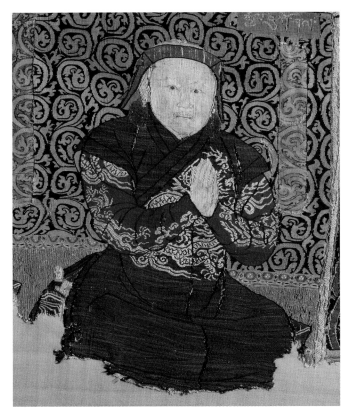

Buddhism had been in decline in India for some time as a result of intense competition from Hinduism, but it was brought to an abrupt end in north India, the place of its origin, following the Ghurid conquest (1192–1206) and by subsequent invasions from competing armies that resulted in the destruction of many great Buddhist centers.[3] The situation was quite different in Tibet, however, where monasteries were being expanded and lavishly refurbished with the support of feudal political elites and merchants. The artistic glorification of Tibetan religious centers occurred at a moment when charismatic monks competed to attract educated monastic communities. We know a great deal about this period from later Tibetan histories, especially those compiled by the monastic historian Taranatha (1575–1634), which describe the eleventh to thirteenth century in terms of important texts, translators, and teachers. Taranatha also tells of Tibetan monks and lay followers who made the difficult journey over the Himalayas and down to the Indian plains seeking authentic Buddhist teachings. Particularly important for the transmission of tantric doctrine were *mahasiddhas* (great awakened ones). These Indian ascetic masters, who lived outside the monastic system, were sought out by Tibetan monks and students. Although *mahasiddhas* like Virupa (see pls. 74–76) are, to greater or lesser degrees, quasi-historical figures, the Tibetan individuals who brought

Fig. 2. Lay translator Marpa. Tibet, 17th century. Bronze inlaid with copper and silver with gold plugs, H. 7 ½ in. (19.1 cm). The Metropolitan Museum of Art, New York, Purchase, Friends of Asian Art Gifts, 1995 (1995.176)

Fig. 3. Vajrabhairava Mandala (pl. 99), detail showing Tugh Temür, a great-grandson of Khubilai Khan. China, Yuan dynasty (1271–1368), ca. 1330–32

back the tantric teachings they revealed are recorded in written monastic histories, together with descriptions of their roles in establishing the teacher-student lineages that form the basis of the various Buddhist orders, or schools, in Tibet. For example, the Kagyu order drew on the tantric teachings of the lay translator Marpa (1012–1097; fig. 2), who made several trips to India to study with the great *mahasiddha* Naropa (956–1040/41). In other instances, learned Indian monks traveled to Tibet. Atisha (982–1054), for one, instructed Tibetan students who went on to establish the Kadam school (pl. 2). The various Tibetan orders offered different tantric teachings and actively competed with one another for students and patronage. Particularly politically adept was the Sakya school, and one of its leaders, the monk Phagpa (1235–1280), established a relationship with the Mongols. Under the emperor Khubilai Khan (1215–1294), Phagpa ultimately became Imperial Preceptor—a role that served to bring prosperity and protection to the Tibetan people (see pl. 99, a Vajrabhairava mandala from China in which the Tugh Temür, a great-grandson of Khubilai Khan, is shown at the lower left; see also fig. 3).

Scholarly understandings of Tibet have often drawn on written Tibetan histories and textual accounts. This volume attempts to explore the eleventh to the fifteenth century from a different perspective by focusing on how visual culture was used to promote Tibetan Buddhism. We already know a great deal about what the texts can tell us, but what does the art itself reveal about Buddhist practice in Tibet and how it changed over time? Dramatic and sumptuous artworks enlivened by dynamic teachers inspired kings and wealthy merchants, who in turn sponsored the creation of even more spectacular sacred precincts (fig. 4). Ultimately, this powerful and sublime imagery attracted foreign sponsors like the Mongols. While Buddhas and bodhisattvas were accessible and drew in the common person, monks had at their disposal the powerful tantric tradition that emphasized secret esoteric rituals centered on Vajrayana deities and was given form through spectacular mandalic imagery, such as a twelfth-century mandala that retains much of the north Indian style of the Pala dynasty (pl. 98), which controlled the great monasteries and sites associated with the Buddha's life. Practices that offered kings material control over this world afforded them the possibility to bring prosperity to their people, subjugate demons, and, perhaps most importantly, defeat enemies in battle.

In terms of introducing Buddhism to Tibet, the complexities of crossing or skirting the massive Himalaya mountains set the stage in ways that one might not expect. Traders, pilgrims, translators, and other travelers could move along the Silk Road to reach India via routes that traverse what is today Afghanistan and Pakistan, and this was the preferred way to reach western Tibet. Alternatively, from central Tibet it was possible to cross the high Himalayas to drop down into the Kathmandu Valley (see Map),

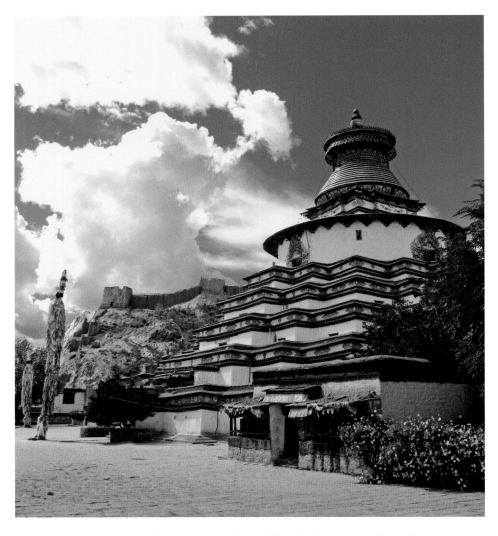

Fig. 4. Kumbum three-dimensional mandala in Gyantse, Tibet, founded 1427

but these passes were dangerous and could only be undertaken during the summer months, when it was relatively warm. However, with the summer arrived the monsoons on the plains of India, and Tibetan accounts speak emphatically about disease during the wet season.[4] It was preferable to wait in the Kathmandu Valley for the dry season, when malaria subsided, before descending to India. On the return, this same process of waiting for a seasonal change in Nepal was repeated, because the high mountains could not be crossed in winter. This meant that Nepal had prolonged contact with stalled travelers from both Tibet and India, leading to profound cultural exchanges. Over time the Kathmandu basin became a vital trading entrepôt and part of an international exchange network. Indian and Nepalese artisans traveled to Tibet seeking patronage along these routes, giving them an outsized role in the artistic development of Buddhist imagery. Ultimately, Nepalese artists traveled as far as China, where artists like Aniko (1245–1306) received imperial commissions from the Yuan court.[5]

Bodhisattvas and Goddesses

The average lay Buddhist in Tibet naturally hoped for prosperity and a positive rebirth, and a large body of sublime and evocative artworks was commissioned to facilitate these goals. Especially important were representations of bodhisattvas, beings who have reached a state of enlightenment but remain in this realm of existence to help others. Particularly popular is Avalokiteshvara, identifiable by the lotus flower he holds in his proper right hand, as he allows for the true perception of reality (pl. 33). Say his name and he will always be present for the devotee, to whom, out of compassion, he offers not only clarity but also protection. The mantra "Om mani padme hum," written countless times on paper spooled within prayer wheels (fig. 5), is activated by the devotee spinning the drum as a way to invoke this tranquil and compassionate deity. He appears in various forms, including a manifestation with a thousand arms and many heads (pls. 34, 35), emphasizing his powerful, universal nature and ability to address the concerns of the masses. Equally important is the bodhisattva Manjushri. He possesses a mastery of words and the ability to convey the

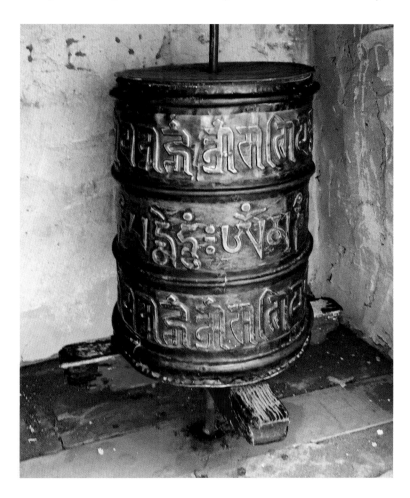

Fig. 5. A prayer wheel containing repeated mantras to the bodhisattva Avalokiteshvara, written on spooled paper contained within the drum, Alchi, Ladakh, India

Buddha's Four Noble Truths, providing the worshipper immediate access to this path to enlightenment. Not surprisingly, he is identifiable by the book, symbolizing doctrine, and the flaming sword that cuts through ignorance, which, in a monumental tapestry from Qing-dynasty China (pl. 30), can be seen supported by lotuses above either of Manjushri's shoulders (fig. 6). Another important bodhisattva is Vajrapani, who embodies the very power of enlightenment, as exemplified by a seventh- to eighth-century image from north India wherein he holds a pronged *vajra* (thunderbolt associated with the power of enlightenment) in his proper right hand (pl. 36). Collectively, these three bodhisattvas capture the idea of correctly perceiving (Avalokiteshvara) the doctrine (Manjushri) that leads to enlightenment (Vajrapani), and this triad is sometimes shown together. The very concept of bodhisattvas having the potential for enlightenment goes back to the second or third century CE, with Maitreya. This bodhisattva waits in heaven for the moment when the doctrine has been forgotten and lost and the Buddha's relics are no longer venerated. Only then will he be reborn, reach enlightenment, and, as the next Buddha, reveal the dharma. In a seventeenth-century example from Mongolia (pl. 28), Maitreya can be identified by the flask of an ascetic that he holds in his left hand, because in his final rebirth, he will retreat to the forest like the historical Buddha in order to reach enlightenment.

Related to the bodhisattvas are the many manifestations of the goddess Tara, wonderfully presented in a late twelfth-century painting (pl. 38; see also pl. 39). She protects her devotees and is often invoked in her twenty-one forms to bring monasteries security and auspiciousness. Goddesses, often paired with male deities in the tantric art of Tibet, are associated with action, including the action of cognition (pl. 102). In this light, the goddess Prajnaparamita often appears on book covers or in illustrated manuscripts, as she embodies the very act of conceiving and understanding the enclosed text (pl. 17).

Protectors of the Dharma

Images of protector deities are another major category of Tibetan artistic production. They defend the community from demons and evil forces and, by extension, safeguard Buddhist teachings. Mahakala, who often guards doorways into monastic sacred enclosures, is the most often represented of these fearsome deities. Mahakala's terrible nature was reassuring to the faithful, as he was understood to be a fierce manifestation of the compassionate bodhisattva Avalokiteshvara, destroying evil and corruption. According to north Indian texts, Mahakala will eat raw anyone who "hates his preceptor [or] is adversely disposed to the Three Jewels [the Buddha, the monastic community, and the dharma]."[6] In one sculpture of the eleventh or twelfth century (pl. 51), Mahakala holds in his upper hands a sword and

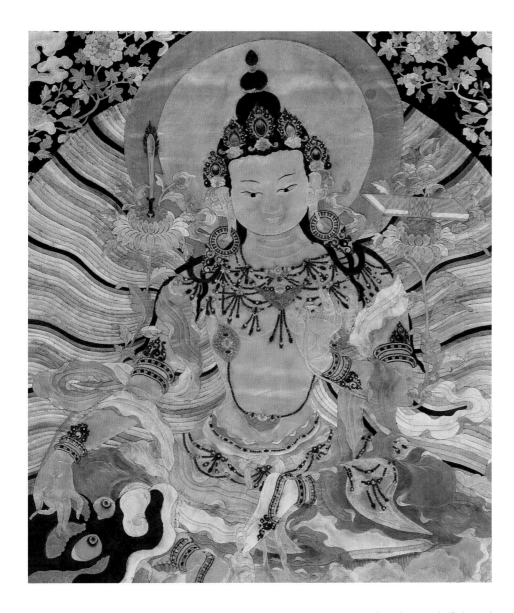

Fig. 6. Manjushri, the Bodhisattva of Transcendent Wisdom (pl. 30, detail). China, Qing dynasty (1644–1911), 17th–18th century

a skull-topped staff (*khatvanga*) with a *vajra* at its tip. In his lower left hand he grasps a skull cup, which would have been understood to contain blood and gore, and his now broken right hand probably once held a flaying knife or chopper, weapons associated with the destruction of one's own ignorance and ego in the pursuit of liberation. The role of Mahakala, who has his origins in India, greatly expanded in Tibet, where his protection of monasteries and the dharma was particularly emphasized (see "Visualizing the Taboo in Esoteric Buddhism" in this volume).

Female protectors who assertively take action to destroy demons are especially favored in the Tibetan tradition, among them Palden Lhamo, seen in a powerful fifteenth-century painting from central Tibet (pl. 57). Yet another protector originating in India is Rahula, who, during eclipses, is understood to swallow the sun, moon, and other planets. A fifteenth-century

Tibetan bronze (pl. 54) shows Rahula with the coiled body of a snake and nine heads, each associated with a different planet, culminating in a raven at the top. Rahula functions to protect "revealed treasure" doctrine—that is, that which is hidden until the correct moment. Key to the veneration of these fierce deities are *gonkhang* shrines, found attached to most monasteries. These shrines were officiated by the monastic community but accessible to the lay public, as they ensured protection from evil forces. Traditionally, protector deities were also understood to punish evil within the community. A particularly suitable category of offerings for these terrible protectors, also housed in the *gonkhang*, are weapons and armor that had been used in battle (pls. 66–72).[7] Often, these military pieces are embellished with Buddhist symbols, such as the *vajra*s done in gold shellac on a leather helmet of the fifteenth to seventeenth century (pl. 66), which were meant to protect the wearer, or the monster masks found on sword hilts (pls. 70–72), which made the weapon more effective. In turn, this iconography carried meaning within the context of the *gonkhang* as an offering suited to a deity tasked with protecting the dharma.

Tantric Deities

Many of the finest Tibetan Buddhist artworks ever produced are tantric or Vajrayana in nature, which is striking, as it shows that this enigmatic and inaccessible ideology was valued at the highest levels of society. Since visualization and self-identification with the divine are central to tantric practice, it is perhaps not surprising that elite patrons sought out the best artists to produce exquisite imagery of this complex Buddhist pantheon. This level of patronage also speaks to the centrality of tantric Buddhism and the importance of the monks and ascetics who were able to conduct tantric rituals on behalf of the individual and the kingdom. The overwhelming intricacy of Vajrayana imagery makes it impressive and awe-inspiring, and it demands interpretation by a ritual specialist, thus elevating the importance of certain learned monks and the monasteries they presided over (see pls. 1–7). It is important to remember that, for the average person, the mainstream Buddhas and bodhisattvas such as Maitreya and Avalokiteshvara were the focus of day-to-day devotional practices. Still, the public also understood that tantric deities were being properly invoked and venerated within great monastic institutions for the benefit of all.

Turning to Vajrayana artworks themselves, we are meant to be impressed by a seemingly overwhelming group of tantric deities that includes Chakrasamvara (pls. 88, 89, 96), Guhyasamaja (pl. 83), Hevajra (pls. 80, 81, 102), Manjuvajra (pl. 97), Vajrabhairava (pl. 99), Heruka (pl. 98), Raktayamari (pls. 82, 103), and Achala (pl. 84), and, on the goddess side, Vajravarahi (pls. 90, 91), Jnanadakini (pl. 101), Kurukulla (pl. 92), and many others. Certainly, when taken together, this complex iconography, drawn from

tantric texts, along with the many secondary deities and intricate contextual framework, is not easily understood or explained. In this light one can think of Vajrayana images as functioning like complex machines. For a ritual to work, all must be correct; every tiny detail must be in place. However, as with any sophisticated mechanism, there is no expectation on the part of the patron to understand its intricacy. Noteworthy is the Buddhist idea that our perception of reality is illusory, while the divine realm described in the tantras, though difficult to grasp, is true and real.

The source of tantric practice in Tibet can be traced back to India, to quasi-mythical ascetic *yogins* who lived outside the great monasteries—that is, the *mahasiddhas* (see pls. 74–79), introduced briefly on pages 18–19 above. The ideal was that an ascetic individual could reach Buddhahood in this life through tantric practice involving visualization with or without the use of mandalas and other artworks, yoga, mantras, and transgressive acts (see also

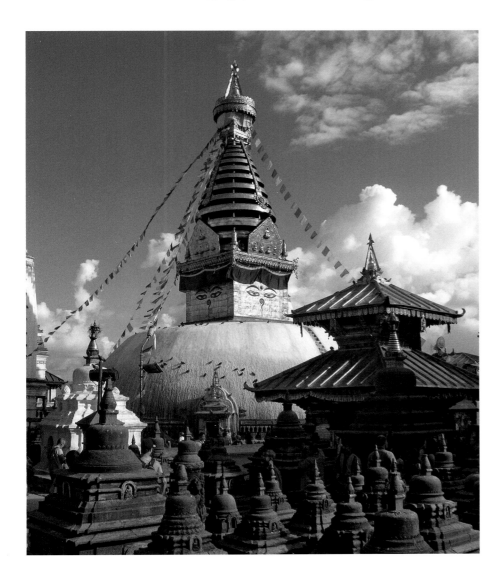

Fig. 7. Swayambhunath stupa in the Kathmandu Valley, Nepal, founded Licchavi period (ca. 400–750) or earlier

"Teachers and Texts" and "Visualizing the Taboo in Esoteric Buddhism" in this volume). These great achievers became extremely important in Tibet as the progenitors of monastic lineages. Fortunately, we know something of how imagery was used and understood in this early period from the *Manjushrimulakalpa*, a northwest Indian text written in about the eighth century. It speaks to how religious images and paintings on cloth, called *thangka* in Tibet, functioned. This text specifies various formats for their creation: large ones, suitable for reaching enlightenment; medium ones, better suited to more mundane goals such as kingship; and small ones, for rituals.[8] The idea of creating order and establishing a pure, uncorrupted foundation for the image is critical; when constructing a temple, this effort involves purifying the ground it sits upon—in effect, plotting a piece of sacred geography. In fact, the tradition of creating mandalas out of sand espouses this idea of crafting an unmoving, purified place in which the central deity can reside (see fig. 21). Once created, a sand mandala cannot be moved; in fact, after ritual use, it is usually swept up and the sand deposited in a river. Considered in this light, the portability of a painting presents a problem, so the woven cloth is consecrated, and there is considerable discussion surrounding the purification of the cotton materials. A correctly structured underdrawing for the divine image is also essential (pl. 41). In fact, we are told that, once completed, the painting should be affixed to the auspicious west face of a stupa, or relic mound (fig. 7), and worshipped with offerings of butter lamps (pl. 65). By ordering base raw materials and creating a painted representation, there is the stated goal of structuring our world like the well-ordered realm of the bodhisattva Manjushri, to whom the *Manjushrimulakalpa* is devoted.[9]

Mandalas

It was put forth at the start of this essay that mandalas are, fundamentally, diagrams of the universe. In Tibet, these ritual diagrams are understood specifically to house tantric deities, and they were created under the guidance of monks familiar with the content of the associated tantric texts. Once completed, painted mandalas were designed to be rolled up for both easy transport and removal from public view, functioning like portable temples dedicated to specific deities. The ritual practitioner often acted on behalf of the patron of the mandala to achieve a particular goal. Indeed, one can understand why, for instance, a king would want to enjoy the favor of certain powerful divine protectors. While seemingly complex, the structure of the mandala follows a logical pattern and is designed to foreground and exalt the central deity, as it presents this figure in a space that is understood to be true and correct.

Let us consider a group of mandalas (pls. 95–103) and break down their common features (fig. 8). As with a temple or a stupa, there is the idea

of moving clockwise through the space, starting at the periphery and proceeding toward the center. Across the top is a horizontal register, often containing a lineage of Tibetan teachers that traces back to a north Indian *mahasiddha*, thus showing the transmission of the specific tantric teaching in question (pls. 95, 99, 101, 103). Alternatively, this top band can contain tantric deities and protectors (pls. 97, 100, 102) or a field of Buddhas and bodhisattvas (pl. 98). Similarly, the bottom register often features a row of deities and protectors that safeguards the space of the mandala. We often also see, in the lower corners, the donor figures who commissioned the mandala or a monk officiating a ritual to eternally consecrate the work (pls. 96, 99). Within the main field in these examples are concentric circles that include bands of multicolored flames, *vajra*s, or lotus petals. These circular bands consistently enclose a square structure representing a palace seen from above. In this sense, the circular bands demarcate the sacred space of the center from the profane space of our world, and if this were a three-dimensional temple, they would serve as its base. The palace structure has four gateways, corresponding to the four cardinal directions. The gates are flanked by arched prongs so that the towers of the gate and the prongs can be read together as a *vajra*. These *vajra*s conceptually connect under the palace and mark a place of perfect stability for the primary figure at its center. A

Fig. 8. Left: Mandala of Raktayamari, Central Tibet, late 14th century (see pl. 103). Right: The basic scheme of a mandala: A) the topmost row is often filled with a monastic lineage tracing back to a *mahasiddha* or Buddha; alternatively, it can be filled with deities or protectors; B) this row is usually filled with deities and protectors; C) often, an officiating monk or patron(s) is shown here; D) a ring of flames, *vajra*s, and lotus petals demarcates the space of the mandala; E) four *vajra*-shaped gateways surround the F) celestial palace, which is seen from above, divided into color-coded directional sections, and populated with manifestations of the central deity and other primary deities; G) the central deity and their consort are the focus of the mandala.

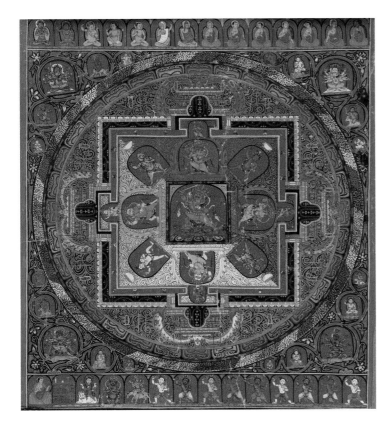

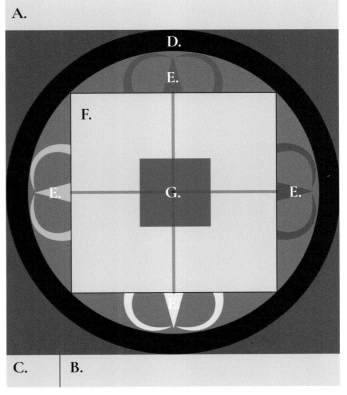

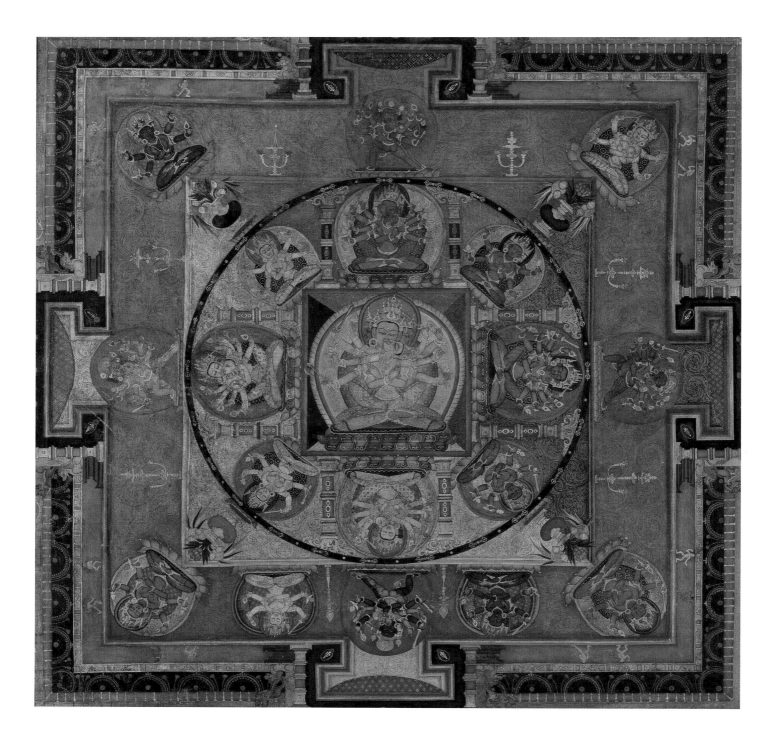

Fig. 9. Manjuvajra Mandala (pl. 97, detail). Tibet, late 12th century

complex array of auspicious and powerful deities and emanations of the main figure populate this palace structure. Finally, we reach the central deity, usually shown in sexual embrace with a consort, for example, Manjuvajra and his consort Prajna (fig. 9).[10] Today, tantra has become almost synonymous with yogic sexual practice, which misses the point, as it is really about the conceptual unity of distinctive qualities associated with the male and female

deities. In essence, the male embodies the concept and the female represents the action of its realization. Manjuvajra is a tantric form of Manjushri, the bodhisattva who cuts through ignorance and preserves Buddhist dharma. The *Nishpanna Yogavali* (Garland of Perfection Yoga), a text written in the eleventh or twelfth century, explains Manjuvajra's function and provides a precise description through which the devotee is meant to visualize him, thereby potentially gaining wisdom, retentive memory, intelligence, and eloquence—the very skills required to understand and master complex tantric texts.

Sometimes mandalas were created in sets, for example, the four mandalas presented together in a single *thangka* of the mid-fifteenth century (pl. 100). The painting was part of a much larger set of works linked to the *Vajravali* (Diamond Garland) text. In this instance, they were commissioned by a student in honor of his late teacher. The creation of groups of mandalas is also seen in early monastic wall paintings, a good example being those embellishing the interior of Alchi monastery in Ladakh (fig. 10). This leaves open the possibility that other portable mandalas were used in groups. Indeed, in modern wall paintings found across the Tibetan cultural zone, multiple tantric deities are shown in juxtaposition, suggesting that the combination of these figures created a more effective space in which to conduct Vajrayana practices. Tenzing Rigdol's installation, with its many mandalas floating in a turbulent sea of emotion, draws on this idea (see pl. 104 and figs. 47–51). Viewed as a unified statement, the multipart composition transcends the meaning or significance of any one of these contemporary mandalas. The installation calls on viewers to contemplate this complex ideology as a single artistic expression. The simple central image, which Rigdol suggests is all about interdependence, invites the viewer to consider just such an interpretation.

Fig. 10. Mandala murals adorning the walls of Alchi monastery, Ladakh, India

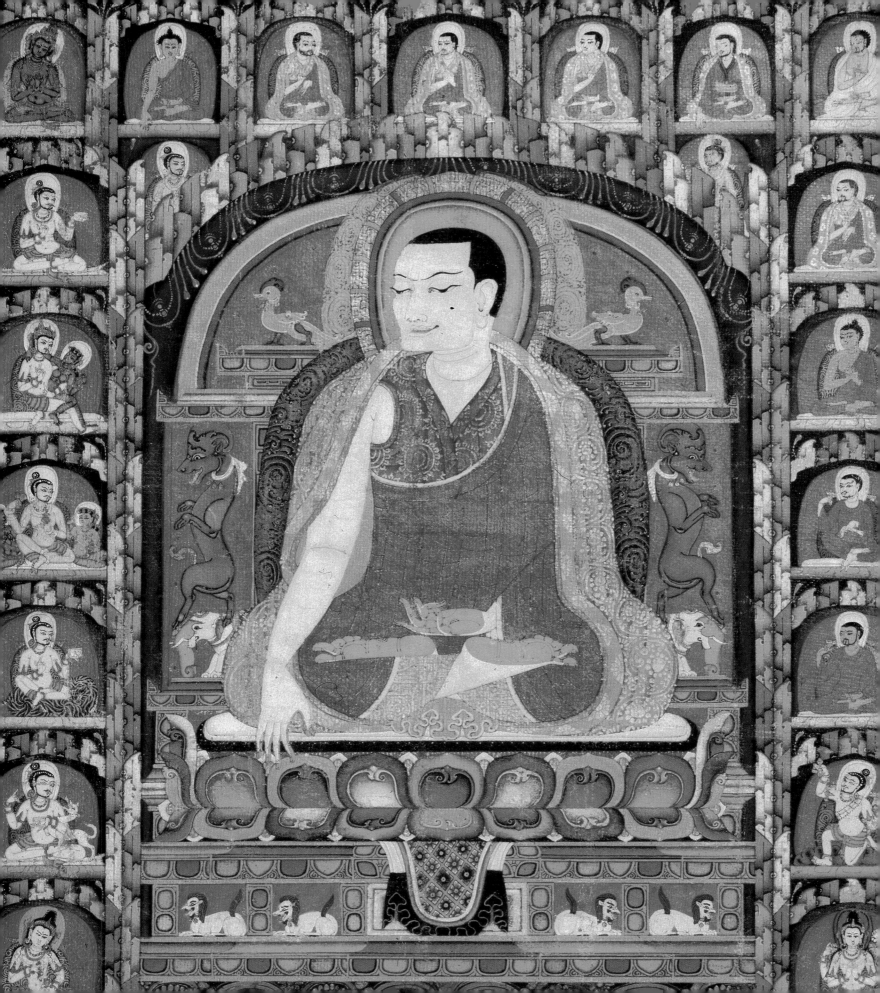

Teachers and Texts

Kurt Behrendt

Tibetan monastic imagery is less about portraying an individual than it is about showing one who has mastered subtle teachings and reached a state of awakening or enlightenment. As a result, these sumptuous images are formal and idealized, with the person presented in artworks almost like the Buddha himself. Such an approach agrees with Tibetan written histories that emphasize how individuals came to obtain an in-depth understanding of sacred texts, and it is this mastery that artists sought to highlight in complex and refined images. Given the importance of bringing the Buddhist scriptures to Tibet and translating them, it is significant that the texts were thought to be incomplete without the guidance of a teacher who was able to reveal and transmit their deeper meaning. For Tibetans, this meant tracing a direct line of transmission from teacher to student, with roots stretching all the way back to the Indian masters and original texts.

Portraying Teachers in Tibet

In the late twelfth to early thirteenth century, the idea of representing a spiritual leader (lama) in Tibet was still new. In fact, the idea of depicting a monk had never been part of the Indian tradition; even prominent monks were seen as insignificant, as they remained caught in the ocean of rebirth and thus were unworthy of depiction. It was in Tibet that the idea was introduced to visually represent an individual as the counterpart to a text—that is, as the one who could reveal the underlying aspects of its teachings. The resulting portraiture is iconographically rich, and its beautiful imagery helped legitimize leading teachers. One example is a fine portrait of a master of the Tibetan Kadam school of Buddhism from about 1180–1220 (pl. 1). While the specific identity of the portrayed lama is unknown, the formality of his depiction and the juxtaposition of other figures and deities around him shed light on his perceived role within the monastic community (fig. 11).[1] Seated immediately above him is the white, four-armed bodhisattva Shadakshari Avalokiteshvara. The affiliation suggests that the lama, like the bodhisattva, comprehends the true or correct nature of reality. Flanking Avalokiteshvara are generations of past teachers that can trace their scholarly lineage back to the north Indian monk Atisha (982–1054), here shown seated to the bodhisattva's right, wearing the high-peaked hat

OPPOSITE: Portrait of the Third Kagyu Taklung Abbot, Sangye Yarjon (pl. 6, detail). Central Tibet, ca. 1262–63

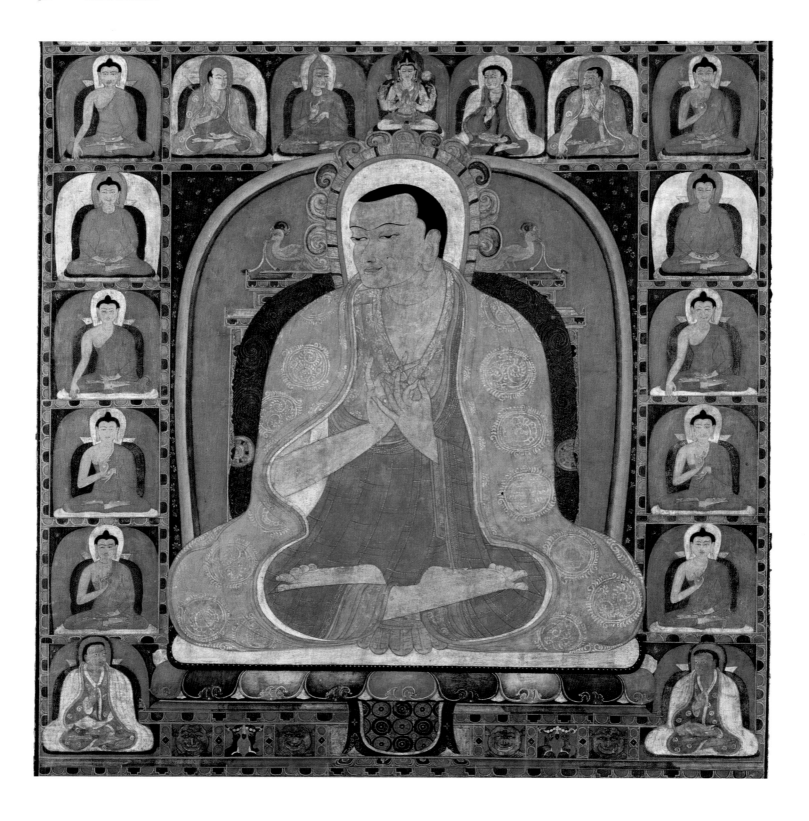

of a *pandita*, or wise and learned one. These figures show that the doctrine originally was transmitted from India and descended along a line of teachers and their students, culminating with the central lama, who holds his hands in a gesture of instruction, much like the Buddha would. The artist further aggrandized the lama by giving him a halo and positioning him on a lotus base, which rests on a throne supported by lions and elephants. Surrounding the composition on the top and sides are multiple seated Buddhas that speak to the limitless potential for reaching enlightenment. Finally, in the bottom register, a monk and five goddesses make offerings, while a fierce, sword-wielding Mahakala (see pp. 63–64 in this volume) protects the space of the painting. Both lay and monastic community members who saw this painting would have understood the lama to be almost like a Buddha, suggesting his ability to provide direct access to enlightenment for the devotee. In turn, the lama loses much of his individual identity to become one who, above all, embodies Buddhahood. Portraits like this massive example also, by implication, legitimized the associated monastic institution and its claim to offer devotees access to authentic teachings that ultimately traced back to the Buddha's first sermon in India.

Atisha is often seen in monastic lineages as a progenitor and source of doctrine, but full-size portraits of him are rare, for within Tibetan monasteries each subsequent generation needed to claim the role of enlightened patriarch for itself. In perhaps the earliest known portrait of the monk, made in the early to mid-twelfth century (pl. 2), a generation or two after his death, Atisha is seen twisting his head as if in conversation, and he holds his right hand in the gesture of discourse (a variant of the *vitarka mudra*). The artist strove to bestow divine status on the figure by endowing him with golden flesh, a halo, and an elaborate lion throne. When Atisha left north India for Tibet in 1042, at the invitation of a West Tibetan king, his stated goal was to restore correct and authentic teachings and to purify Mahayana Buddhist tradition, the foundation of Buddhist practice in Tibet. Here, the long north Indian manuscript he holds in his left hand (fig. 12) is an iconographic indicator of this goal. While numerous Tibetan monks had visited India seeking texts, only a handful of Indian teachers ever traveled to Tibet. By Atisha's time, Buddhism was flourishing, with historical records suggesting that there were two to three hundred active temples in central Tibet.[2] This lively cultural exchange with India is evident in the painting: Atisha is dressed in the manner of a north Indian monk, with his pointed scholar's hat and robes that leave his right arm uncovered. Biographies tell us that Atisha was initiated as a monk at the north Indian site of Bodhgaya, where the historical Buddha Shakyamuni attained enlightenment. He then studied at Nalanda, the influential monastic university in north India renowned for its great libraries (see Map). Atisha went on to become the abbot of Vikramashila monastery, a famous tantric center and probably

Fig. 11. Portrait of a Kadam Master with Buddhas and His Lineage (pl. 1, detail). Central Tibet, ca. 1180–1220

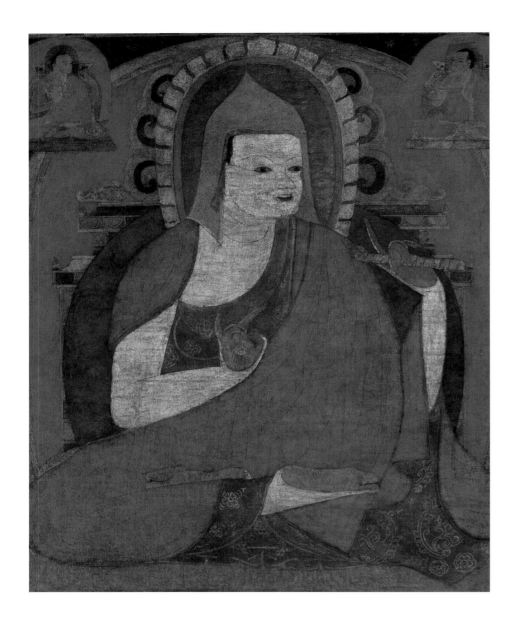

Fig. 12. Portrait of the Indian Monk Atisha
(pl. 2, detail). Tibet, early–mid-12th century

the largest monastic establishment ever built on the subcontinent.[3] He
purportedly also took advantage of maritime trade routes to travel to
peninsular Southeast Asia to study at the Vajrayana centers of Srivijaya.[4]
Such actions gave Atisha credibility and status, but one wonders whether his
many achievements in fact reflect the combined efforts of numerous monks,
who are remembered together in Atisha's biography. While several early
sources recount his work as a translator and scholar,[5] the story of his life
known in Tibet today was recompiled at the end of the sixteenth century by
the monastic historian Taranatha (1575–1634).

Shakyashribhadra (1127–1225), originally from the tantric center of
Kashmir, served as the abbot of Nalanda and was another influential monk
who traveled to Tibet. In a portrait from the early to mid-fourteenth century

(pl. 3), executed about a century after his death, Shakyashribhadra sits at center within an architectural structure,[6] identifiable as the Mahabodhi temple at Bodhgaya; note the branches of the Bodhi tree among the temple's eaves. The emphasis on the temple (fig. 13) is significant, as Tibetan historical records mention at least eighteen named Tibetans and nine others that visited the site, and many replicas of the temple were created in Tibet, leaving little doubt about the recognizability of this structure. Like the Buddha, Shakyashribhadra has a halo, but he is flanked not by bodhisattvas but by two monks, likely members of his entourage. Shakyashribhadra, like Atisha, was committed to disseminating Mahayana teachings as the necessary and popular foundation for tantric practices. His biography, which is recounted in the surrounding episodes, emphasizes the site of Bodhgaya, deities such as the future Buddha Maitreya (see pls. 27, 28), and visions that Shakyashribhadra had of the goddess Tara (see pls. 38, 39), all of which form part of the core of the Mahayana tradition. However, there

Fig. 13. Mahabodhi temple at Bodhgaya, Bihar, India, which sits adjacent to the Bodhi tree where the historical Buddha Shakyamuni reached enlightenment

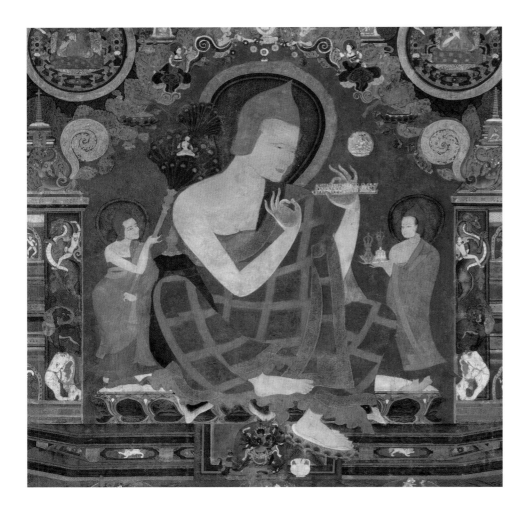

Fig. 14. Portrait of the Last Indian Pandit, Vanaratna (pl. 4, detail). Central Tibet, first half 15th century

are also episodes showing the monk's ability to invoke powerful Vajrayana deities such as Chakrasamvara (pls. 88, 89). Additional imagery highlights Shakyashribhadra's standing as a tantric practitioner and his ability to initiate advanced students so that they, too, could visualize and access esoteric deities (see pl. 94).[7] One of this teacher's most significant legacies is his role in establishing enthusiasm for Indian scholarship in Tibet. A good example is his argument for a Buddhist chronology that likely has its roots in the Sri Lankan Theravada tradition, a position largely consistent with scholarship today.[8]

The last great Indian teacher to visit Tibet was the monk Vanaratna (1384–1468), who can be seen in a painting made in the first part of the fifteenth century (pl. 4).[9] Vanaratna, who was born far to the east in the city of Chittagong, in present-day Bangladesh, went in search of teachings long after the great Buddhist centers of north India had fallen into ruin at the end of the twelfth century. He traveled to south India and Sri Lanka before looking to the Himalayas and settling in Nepal. He made three trips to Tibet, in 1426, 1433, and 1453. There, he met with important Buddhist

masters, taught students, and wrote extensively. He was revered for his establishment of Kalachakra Tantrism, though in the present painting, the surrounding figures trace a Vajravali lineage (see pl. 100).[10] Vanaratna had truly international status, as attested in biographical accounts of his disciples and in imagery like this spectacular portrait, which reflects the adoption of a Nepalese style in Tibet (fig. 14).[11] The fact that Vanaratna was the last to come from the eastern plains of the Indian subcontinent was important to the Tibetans, and the artist makes efforts to indicate this connection. Like Atisha, the monk wears the pointed hat of a *pandita*, and his robes leave one shoulder exposed, perhaps in reference to the warmer climate of India. Small stupas (relic mounds) above may suggest the sacred geography of India or even of Nepal. Perhaps the most significant symbol underlining Vanaratna's authority and connection to India is the long, open palm-leaf Sanskrit manuscript in his left hand.[12]

Each generation of monks established legitimacy by tracing its teachings back through teacher-student lineages to an enlightened founder, and often a series of monastic portraits was sequentially presented in major monastic centers to emphasize this religious authority. The original source could be the historical Buddha or a yogi who had attained enlightenment through tantric practice—that is, a *mahasiddha* (see pls. 74–79). These ascetic *yogins*, who lived outside the great monasteries in India, were considered the source for most tantric practices. It was believed that an ascetic individual with strong mental faculties could daringly walk down the riskier tantric path and reach Buddhahood in this life. Through yoga, the propitiation of deities, the recitation of mantras, visualizations, the use of mandalas, and transgressive acts, *mahasiddha*s attempted to gain power over different spheres of existence. If successful, these efforts led to a *siddhi,* or "attainment." *Siddhi* powers could be grounded in this world, such as the ability to fly or to attract a lover, or as transcendent as reaching Buddhahood. The key idea is that divine forms are absolute and true and not arbitrary imagination, and it is this that the *mahasiddha*s were able to perceive through tantric practice. To put it another way, self-identification with these awe-inspiring and terrifying tantric deities is essential to achieving rapid progress toward enlightenment, which would otherwise dissolve before the individual could realize a *siddhi*.[13] These "great achievers" (the literal translation of *mahasiddha*) came to be extremely important in Tibet and are frequently represented visually in painting and sculpture.

The idea of who might become a *mahasiddha* is inclusive and applies to all walks of society. One story tells of the warrior-king Kirapalapa, infamous for leading violent campaigns of plunder against neighboring cities. In a fourteenth-century Nepalese terracotta sculpture (pl. 79), he stands in an active pose holding a sword and gesturing with a diminutive shield, as befits his history of violence. He is dressed in fine garments with

the jeweled diadem, earrings, and necklace of a king (fig. 15). According to legend, after witnessing women, children, the sick, and the elderly suffering in the wake of one of his army's conquests, he repents, and like many pious Buddhist kings before, he begins to distribute his wealth to the needy as an act of compassion. This age-old story is given a tantric twist when Kirapalapa meets an ascetic begging at the palace gates. This stranger offers him instruction on the bodhisattva path and how, through initiation to the tantric deity Chakrasamvara, he could reach Buddhahood in a single lifetime. However, Kirapalapa's previous lust for wealth overwhelms his concentration. Only after twelve years under this *yogin*'s guidance, meditating on the defeat of enemies and the bliss of victory, does he achieve a *siddhi*. In a classic tantric sense, Kirapalapa spoke of this attainment through the notion of one poison destroying another, stating, "And with your warrior's rage / Destroy every demon that enters your mind."[14] The *mahasiddha* tradition is wonderfully flexible in that it recasts old Buddhist

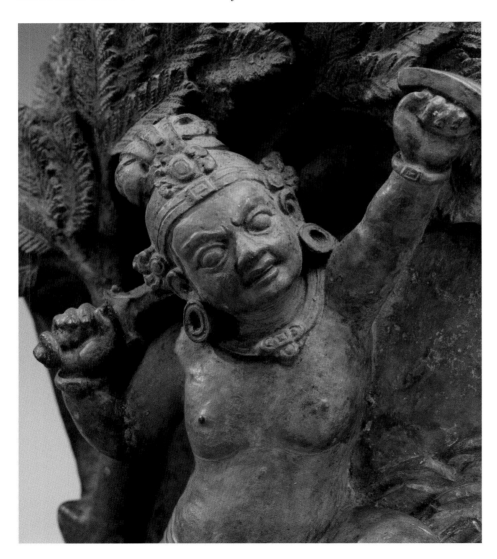

Fig. 15. Mahasiddha Kirapalapa (pl. 79, detail). Nepal, Kathmandu Valley, ca. 14th century

ideas to allude to new ways of reaching enlightenment. Moreover, the many *mahasiddhas* from different social strata must have appealed to both monks and laypeople who shared similar personal histories and saw in them a path to their own salvation.

Indeed, not all the great seekers of Buddhist knowledge in Tibet were monks. The lay community also participated, and some of these individuals were revered as important teachers and ordained lineage holders on a par with the most prominent monks. For example, the Kagyu order drew on the tantric teachings of the lay translator Marpa (1012–1097), the son of a prosperous merchant who financed three trips to India via Nepal to study with the influential tantric *mahasiddha* Naropa (956–1040/41), ultimately leading to his mastery of the *Chakrasamvara Tantra*, which became important in both Nepal (pl. 96) and Tibet (pl. 89). Depictions of Marpa tend to portray him in lay garments and with a full head of hair, emphasizing his status as a nonmonastic transmitter of doctrine (see fig. 2). After his final trip to India, he returned to his life as an ordained lay follower, managing his family's farms, engaging in translations, and taking on students, including the important meditator Milarepa (1040–1123). These religious pursuits led to the establishment of the Kagyu school of Tibetan Buddhism.

Along with the Kagyu school, other key schools of Buddhist teaching in Tibet included the Nyingma and Sakya orders and, ultimately, the Gelug school, which was founded in 1409. These schools each had different lineages and, hence, variably sourced tantric traditions centered on charismatic living masters who competed for the best students, built extensive libraries, and established monasteries. Lineage portraits served not only to give status to the living lamas but also to trace their teachings to enlightened founders. In a portrait of Ngorchen and his successor München, done about 1450–1500 (pl. 7), the two monks are nearly identical in appearance, which corresponds to the idea that the student has fully mastered the doctrine transmitted by his teacher and can convey it thereafter to his own pupils. The painting contains symbolism indicative of the clarity of enlightenment, such as the elaborate lotus throne they share, their halos, the flaming jewels above their heads, and the wealth of auspicious symbols surrounding them (fig. 16). Status and reverence are further expressed by the sumptuous materials, for instance, the extensive presence of gold, especially in their clothing, and of lapis lazuli, a costly mineral pigment. The use and masterful execution of such boldly contrasting colors imbues the lamas with a visceral presence, and such a lavish painting clearly reflects the most elite echelons of patronage. While the portrait shares iconographic features with certain depictions of the Buddha (see pl. 18), note how it is more decorative and materially luxurious, characteristics that may relate to the subjects' presence in our world. Indeed, the use of such materials and the emphasis on detail are defining characteristics of all monastic portraiture.

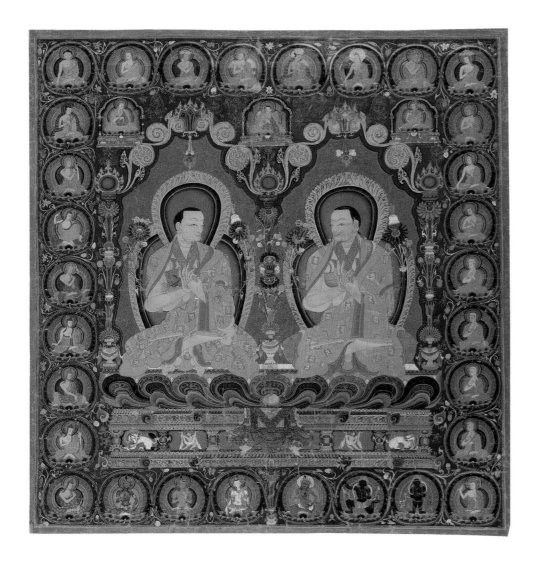

Fig. 16. Portrait of the Monk Ngorchen and His Successor München (pl. 7, detail). Central Tibet, 1450–1500

Illustrated Manuscripts and Their Covers

The transmission of Sanskrit texts to Nepal and Tibet was vital to the development of Himalayan Buddhist communities. In India, however, strong oral traditions emphasized the memorization of texts, so written sources were not always easily accessible, especially in the nonmonastic tantric tradition. For this reason, the libraries at major north Indian monasteries like Nalanda became especially critical repositories of Buddhist knowledge. In India's wet monsoon weather, texts quickly deteriorated and needed to be continuously copied, and by the eleventh and twelfth centuries, the corpus of Buddhist literature was vast. Many canonical texts are known today from only a limited number of original documents and from translations that survive in Nepal, Tibet, China, and elsewhere in the greater Buddhist world.

Certain texts were copied as pious acts of devotion, giving rise to the art of manuscript illustration. Of all the north Indian texts subject to repeated

transcription, the one most often copied as an act of devotion was the *Ashtasahasrika Prajnaparamita Sutra* (Perfection of Wisdom Sutra), as this source is thought to contain the totality of Mahayana Buddhist teachings. Take, for example, one manuscript that we know from its colophon was created in Nalanda during the third quarter of the eleventh century (pl. 8).[15] It then was brought to Tibet, where it passed through various hands, as recorded in colophons that date between the early thirteenth and mid-fourteenth centuries, even those of the Buddhist scholar Buton Rinchen Drub (1290–1364).[16] Marking its chapter headings are vibrant paintings of the finest quality, reflecting a donor's desire to spare no expense, as the creation of such a work was a way to generate merit for future rebirths. The central image of each of these headings shows a deity. The top page features the goddess Prajnaparamita, the very personification of the sutra in question. Other pages present the major bodhisattvas and the goddess Tara, all deities that protected and brought auspiciousness to the enclosed text. To either side of these central deities are depictions of events from the Buddha's life, including his birth from the side of his mother, Maya (fig. 17); his enlightenment; the first sermon; the miracle at Shravasti by which he multiplied himself; the descent from Trayastrimsha heaven; the taming of the maddened elephant Nalagiri; the monkey's gift of honey; and finally, the Buddha's death (*parinirvana*). Each event is associated with one of the eight great pilgrimage sites, mapping out a sacred geography specific to the Buddha in north India and, in the case of the birth, the edge of Nepal (see Map). Texts such as the *Prajnaparamita Sutra* were placed on altars and venerated as objects of power by devotees. This particular copy of the sutra would not have been read—accounting for its remarkable preservation—but rather treated as a dharma relic (textual teachings that stand in for physical relics), an idea that goes back to at least the sixth century in India.[17]

In Tibet, monastic libraries were often organized around the primary image hall surrounding the main devotional sculpture groups, as can be seen today at major temples such as Sakya and Hemis, among others. Texts translated from Indian originals included monastic rules of conduct (*vinaya*) and the Buddha's teachings (sutras), which were collected into 100 or 108 volumes and known in Tibet as the Kanjur (or Kangyur). The extensive commentaries that accompany these texts were also translated and assembled into the 225 volumes of the Tanjur (or Tengyur). All these texts came to be reproduced, and by the fifteenth century hundreds of monastic libraries contained the Kanjur and Tanjur as a foundation for their practice.[18] Since texts charge a sacred space with the power of the Buddhist teachings they contain, a library can be understood as an intrinsic component necessary to consecrate the space where monks gather for religious purposes. For the agricultural community, these texts shared a similar kind of meaning: they were taken from monastic libraries and processed around the fields at the

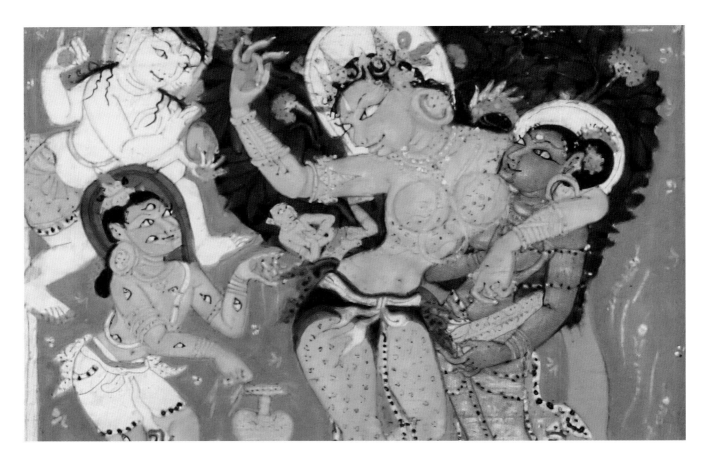

start of the growing season, to bless the crops and spread good fortune.[19] Thus, these books functioned not only as repositories of Buddhist knowledge but also as ritually potent objects to be worshipped and activated for the benefit of the community.[20]

Artists in Nepal were also keenly aware of the conventions and styles established in north India in the regions controlled by the Pala and Sena dynasties during the eighth to twelfth and eleventh to twelfth centuries, respectively. From this foundation they began to produce sophisticated illustrated manuscripts in a distinct Nepalese style.[21] The top half of one Nepalese wooden manuscript cover from the tenth to eleventh century again has at its center the four-armed goddess Prajnaparamita (pl. 12). As she is associated with the action of comprehending, her presence activates the text, which is understood to be male. This kind of dualistic relationship runs through the arts of the Himalayas, where male and female deities are shown in sexual embrace, signifying the idea of content and its conception. Flanking the goddess are four scenes from the life of the Buddha that draw attention to his sacred geography, similar to the palm-leaf manuscript discussed above on page 41 (pl. 8). Presumably, there were four more life scenes on the other cover, now lost, that together celebrated the eight great events of the Buddha's life.

Fig. 17. Leaf from an *Ashtasahasrika Prajnaparamita Sutra* (pl. 8), detail showing the birth of the Buddha. India, Bihar, Nalanda monastery, Pala period, third quarter 11th century

Not surprisingly, popular Mahayana texts were the most frequently commissioned in Nepal, as their reproduction was seen as an important way to generate merit. Consider a late eleventh- to twelfth-century illustrated *Gandavyuha* manuscript (pl. 10). As in north India, the text was inscribed into the surface of a prepared palm leaf, after which the letters were inked. However, the presentation of the narrative is quite unique, reflecting the Nepalese embrace of a more elongated figural type set against deep blue and red color fields. In this series, the devout son of a merchant named Sudhana appears repeatedly as he pursues a spiritual pilgrimage to find a teacher. To this end, he visits many bodhisattvas, including Maitreya and Avalokiteshvara, who each offer insight along his path to enlightenment. Closely related in style is a pair of twelfth-century Nepalese manuscript covers (pl. 13). Saturated fields of blue, green, and red create distinct spaces within which the narrative unfolds. The artist used different scales to integrate the figures into the scenes, as indicated by a tree or the built architecture of the cities (fig. 18). Fictive openings into the heavens allow celestial beings to witness the story of Sadaprarudita, who in his devotion to the goddess Prajnaparamita, seen to the left, offers his heart, blood, and the very marrow of his bone, which is what is being depicted as he leans against a wall to the right.[22] Related stories of self-sacrifice can be traced back to the earliest horizons of Buddhist narrative that present the past lives of the Buddha (*jataka*s). While demonstrating an awareness of the north Indian Pala style, the figures are more sculptural and strike dynamic poses, which speaks to the emergence of a distinctive and highly sophisticated Nepalese painting tradition that would go on to have a tremendous impact in Tibet (see pl. 97).

Works from Kashmir also contributed to the development of Tibetan illustrated manuscripts, especially in western Tibet. Trade routes readily crossed the high passes connecting Kashmir to early Tibetan monasteries like Tabo, in Spiti, and Tholing, in the high plateau region of Guge (see Map). Again, the Mahayana text of the *Prajnaparamita Sutra* was the focus of much patronage, and in one key example (pl. 11) we see the eponymous goddess holding aloft a book and a *vajra*, while her primary hands make the teaching gesture (*dharmachakra mudra*). A rainbow-rimmed full-body halo of gold frames her distinctive hourglass figure (fig. 19). It is not easy to know if this work was executed in Kashmir or western Tibet, as there is good reason to believe that its artists worked together in a multilingual, multicultural environment.[23] Textile patterns evoke Central Asian trade, and motifs like the swirling drapery have an even longer history, going as far back as Sasanian forms seen in Afghanistan. Here, the artists strove to provide dramatic images emphasizing saturated colors, namely, gold, lapis lazuli, cinnabar, and a green hue made from a mixture of indigo and orpiment pigments.[24] One significant difference observable in West Tibetan manuscripts is the shift to paper, a technology imported from China. While

the long, thin palm-leaf substrate used in north India and Nepal restricted the size of illustrations, paper manuscripts generally afforded the artist more pictorial space and, thus, resulted in larger images, as well as a greater emphasis on architecture and other contextualizing elements (see pl. 11c).

Looking at central Tibetan manuscript covers, the less oblong, rectangular format reveals the growing importance of paper in this region as the medium of choice. An exceptionally well-preserved pair of wooden covers from the late eleventh century gives us a sense of how north Indian painting styles of the Pala period impacted central Tibet (pl. 15).[25] Note especially the figural style and compare it to that in the north Indian manuscript of the *Prajnaparamita Sutra* discussed above (pl. 8). The upper cover shows, at center, the Buddha attaining enlightenment with the bodhisattvas Manjushri and Vajrapani to his right and Shadakshari Avalokiteshvara and Shyama (Green) Tara to his left. In contrast to this serenely composed pantheon, fierce tantric deities appear across the lower cover, protecting and bringing auspiciousness to the enclosed Buddhist text. Although these Vajrayana deities do appear in north Indian sculptures and manuscript illustrations, the grouping seen here, with a central bodhisattva flanked by Achala and Marichi at his right and Mahapratisara and Mahakala to his left, is a Tibetan innovation intended to provide more immediate access to the ideas contained within the enclosed manuscript.

Before long, as more and more manuscripts were written on paper, the Tibetans shifted to larger-format books that could accommodate greater amounts of text. Correspondingly, more-elaborate book covers began to be produced, placing even greater emphasis on these texts' exteriors. Take, for example, a late twelfth-century cover that places Prajnaparamita at the center surrounded by the Buddhas of the ten directions (pl. 17). This elegant gilded cover sets the stage for a long and varied Tibetan tradition, with motifs such as the intricate foliage seen here painted along the edges being translated into deep carving. Still, the early date of this cover is evident because of its relation to Pala motifs such as the spiked crown of the goddess, which is something seen only in early paintings (see pl. 38).

Fig. 18. Manuscript Cover (pl. 13), detail showing Sadaprarudita's self-sacrifice (right) as an act of devotion to the goddess Prajnaparamita (left). Nepal, Kathmandu Valley, 12th century

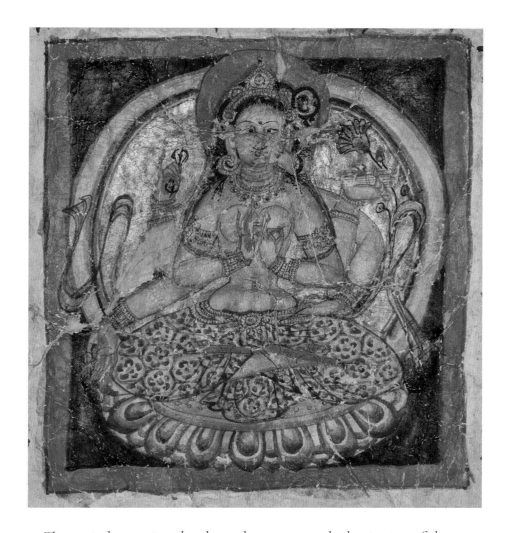

Fig. 19. Fragmentary Leaf from an
Ashtasahasrika Prajnaparamita Sutra (pl. 11b),
detail of the goddess Prajnaparamita. Kashmir
or western Tibet, 12th century

The period spanning the eleventh century to the beginning of the
thirteenth century was one during which Tibet absorbed the Buddhist
teachings of India. It was a time when many Tibetans traveled down to
the Gangetic plains to visit the last of the great monasteries, seeking out
both important texts and skilled teachers with the capabilities to interpret
and impart their subtle meanings. They also studied with ascetic masters,
the *mahasiddha*s, who were the progenitors of the teacher-student lineages
that came to be of fundamental importance to each of the major schools of
Tibetan Buddhism. Equally, a handful of accomplished monks from India
found their way to Nepal and Tibet, where they had a tremendous impact
on educated monastic elites at increasingly powerful Tibetan religious
establishments. It was a time when texts were translated and India's complex
artistic heritage was reinterpreted to serve new Tibetan needs. Standing at
the center of this flow of ideas and imagery was Vajrayana Buddhism and its
potential to offer enlightenment in this lifetime.

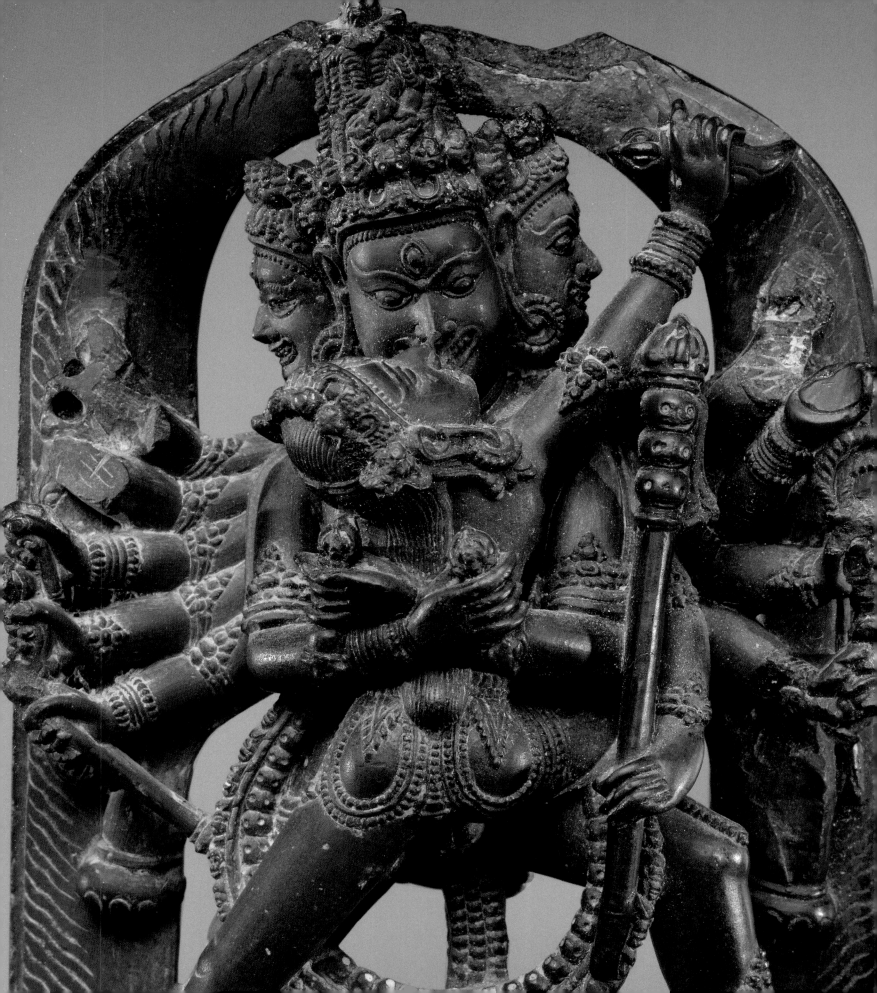

Visualizing the Taboo in Esoteric Buddhism

CHRISTIAN LUCZANITS

As WITH THE TANTRIC MOVEMENT IN ITS ENTIRETY, esoteric
Buddhism as it developed from the sixth century onward in India can be
read as a rejection of social norms. What is forbidden, not talked about,
or shunned in society is utilized in Tantrism to speed up the otherwise
exceedingly lengthy path toward awakening. Secrecy has thus been an
integral part of the movement from the time of its emergence, as is a
dearth of visual or material evidence. In this regard, we have to assume
that, when tantric teachings are depicted in art, their secrecy has given way
to a broad acceptance in society. Naturally, this goes hand in hand with a
weakening of the antisocial character of the teaching. In fact, in South Asia
aspects of tantric Buddhism only came to be depicted visually when they
were replaced by new trends within the movement, resulting in a series
of differentiations that ultimately led to classification schemes of tantric
teachings, from lower to higher.[1] Broadly speaking, one can differentiate
between tantric teachings of external action or ritual and those of yoga—
that is, of internal ritual action.[2] The former are commonly performed
for specific purposes and harness the power of a deity, while in the latter,
the practitioners identify in some form with the deity and its qualities to
further their own spiritual progress.

The objects in this volume reflect the antinomian (socially contrarian
or taboo) character of Tantrism but only set in chronologically after the
development of esoteric Buddhism in India had already culminated in the
all-encompassing system of the Kalachakra mandala (fig. 20), the associated
texts of which date to around 1000 CE.[3] Tibetans began to adopt esoteric
Buddhism during the Imperial period (7th–9th century CE), but full
acceptance of the highest tantric teachings only became visually apparent
around 1200 CE. Even then—and up to today—the different schools of
Tibetan Buddhism have held divergent attitudes toward the depiction of
mandalas, sexual symbolism, and death.

There is an infinite variety of visual expressions in Tibetan Buddhism,
and some of its themes are bewildering (a good example is pl. 86). However,
neither the variety nor the themes are random; they build on notions that
came to the fore during different phases of the development of esoteric
Buddhism. In Tibet, concepts of these different phases overlap, with one

OPPOSITE: Twelve-Armed Chakrasamvara with
His Consort Vajravarahi (pl. 88, detail). India
(West Bengal) or Bangladesh, ca. 12th century

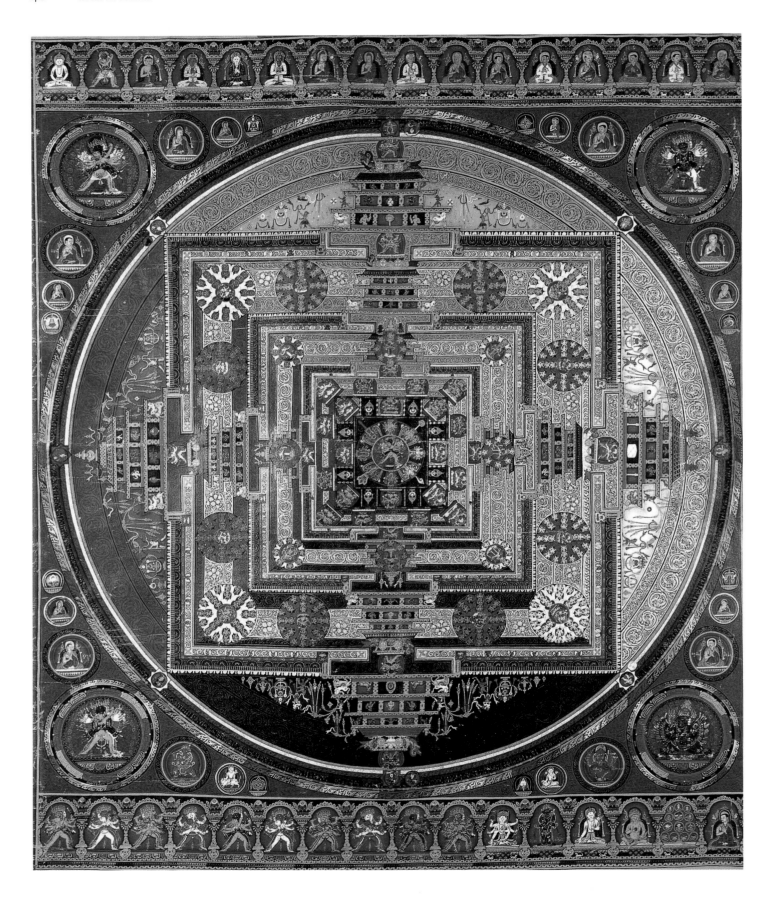

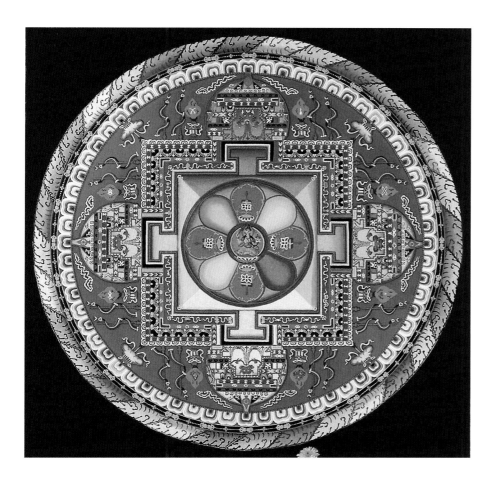

Fig. 20. Kalachakra mandala; painting 13 of the Vajravali set commissioned by Ngorchen Kunga Zangpo (1382–1456). Central Tibet, Ngor monastery, 1429–56. Distemper on cloth, 35 ⅝ × 29 ¾ in. (90.5 × 75.5 cm). Michael Henss Collection

Fig. 21. Sand mandala of Manjushri, made at Emory University, Atlanta, June 2008

layer of interpretation supporting or complementing the other while also incorporating native ideas. Recognizing these layers is, thus, an integral part of analyzing the material culture of Tibetan Buddhism.

Mandalas

Probably the most well-known visual manifestation of Tibetan Buddhism in the West is the mandala. The original understanding of this word has been distorted by its usage in early twentieth-century theosophy and psychology. In a Buddhist context, the mandala is first and foremost a ritual tool, namely, the layout of a purified ritual ground to which a certain set of deities is temporarily invited. In early esoteric Buddhism, ritual use of mandalas may have served to harness the power of the deity, but in mature esoteric Buddhism, it introduced new practitioners to the deity and, thus, initiated them into its practice. The use of mandalas emerged early in the development of Tantrism but continuously evolved through the incorporation of additional elements and harmonization. In today's practice these origins are reflected in the making of temporary mandalas of colored sand (fig. 21).

To briefly describe the basic components of a fully developed mandala, moving from the center of the composition outward, the main assembly

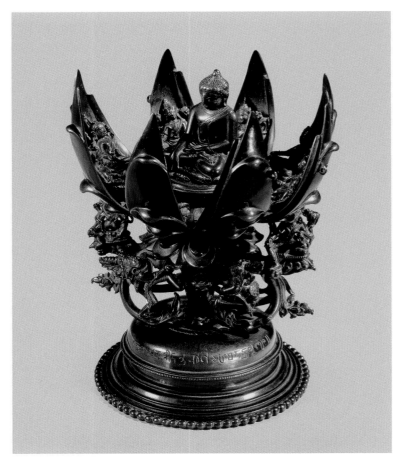

of deities most commonly occupies a circular element at center, which is itself surrounded by one or multiple square palaces that house additional divine beings (see fig. 8). The outermost square features superstructures for the four doors of the cardinal directions. Often, these doors are flanked by the prongs of a crossed *vajra*, which should be imagined lying beneath the palace and forming its foundation. Finally, there are three outer rings: a lotus ring (symbolizing the purified space on which the mandala rests) and the protective *vajra* and fire rings. Some mandalas centered on wrathful deities have a ring depicting the eight charnel grounds (a place where the dead are disposed of, to be eaten by animals), and the Kalachakra mandala features rings that hint toward the superimposed disks that make up the cosmos (for more on which, see below).

Conceptually, there are two complementary parts to the mandala: the ritual ground and the assembly of deities invited to it. The former is drawn in chalk or colored powder and demarcated on the outside by a symbolic fire pit protecting the space. Originally, this ground was square, as seen in early mandalas from Dunhuang (fig. 22) and Japan. The term *mandala*, meaning "round" or "surrounded," thus originally did not refer to an overall circular shape but, rather, to the circle of deities within that square. This alignment

Fig. 22. Healing ritual with mandala. Dunhuang, Library cave, 10th century. Distemper on paper, 16 ⅞ × 11 ⅞ in. (42.8 × 30.1 cm). National Museum, New Delhi (Ch.00379)

Fig. 23. Lotus mandala. Northeast India, 12th century. Bronze inlaid with gold, silver, and copper, H. 5 ½ in. (14 cm). British Museum, London (1982,0804.1)

of the habitation with the assembly of central deities is also expressed by so-called lotus mandalas, which reduce the mandala to its core—that is, to a central circle of deities within the purified space of a lotus blossom (fig. 23). For both the mandala palace and the mandala assembly, basic information is alluded to in the root texts of esoteric Buddhism, the tantras. However, fully developed mandalas are the result of a lengthy interpretative process that is only partially recorded in commentaries to these tantras. Only these latter works contain the visual details we find in art and explain their symbolic connotations in greater detail.

It is unclear when the mandala palace came to be surrounded by an outer circle, but it likely resulted from the alignment of the ritual space with the Buddhist understanding of the cosmos. Regardless of whether one accepts the description of the cosmos as put forth in the fifth-century *Abhidharmakosha* or in the Kalachakra system, its outer periphery is described as round.[4] The Kalachakra system explicitly aligns the mandala with its distinct understanding of the cosmos (macrocosmos), as it does with the practitioner's body (microcosmos). It is for these reasons that the Kalachakra mandala (see fig. 20) went on to become the foremost mandala in Tibetan Buddhism, which, in turn, became the basis on which the making and symbolism of the mandala has been explained in the West.[5] Accordingly, dictionaries define the mandala as "a circular figure representing the universe in Hindu and Buddhist symbolism."[6] However, while elements of the cosmos are present in some earlier mandalas, the extent to which this may have affected their depiction remains unclear.[7]

The mandala's origins as a ritual tool have had implications on their ensuing variety—as permanent wall paintings, portable scroll paintings (*thangka*), and three-dimensional models (fig. 24), the latter a relatively late form of expression. Such depictions are most often described as "meditation aids," but a closer look at the diverse practices associated with mandalas indicates that there is no basis for this interpretation.[8] While early Dunhuang mandalas had an instructional or commemorative function and stand alone, Tibetan mandala paintings often form parts of groups or sets that together represent a discrete body of esoteric Buddhist teachings. Within this framework, each mandala has a distinct shape that directly relates to the deities that inhabit it and to the rituals described in the root tantra or its commentaries. In other words, mandala sets in Tibet—the two best known being the Vajravali and the Tantrasamucchaya sets— have retained their educational function. Sets dedicated to the mandalas described in the *Vajravali*, an eleventh-century text written by the Indian ritual specialist Abhayakaragupta, may have been used in bulk initiations (pl. 100). In such cases, only the main mandala of the set, the Kalachakra mandala, may have been made in sand, while all the others may have been scroll paintings. The mandala of Jnanadakini (pl. 101), a deity that is rarely

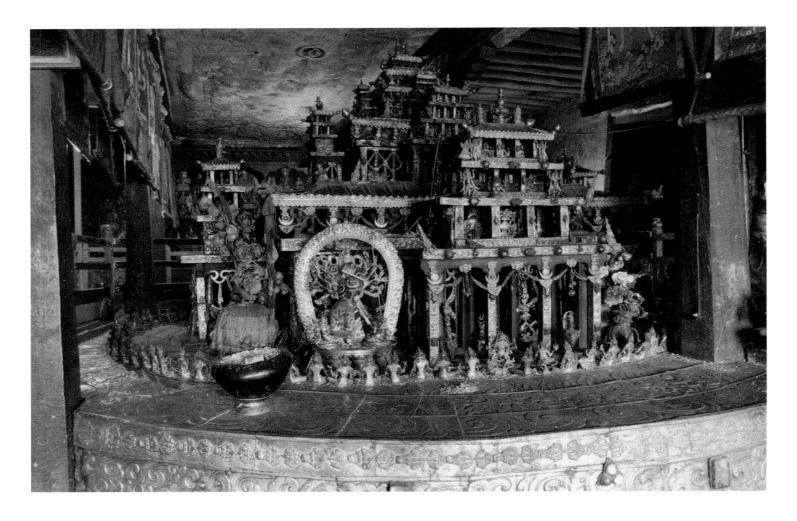

depicted otherwise, is from such a set dating to the late fourteenth century. The excellent condition of the mandalas in this set indicates that they were seldom used in the past.[9] That mandalas were made in sets also gave rise over time to their becoming more similar to one another through a process of adoption and adaptation. It is this process that resulted in what we know today as the Tibetan Buddhist mandala.

Mandalas also vary in appearance based on their discrete ritual function and the nature of the deity they house. While the former most likely affects the central circle, the latter results in the inclusion of optional components, such as the eight charnel grounds. Mandalas of wrathful deities may also be decorated with objects associated with the charnel grounds, frequently, parts of the human body (pl. 86).

Fig. 24. Three-dimensional model of the Kalachakra mandala, Potala Palace, Lhasa, ca. 1700

Families of Deities

As noted above, the deity inhabiting the center of a mandala is surrounded by a retinue of lesser divinities. The main deity is thought to encompass all the surrounding ones, which represent aspects of it. Further, tantric deities

are highly symbolic, with each element of the deity referencing distinct concepts and qualities. It is according to the latter that a teacher assigns a specific deity to a disciple. While these symbolic connotations theoretically allowed Tantrism to develop an infinite variety of deities, those that are based on earlier notions are historically most successful. For example, in early esoteric Buddhism the concept of three families of deities played a major role. These families—of the Buddha, the lotus, and the *vajra*—are often expressed as a triad. Each family can be represented by a different deity, its familial associations established by the quality ascribed to it. Accordingly, Buddha-family deities signify wisdom, and thus the bodhisattva Manjushri (pls. 29–31), the personification of wisdom, may stand for this family. Lotus-family deities represent compassion and are therefore most often represented by a form of the bodhisattva Avalokiteshvara, who embodies this quality (pls. 33–35). *Vajra*-family deities signify power, and their primary representative is thus the bodhisattva Vajrapani (pls. 36, 37). Each of these qualities counters one of the so-called three poisons—delusion, passion, and aggression—that perpetuate the cycle of rebirth (*samsara*). The following table summarizes the main elements of the three families, depictions of all of which are extremely popular in Tibet, including the iconographic details associated with their representations as bodhisattvas:

Three Families

FAMILY	LOTUS	BUDDHA	VAJRA
DEITY	Bodhisattva Avalokiteshvara	Buddha or Bodhisattva Manjushri	Bodhisattva Vajrapani
COLOR	White	Orange	Blue
ATTRIBUTE	Lotus (*padma*)	Sword and book	Thunderbolt (*vajra*)
QUALITY	Compassion	Wisdom	Power
EMOTION	Passion	Delusion	Aggression
ANIMAL AT THE CENTER OF THE WHEEL OF LIFE	Cock	Pig	Snake
RELATION TO THE FIVE ESOTERIC BUDDHAS	Buddha Amitabha	Buddha Vairochana	Buddha Akshobhya

Triads of deities representing the three families themselves express an internal hierarchy, from the center (wisdom) to the left (compassion) and right (power). A teacher assigns a disciple the ritual practice of a deity from one of the three families, according to the disciple's dominant poison. For example, an easily angered person would be assigned the practice of a *vajra*-family deity and initiated into its practice, as the *vajra* family is associated with aggression. This disciple would not, then, be permitted to practice a deity of the other two families, while a disciple initiated into the practice of a Buddha-family deity could also practice those of the other ones. The notion that initiation to a higher practice qualifies the initiated to also practice and teach tantric transmissions considered lower is, thus, attested from the beginnings of early esoteric Buddhism. Nevertheless, Tibetan Buddhism from about the thirteenth century onward places the lotus family at center, as Avalokiteshvara is considered the patron deity of Tibet.

By the eighth century the notion of five families headed by the five esoteric Buddhas had built on the original three-family concept, with Amitabha in the west, Vairochana in the center, and Akshobhya in the east forming a three-family triad within it.[10] The Buddhas Ratnasambhava in the south and Amoghasiddhi in the north completed the group of five. The table below summarizes the iconographic characteristics of the five esoteric Buddhas. Note that the arrangement here starts from the center and moves eastward, and continues in a clockwise direction:

Five Esoteric Buddhas

DIRECTION	NAME	COLOR	GESTURE (*MUDRA*)	VEHICLE (*VAHANA*)	SYMBOL
CENTER	Vairochana	White	Highest awakening (*bodhyagri mudra*) or teaching (*dharmachakra mudra*)	Lion (dragon)	Wheel (*chakra*)
EAST	Akshobhya	Blue	Touching the earth (*bhumisparsha mudra*)	Elephant	Thunderbolt (*vajra*)
SOUTH	Ratnasambhava	Yellow	Boon bestowing (*varada mudra*)	Horse	Jewel (*ratna*)
WEST	Amitabha	Red	Meditation (*dhyana mudra*)	Peacock	Lotus (*padma*)
NORTH	Amoghasiddhi	Green	Reassurance (*abhaya mudra*)	Garuda	Crossed *vajra* (*vishvavajra*)

In the original concept of the five esoteric Buddhas, each family stands for a type of wisdom, with that of Buddha Vairochana encompassing all others. This idea spread throughout the Buddhist world and generally has been extremely influential in both conceptual and visual terms. Among other characteristics, the five esoteric Buddhas are distinguished by their relative position to one another and their color. Accordingly, the colors of the Buddhas surrounding the central one are used to fill the quarters of the mandala palace that represent their respective directions. For example, in the Vajradhatu mandala (pl. 95), which is based on the original concept of the five esoteric Buddhas, the quarters are colored blue, yellow, red, and green. This color scheme attributes the mandala to Buddha Vairochana, whose white color is represented through the central deity only. Most of the highest esoteric deities are attributed to the *vajra* family of Buddha Akshobhya (pl. 18), meaning that the eastern quarter is white, as blue has moved to the center (pl. 97). Further, the prongs flanking the gates of the mandala follow this color scheme, most often directly and at times also reflecting the neighboring quarters (pl. 101).

Finally, it needs to be mentioned that, in the highest esoteric teachings, an ultimate Buddha (*adibuddha*)—most often, Buddha Vajradhara—is introduced who supersedes the five esoteric Buddhas. He is considered the ultimate source of many teachings and is thus often represented at the beginning of teaching-transmission lineages (see the upper left corners of pls. 83, 89, 95, 99, and 101–3).

Wrath, Sex, and Death

As the family concepts demonstrate, the symbolic connotations that a deity carries are crucial. Esoteric Buddhism utilizes the entire spectrum of human emotion, including passion and aggression. Within the highest tantra classes, these emotions also become aspects of the central Buddha image, meaning that even Buddhas might be depicted in sexual embrace or exhibiting wrath. Wrathful images entered the early tantric pantheon as personifications or accompanying figures (pl. 36). They are an expression of both the harnessing and the overcoming of anger or aggression. Depending on the purpose of such images, Tibetan Buddhism differentiates so-called awakened protectors from worldly ones. While the former count among some of the highest esoteric deities, occupying the centers of mandalas (pls. 98, 99), the latter have a supplementary protective function (for more on which, see below).

Visually, wrath is indicated in many ways. The facial expression may be mildly or fully angry, the hair may stand on end, and the ornamentation may allude to death: what might be gold ornaments and cloth on peaceful deities are replaced on wrathful ones with skulls and bones, garlands of severed heads and snakes, and the skins of animals and humans. Further, the offerings symbolically given to such deities are likewise fearsome, best

demonstrated by the offerings to the five senses. While peaceful deities are presented with pleasing jewels (appealing to sight), music (sound), scents (smell), fruits (taste), and fine cloth (touch; see pls. 1 and 65 for goddesses personifying these offerings), wrathful deities might be given the sensory organs themselves, in a skull cup brimming with the eyes, ears, nose, tongue, and heart of a human (see the center of pl. 55).

Symbolically, wrathful deities are charged with overcoming the enemy, who stands for false beliefs and negative emotions. The conversion of the Hindu god Shiva to Buddhism takes a particularly prominent position in this regard and is expressed in many esoteric deities, owing to the emergence of tantric Buddhism in dialogue with Shaiva Tantrism, which in many ways served as a model.[11] This idea is particularly apparent with the deity Chakrasamvara (pls. 88, 89), who not only has many characteristics of the wrathful form of Shiva, Bhairava, but also tramples on Bhairava and Kalaratri, the wrathful form of his consort Parvati. A more subtle form of this concept is communicated through images of Achala, who often tramples on the elephant-headed Ganesha (fig. 25).[12] As this god is considered the remover of obstacles, Achala symbolizes the overcoming of this belief.

Sexual embrace must likewise be considered within the broader tantric movement. In cases where Buddhist deities are shown in such couplings, male and female represent the duality of method and wisdom, which must be overcome to attain awakening. Their sexual embrace thus symbolizes this achievement and a resulting state of bliss associated with its attainment. Again, a strong human emotion is utilized for the spiritual benefit of the practitioner.

Gender symbolism entered esoteric Buddhism with the Vajradhatu mandala cycle, which is also the basis for the five esoteric Buddhas. In its earliest conception, Vairochana quite literally generates the families of deities with the four goddesses—the "mothers of the families"—that surround him in his central circle (fig. 26). Vairochana's canonical gesture of highest awakening (*bodhyagri mudra*), in which he embraces the index finger of his left hand with his right, hints toward sexual embrace as well, with the stretched index finger symbolizing the male sexual organ and the embracing hand the female one. In the highest esoteric teachings, the sexual organs may also be symbolized by the ritual implements of *vajra* (male) and *ghanta*, or bell (female), and holding these objects in hands crossed in front of the chest stands for the embrace (pls. 80, 83, 88, 89). Additionally, a deity dancing with a tantric staff (*khatvanga*; pl. 62) hints toward union with a consort (pl. 91). In other words, in the highest esoteric Buddhist teachings, gender symbolism is so ubiquitous that the practice cannot be understood without it, although the visuals are often not explicit. For example, in the Vajradhatu mandala (pl. 95), the goddesses surrounding Vairochana are represented as

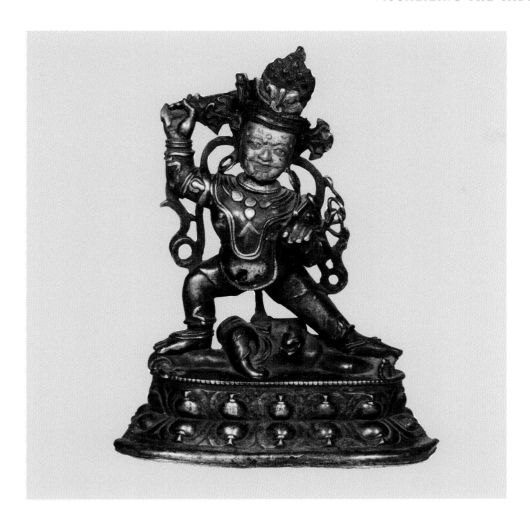

Fig. 25. Achala trampling on Ganesha. Tibet, 13th century. Brass, H. 7 ¾ in. (19.6 cm). Jokhang Collection (inv. no. 356)

the family symbols, and Vairochana's main gesture is far from clear. Both features can be interpreted as obscuring the associated symbolism.

More broadly, early Indian and Nepali imagery generally avoided the overt depiction of sexual embrace. For example, on the upper book cover of pl. 14, we see the five Buddhas with Vairochana performing the gesture of highest awakening (*bodhyagri mudra*) at center. He is six-armed, and his other hands hold symbols that stand for his family (the wheel, in the lower left hand) and those of the surrounding Buddhas (the sword, jewel, and lotus). The lower book cover, centered on the goddess Prajnaparamita, complements the upper one, as the five protectresses (*pancharaksha*) depicted on it are often paired with the esoteric Buddhas. While the exact origin of this iconography is uncertain, it clearly builds on the *Guhyasamaja Tantra*, in which the five esoteric Buddhas are three-headed and six-armed and hold the symbols of the surrounding families. The same tantra is also the source for the deities depicted on the crown of a Newari tantric priest, or *vajracharya* (pl. 32). Here, however, the top central deity crosses its main hands at the chest, symbolizing sexual embrace. Few exceptions aside (for example,

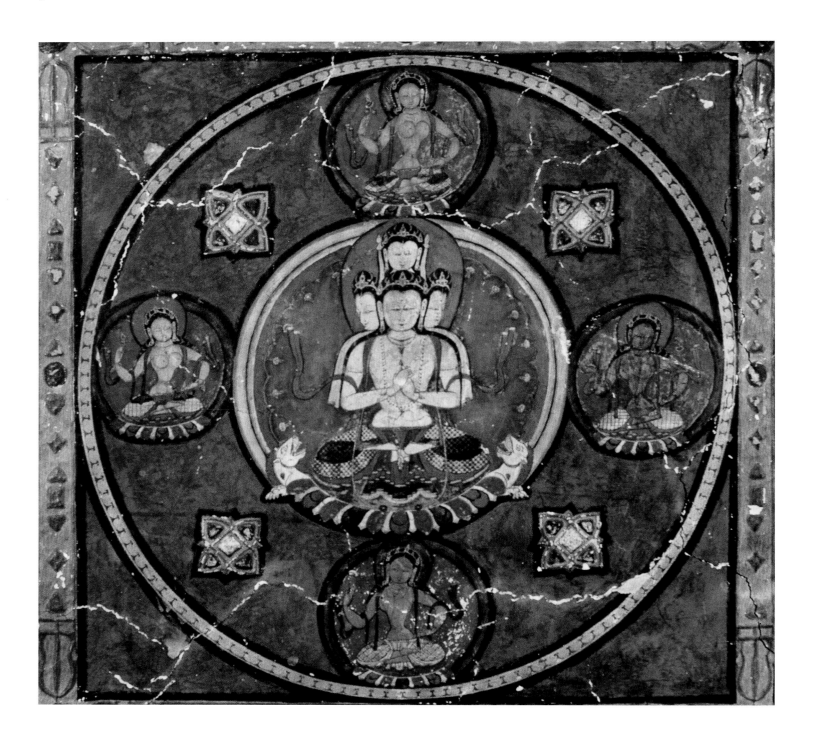

pl. 94), Tibetan depictions are explicit in this regard, as can be demonstrated through the representations of Guhyasamaja Manjuvajra and Akshobhyavajra (pls. 16, 83, 97).

We can see from these examples, all associated with the *Guhyasamaja Tantra*, that one root text may result in many variations of deities through the commentarial process in different cultural and social contexts. The same is true for the symbolism each deity carries, which is specific to it and changes over time and with place. In addition, individual interpretations can be further adapted by a teacher to suit the needs of his disciple. Such diversity makes it impossible to account for all the deities on display in this volume. However, by examining the esoteric Buddhist deities and their symbolism in terms of typology, we can extract notions that account for most of them.

Generally, esoteric Buddhism incorporates an emphasis on ritual action, which becomes particularly prominent with the Vajradhatu mandala (pl. 95) and its associated teachings. Here, it is the practitioner's self-identification with all the core deities through external ritual action that yields its result. The highest esoteric teachings, in contrast, relate in their symbolism to the main deity alone and to the two complementary paths that lead to awakening, namely, wisdom and contemplation. The emphasis on wisdom is already apparent in the three-family concept through the Buddha family and the deities representing it. Accordingly, forms of Manjushri, the bodhisattva of wisdom, are found throughout the development of esoteric Buddhism and range from Manjushri (pl. 29) to Manjuvajra (pl. 97), of the *Guhyasamaja Tantra*. The goddess Prajnaparamita, the personification of the Perfection of Wisdom literature who is often depicted on book covers (pls. 12, 14, 17), is another prominent wisdom deity.

At the same time, the deities connected to overcoming death (Yamantaka) can be attributed to this same path, as their symbolism is mostly related to wisdom. These divinities are conceived in resonance with the god of death, Yama, whose vehicle is a bull. Yamantaka deities are thus recognizable by their bull element, visualized as either the main head of the deity or its vehicle (pl. 82). In the case of Vajrabhairava, the association with wisdom is further reinforced by his topmost head, which is that of the bodhisattva Manjushri (pl. 99). Other deities, such as Hevajra (pls. 80, 81), Chakrasamvara (pls. 88, 89), and Vajravarahi (pls. 90, 91), carry symbolic connotations that emphasize contemplation. Accordingly, these gods have been popular with schools that emphasize religious practice in retreat, such as the diverse Kagyu schools.

Esoteric Practice

We have already seen that, in terms of practice, the main premise of esoteric Buddhism is that the practitioner identifies in some form with the qualities

Fig. 26. Vairochana surrounded by the four "mothers of the families," detail from the Trailokyavijaya mandala of the Vajradhatu cycle. Alchi Dukhang, late 13th century. Distemper on clay, approx. 15 ¾ × 17 ⅜ in. (40 × 44 cm)

and symbolism of the deity, and in this way counters his own negative emotions. Once a practitioner (*sadhaka*) has been introduced to the deity using a temporal ritual mandala, he is meant to perform its ritual practice (*sadhana*) daily. Integral to this practice is the visualization of the deity and, in more advanced practices, merger with it. Here, too, there is a great variety in the practices described with each root text and the commentaries linked to them; the following mentions only the most widely shared aspects.

Depending on the teaching, the initiation (*abhisheka*) into the practice of a deity is more or less complex. The *abhisheka* shares many features with the royal coronation ritual, for example, the sprinkling of the head, as well as the crown and ribbon initiations, which reference the ritual crown of a tantric priest (pl. 32). The ribbon refers to the importance of the diadem that was used prior to the emergence of a crown. The highest esoteric teachings also involve so-called secret initiations, which may include sexual practices undertaken with a tantric consort, often referred to as *yogini*. Needless to say, this aspect of initiation is rarely made explicit, and approaches to it can be quite different, depending on the tradition. In a monastic context, where such rituals would contravene the monastic vow, they are interpreted symbolically.[13]

In the idealized world of the highest esoteric teachings, the initiation takes place at a charnel ground in the form of a tantric feast (*ganachakra*), at which impure food is ingested and sexual acts are performed. Accordingly, an early Chakrasamvara mandala in the collection of The Met depicts the mandala within a large charnel ground (pl. 96). In this painting, produced in a Nepalese context, we see numerous solitary practitioners and couples engaged in different activities against a black ground strewn with body parts. As explicit as the composition is, the chain of *vajra*s demarcating the black ground indicates that this area, too, is part of the visualization. A practitioner is depicted in the lower left corner with a small ritual mandala in front of him.

The eight charnel grounds, distributed over the Indian subcontinent, are considered ideal places of tantric practice. Their spatial distribution is indicated by the deities that preside over them—the guardians of the directions (*dikpala*). This group of deities is shared across Indian religions and includes some of their most prominent gods: in the east is Indra (Shakra); the southeast, the fire god Agni; the south, the lord of death, Yama; the southwest, Nairrita, the chief of demons, sitting on a corpse; the west, the water god Varuna; the northwest, Vayu, the wind god; the north, Kubera, the god of wealth; and the northeast, Ishana, that is, Shiva.[14] Their directional distribution also influenced the Buddhist mandala. In particular, the location of Yama in the south resulted in some mandalas containing Yamantaka deities that were oriented in that direction (fig. 27). Others, however, including pls. 99 and 103, retain the more common eastern orientation, as

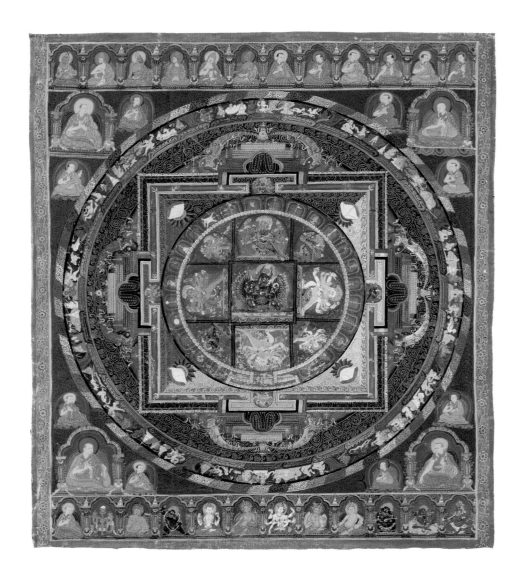

Fig. 27. Vajrabhairava mandala, oriented toward the south. South Central Tibet, Ngor monastery, 1515–35. Pigments on cloth, 19 ⅝ × 17 ⅛ in. (49.8 × 43.5 cm). Rubin Museum of Art, New York (C2005.16.40; HAR 65463)

can be seen from the color scheme of their palaces, where the white quarter (east) is represented at the bottom.

Certain elements of mandalas may derive from visualization practice. Advanced tantric ritual may include the imagining of a purified space, which must be thought of in three dimensions. Usually, this space is less complex than the depicted mandala, but certain elements described in visualization appear to have become integral to the latter. For example, the purified space may have to be imagined as a *vajra* cage or tent (*vajrapanjara*) atop a crossed *vajra* (*vishvavajra*); both elements eventually became a part of mandalas in the form of a *vajra* ring surrounding the palace and a crossed *vajra* forming its foundation.

Another visualization that has since found physical expression in mandalas is the "source of all dharma," or *dharmodaya*. There are different

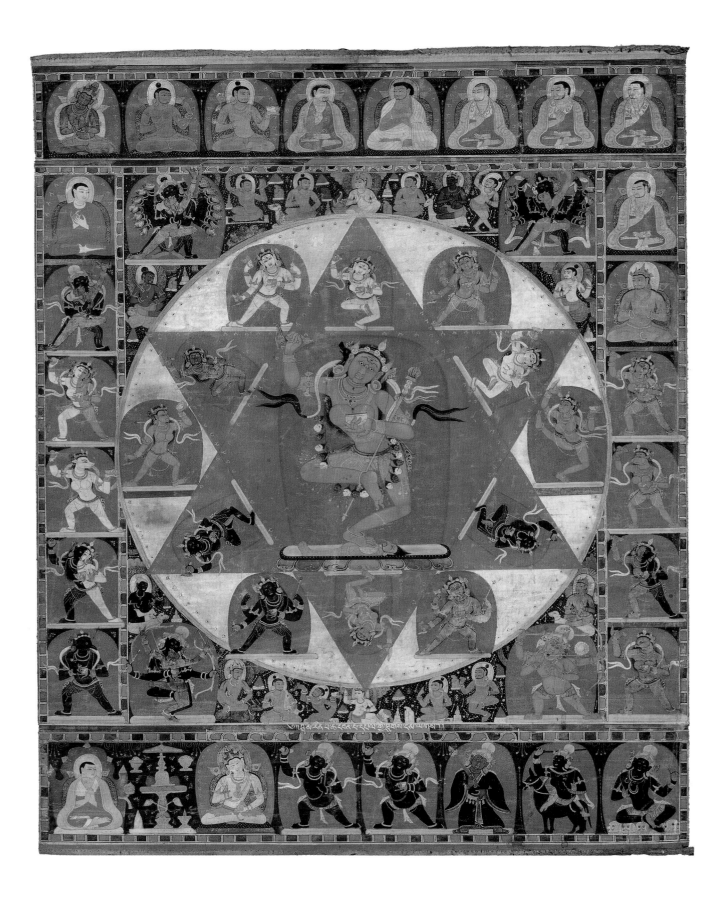

usages of this term in esoteric Buddhist literature, the most antinomian of which is its identification with the vagina, which in painting is expressed as a triangle standing on one of its points. Being the base on which the goddess Vajravarahi, a form of Vajrayogini, is to be visualized, early representations of her depict such a triangle prominently (an exceptionally early example, from the late twelfth century, being pl. 90). Later Vajravarahi mandalas have two intertwined triangles making up the central circle (fig. 28).

There are two main types of visualizations associated with the highest esoteric teachings, one in which the practitioner visualizes the deity in front of him, and another in which he visualizes himself *as* the deity. It is the latter type that more clearly demonstrates the utilization of the deity's abiding qualities for the practitioner's spiritual advancement. In these instances, the practitioner's body itself becomes the microcosmic localization of the mandala and its assembly of deities, and he is tasked with manipulating his inner wind channels, which connect the energy nodes (*chakra*) throughout his body. It is this form of visualization practice that best aligns with yoga. Further, in the context of the highest esoteric teachings, the practitioner may replace the deity with his teacher in a practice called *guruyoga*. A visual expression of this concept is pl. 81, in which the teacher, through his portrait and footprints, and the deity Hevajra share the large central lotus. They are, thus, interchangeable.

Protector Deities

In addition to the main deities that occupy the center of a mandala with their retinues of lesser divinities, esoteric Buddhism features many supplementary deities whose powers are considered essential to enabling the conditions for higher spiritual practice. Their functions range from ensuring long life and health (the goddess Ushnishavijaya; pl. 41) to securing wealth (Vaishravana; pl. 50) to providing protection. This latter category is vast and includes both peaceful and wrathful deities.

Certain forms of deities of compassion, such as Avalokiteshvara (pls. 33–35) and Tara (pls. 38, 39), act as protectors from danger. However, the ultimate early protector is Vajrapani, whose power is expressed by the *vajra* he wields. While Indian and early Tibetan representations commonly show him as a peaceful deity (pl. 36), in Tibetan Buddhism he is most often depicted as wrathful (pl. 37). Vajrapani is also one of the deities traversing the distinction between awakened and worldly protectors. The other important group of protective deities traversing these categories are manifestations of Mahakala. Known as a protector in India (pl. 51), Mahakala takes different forms that have gained prominence in many Tibetan Buddhist schools. The Kagyu schools, for example, tend to focus on four-armed forms of Mahakala (pl. 52), while the Sakya school has particularly high regard for Panjara Mahakala, easily recognized by the magic staff he holds horizontally across

Fig. 28. Vajravarahi mandala. Central Tibet, Taklung monastery, first half 13th century. Distemper on cloth, 27 ½ × 22 in. (70 × 56 cm). Private collection

Fig. 29. Thighbone trumpet (*rkangling*). Tibet, late 19th–early 20th century. Human bone and copper, L. 12 ¹¹⁄₁₆ in. (32.3 cm). The Metropolitan Museum of Art, New York, Gift of Miss Alice Getty, 1946 (46.34.11)

Fig. 30. Hand drum (*damaru*). Tibet, 19th century. Human skull, cloth, wax, 5 ⅜ × 7 × 6 ⁷⁄₁₆ in. (13.7 × 17.8 × 16.4 cm). The Metropolitan Museum of Art, New York, The Crosby Brown Collection of Musical Instruments, 1889 (89.4.213)

his arms. The quality and size of a painted Panjara Mahakala depicting the Sakya hierarchs along its edges demonstrates the importance of this fearsome deity (pl. 53).

Most forms of Mahakala hold a curved knife (*kartrika*; pl. 63) and a skull cup (*kapala*; pl. 64) in their main arms. The former is particularly suitable for flaying skin, and the latter collects the blood of a freshly severed being; both tools reference the charnel grounds. Such activities are also directly referenced by another form of the deity, namely, Brahmarupa Mahakala, or Mahakala in the form of a brahmin (pl. 58). He is depicted as an agitated, aged ascetic playing a bone trumpet and holding a skull cup. As with other forms of this deity, he sits on a corpse. Protective deities build on the idea of the charnel grounds as an ideal space for esoteric practice, because it serves as a reminder of the perishable nature of human existance. Most of their attributes and paraphernalia derive from this space, be it the skull cup, which is harvested there (pl. 64 is a replacement in stone), or the thighbone trumpet that Brahmarupa plays (fig. 29). Together with the hand drum (*damaru*), ideally also made of skulls (fig. 30), the thighbone trumpet serves as a musical instrument for the tantric practitioner, both within and outside monastic contexts (fig. 31).[15]

Fig. 31. A "Trup-tor lama," or Tibetan Buddhist tantric adept, photographed at Rabden Lepcha, Lhasa, 1921. Pitt Rivers Museum, University of Oxford (1998.285.226.1)

Tibetan Buddhism also includes a large group of local deities who were converted to Buddhism by Padmasambhava, an Indian tantric adept of the eighth century, with the help of a ritual dagger (pl. 87) and who now serve as protectors. Padmasambhava's teachings thus include the personified ritual-dagger deity, Vajrakilaya (pl. 59), and are the main source of Nyingma, or old-school, transmissions adopted widely by other Tibetan Buddhist branches. Despite her name indicating an Indian origin, Sri Devi, or Palden Lhamo, in her diverse manifestations likely derives from such localized contexts (pls. 57, 93).

Owing to the potentially upsetting character of these deities—that is, the danger they pose—Tibetan monasteries often collect the wrathful protectors in so-called protectors' chapels, the *gonkhang* (*dgon khang*), which are furnished with associated paraphernalia (fig. 32). For example, a table in such a space might be decorated with the lords of the charnel grounds; a carpet with the flayed skins of humans (pl. 85); and storage boxes painted with wrathful offerings (pl. 55). Equally, the lords of the charnel grounds are a popular dance costume (fig. 33), assisting black-hat priests and higher deities presiding over dances in a humorous way (pls. 42, 43). Protective symbols deriving from esoteric Buddhist practice are also used on ritual vessels

Fig. 32. A gigantic effigy of Vajrabhairava in the *gonkhang* of Thiksey monastery, Ladakh, 2023

(pl. 60) and weapons, be they *vajra*s and mantras painted on a leather helmet (pl. 66) or protective faces on the hilts of swords (pls. 70–72).

Formalization

As can be seen, there are many ways in which the taboo is visualized in the material culture of esoteric Buddhism, adopted in turn in Tibet and integrated into its own Buddhist tradition. However, there are considerable differences throughout history and between schools and regions with respect to how much the most controversial aspects of Tantrism have been shown to the public. There is also extensive debate as to how literally the practices described or alluded to in tantric literature should be taken, especially in a monastic context.

There are, of course, innumerable other aspects of esoteric Buddhist art that have only been hinted at above. For example, there is a strong royal connotation not only in the initiation ritual but also, according to some scholars, in the very conception of parts of esoteric Buddhism itself.[16] Moreover, social aspects are expressed through ideal practitioners—the great adepts, or *mahasiddha*s—who often have origins as outcasts (pls. 74–79). Similarly, as explored in the preceding essay, the relationship between teacher and disciple and the oral transmission of esoteric teachings according to lineages are central to understanding Tantrism. Esoteric Buddhism cannot be practiced without a teacher, which explains the prominent portrayal of historic scholars in many paintings (pls. 1–7) and the representation of teaching-transmission lineages at the tops of Tibetan scrolls (see pls. 82, 95, 99, 101).

Fig. 33. Dancers dressed as the lords of the charnel grounds performing during Tiji Festival, Lo Manthang, Mustang, 2012

Esoteric Buddhism is characterized by a diversity of approaches that defy easy explanation. The revolting, upsetting, and obscene are integral to its message—as integral as they are to human nature. Ultimately, these aspects of Tantrism serve to support our realization of the temporary, perishable nature of existence. Tantric Buddhism in its highest form incorporates these more taboo elements into its visual culture, but it is precisely these elements that make it so unusual and interesting, particularly in the case of some of the earliest expressions of high esoteric Buddhist art, among them pls. 90 and 96, which emphasize the charnel grounds as the habitation of the deities.

Later objects in this volume document the formalization of esoteric Buddhism in Tibet. This process is particularly apparent in mandalas, but it is also characteristic for wrathful themes. For example, the guardians of the charnel grounds have become a motif seen in furniture and dance (pl. 43), or the human skull cup has been replaced by imitations in other materials, such as stone (pl. 64). Such visual and material formalizations make the antinomian more digestible for a broad audience unfamiliar with the symbolism of esoteric Buddhism. But, regardless of its age, content, and degree of formalization, all material culture of esoteric Buddhism is meant to support the attainment of awakening more speedily.

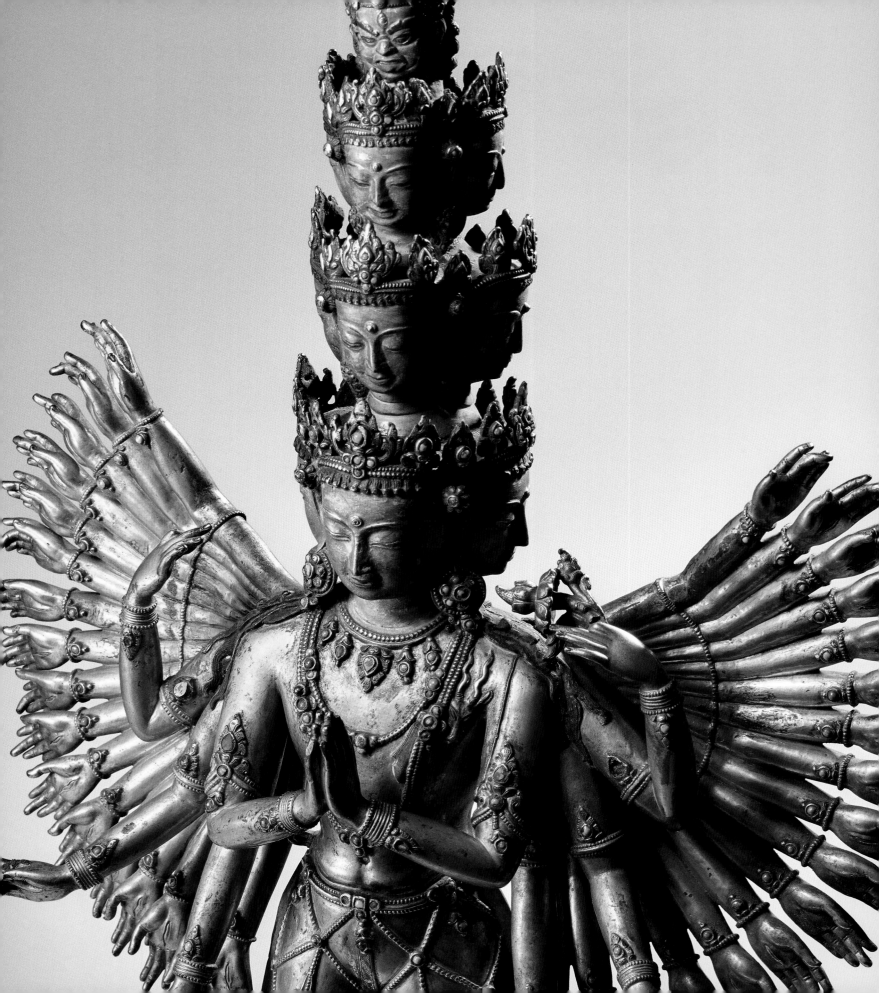

Compassion as Essence: Bodhisattvas as Spiritual Guides

Amy Heller

A BODHISATTVA IS A DIVINE BEING who has made a vow to become a Buddha. *Bodhi* means "awakening" and *sattva*, "being," thus a bodhisattva is a being who, inspired by compassion and altruism, encourages others to achieve spiritual awakening.[1] Bodhisattvas often take the form of deities who are understood to have enormous powers to help us understand and realize the teachings of the Buddha. In ancient India, the four principal bodhisattvas were Maitreya, the future Buddha; Avalokiteshvara, the lord of compassion; Manjushri, the lord of wisdom; and Vajrapani, who represents the power of all Buddhas to defend the dharma, or sacred teachings. However, the term *bodhisattva* does not imply only male deities; there are several goddesses, like Tara, Prajnaparamita, and Ushnishavijaya, who play the same salvific role. These goddesses are sometimes referred to as bodhisattvas and sometimes even as female Buddhas. As understandings of bodhisattvas and goddesses have evolved over time, it is instructive to begin with the original Buddha and his teachings, then to discuss bodhisattvas and goddesses as progressive developments in Buddhism.

The Buddhist religion was founded in northern India in the sixth century BCE by Shakyamuni, known by epithet as Buddha, or the "Enlightened One." His spiritual quest from Indian prince to awakened Buddha began when he was confronted with the sufferings wrought by the impermanence of life and unfulfilled desires. Spurred by altruism, he renounced royal life and left the palace in search of ways to protect living beings from suffering. After years of austerity, which proved fruitless, he turned to meditation, eventually reaching a state of perfect concentration (*samadhi*), peace, and inner tranquility. This moment of enlightenment is represented quintessentially in a twelfth-century Tibetan sculpture of Shakyamuni seated in a yogic posture, his expression calm and gentle (fig. 34). His left hand rests in his lap, while his right gestures downward to the earth. His wisdom is represented by the characteristic raised bump at the top of his head, lit by a gold flame. Prolonged through meditation, the Buddha's clarity of mind blossomed like a lotus, leading him to develop love and compassion for all beings. The system he proposed so that others might also achieve such peace focused on the accumulation of good deeds—karma—and the honing of a wise and disciplined mind, thus ensuring a positive rebirth by which it was possible to attain salvation. The doctrine of rebirth was common in India at the

OPPOSITE: Sonam Gyaltsen (active 15th century), Thousand-Armed Chenresi, a Cosmic Form of the Bodhisattva Avalokiteshvara (pl. 34, detail). Central Tibet, Shigatse, 1430

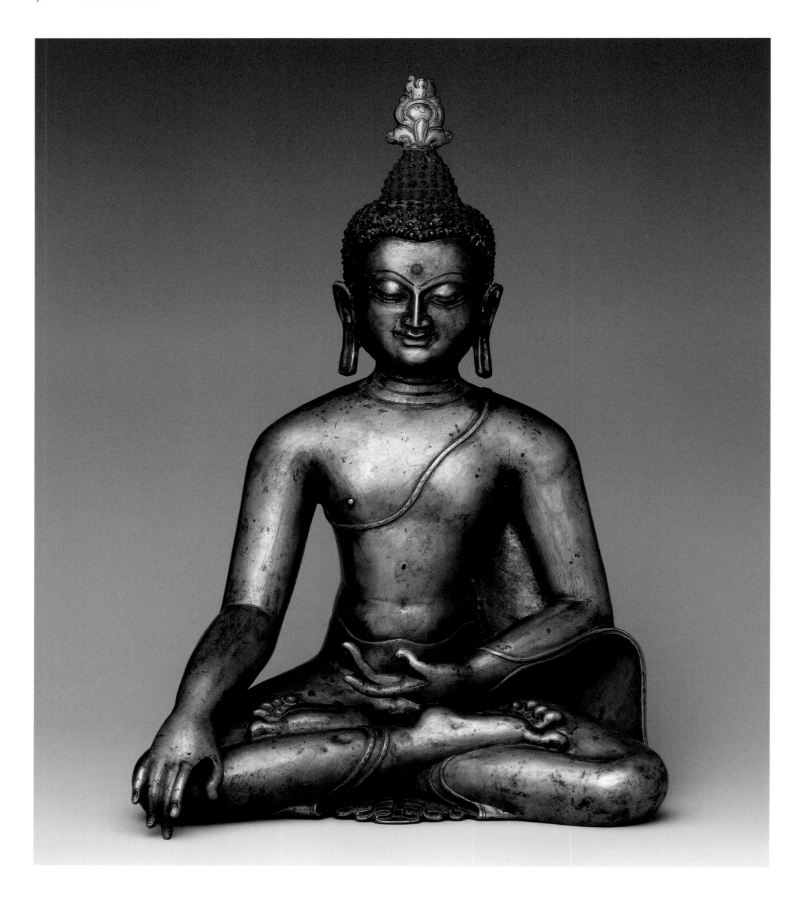

time, but in a radical departure from contemporary spiritual movements, Shakyamuni opened the road to salvation for all who followed his precepts, regardless of their caste.

The historical Buddha was regarded as both a teacher and a spiritual leader during his lifetime, admired as a hero intent on the welfare of others.[2] His early teachings became a path for monks and nuns who strove as individuals to reach deliverance from suffering. Over time new doctrines developed, notably the notion of the bodhisattva, a state of being achievable by both clergy and laypeople. Here, the goal is not individual but collective—that is, for all sentient beings to know supreme happiness beyond suffering and to rest in an immeasurable equanimity free from duality, attachments, and hatred. The bodhisattva practice is rooted in the compassionate drive to help others attain enlightenment.

By the first to second century CE, the ideal of the bodhisattva developed into the highest of human aspirations. Candidates vowed to practice the ten great perfections: generosity, morality, forbearance, energy, meditation, wisdom, skill in means, resolution, strength, and knowledge. Compassion was extolled above all as the means to enlightenment, thus *means* (Tibetan: *thabs*) and *wisdom* (Tibetan: *shes rab*) came to represent twin coefficients of this perfection, while it was the *thought of enlightenment*, eventually conceived as a subtle essence, that impelled the bodhisattva toward this goal. Working for the benefit of all living beings on the collective spiritual path, the bodhisattva postponed personal liberation, remaining accessible through prayer and offerings to bestow solace and protection on their devotees.

As special manifestations of the Buddha's teachings, bodhisattvas are conceived as residing in the heavens and having glorious bodies (*sambhoga-kaya*, "a body of bliss"), replete with jewelry and garments befitting their divine nature. Indeed, devotees often commissioned elaborate jewelry to adorn sculptures in addition to offering their own jewels, amulet boxes, or other luxury objects (pls. 19–26). In a Mongolian sculpture of the seventeenth century, the bodhisattva Maitreya, the future Buddha, is portrayed as a tall, handsome prince (pl. 28). Adorned with a high, stacked hairstyle and regal garments, he exudes elegance, and hanging across the left side of his torso is the sacred thread (*upavita*) that symbolizes the religious commitment of all bodhisattvas (fig. 35). The beauty, harmonious proportions, and smooth modeling of his body bear the mark of a master sculptor. His stance is the triple-bend posture, inherited from India and intended to give motion to the figure. Maitreya's right hand gestures in the *vitarka mudra* of philosophical dispute. He holds in his extended left hand the *kamandalu*, or waterpot, a symbol of vitality and a reminder that the teachings of the Buddha retain their message in the past, present, and future. This latter concept speaks to the idea of the Buddha of the Three Times, whereby Maitreya, channeling the teachings of the historical Buddha, simultaneously signals future

Fig. 34. Buddha Shakyamuni. Central Tibet, 12th century. Brass with colored pigments, 15 ½ × 10 ⁷⁄₁₆ × 8 ⅝ in. (39.4 × 26.5 × 21.9 cm). The Metropolitan Museum of Art, New York, Zimmerman Family Collection, Purchase, Lila Acheson Wallace, Oscar L. Tang, Anthony W. and Lulu C. Wang and Annette de la Renta Gifts, 2012 (2012.458)

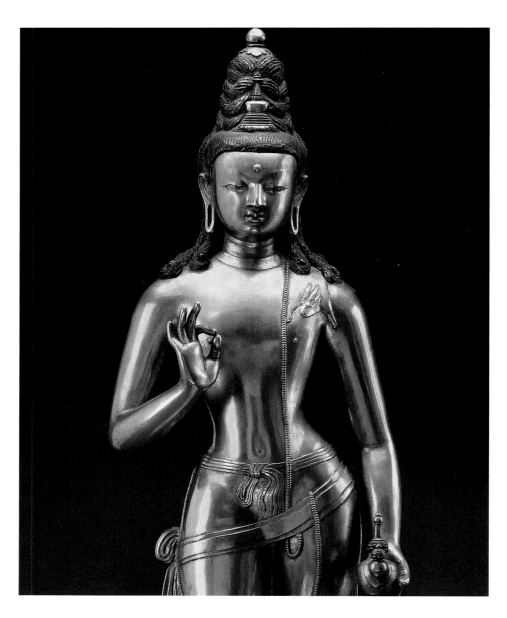

Fig. 35. The Bodhisattva Maitreya, Buddha of the Future (pl. 28, detail). Mongolia, school of Zanabazar (1635–1723), second half 17th century

Buddhahood while also remaining active in the present in his capacity as a bodhisattva.

Over the centuries, Buddhists in India produced a vast literature comprising philosophical and spiritual discourses (sutras) attributed to the Buddha, as well as disciplinary codes and cosmological treatises. A sutra not only comprises words, it may also be conceived as the body of the Buddha, which becomes the focus of celebration and devotion in a manner akin to relic worship.[3] Some sutras eventually existed in several voluminous recensions, such as the *Prajnaparamita Sutra* (Perfection of Wisdom Sutra), versions of which exist in eight thousand verses (pl. 8) and as many as one hundred thousand. By the seventh century, another category of Indian Buddhist literature emerged, the tantras, which centered on invoking

powerful deities that could help expedite the path to enlightenment. Such ritual texts involved the visualization of the Buddha, bodhisattvas, and deities; recitation of sacred syllables (mantras); playing music; and making gestures (mudras) using divine attributes as ritual implements, such as the *vajra* (thunderbolt scepter; see pl. 61) and *ghanta* (sacred bell, seen clasped in Hevajra's hands in pl. 80). The tantras describe a given deity's abode within the sanctified circle of a mandala, as well as meditative and yogic techniques that engage both the physical and the mental energies. Spiritual practice based on tantric texts is known as Vajrayana ("the path of the *vajra*"). In contrast to earlier Buddhist practices requiring numerous lifetimes to progress toward enlightenment, the Vajrayana path is believed to be effective in one lifetime and is thus reserved for those who have already made spiritual accomplishments and wish to accelerate their spiritual progression.

Image and Devotion: The Primary Male Bodhisattvas

Images, both sculpted and painted, play an important role in the rituals associated with Vajrayana. The practitioner studies an image, concentrating on the physical appearance of a deity or deities, which then forms the basis for meditations in which they visualize the divine being(s) and chant associated mantras. Visualizations and recitations took place in both monasteries and private residencies, thus requiring an immense production of paintings, sculptures, and illuminated manuscripts to aid practitioners in their devotions, including those who might be illiterate and thus especially reliant on visual imagery. In motivation for their successful rebirths, devotees also made donations of artworks and manuscripts to generate individual merit, to petition for the longevity of loved ones, and to honor the memory of the deceased.

 With respect to common types of visual depictions, triads of divine beings appear frequently in both sculpture and painting, often centered on a Buddha and two bodhisattvas. A Tibetan *thangka* of the eleventh or early twelfth century (pl. 27) portrays the seated golden Maitreya flanked by two smaller standing attendants, the white Avalokiteshvara holding a white lotus and the golden-hued Manjushri holding a *nilotpala*, or blue lotus (fig. 36). Maitreya holds his characteristic waterpot as he maintains a meditative pose. Around Maitreya's shoulders are eight bodhisattvas of varying colors, making hand gestures that may represent the eight great attributes of Shakyamuni: wisdom, compassion, power, activity, merit, qualities, blessings, and aspirations. The male bodhisattvas exhibit the styles of Pala India, including pronged crowns, high chignons, lozenge jewelry, and short loincloths (dhoti) that are similar to those seen in illustrated manuscripts from Pala India (see, for example, pls. 8, 9). The entire *thangka* is bordered by semicircles with interlocking gold dots, likewise evocative of certain motifs in Pala manuscripts. That this painting was produced in Tibet is certain, however,

Fig. 36. The Bodhisattva Maitreya, Buddha of the Future (pl. 27), details showing the bodhisattvas Avalokiteshvara (left) and Manjushri (right), who flank the main portrait of the deity. Tibet, 11th or early 12th century

because in the uppermost register are the portraits of seven Tibetans, all lay devotees wearing Tibetan garments. The lower register has two Tibetan donors in the left corner and a monk performing a consecration ritual in the right corner.

Another variation of a triad offers three bodhisattvas as a group; in one example (pl. 33), we see a large, white Avalokiteshvara at center with smaller figures of a yellow Manjushri and a deep-blue Vajrapani in the uppermost corners of the central panel. Avalokiteshvara sits enthroned, surrounded by bodhisattva attendants, monks, miniature Buddhas, and donors. He assumes his four-armed aspect, known as Shadakshari, or "He of the Six Syllables."[4] This aspect of the bodhisattva embodies the great compassion evoked by the sacred six-syllable mantra "Om mani padme hum." Avalokiteshvara clasps two of his four hands over his heart in the *namaskara mudra* of devotion. With his second left hand he clasps a strand of delicate white-pearl prayer beads, and with his second right hand he holds aloft a lotus in bloom (fig. 37). Shadakshari Avalokiteshvara is traditionally regarded as the designated protector of Tibetans—and the Dalai Lama as a human embodiment of this aspect of the bodhisattva.

The twelfth-century ritual description accompanying this *thangka* explains that Avalokiteshvara has two attendant four-armed bodhisattvas, one male

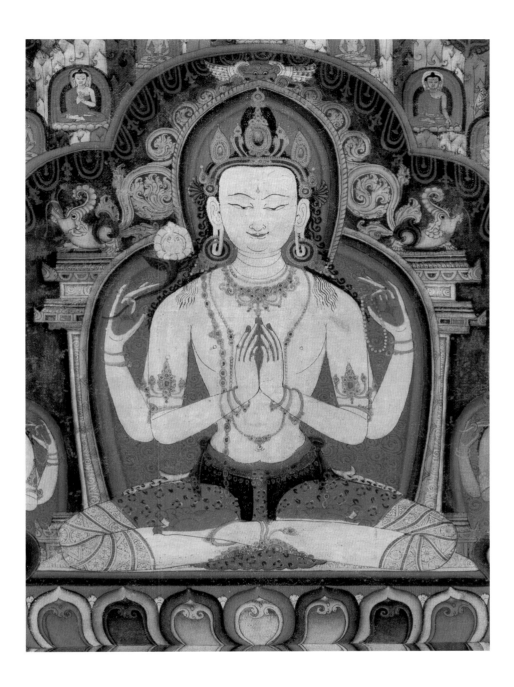

Fig. 37. Shadakshari Avalokiteshvara, the
Bodhisattva of Compassion (pl. 33, detail).
Tibet, 1300–1350

and one female, and all three figures sit serenely within a deep grotto.[5]
Here, the rock staves above the grotto entrance are populated by a host of
miniature animals—mountain goats, monkeys, tigers, birds—accompanied by
four seated hermits, who are interspersed amid the five Tathagata Buddhas,
with the red Amitabha Buddha seated directly above Avalokiteshvara.
Amitabha presides over the lotus family, of which Avalokiteshvara is the
principal bodhisattva (see table on p. 53). At the top of the painting sits
a row of male and female teachers, as well as Indian and Tibetan monks
who transmitted the teachings of this special aspect of Avalokiteshvara.

Fig. 38. Buddha with the bodhisattvas
Padmapani and Vajrapani. Tibet,
ca. 10th century. Fired clay, molded and
polychromed, 10 × 7 × 1 ½ in. (25.4 × 17.8 ×
3.8 cm). The Metropolitan Museum of Art,
New York, Purchase, Friends of Asian Art
Gifts, 2008 (2008.504)

The Indian monk Atisha (pl. 2), who sits at center wearing a red hat, played
a major role in the spread of the cult of this form of Avalokiteshvara in
Tibet, composing ritual texts in his praise and translating earlier Indian
meditative texts.

Among Avalokiteshvara's many forms, particularly popular is his
aspect as Padmapani, or "Lotus-in-Hand," whereby he stands tall on a
lotus pedestal (fig. 38). His right arm extends with palm up in the *varada
mudra* of blessing and boon bestowing, and the left clasps the stem of a
lotus. Avalokiteshvara may also be represented with eleven heads and one
thousand arms, an eye in each hand expressing his vow to constantly watch
over humanity (pls. 34, 35).

Another principal figure in Buddhist devotion is Manjushri, the
bodhisattva of transcendent wisdom and enlightenment, whose role is to
safeguard the Buddha's teachings, or dharma. As the dharma is deemed
sacred, Manjushri's defense of it from heresy or destruction is crucial. In a
very large Chinese silk tapestry (pl. 30), Manjushri, seated on a blue lion,
protects these teachings with his two principal attributes: a sword, with
which he cuts through ignorance, and a volume of the *Prajnaparamita Sutra*,
the text encapsulating the Buddha's "perfect wisdom." Above the central
image of Manjushri is the blue Buddha Akshobhya, who embodies the

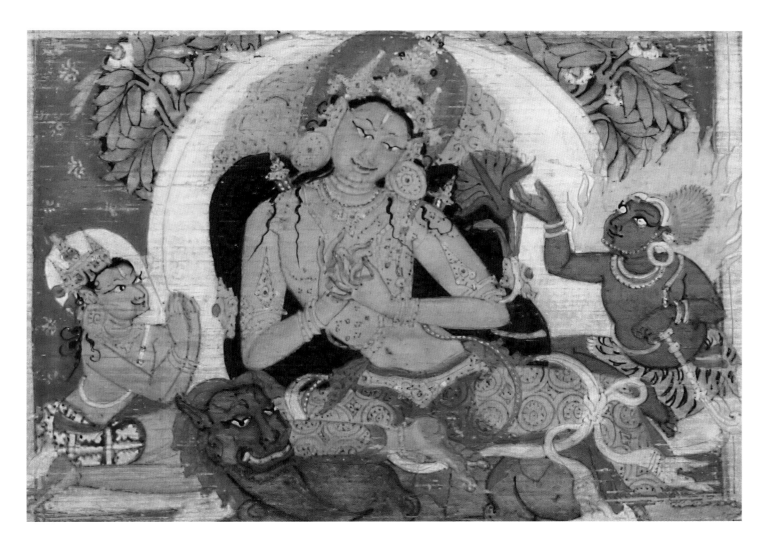

indestructability of enlightenment. His right hand gestures toward the earth; his left hand rests in his lap in the gesture of meditation.

Manjushri has many appearances, both benevolent and wrathful, and while he is often shown with two arms, he can have four or as many as eight. In addition to the sword and the sutra, he may also hold the stem of a blue lotus, a symbol of the triumph of wisdom; a *vajra* and *ghanta*; a bow and arrow; or a seed of the myrobalan plant, emblematic of knowledge. Crowned, he may wear braids to his shoulders, or he may have ornaments befitting a youth, such as hair tied into tufts (a boy's coiffure in India) or a necklace of tiger's teeth (protective charms for boys in ancient India).[6] Manjushri had a long history in India, Nepal, and China prior to his paramountcy in Tibet. By the eleventh century, he was primarily portrayed in Tibet seated, accompanied by his attributive sword and volume of scripture, the latter resting on a blue lotus (pl. 15). His body may be white, yellow (pl. 8), or orange-red (pl. 16). The Tibetans adapted this iconography from Buddhist manuscripts brought to Tibet by pilgrims and teachers.

Fig. 39. Leaf from an *Ashtasahasrika Prajnaparamita Sutra* (pl. 8), detail showing the bodhisattva Manjushri. India, Bihar, Nalanda monastery, Pala period, third quarter 11th century

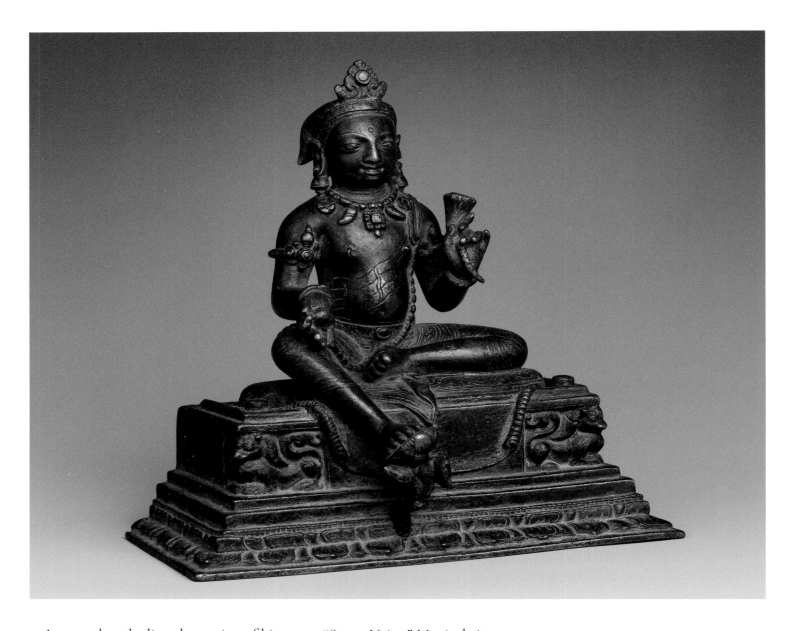

In regard to the literal meaning of his name, "Sweet Voice," Manjushri has an alternative aspect in India by which he is known as the "Lord of Speech." In a Pala-period manuscript of the *Prajnaparamita Sutra* (pl. 8), the bodhisattva is the epitome of calm and gentleness, his yellow body swaying slightly as he sits in total tranquility on the back of a recumbent blue lion (fig. 39). It is not the sword that tames the lion but Manjushri's gentle voice, which speaks the words of the Buddha. His arms are positioned in front of his heart in the teaching gesture, and his left hand clasps the stem of a blue lotus, which blooms over his shoulder.

Manjushri may also be recognized in his representation as Siddhaikavira, or "Perfect Hero," as exemplified in a fine bronze from the late tenth or early eleventh century (pl. 29). The sculpture was probably produced in

Fig. 40. Bodhisattva Manjushri as a youth. Nepal, Kathmandu Valley, Licchavi–Thakuri period, 10th century. Copper alloy, 6 ½ × 6 ½ × 4 ½ in. (16.5 × 16.5 × 11.4 cm). The Metropolitan Museum of Art, New York, Gift of Mr. and Mrs. A. Richard Benedek, 1978 (1978.394.1)

Guge, in western Tibet, after Kashmiri aesthetic models. Kashmiri Buddhist teachers, translators, and artists were active in Tholing, the capital city of Guge, at that time, collaborating with Tibetans who were eager to learn their skills. Here, the bodhisattva's crescent crown, broad shoulders, and strong chest, as well as the inlaid eyes and the floral motifs on his long loincloth, are typical of the work of Kashmiri artists or their Tibetan pupils. The lowered right hand, palm facing upward in *varada mudra*, could be assigned to either Manjushri Siddhaikavira or Avalokiteshvara Padmapani, but his identification as Manjushri is made clear by his necklace: six tiger claws surround the rectangular gemstones of the central medallion, a protective garland emblematic of Manjushri's iconography. This attribute is likewise visible in a Nepalese sculpture of the bodhisattva portraying a fearsome Manjushri in the prime of adolescence, scowling and strong in a belligerent pose (pl. 31). In his right hand is the hilt of a sword; the blade has been lost to time, as has the object he once grasped in his now empty left hand. Still visible, however, is the tiger-claw necklace, as well as the requisite locks of hair at the back of his head. These same two attributes identify a youthful yet peaceful Manjushri in another early sculpture from Nepal, in which he appears seated on a plinth supported by lions (fig. 40). The blue lotus in his left hand is cuplike, and in his outstretched right hand, he holds a spherical myrobalan seed.[7] Thus, while there are many variant aspects of Manjushri, all exhibit at least one element, whether the sword, the seed, the blue lotus, or the book of scripture, that recalls his association with the Buddha's wisdom.

Another of the principal bodhisattvas, Vajrapani, embodies valiant protection, defending Buddhism against would-be enemies. As holder of the *vajra* (thunderbolt), he also represents the dynamism of the Buddha's enlightenment for the benefit of all living beings. Vajrapani is closely related to the Buddha Akshobhya, whose emblem is also the *vajra*, and he seems to be an adaptation of the ancient Indian god Indra, who is often identified with thunder and, at times, the sword. Indra is thought to destroy the demons of drought by bringing the annual rains, and thus is seen as a source of vitality.[8] Analogously, Vajrapani represents the vital energy of all living beings.

As with other bodhisattvas, Vajrapani can assume many different aspects. A seventh- to eighth-century stone Vajrapani from north India shows him standing stalwartly with his *vajra* cupped in his right hand (pl. 36). He wears a knee-length dhoti, sashes, and jewelry. The sacred thread signaling his status as a bodhisattva descends prominently from his left shoulder to his hip. His hair is combed into high dreadlocks, indicating his alternative esoteric identity that links him to the Hindu god Shiva, who is usually portrayed with piled locks of matted hair. At his left is a small *krodha* (anger) attendant with fangs, whose head Vajrapani caresses. By contrast, a

twelfth-century painting from Guge (pl. 37) presents him as a hefty, blue-bodied manifestation wearing an animal pelt above his powerful thighs, holding the *vajra* and adorned with both a crown and golden jewelry. He stands valiantly below the blue Buddha Akshobhya, ready to defend his teachings. His eyes are red and globular; his mouth, beneath a thin mustache, is open to reveal his teeth. Here, Vajrapani is strikingly poised and still, not growling in wrath, in contrast to so many ferocious Tibetan deities shown lunging to attack enemies or demons. He strides above a multicolored lotus pedestal, which rises amid meandering vines, flower buds, and white lotuses in full bloom. Seated in the lower register are, at left, the painting's Tibetan donor and, at center, Jambhala, the god of wealth, summoned to assure the prosperity of the Buddhist community.

The Great Goddesses and Female Bodhisattvas

The benevolent goddesses of Indian and Tibetan Buddhism are perceived as overwhelmingly kind, omniscient, and compassionate figures. They represent the means by which the wisdom of Shakyamuni Buddha will reach and succor the faithful. Their multiple roles and classifications evolved during the long history of Buddhism, ranging from goddesses to bodhisattvas to even female Buddhas. There is a perceived transition in their roles during successive phases of existence, such as that invoked for Tara, "a completely enlightened buddha . . . [who] promised to appear [after enlightenment] in the form of a female bodhisattva and goddess for the benefit of all beings."[9] This concept may apply to other goddesses as well.

In appearance, Buddhist goddesses in the Himalayas and Tibet systematically follow the aesthetic imprint of Pala India, where their sensuous bodies were royally adorned and draped in diaphanous fabrics. Gracefully, they stand or sit with successive bends at the shoulder, waist, and hip, as previously immortalized in Indian stone sculptures or manuscript illuminations. In a twelfth-century Tibetan *thangka* of Green Tara, she sits serenely yet in rapt attention to those in need, the epitome of compassion and mercy (pl. 38). Goddesses may also convey vigor, for instance, Prajnaparamita, portrayed in sculpted relief on the cover of her eponymous sutra as a robust figure, wielding a *vajra* to defend the teachings contained therein (pl. 17).

As the embodiment of the dharma, Prajnaparamita is so revered that some ancient Buddhist texts refer to her as "the female Buddha," while others deem her "the mother of all Buddhas." She shares her name with the *Prajnaparamita Sutra*, and both goddess and scripture are understood to encapsulate the supreme perfection (*paramita*) of wisdom (*prajna*) that is crucial to achieving enlightenment. Accordingly, she is often represented in manuscript illuminations and on book covers. In the Pala manuscript (pl. 8), crowned and bejeweled, she holds her two hands over her heart

in the teaching mudra, each hand simultaneously clasping the thin stalk of a spherical lotus on which a rectangular volume of the scriptures is placed. The lotus alludes to her close association with Avalokiteshvara, for Buddhist wisdom is understood to be transmitted to devotees in a spirit of compassion. In a manuscript dating from the twelfth century (pl. 11), Prajnaparamita has six arms: again, she holds two hands over her heart in the teaching mudra, but here, her upper right hand clasps a *vajra*, the lower right hand extends with palm open in the gesture of boon bestowing and generosity, the upper left hand holds aloft the scripture, and her lower left hand grasps the stalk of a lotus. It is noteworthy that she holds a blue lotus, a reminder of her close relationship with Manjushri, the bodhisattva of transcendent wisdom, while the presence of the *vajra* invokes Vajrapani, defender of the Buddha's teachings. These references demonstrate how Prajnaparamita, the personification of wisdom and compassion as reflected in the *Prajnaparamita Sutra*, occupies a pivotal position in relation to the great male bodhisattvas.

Likewise important in the pantheon of Buddhist goddesses is Tara, the "savioress" whose mercy leads her to cherish, protect, assist, and nurture all those who seek her help.[10] In Tibet, Tara is perhaps the most popular of all the Buddhist deities, alongside Avalokiteshvara. Both are associated with the Buddha Amitabha, lord of the lotus family. One Tibetan tradition describes Tara as a tear emanating from Avalokiteshvara, subsequently taking female form to aid the latter in his role as a protector. Tara herself is understood to protect against the eight perils: lions (pride), elephants (delusion), fire (hatred), snakes (envy), thieves (false views), imprisonment (greed), floods (lust), and demons (doubt). She is thus invoked by devotees seeking to avoid both physical dangers and spiritual pitfalls. In an elegant Tibetan painting of the late twelfth century (pl. 38), Tara's tiered crown, gauzy garments, and abundant jewelry— even toe rings—reflect Pala Indian aesthetics, as do her orange palms and soles, adorned with henna. Originally, the eight perils were visible in the eight lateral manifestations of Tara that appear to either side of the central image, but these renderings are now largely effaced. In the top register immediately above Tara is the green Buddha Amoghasiddhi, making the *abhaya mudra* of protection. Amoghasiddhi is often seen as a parallel to Tara, sharing her role as a savior (fig. 41).[11] The etymology of her name in Sanskrit has been associated with the verb root "to cross" or, alternatively, "to save" or "to protect" (*tar*) while her name in Tibetan means, literally, "she who liberates" (*sgrol ma*), referring to her capacity to free beings from suffering. From the eighth through the twelfth century, the cult of Tara became increasingly popular in monastic and secular society as devotional texts composed in India and Nepal to aid in her worship were translated into Tibetan.

Among Tara's various manifestations is Green Tara, who is variably portrayed among throngs of devotees, actively dispensing aid (fig. 42), or as

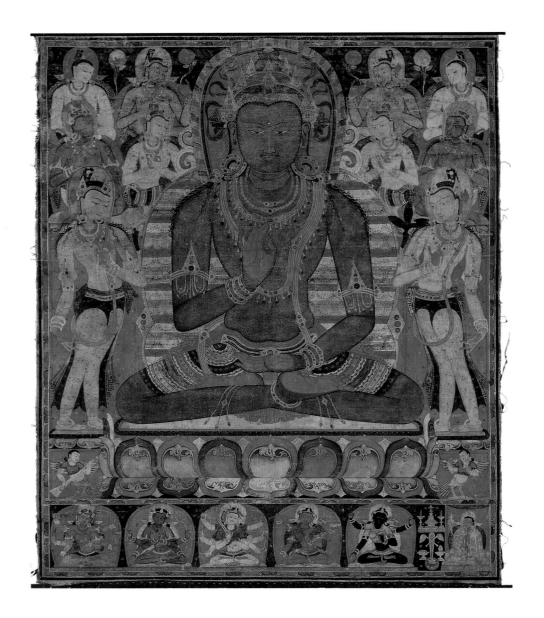

Fig. 41. Buddha Amoghasiddhi with eight bodhisattvas. Central Tibet, ca. 1200–1250. Distemper on cloth, 27 ⅛ × 21 ¼ in. (68.9 × 54 cm), The Metropolitan Museum of Art, New York, Purchase, Miriam and Ira D. Wallach Philanthropic Fund Gift, 1991 (1991.74)

a lone figure, emanating compassion. In one example of the latter, an elegant sculpture from Nepal (pl. 39), she stands attentive and alert, making the *varada mudra* of boon bestowing with her right hand and holding a lotus in her left. The sashes of her long dhoti are modeled in multiple pleats, so characteristic of Nepalese casting of this period. Ritual descriptions stipulate that she holds the blue lotus and makes reference to the presence of the Buddha Amoghasiddhi.[12]

In Nepal and Tibet, it is a convention that, when seated, Green Tara is most often shown in a royal posture of ease, with her right leg pendant (see pl. 38), while another manifestation of the goddess, White Tara, is shown with her two legs folded in the meditation pose (*vajraparyanka*). Tibetan rituals describe White Tara as having seven eyes,

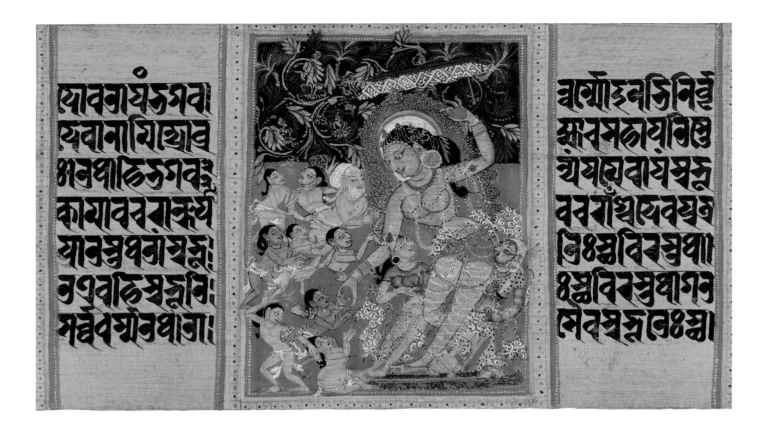

Fig. 42. "Green Tara Dispensing Boons to Ecstatic Devotees," detail of a leaf from an *Ashtasahasrika Prajnaparamita Sutra*. India, West Bengal or Bangladesh, Pala period, early 12th century. Opaque watercolor on palm leaf, page: 2 ¼ × 16 ⁷⁄₁₆ in. (7 × 41.8 cm). The Metropolitan Museum of Art, New York, Purchase, Lila Acheson Wallace Gift, 2001 (2001.445i)

with a hue white like an autumn moon—radiant like a stainless crystal jewel, shining with rays of light, one face, two hands, and having three eyes . . . seated with the legs in *vajra* posture. The palms of the hands and feet each have an eye—the seven eyes of pristine awareness.[13]

This description corresponds precisely to a Tibetan stone sculpture of the seated Tara surrounded by her twenty-one emanations (fig. 43). Her third eye is represented as a thin crescent vertically aligned in the center of her forehead, while the eyes of the hands are spread horizontally across the palms. In addition to her compassion, White Tara is revered for her capacities to heal illness and bring longevity to her devotees.

Similarly revered for her powers of longevity is Ushnishavijaya. One of her attributes is a flask containing the elixir of immortality, symbolizing her capacity to prolong life. Her name literally means "victory of the *ushnisha*," and thus the triumph of the Buddha, as the *ushnisha* is the protuberance atop the Buddha Shakyamuni's head that emerged as he attained the wisdom of enlightenment. Ushnishavijaya is associated with the ancient funerary mounds known as stupas, emblems of the Buddha's passage from the earthly to the transcendental realm (see fig. 7). In paintings she is represented

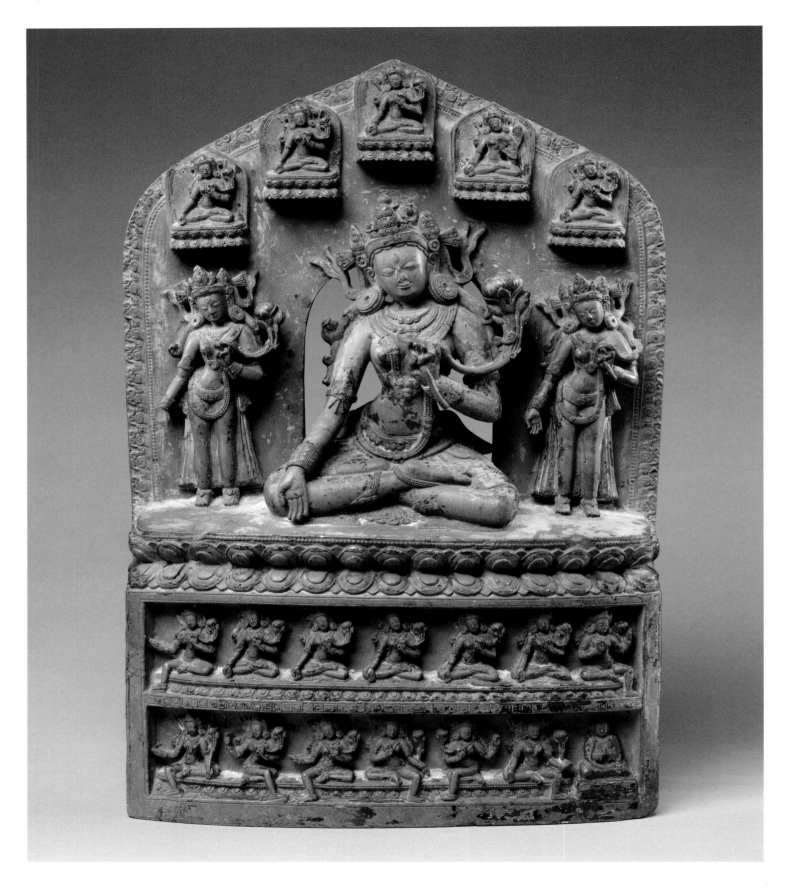

inside a stupa, while sculptures often portray her in front of one. When within a stupa, she may also be at the center of a sacred triad, as shown in a painting on silk from about 1300 attributed to central Tibet, owing to the long dedication in elegant Tibetan script on the reverse (pl. 41). Here, Ushnishavijaya, seated on a lotus pedestal within a stupa, is flanked on her right by Avalokiteshvara and on her left by Vajrapani. Above her right shoulder, a small Buddha Amitabha, dressed in monastic robes and performing the teaching gesture (*dharmachakra mudra*), sits on a lotus pedestal. Four male guardian deities occupy the lower register. The style of Ushnishavijaya's facial features, jewelry, and body proportions, as well as the architecture of the stupa, exhibits extremely close ties to Pala models; indeed, it is the earliest known painting on silk in the Pala style.[14] The use of silk, rather than linen, requires exceptional dexterity of the artist. This work of art is fascinating for the underdrawing, which is quite unique.

Dance as a Means Toward Enlightenment

In Tibetan sacred spaces, the lay public primarily had access to the main Buddhas, attendant bodhisattvas, and female deities in the form of sculpted effigies. These sculptures were vitally important to daily life and were actively venerated by the public. As explored in the preceding essay, tantric Buddhist imagery, by contrast, was the focus of esoteric rituals conducted by monastic elites. However, while much esoteric imagery was largely inaccessible to the public, it was still understood to exist and to be carried out for the overall benefit of the people.

Festivals of masked dances (*cham*) represented another form of devotion in which the lay community could participate as spectators (figs. 44–46; see also fig. 33). These dances, which marked the Tibetan ritual calendar, sought to bring powerful deities into the public realm so that they might bestow prosperity and abundance on the community. They reflect the impact of Indian traditions, both Hindu and Buddhist, which were adapted and transformed in Tibet, Nepal, and the Himalayas, notably in Bhutan. Some elements of these performances, such as the deer and stag masks donned by dancers (pl. 44), may reflect pre-Buddhist Tibetan religious practices.[15] The deer is sacred in Tibet, as it is in much of Central Asia, owing to the spontaneous, almost "miraculous" growth and subsequent shedding of the stag's antlers each year. The deer is thus a potent symbol of perpetual vitality, immortality, and rebirth. Deer dancers are deemed apt to subjugate demonic forces and to transform negative energies into positive ones, thus accomplishing the liberation from all evil (*sgrol 'cham*). With time, many aspects of Tantrism found their way into these performances, rendering them an opportunity for laypeople to access esoteric practice.

Performing the *cham* was, for monks and laypeople, a way of accruing good karma, both for themselves as individuals and for the community at

Fig. 43. Twenty-one emanations of the goddess Tara. Tibet, 14th century. Stone with polychrome, 15 ¼ × 10 ¼ × 3 ½ in. (38.7 × 26 × 8.9 cm). The Metropolitan Museum of Art, New York, Gift of Florence and Herbert Irving, 2015 (2015.500.4.19)

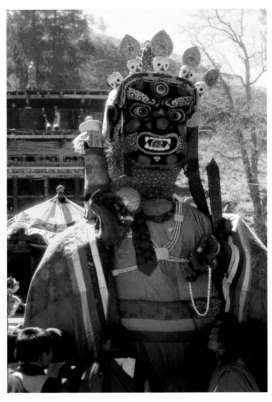

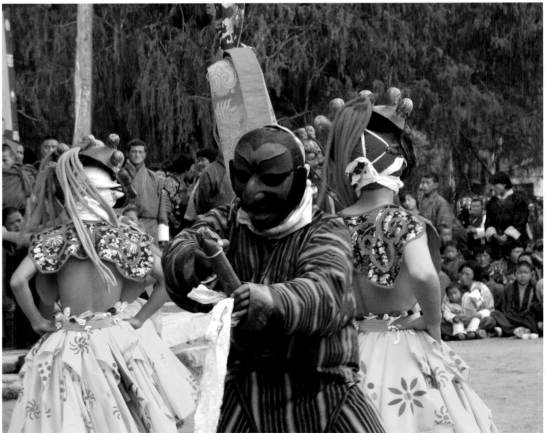

large, contributing to advantageous rebirths in future lives. In the same way that copying the scriptures generates merit for both the copyist and those who read the scriptures or hear them read aloud, *cham* generated merit for the dancer, for those who commissioned the dance and its complementary rituals, and for all those who observed the performances. These dances are a moment of communion, the rhythmic sounds of drums, cymbals, and horns (pls. 46–49) and the captivating sight of swaying and leaping dancers wearing dramatic masks and brilliantly hued robes of silk brocade (pls. 44, 45) coming together to mesmerizing effect. Many *cham* festivals also feature more solemn dances invoking the deity Yama, lord of death. Yama is summoned to evaluate and pass judgment on the good and bad deeds of individuals following their deaths. Yama has several different kinds of animal helpers, as well as humans, including the skeleton dancers, or *chitipati*, lords of the charnel grounds. *Chitipati* dancers wear masks and costumes (pls. 42, 43) that transform them into grinning skeletons, mirthfully reminding us of the impermanence of human existence and the importance of accumulating good karma. These dancers are usually male, but sometimes a male-female couple will perform together.[16] Simultaneously, there are often additional performers, for instance, the more comic buffoons, who elicit gales of laughter through lewd gestures and provocative humor that mimic the rituals performed by other dancers. *Cham* are thus a means to avert evil for the assembled community and to the benefit all living beings, in the profound belief that all those who have witnessed the purificatory dances will enjoy a long life, prosperity, and freedom from suffering and illness.

Buddhist devotion to the bodhisattvas and goddesses reflects an unwavering belief in their compassion and in their ability to help all beings achieve long, peaceful lives in the earthly realm and spiritual awakening leading to salvation in the next. These objectives are mirrored in and manifested by *cham* dances, which represent a collective hope for the appeasement of all evil and salvation for all living beings. These ideals of generosity, mercy, and auspiciousness, embodied by the goddesses and bodhisattvas who promote and protect the Buddha's teachings, continuously motivate both monastic and lay individuals to work together for the sake of all beings, to manifest enlightenment in both this life and the next.

Figs. 44–46. Masked dancers participating in *cham* rituals in Thimphu, Bhutan

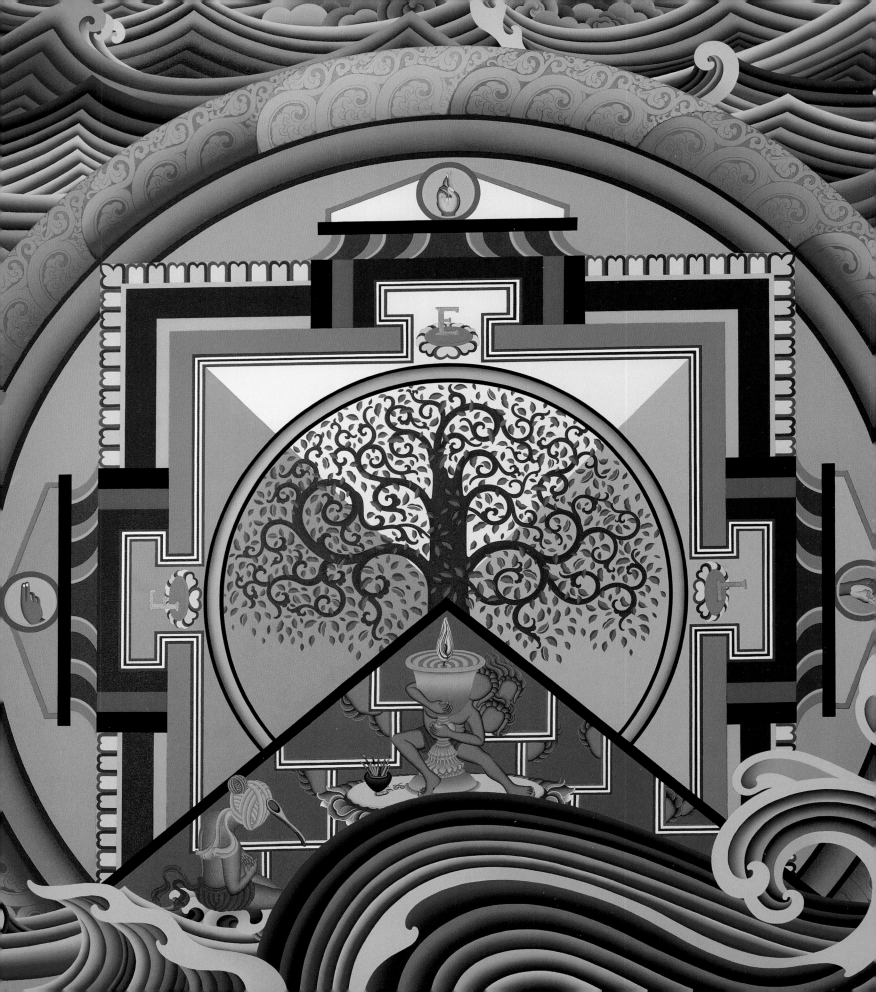

Biography of a Thought: A Discussion with Tenzing Rigdol

KURT BEHRENDT AND TENZING RIGDOL

TENZING RIGDOL WAS BORN in 1982 in Kathmandu, Nepal, after his Tibetan parents, Norbu Wangdu and Dolma Tsering, fled occupied Tibet in the late 1960s. Rigdol came to the United States in the late 1990s to study at the University of Colorado Denver, earning a BFA in painting and drawing and a BA in art history in 2005. During this same period, he also studied traditional Tibetan sand painting and butter sculpture at the Shekar Chorten monastery and *thangka* painting under Phenpo Tenthar at the Tibetan Thangka Art School, both in Kathmandu. Rigdol has said of his formative years:

> I was born in Nepal to a Tibetan refugee family, and later my mother and I got naturalized citizenship from America. I studied in India, I studied in Nepal, I studied in the U.S. and many other places. So, I'm kind of a cocktail of all these cultures—it's a part of my identity. However, I also feel that identity is like an ice cream; the meaning of it depends on its temperature. If you raise the temperature of your question, then everything starts to melt and merge into one.[1]

Rigdol is one of several Tibetan and Nepalese artists who have found significant success on the global contemporary art stage in recent years.[2] While the artistic production of this group is diverse, Rigdol and a handful of others initiated the practice of recontextualizing early motifs, styles, and ideas from the classical Himalayan canon to comment on a range of social and political issues. This opened the door to recasting earlier Buddhist imagery to convey secular ideas and to consider Buddhist values in today's society. One of the early major exhibitions to gather this community of artists in the United States was *Waves on the Turquoise Lake: Contemporary Expressions of Tibetan Art*, held at the University of Colorado Art Museum in 2006.[3] Since that time, Rigdol and other members of this transformative group have gone on to show their work at major museums, galleries, and events across North America, Europe, Nepal, Tibet, and China. With respect to Rigdol, of particular significance is his 2011 site-specific work *Our Land, Our People*, for which he brought twenty thousand kilos of soil from Tibet to Dharamshala in India so that Tibetan exiles could walk on a piece of Tibet.[4] Following on this, in 2015, he established the Khanyara artist residency in Dharamshala to support emerging artists in exile and to foster exchange and collaboration within this community.

It is in acknowledgment of how Rigdol's work traverses the traditional and the contemporary, as well as geographic and cultural boundaries, that I invited him to participate in *Mandalas: Mapping the Buddhist Art of Tibet* by creating a site-specific installation at The Met. His work complements and helps contextualize the historical material that forms the majority of the exhibition. The piece, like all of Rigdol's work, approaches Buddhism in multipronged ways and embraces core tenets such as mindfulness, or living in the present moment. Using tantric or esoteric Buddhist ideas to structure his artistic presentation is equally critical to Rigdol's process in terms of the viewer's ability to understand the mechanism of thought. The title of the work, *Biography of a Thought*, hints at the tantric idea of taking a notion and untangling its myriad components, then visually representing these constituent parts to achieve deeper

OPPOSITE: Tenzing Rigdol (b. Kathmandu, 1982), *Biography of a Thought* (pl. 104), detail showing a mandala amid waves

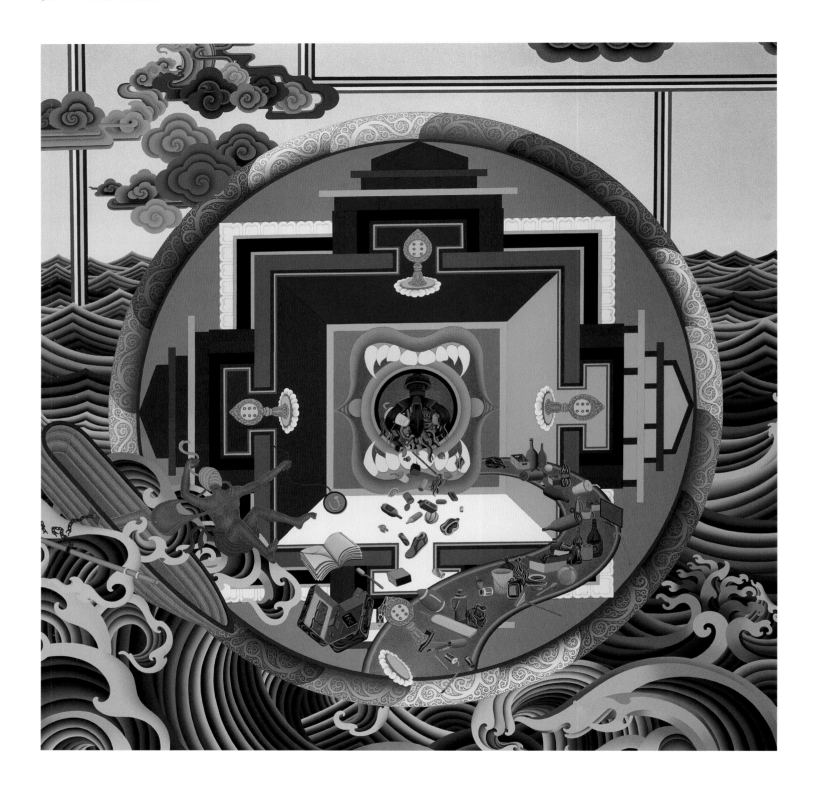

Fig. 47. Tenzing Rigdol, *Biography of a Thought* (pl. 104), detail of a mandala containing an individual being tossed from a boat and an open mouth spewing trash

insight. Still, the artist is adamant that his work, with its social and political content, is secular, despite employing charged motifs and iconography from the Buddhist canon, such as the mandala, to frame complex ideas. For this reason, the many eleventh- to fifteenth-century works in the surrounding galleries provide a foundation for understanding the subtle content of his installation. For example, the red line work he uses throughout references the complex underdrawing present in all classical paintings (see pl. 41). Historically, such underdrawing provides the very structure that establishes a consecrated space within which images of traditional deities reside. Like bones in the body, this framework helps articulate meaning. Reciprocally, Rigdol's contemporary use of the mandala and other Buddhist motifs offers the audience a window to better conceptualize the early material.

Biography of a Thought also draws on a body of personal iconography, which pervades the installation. For example, the red line work noted above, beyond referencing classical traditions, also evokes the plans followed by weavers when making carpets, a practice the artist's family was engaged with in Nepal after they fled Tibet as refugees. In this context, the handwoven carpet at the center of the installation is unifying—its composition employs lotuses as a reflection of the many mandalas on view. All of this stems from the artist's personal history. As he explains:

> You will find throughout the paintings a miniature figure with his head wrapped. The figure represents "me," wherein the wrapped head symbolizes my awareness about my limited knowledge and ignorance. In the first painting [fig. 47], you can see the individual being thrown into the world with the boat—a very existential approach.[5]

Indeed, being cast into this world and struggling to overcome ignorance are both Buddhist concepts, as is the idea embodied in the associated mandala evoking sound as the ultimate, cosmic source of all things, here shown as an open mouth. At the same time, Rigdol uses other imagery—a construction crane, trash, smokestacks—that we can immediately read as a comment on environmental pollution, exemplifying how his work has many levels of embedded symbolism that can be read both literally and at a deeper level. The very idea of discovering underlying meaning is integral to tantric art, but Rigdol attempts to do so with symbolism accessible to a modern audience. At the same time, throughout the installation he has integrated elements of American Sign Language, which he calls "ASL mudras," related to classical deities or specific ideologies. Only those who know ASL can readily interpret the meaning of these mudras. Equally, he has embedded into the work poetry written in braille, which again is meant to be discovered by those familiar with this system of reading. Thus, while the installation overall is directed at a contemporary audience, by limiting access to certain parts of it to those who can understand braille or ASL, it aligns with tantric ideas of deeper meanings that can only be accessed by someone with special training and knowledge. One could, however, also note that the incorporation of ASL and braille serves to reach across lines demarcated by disability and language, reflecting Rigdol's self-professed desire to communicate as a human "without belonging to any nation, race, class, group, tribe, club, or creed."[6] In one mandala within the installation, for instance, he shows a *vajra*, a symbol of the power of enlightenment, being disassembled by divergent languages, as embodied in the story of the Tower of Babel (fig. 48).

When this project was first proposed, it was just days before the Covid-19 pandemic shut down the world in 2020. There followed a moment when society rethought issues of race, gender, disability, and equality. It was a time when people gave thought to how they were living their lives, their place in the world, and one's own responsibility to or role in society. As a mandala is meant to be used and interpreted by an individual to reach personal insights, this installation offers the opportunity to simultaneously consider many aspects of this issue. In conversations, Rigdol and I were able to share and to question, conceptually, how contemporary and ancient expressions relate and how a fusion of these ideas might be explored. What follows is an edited and condensed version of our conversations, which occurred throughout the creation of *Biography of a Thought*.

Fig. 48. Tenzing Rigdol, preparatory sketch for *Biography of a Thought* (pl. 104) showing a *vajra* being disassembled by divergent languages

Kurt Behrendt: How did the process of making this massive artwork impact your thinking?

Tenzing Rigdol: When you showed me the space, [the skylit galleries of The Met's Robert Lehman Wing] there was really no beginning and end. It was a mandala in itself. The artworks are installed on four big walls, and you can read the painting from whatever angle you want. On each wall, you see five panels of paintings that are mirrored in a carpet [at the center of the space, where the viewer can sit]. It is like we ourselves are in the ocean of ideas. There is a sequence in the sense that there is a beginning and there is an end, where one can enter from any point. The first wall deals with our behavior and our ecosystem; the second, with conflicts between humans and among ourselves. The third wall is trying to celebrate and explore great ideas about virtue, beauty, and peace. Then, the fourth panel hopes to capture silence or calmness or stillness. There is also a central piece uniting the whole, which talks about the idea of interdependency.

The intention behind the installation as a whole is to explore the content of *Biography of a Thought*—the title of the artwork. It is about a journey of a single thought that gathers momentum and produces many thoughts, which in turn cluster and become ideas, and these ideas start changing people's lives. In this series of works, I see vibrant thoughts as clouds and feel volatile emotions as waves, and in between we have what I call the mandalas of our time. In fact, the churning ocean [drawn from direct observation], the clouds, and the structured grid unify the four walls and set the stage for the mandalas that emerge from this environment. The tree explores issues of air quality and pollution. The second mandala explores self-transformation as expressed through a self-tuning lute (fig. 49). The whole relates to our responsibility for violence directed at our own environment.

KB: The core root of human conflict lies in how thoughts are constructed. The first wall of the installation addresses our world, while the second is about unstable thoughts, which create conflict among humans.

TR: I am talking about the human relationship between thoughts and violence. As an individual, throughout my learning process, I found and I still find certain issues quite powerful, shocking, or unsettling. The artworks reflect upon war, colonialism, racism, gun violence, terrorism, and how they are all a product of turbulent thoughts.

Racism being one of the most debated and discussed issues in the United States, I couldn't help but depict George Floyd [the unarmed Black man who was murdered by police in Minneapolis in 2020] in a form of Maitreya, the friendly future Buddha, behind whom the aura of the tragic past lingers. ASL mudras run along the edges of the mandala, which read *prosperity*, *hope*, and *desire*—three early ships built in America to bring slaves. I believe that confronting truth with a brave and warm heart is a way forward. We can transcend from inheriting pain and suffering to inheriting wisdom and love.

KB: In the center of this wall is a complex image of the tantric deity Kalachakra. How does this figure relate to the core ideas of this section?

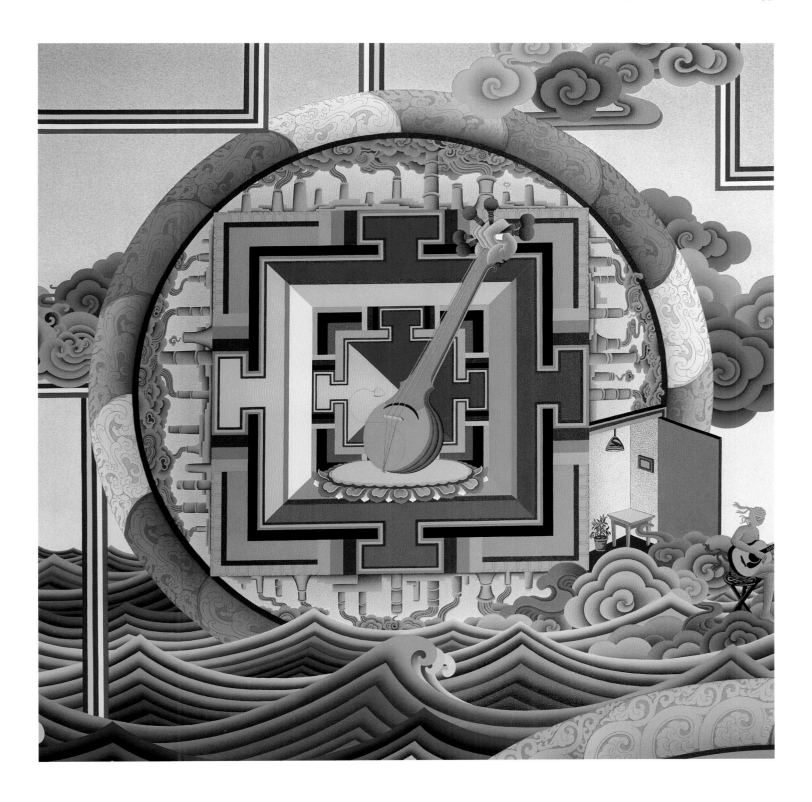

Fig. 49. Tenzing Rigdol, *Biography of a Thought* (pl. 104), detail of a mandala showing a self-tuning lute surrounded by smokestacks

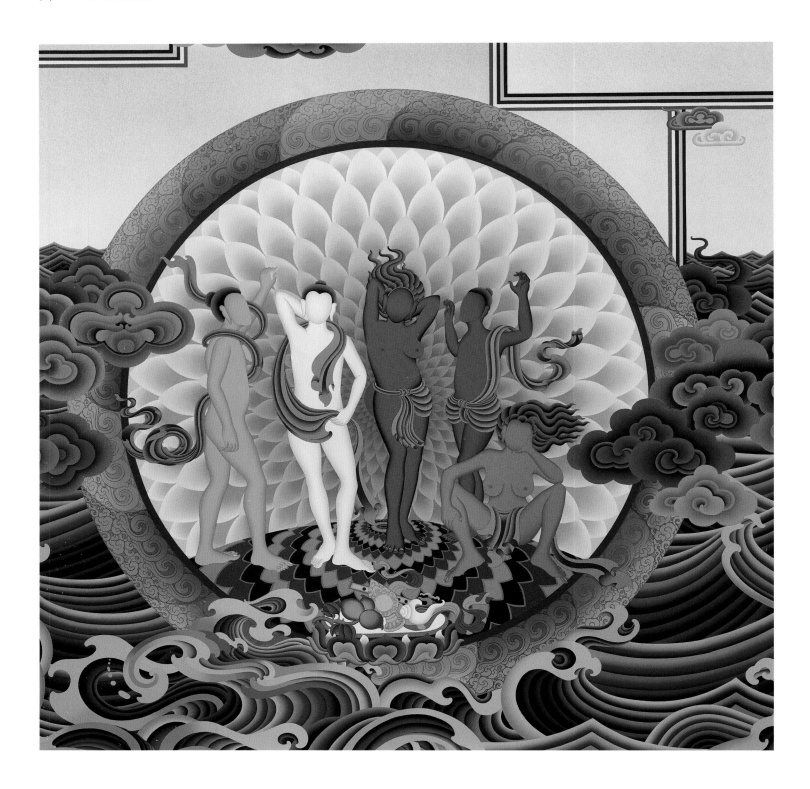

Fig. 50. Tenzing Rigdol, *Biography of a Thought* (pl. 104), detail of a mandala showing an interpretation of Picasso's *Les Demoiselles d'Avignon*

TR: The central panel expresses the complex wheel of time. The *Kalachakra Tantra* is considered Buddha's last tantric teaching, wherein he revealed the subtle relationship of breath to thought, then thought to time, then time to motion, then motion to suffering, and then suffering to thought. Therefore, it is interesting to me as an artist to imagine a composition that expresses both the sense of motion and non-motion. In the painting I depict the Kalachakra deities against the mechanism of time, with miniature figures ushering awareness toward collective human suffering.

KB: On the next wall, you mention that the goal was to address paradigmatic ideas that shape or govern our world.

TR: I start the third wall by subtly poking at Picasso's painting *Les Demoiselles d'Avignon* (fig. 50). In the painting he has depicted five women from a brothel. It is considered one of the most important artworks of the West, and I also love the work. However, I reconstruct them and give them a new form, along with a new status. I also turned Picasso's models into the symbolic Buddhist offerings of the five sensory faculties. In tantric texts, they say that if you have a proper understanding of all five of your mental faculties [sound, touch, sight, taste, and smell, represented below the figures], then you immediately realize that you are not male or female or any gender; you are just pure awareness. One of the core messages of Tantra is that you are much more than just your mere body and mind.

In an adjacent mandala are figures of whistleblowers [who have drawn the world's attention to issues such as government surveillance of private citizens and the surreptitious mining of our personal data by certain tech companies], such as Frances Haugen, Chelsea Manning, Edward Snowden, and Julian Assange. I'm talking about how, in our present-day life, we are surrounded by digital media, with everybody trying to collect data. Individuals are even discussing whether this whole world is a simulation or not. That's been happening in the East for thousands of years, where even the Buddha himself says, "I am Buddha," meaning, I am awake, I have woken out of a simulation, and he says, "You guys are in a dream state."

KB: There is so much more that we could talk about regarding the mandalas and the last wall related to the idea of, as you put it, "silence or calmness or stillness."

TR: The thoughts—the explosive clouds—that run across every frame on every wall decant and settle on this final wall. The central piece of the final wall is a dignified, empty chair (fig. 51), behind which a poem in ASL mudra reads:

A thought is a painting, a design, a composition.
A thought is a breath, a line, a dot without the edges.
A thought is a melody, always strumming on instruments,
With or without the listener.

KB: Then there is the central image—the core of the mandala. How does it relate to all that surrounds?

TR: On the central panel, I'm trying to explore the quintessential tantric idea of universality and oneness and how intricately interconnected we all are. It is said that when the Buddha reached enlightenment, he looked at a leaf and on that leaf he saw stars, he saw rain, he saw soil, he saw air, and, in essence, he saw interdependency. He saw how we are all interconnected at a much deeper and profound level. Even though we say interdependence, it's really celebrating how we all have the power of being interdependent; that is a very powerful thing. So the central piece becomes something hopeful.

KB: The actual creation of this massive work has been quite an undertaking. From the outset, you have been very deliberate. For instance, I know you have been enjoying focusing on the unique characteristics of each wave drawn from direct observation in New York, or the clouds based on numerous photos taken in Santa Fe, New Mexico.

TR: If I really believe in process, then I can believe in the painting, because it does something. The paradoxical thing is that, every time I paint, if my mind goes to our exhibition, then I look at myself in a mirror and I scold myself: "Shame on you, you're going to the future." This is one of the fundamentals of my practice. Art is really about understanding yourself and improving yourself. Once I put

all the pieces together, I was, like, wow, it looks quite alive, it's breathing.

KB: In terms of the creation of this work, you have had to structure it to conform to and accommodate the specifications of the space, for instance, in the use of acrylic paints that can take high levels of ultraviolet light. Starting with preliminary drawings (see fig. 48), I have watched your work transform and come into focus. These drawings were in turn transferred to the canvases. In terms of materials, you sourced handwoven canvases from Nepal. Equally, you designed a carpet that is mandalic in its conception, which was handwoven in Kathmandu. What are your feelings about such a sustained and complex artwork?

TR: The study of the core composition took me about two and a half years, and then about three more years to complete. This is my biggest composition thus far, and I hope that viewers will find it interesting in their own ways. To create the paintings, I needed a big studio with two or three forty-foot-long walls and, at least, eleven-foot-tall ceilings. However, I couldn't find such space in Kathmandu, so I had to create a studio on the roof of a building. I found a very generous and kind man named Neljo Gurung who made a studio according to our needs, which helped tremendously. I told him I wanted the studio to have horseshoe-shaped windows, an inverse design of an arched Ajanta cave, running through the three consecutive walls so I could get as much light as possible. The entire work is done almost entirely under bright, natural sunlight.

KB: I know that you are working with a group of local painters to help execute elements of the installation, especially the clouds, sky, and waves. Working with a team has allowed you to apply a stippling technique, which gives these features volume and dimension but is a time-consuming, detailed process.

TR: All my assistants are of various backgrounds. For the first six months, I did a lot of studies on color and focused on training the assistants. They are all wonderful, talented individuals,[7] and I have come to know them and their families. I am grateful for their kind assistance, and I must also say that this work would not have been possible without the support of my mother and my wife. What I genuinely love about such a large-scale, multifaceted project is that I got to know and befriend individuals from various backgrounds, and I learned a lot more about this grand process called life.

Fig. 51. Tenzing Rigdol, *Biography of a Thought* (pl. 104), detail of a mandala showing an empty chair amid waves

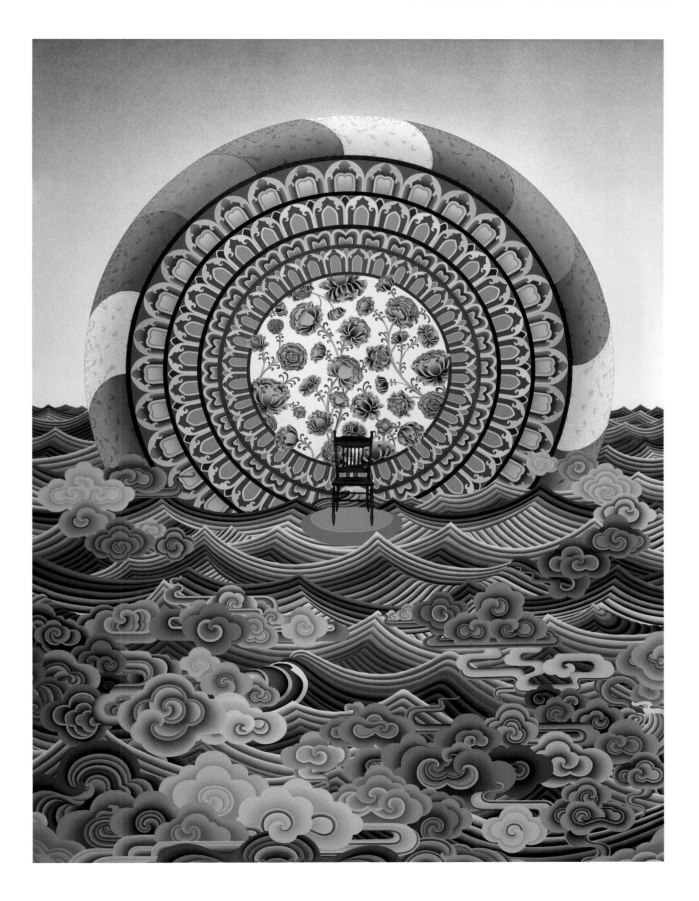

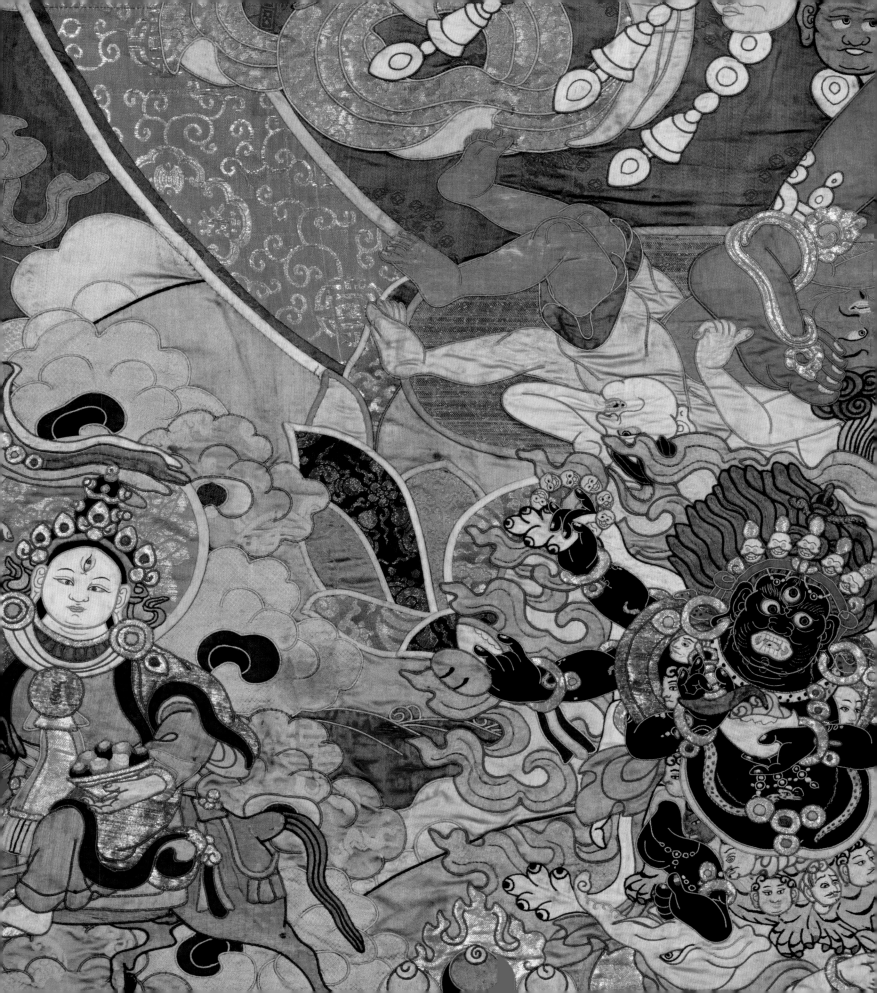

PLATES

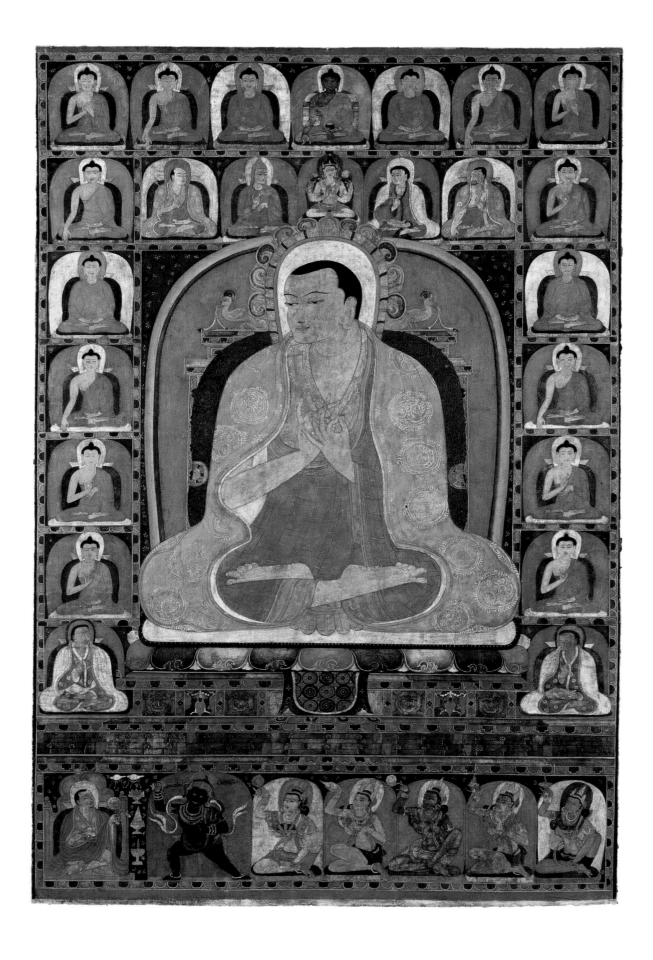

1
Portrait of a Kadam Master with Buddhas and His Lineage
Central Tibet, ca. 1180–1220.
Distemper on cloth

2
Portrait of the Indian Monk Atisha
Tibet, early–mid-12th century.
Distemper and gold on cloth

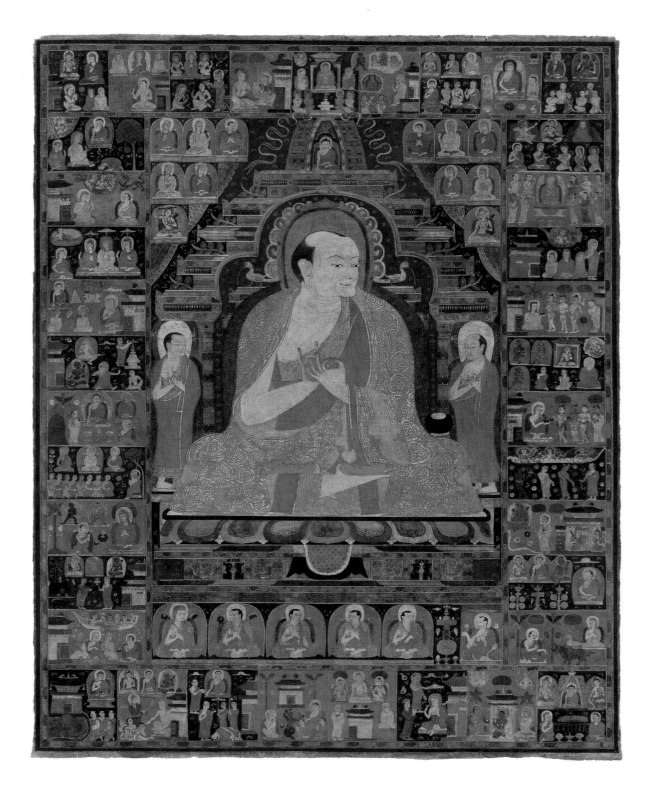

3
Portrait of Shakyashribhadra with His Life Episodes and Lineage
Tibet, early–mid-14th century. Distemper on cloth

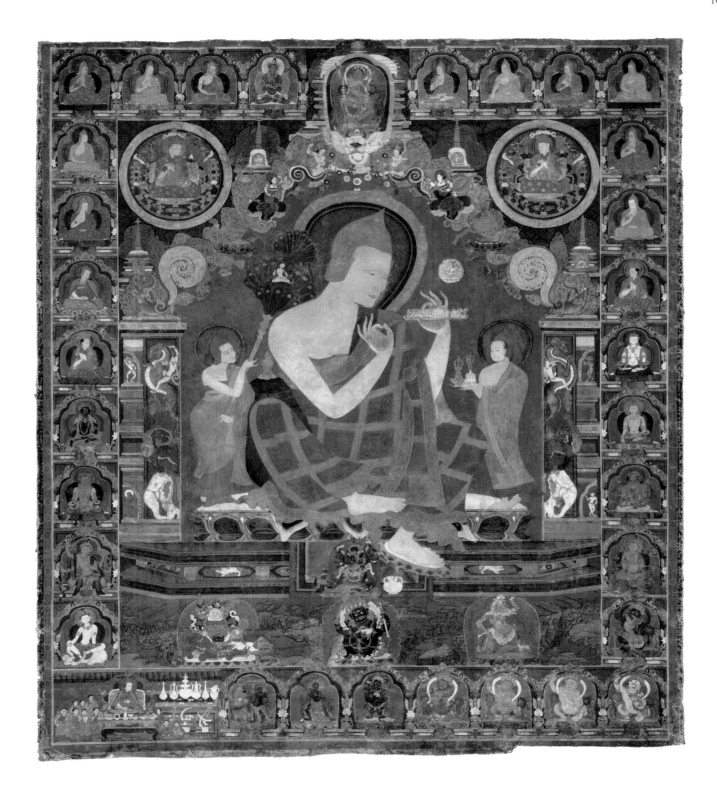

4
Portrait of the Last Indian Pandit,
Vanaratna
Central Tibet, first half 15th century.
Distemper on cloth

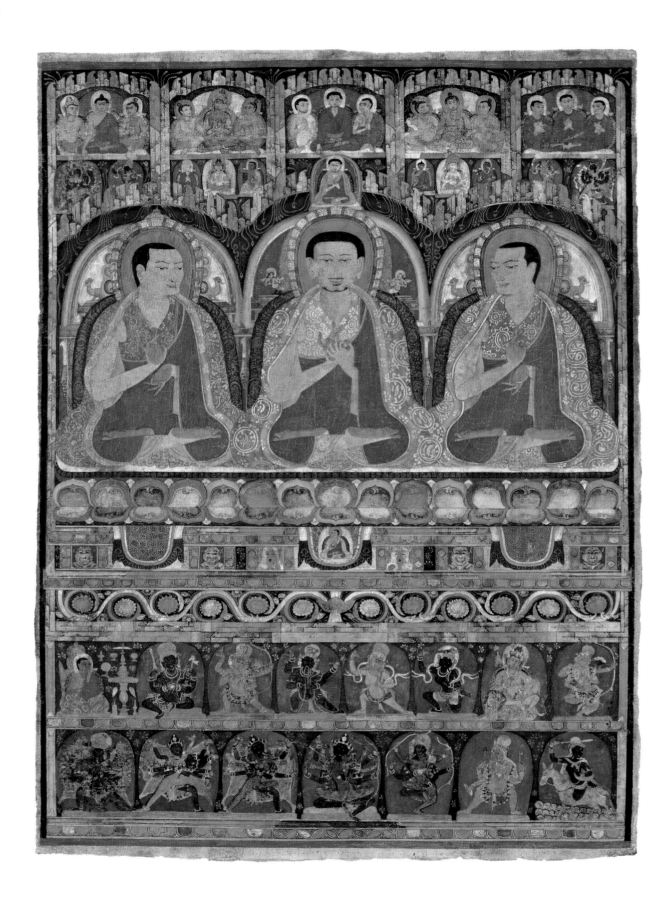

5
The Founding Masters of Taklung Monastery
Tibet, Taklung, last quarter 13th
century. Ground mineral pigment
on cotton

6
Portrait of the Third Kagyu Taklung Abbot, Sangye Yarjon
Central Tibet, ca. 1262–63.
Distemper and gold on cloth

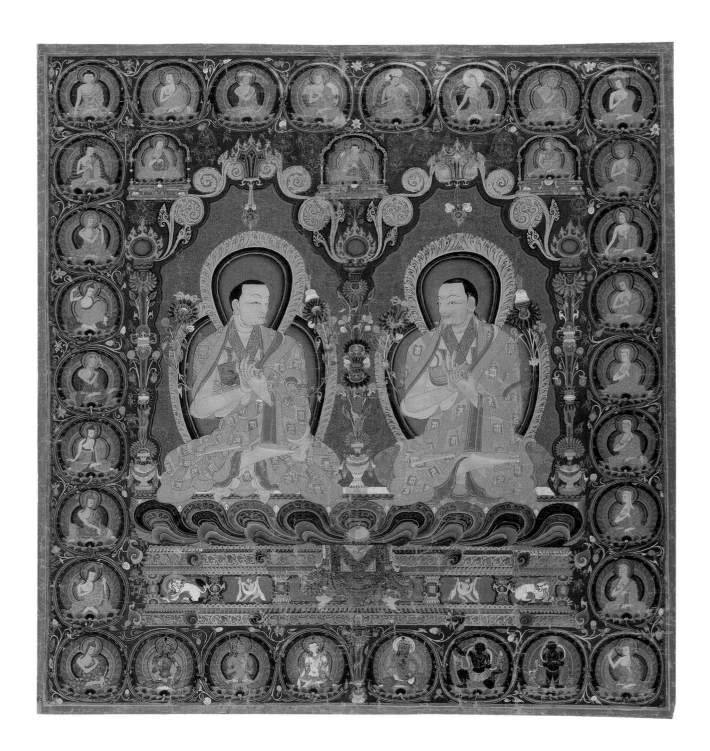

7
**Portrait of the Monk Ngorchen and
His Successor München**
Central Tibet, 1450–1500. Distemper and
gold on cotton

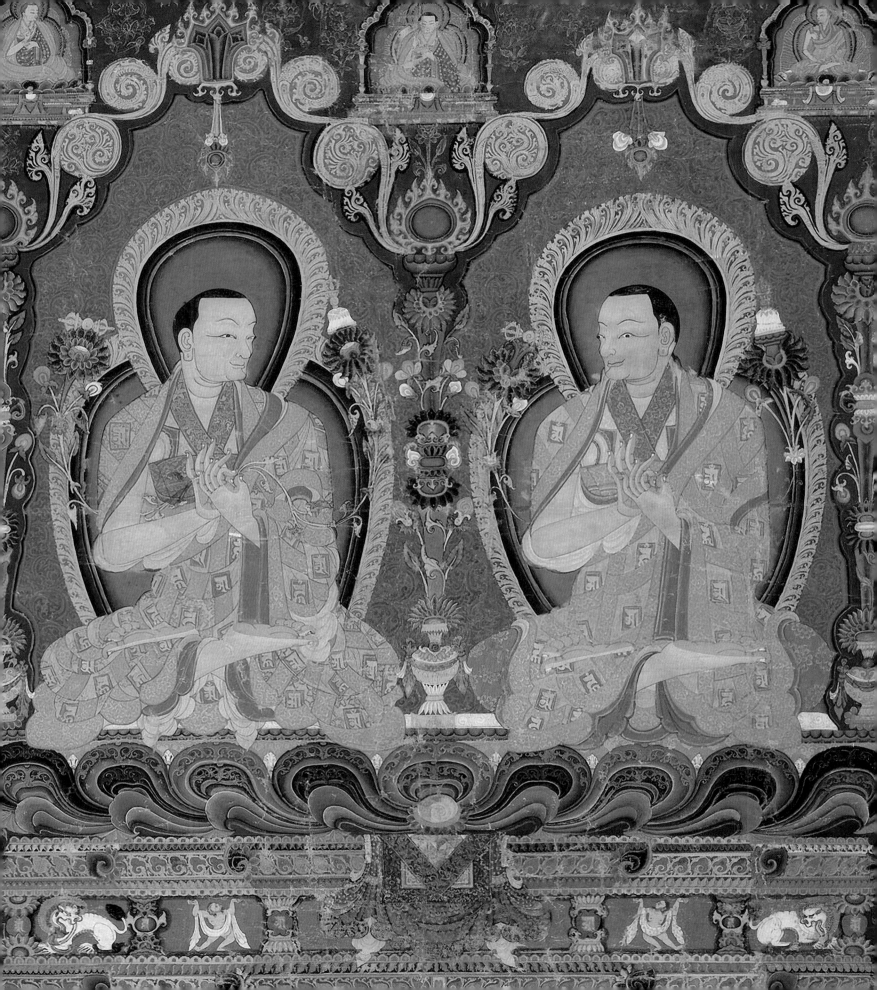

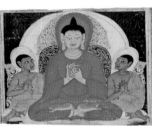

8
Four Leaves from an *Ashtasahasrika*
Prajnaparamita Sutra
India, Bihar, Nalanda monastery, Pala
period, third quarter 11th century. Ink and
opaque watercolor on palm leaf

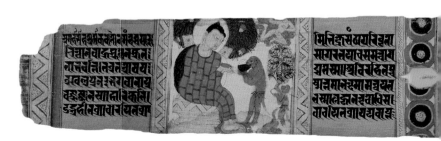

 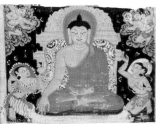

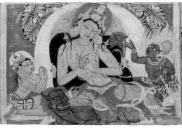 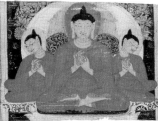

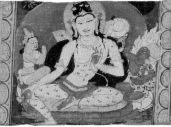

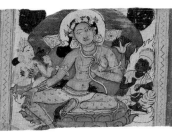

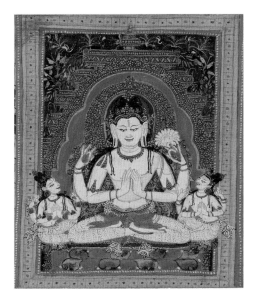

a. Shadakshari Avalokiteshvara

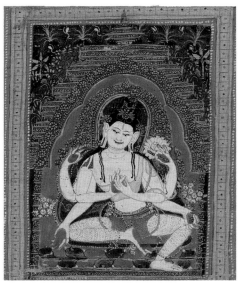

b. Six-Armed Avalokiteshvara Sitting in a Posture of Royal Ease

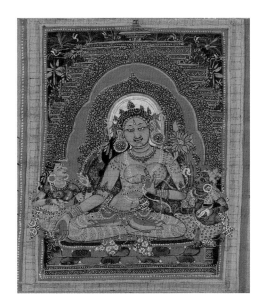

c. Green Tara

9
Four Leaves from an *Ashtasahasrika Prajnaparamita Sutra*
Artist: Mahavihara Master, India (West Bengal) or Bangladesh, Pala period, early 12th century. Opaque watercolor on palm leaf

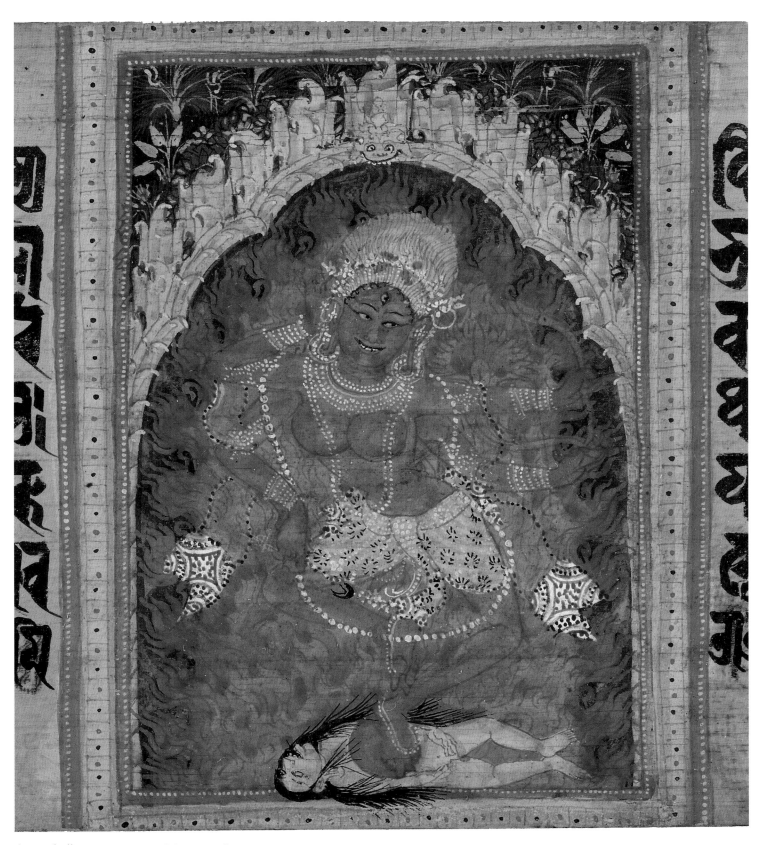

d. Kurukulla Dancing in Her Mountain Grotto

10
**Four Leaves from
a *Gandavyuha* Manuscript**
Nepal, Transitional period (880–1200),
late 11th–12th century. Ink and opaque
watercolor on palm leaf

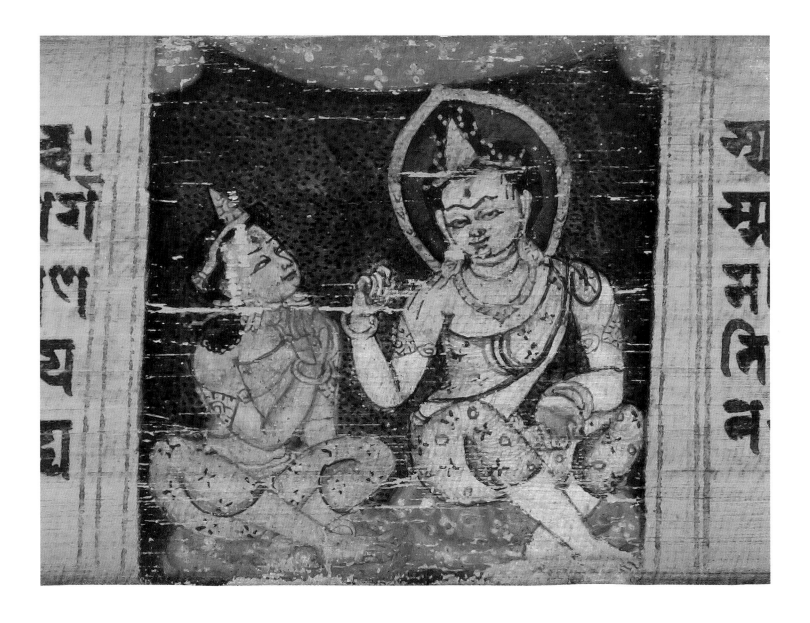

113

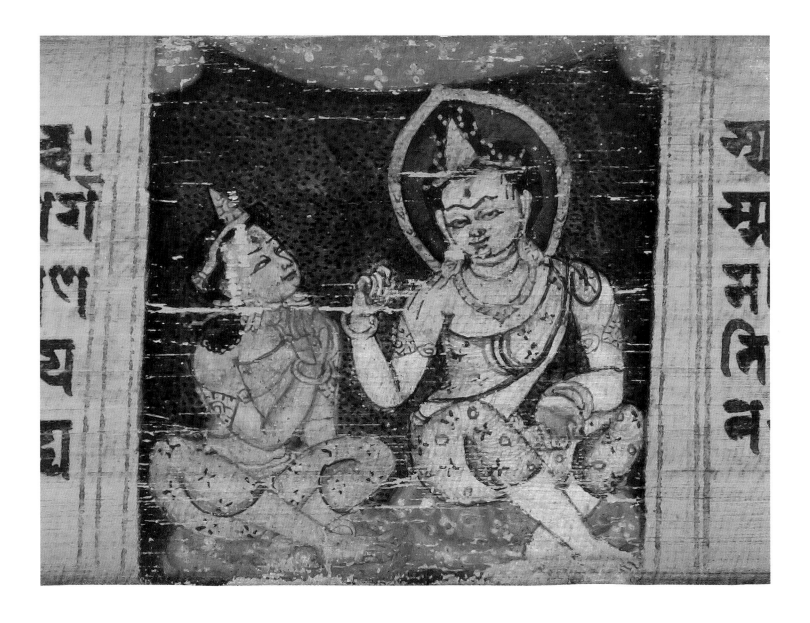

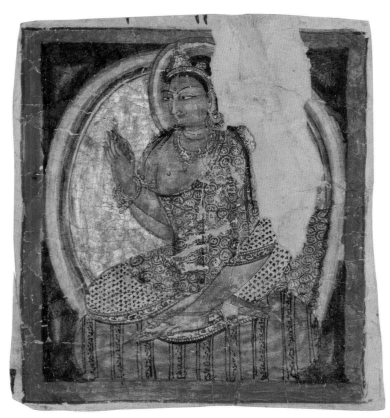

a. A Royal Worshipper

11
Three Fragmentary Leaves from an
Ashtasahasrika Prajnaparamita Sutra
Kashmir or western Tibet, 12th century.
Colors and black ink on paper

c. Buddha, Probably Amoghasiddhi

b. The Goddess Prajnaparamita

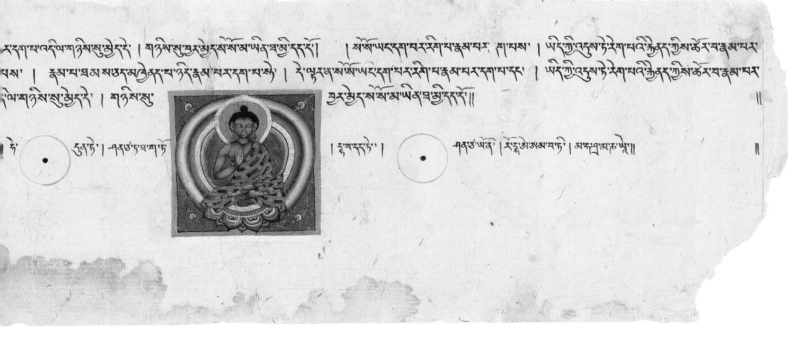

12
Cover for an *Ashtasahasrika Prajnaparamita Sutra*

Nepal, Kathmandu Valley, Thakuri–Malla period, 10th–11th century. Ink and color on wood with metal insets

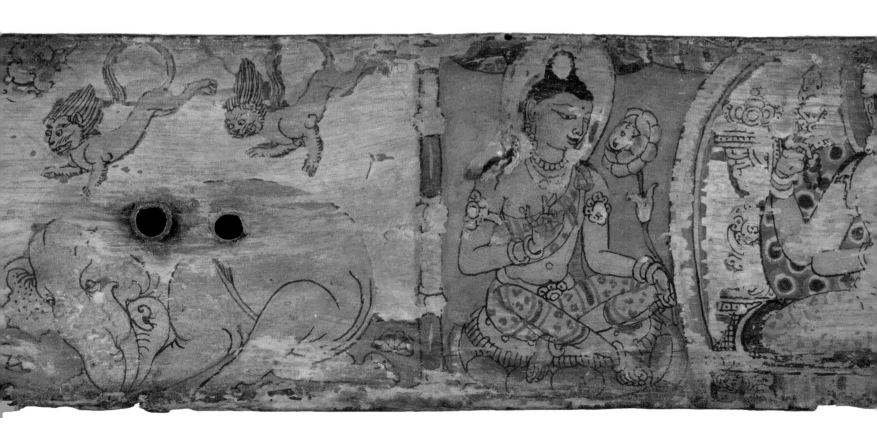

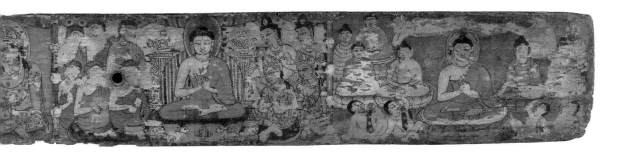

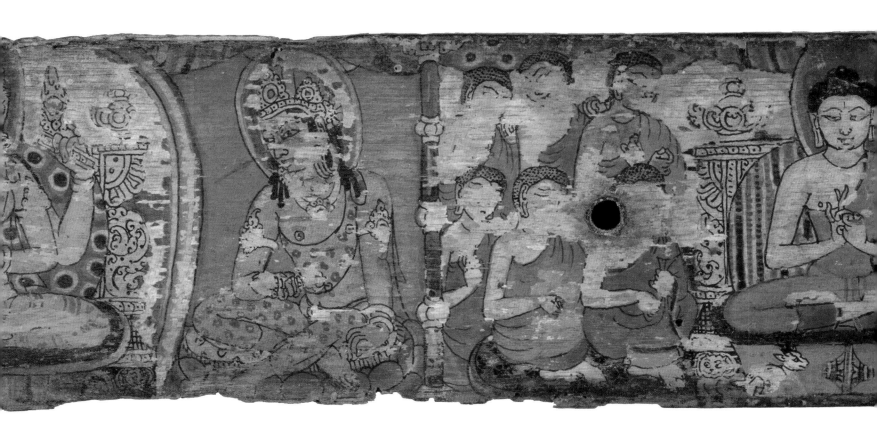

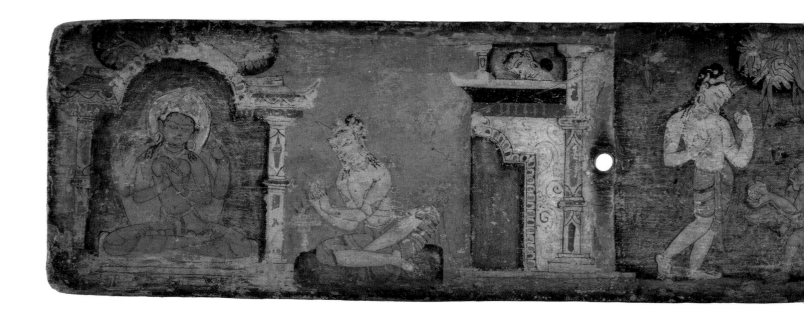

13
**Pair of Manuscript Covers
Illustrating Sadaprarudita's
Self-Sacrifice**
Nepal, Kathmandu Valley, 12th century.
Distemper on wood

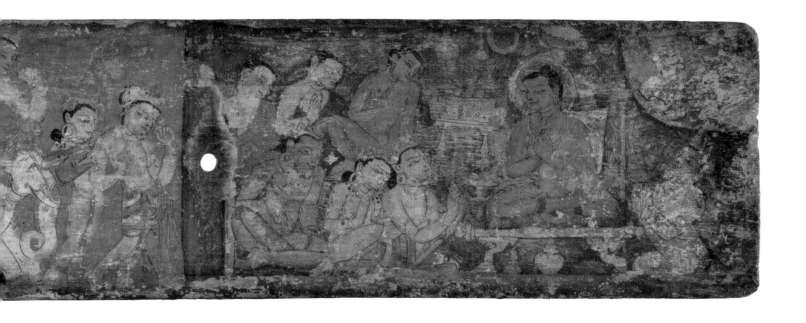

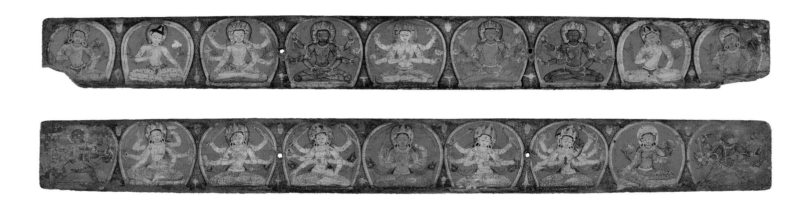

14
**Pair of Manuscript Covers with
Buddhist Deities**
Nepal, Thakuri period, 11th–12th century.
Ink and color on wood

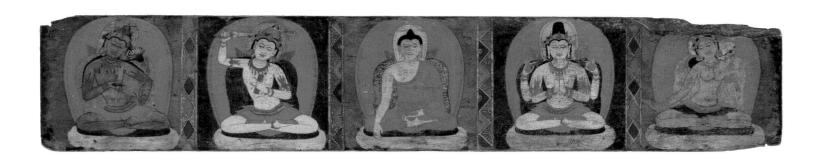

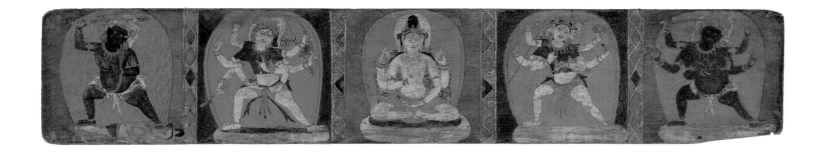

15
**Pair of Manuscript Covers, Each
with Five Deities**
Tibet, end of the 11th century. Distemper
and gold on wood

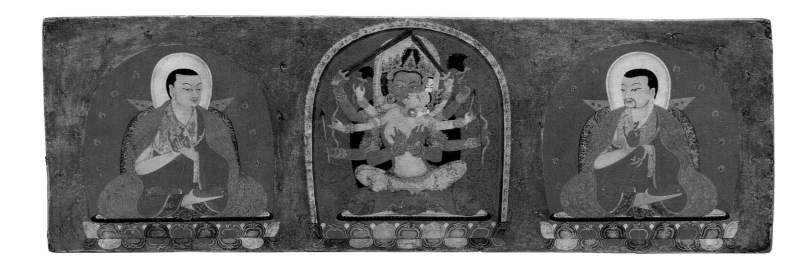

16

**Interior of a Manuscript Cover:
Manjuvajra Embracing His
Consort, with Attendant Lamas**
Tibet, late 13th century. Distemper on
wood

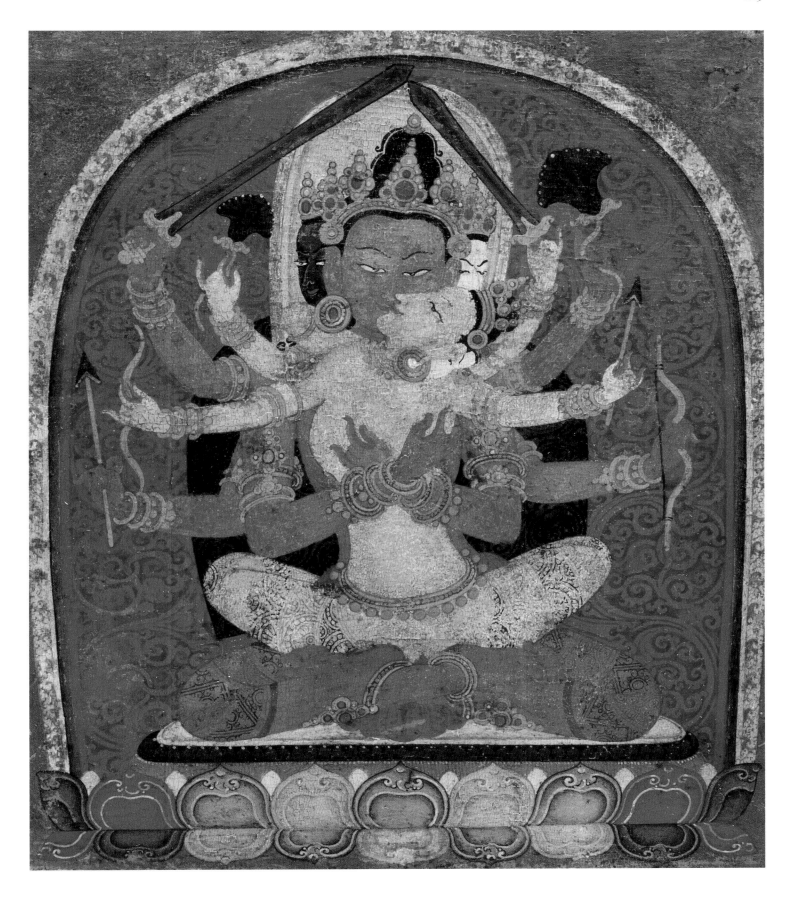

17
**Manuscript Cover with
Prajnaparamita Flanked by Ten
Buddhas**
Tibet, late 12th century. Wood with gilding
and polychrome

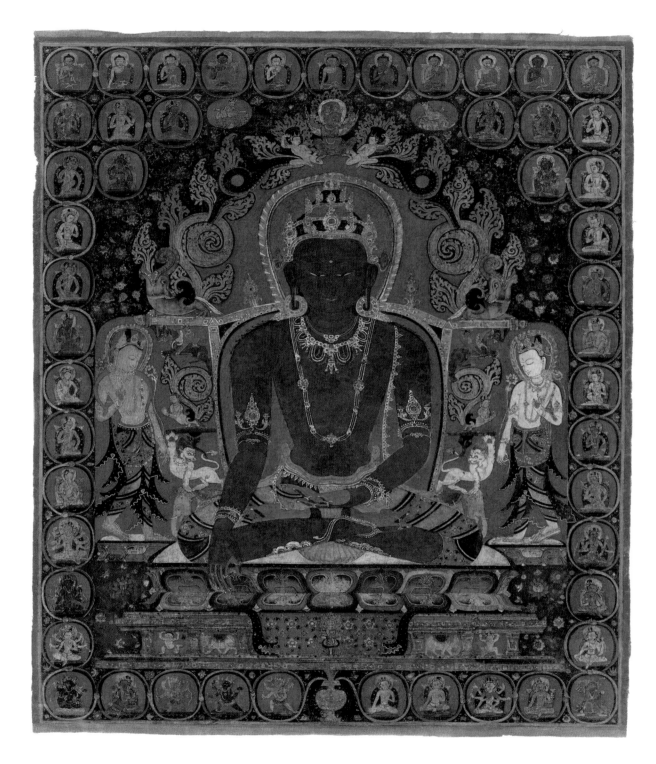

18
The Transcendent Buddha
Akshobhya
Central Tibet, 13th or early 14th century.
Distemper on cloth

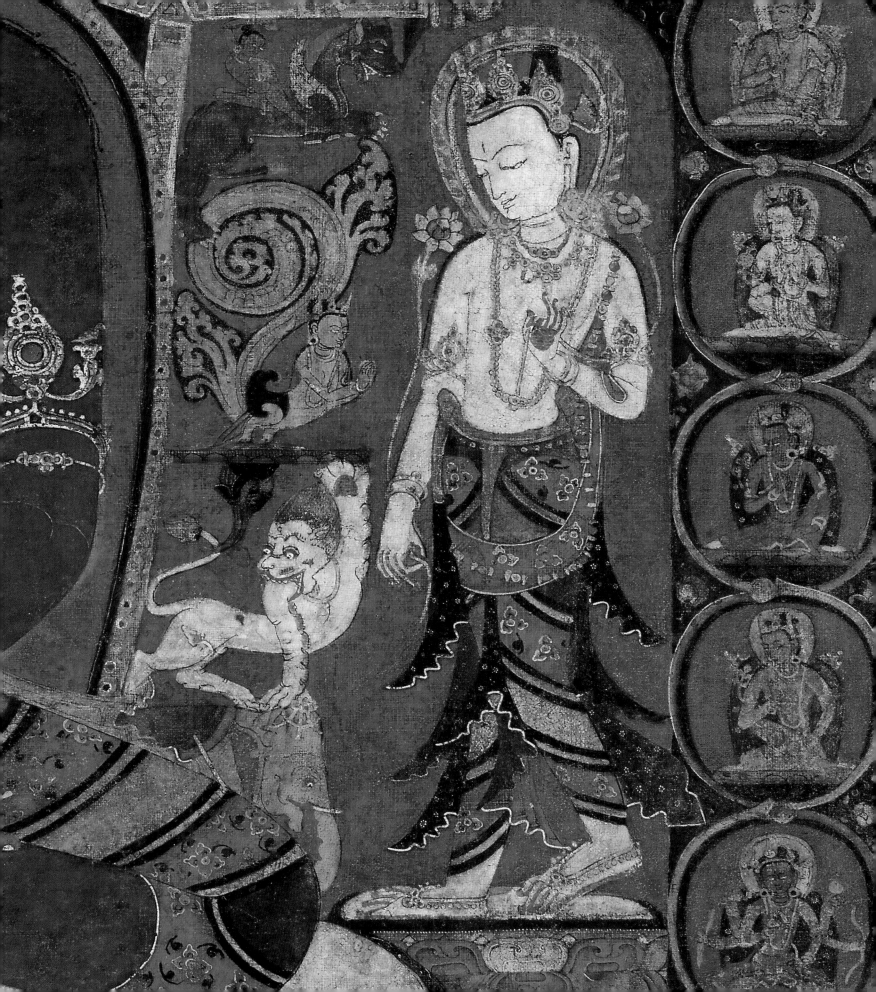

19
Crown Ornaments for a Deity
Newari for the Tibetan market, 17th–19th
century. Gilt silver, emeralds, sapphires,
rubies, garnets, pearls, lapis lazuli, coral,
shell, and turquoise

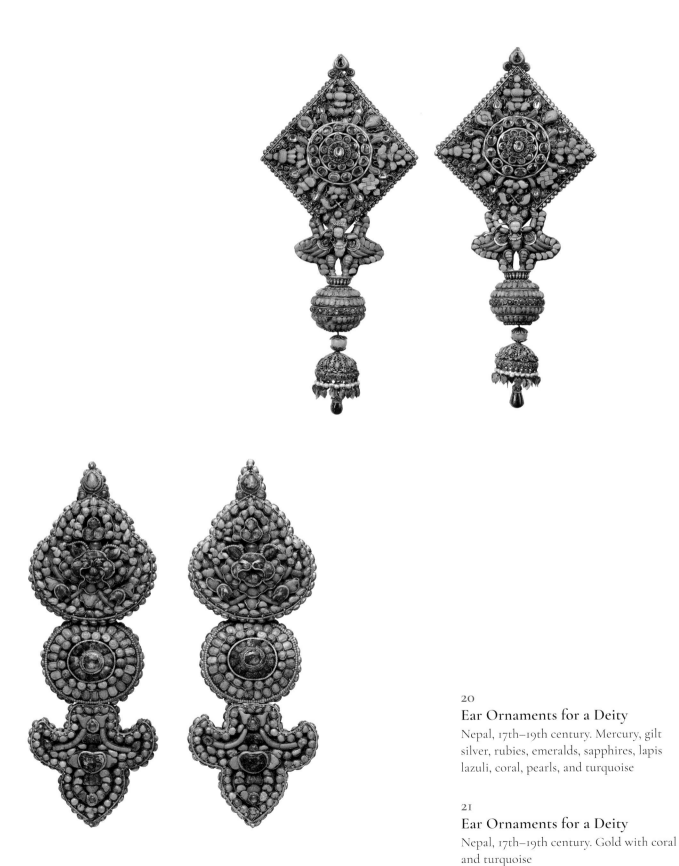

20

Ear Ornaments for a Deity
Nepal, 17th–19th century. Mercury, gilt
silver, rubies, emeralds, sapphires, lapis
lazuli, coral, pearls, and turquoise

21

Ear Ornaments for a Deity
Nepal, 17th–19th century. Gold with coral
and turquoise

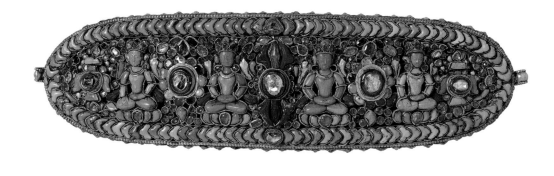

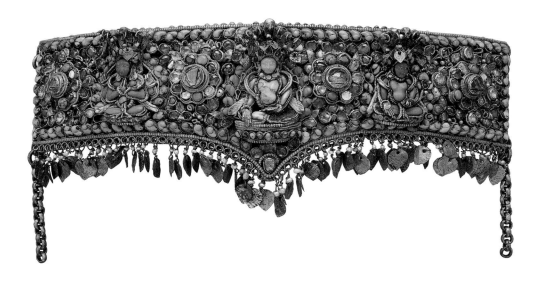

22

Forehead Ornament for a Deity

Newari for the Nepalese or Tibetan
market, 17th–19th century. Gold,
diamonds, rubies, emeralds, sapphires,
garnet, lapis lazuli, coral, and turquoise

23

Forehead Ornament for a Deity

Newari for the Nepalese or Tibetan
market, 17th–19th century. Gilt silver,
brass, diamonds, emeralds, rubies,
sapphires, pearls, coral, shell, turquoise,
and semiprecious stones

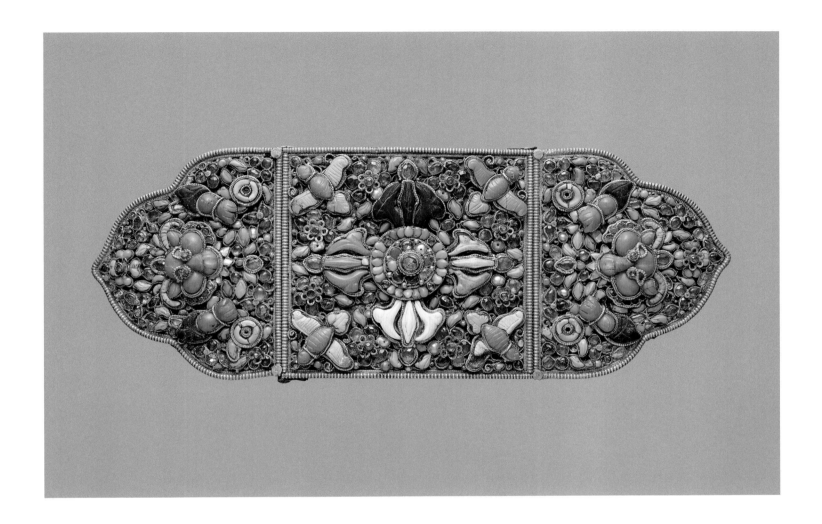

24
Armlet for an Image with Crossed
Vajras
Nepal, 17th–19th century. Mercury,
gilt silver, diamonds, rubies, emeralds,
sapphires, pearls, lapis lazuli, coral, shell,
and turquoise

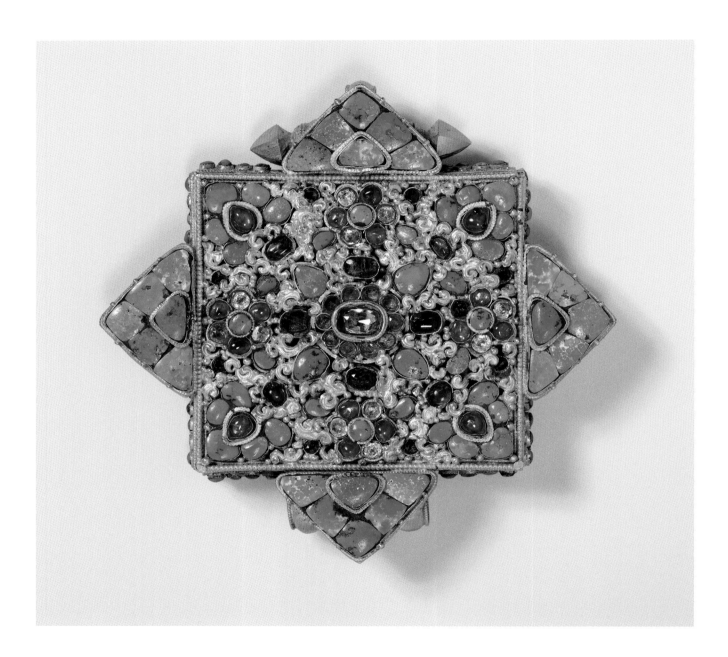

25

Amulet Box of a Noblewoman

Tibet, late 19th–early 20th century. Gold,
beryl, rubies, emeralds, sapphires, and
turquoise

26
Dish for Ritual Offerings
Nepal, 17th–19th century. Gilt silver,
rock crystal, emeralds, rubies, sapphires,
yellow quartz, garnets, spinels, coral,
shell, lapis lazuli, and semiprecious stones

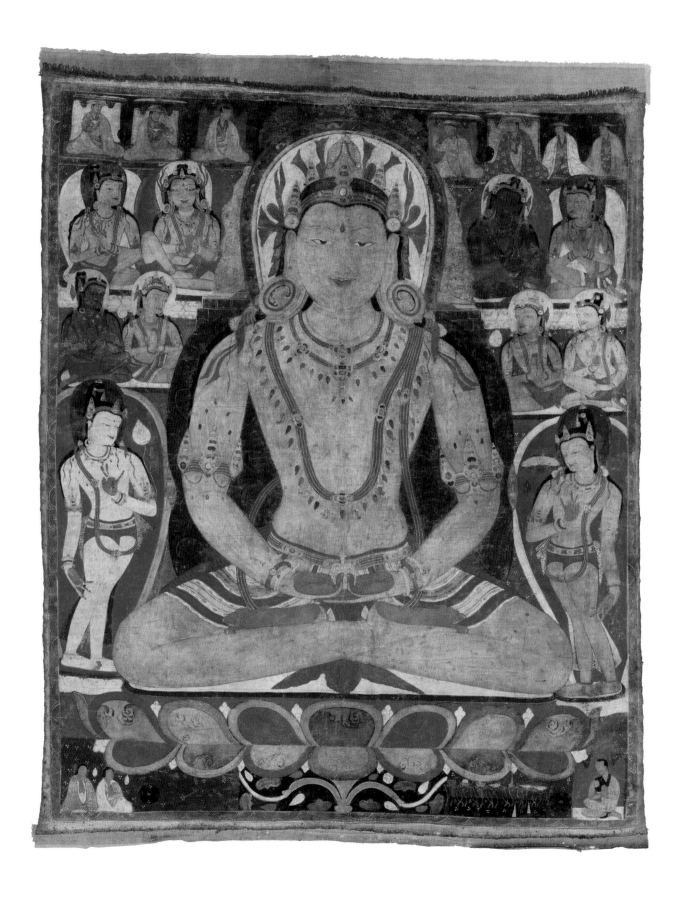

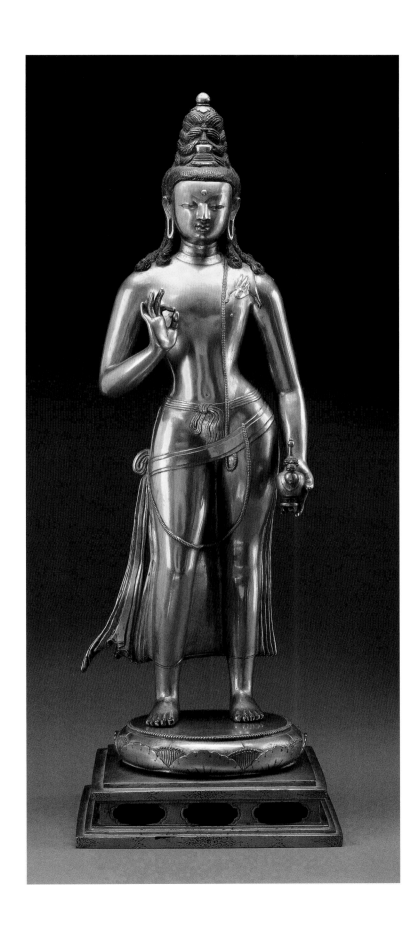

27
The Bodhisattva Maitreya,
Buddha of the Future
Tibet, 11th or early 12th century.
Distemper on cloth

28
The Bodhisattva Maitreya,
Buddha of the Future
Mongolia, school of Zanabazar
(1635–1723), second half 17th
century. Gilt bronze with blue
pigment and traces of other
pigments

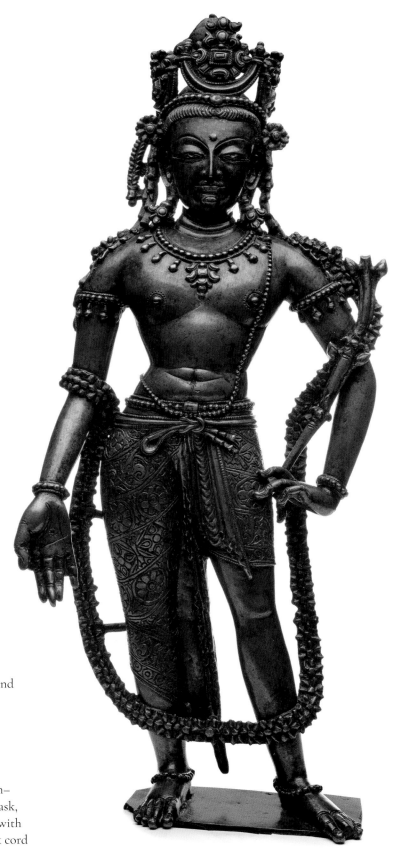

29

Manjushri, the Bodhisattva of Transcendent Wisdom

Western Tibet, late 10th–early 11th century. Brass with inlays of copper and silver

30

Manjushri, the Bodhisattva of Transcendent Wisdom

China, Qing dynasty (1644–1911), 17th–18th century. Silk appliqué with damask, satin, brocade, and leather substrate with silver finish and embroidery with silk cord (raw silk wrapped in fine silk floss)

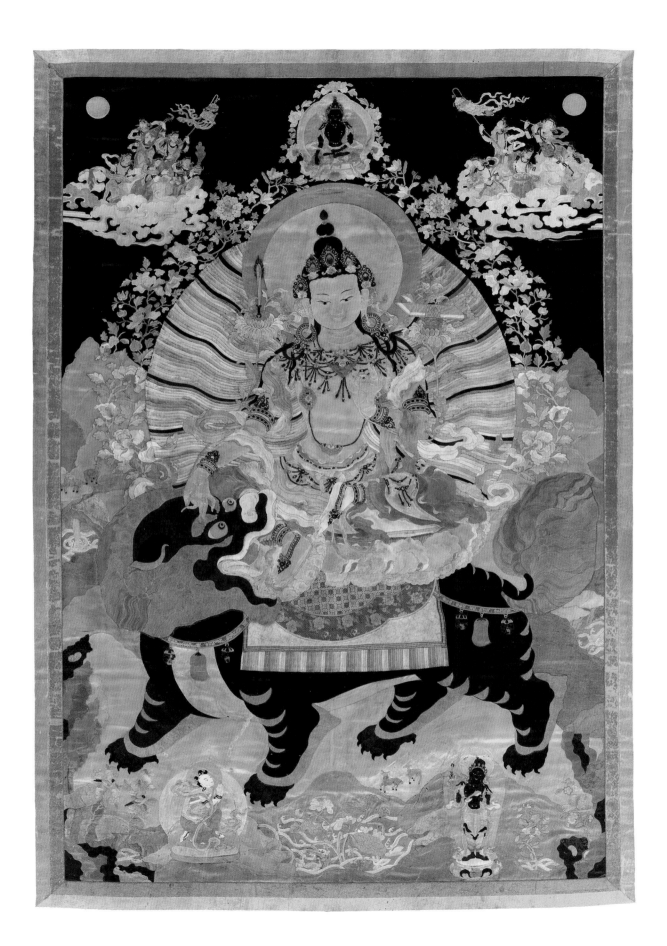

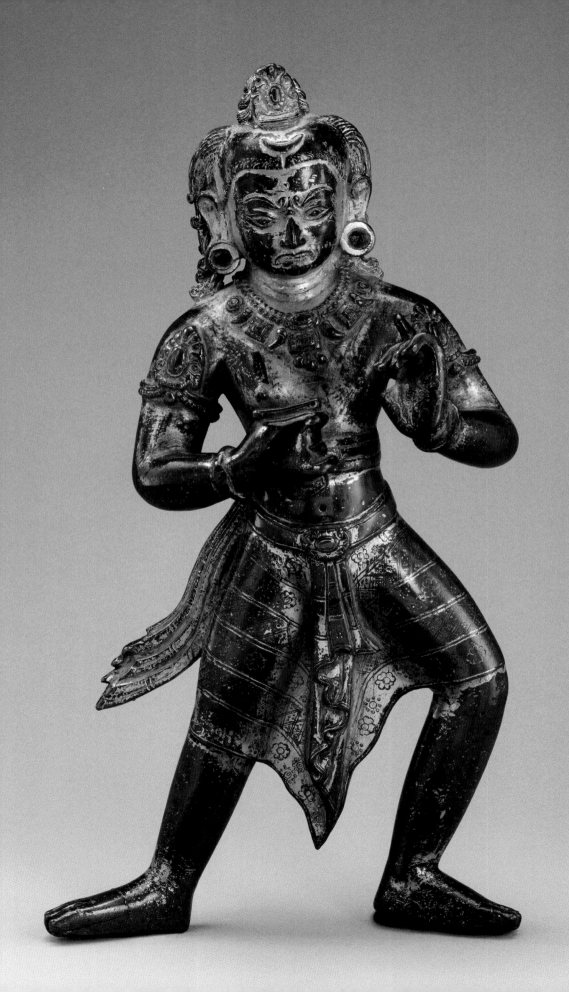

31
The Bodhisattva Manjushri as a Ferocious Destroyer of Ignorance
Nepal, Kathmandu Valley, Thakuri period, 10th century. Gilt copper alloy with color and gold paint

32
Vajracharya Priest's Crown
Nepal, early Malla period, 13th–early 14th century. Gilt copper alloy inlaid with semiprecious stones, lapis lazuli, and turquoise

140

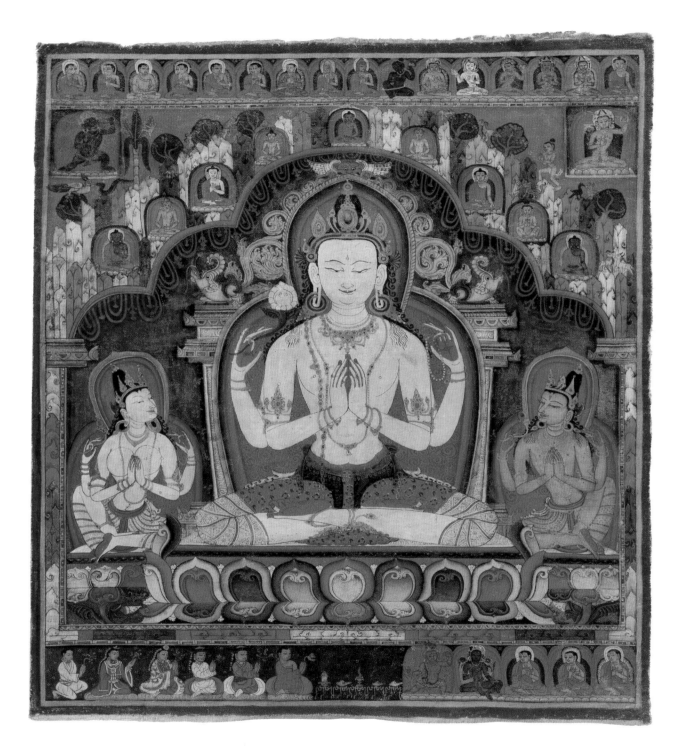

33
Shadakshari Avalokiteshvara, the
Bodhisattva of Compassion
Tibet, 1300–1350. Distemper on cloth

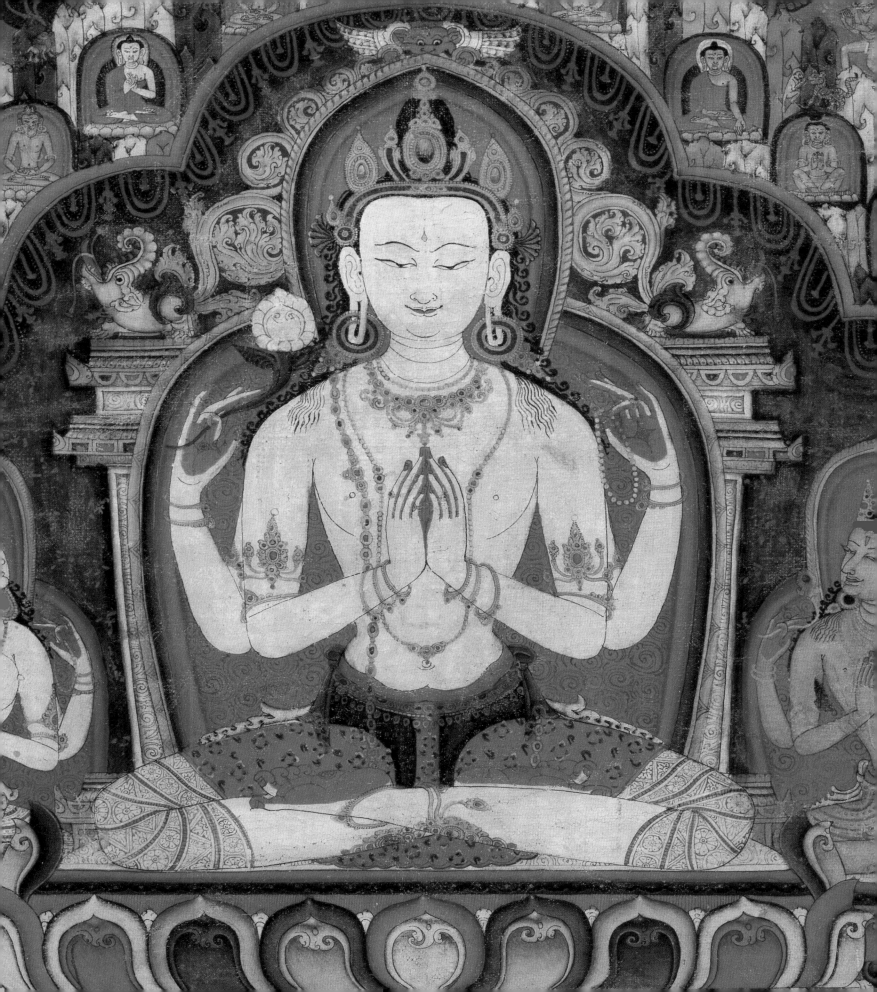

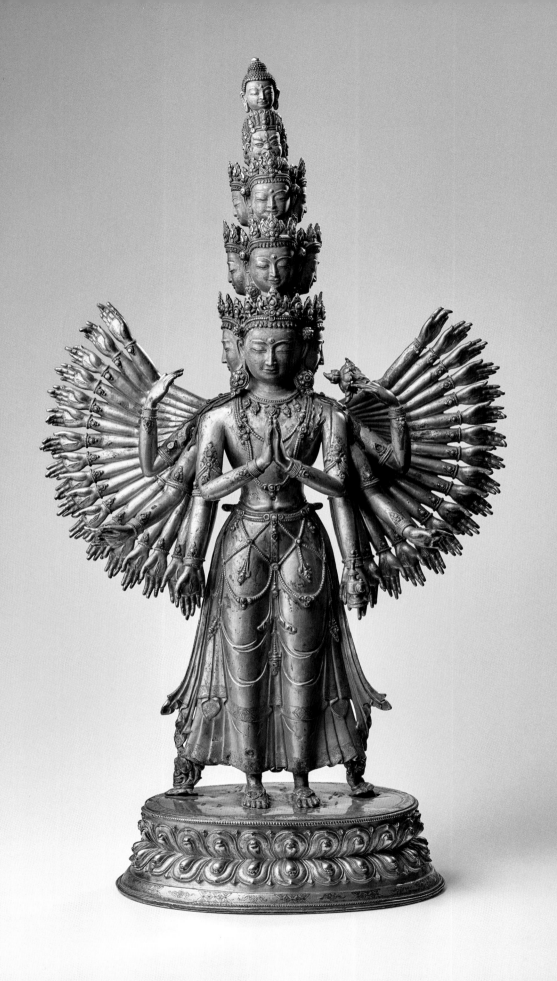

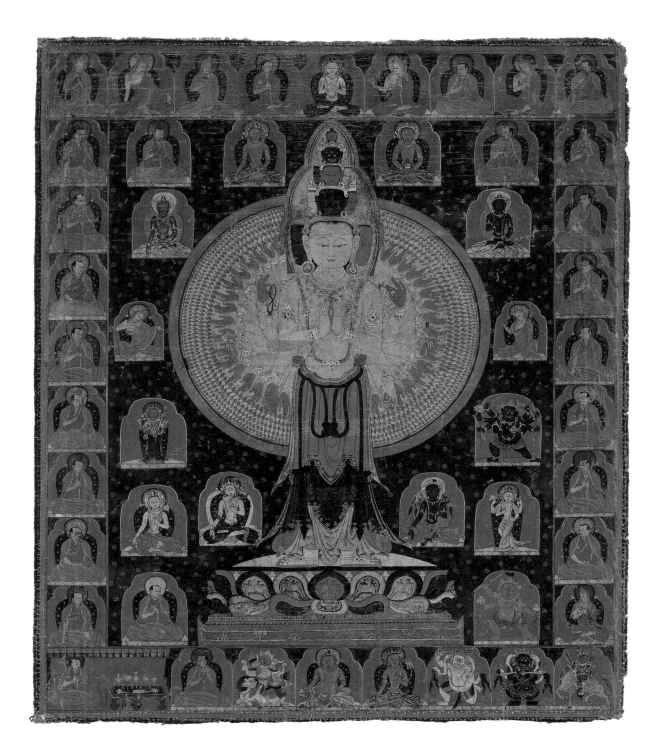

34
Thousand-Armed Chenresi, a Cosmic Form of the Bodhisattva Avalokiteshvara
Artist: Sonam Gyaltsen (active 15th century), Central Tibet, Shigatse, 1430. Copper alloy with gilding

35
Thousand-Armed Chenresi, a Cosmic Form of the Bodhisattva Avalokiteshvara
Tibet, 14th century. Distemper and gold on cloth

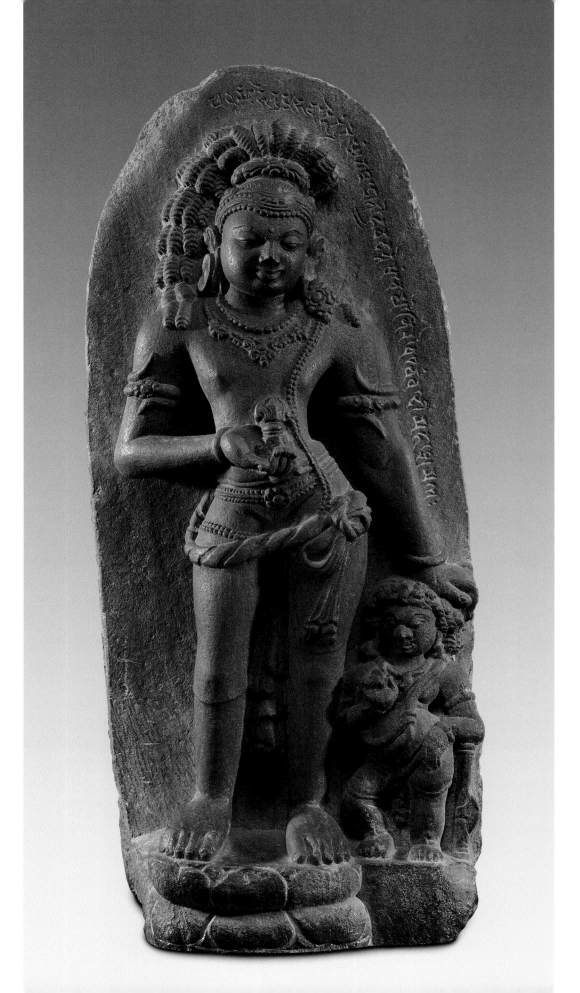

36
The Bodhisattva Vajrapani
Eastern India, Bihar, probably
Nalanda monastery, 7th–early 8th
century. Sandstone

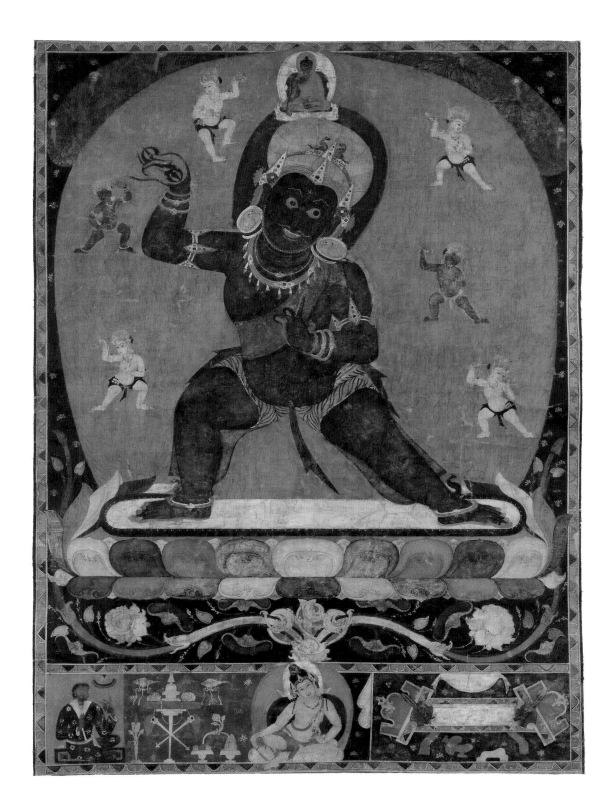

37
The Bodhisattva Vajrapani
Western Tibet, Guge, early 12th
century. Distemper on cotton

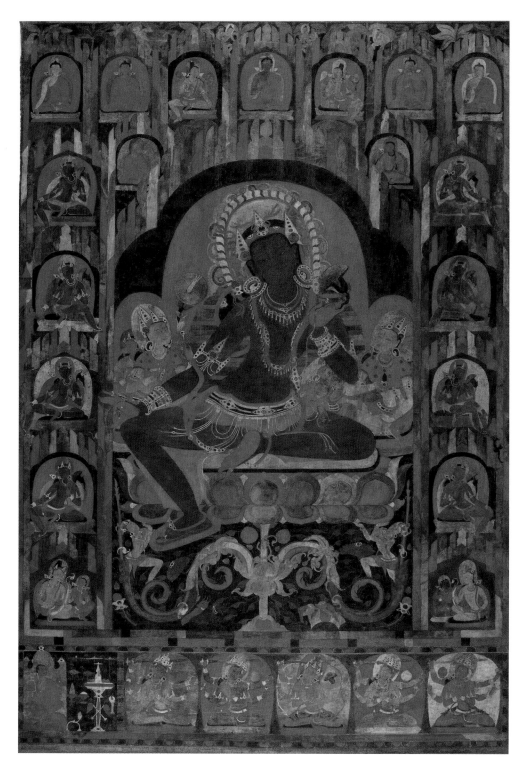

38

Ashtamahabhaya Tara, Savior from the Eight Perils

Tibet, Reting monastery, late 12th century.
Mineral and organic pigments on cloth

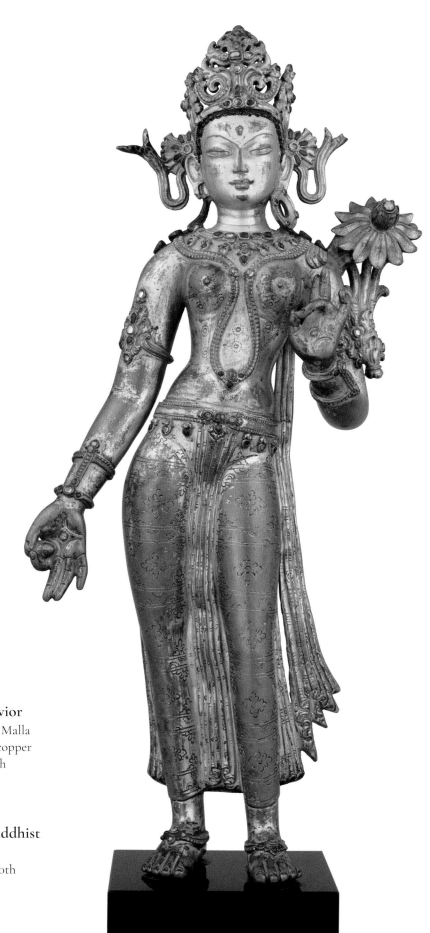

39
Tara, the Buddhist Savior
Nepal, Kathmandu Valley, Malla
period, 14th century. Gilt copper
alloy with color, inlaid with
semiprecious stones

40
**Mahapratisara, the Buddhist
Protectress**
India, Bihar, Pala period, 10th
century. Black stone

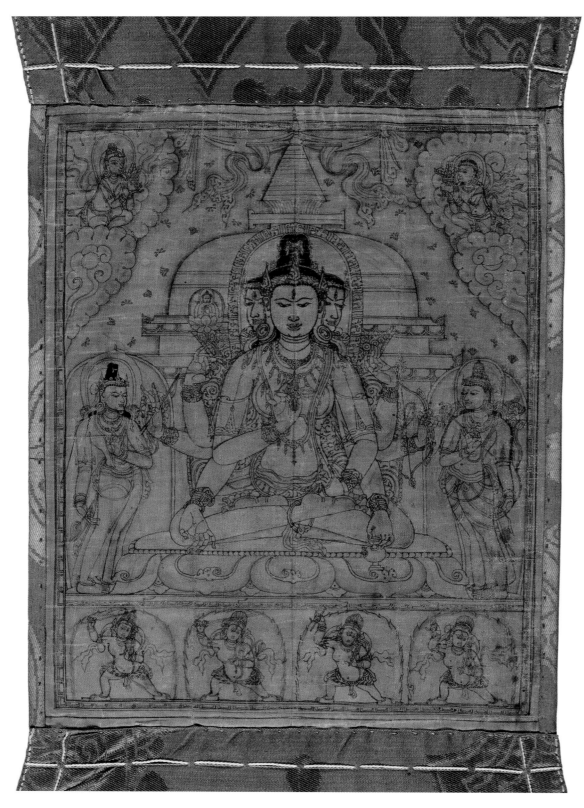

41
Ushnishavijaya
Central Tibet, ca. 1300. Distemper on silk

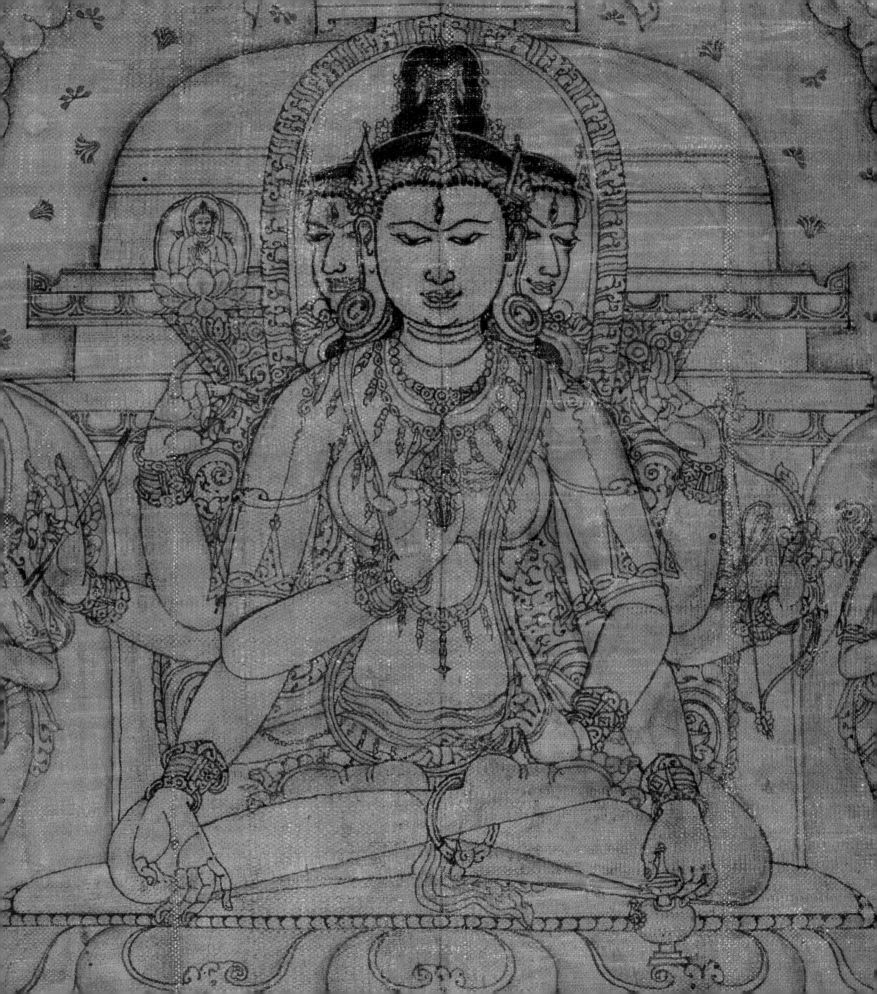

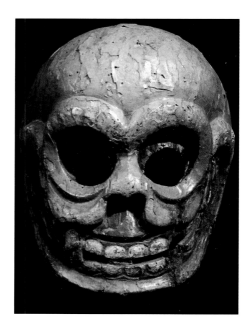

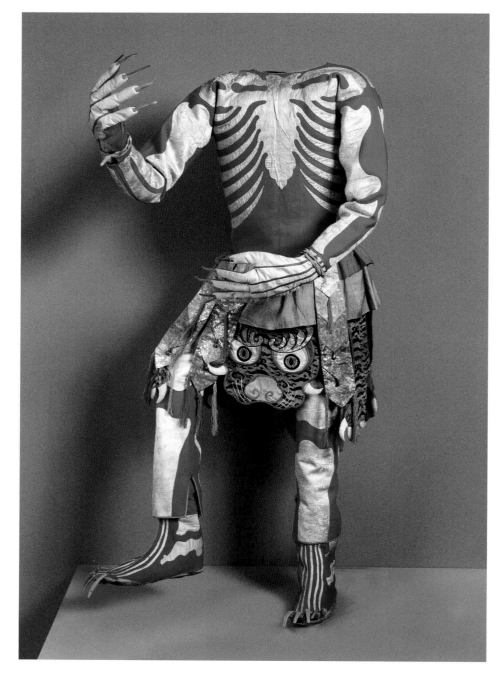

42
Skeleton Mask (*Chitipati*)
Bhutan, 20th century. Papier-mâché

43
Skeleton Dance Costume
Tibet, late 19th or early 20th century.
Silk and flannel

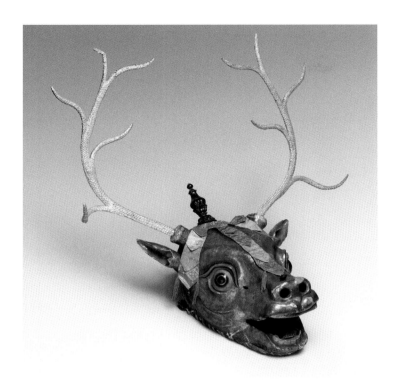

44
Stag Mask
Tibet, late 19th–early 20th century.
Papier-mâché, polychrome, gilding,
leather, and silk

45
Monastic Dance Robe
China, Qing dynasty (1644–1911),
early 19th century. Plain-weave silk
brocaded with silk and metallic
thread

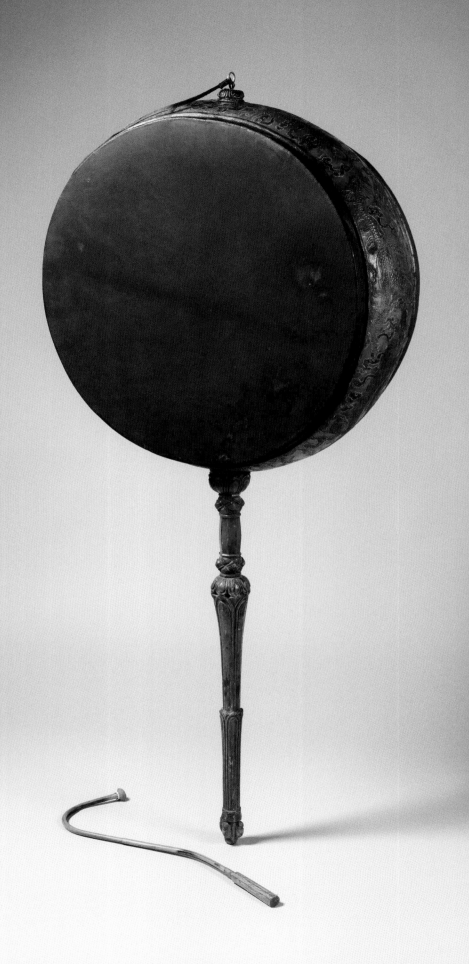

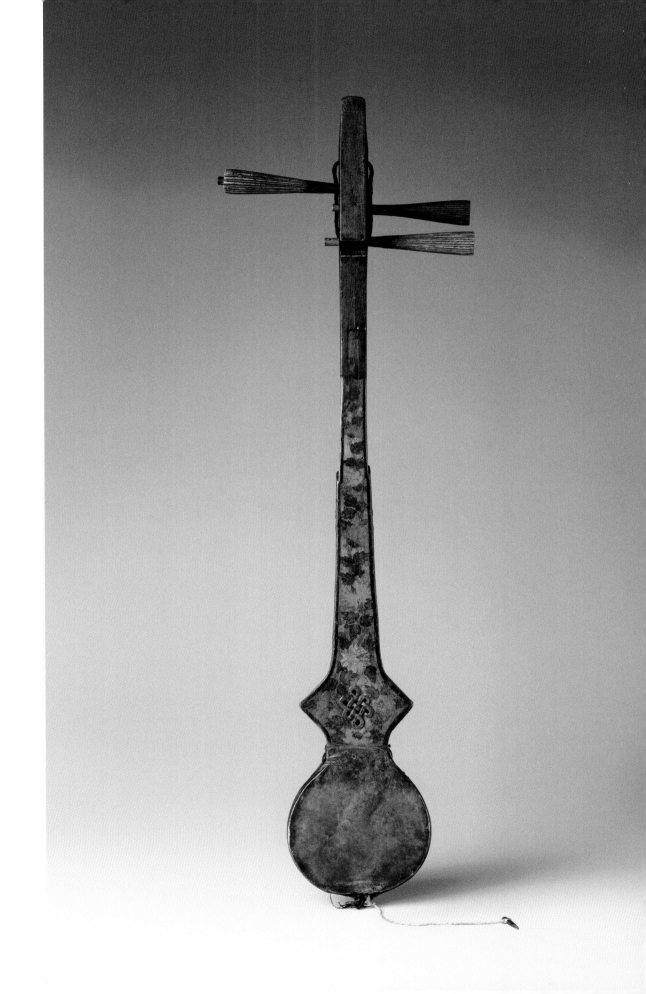

46
Frame Drum (*Rnga* or *Lag-rnga*)
Tibet, 18th century. Wood, paint, lacquer, and hide

47
Lute (*Sgra-snyan*)
Tibet, late 19th century. Wood, hide, wire, and polychrome

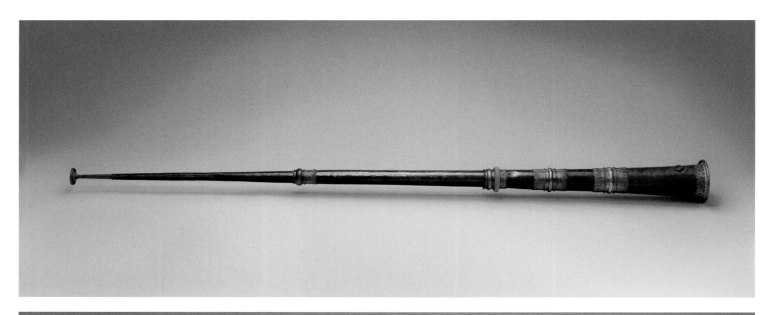

48
Trumpet (*Dung chen*)
Tibet, late 18th–early 19th century. Metal

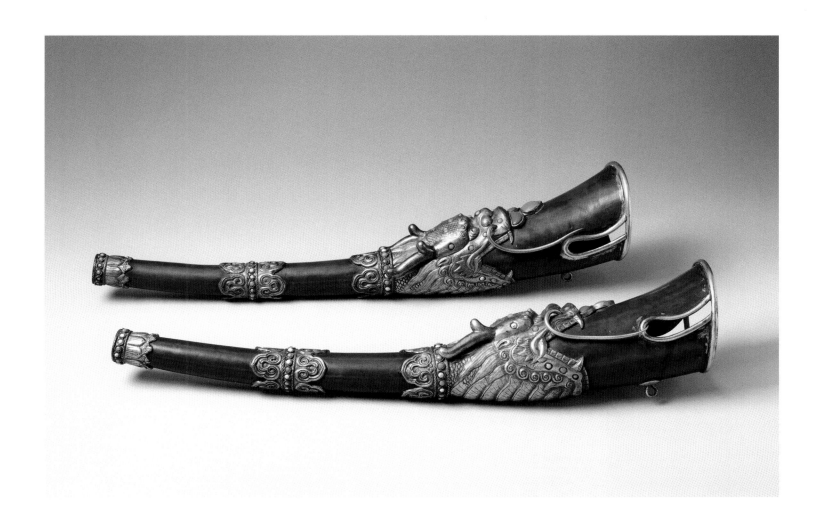

49
Pair of Trumpets (*Rkangling***)**
Tibet, 19th century. Copper, brass, glass,
turquoise, and coral

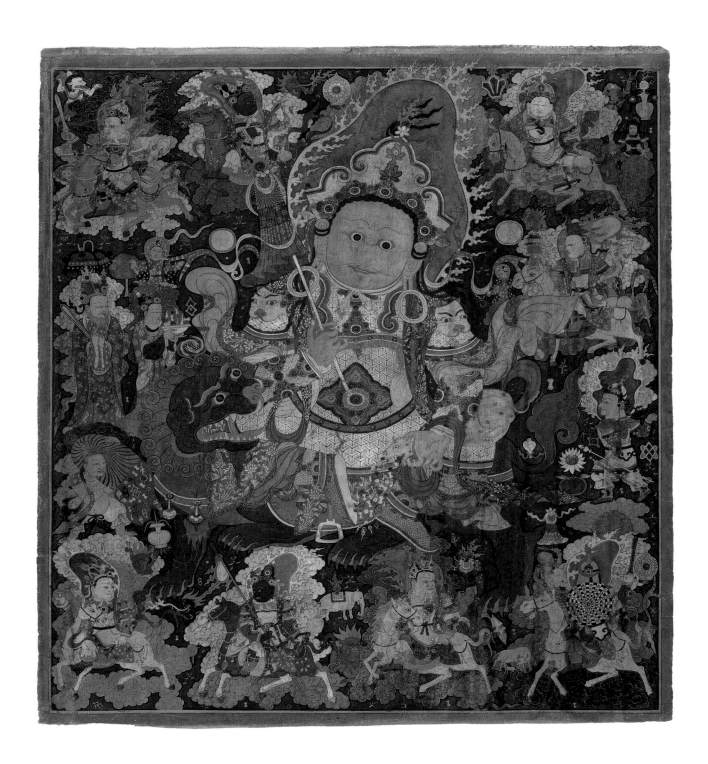

50
**Vaishravana, the Guardian of
Buddhism and Protector of Riches**

Tibet, 15th century. Distemper on cloth

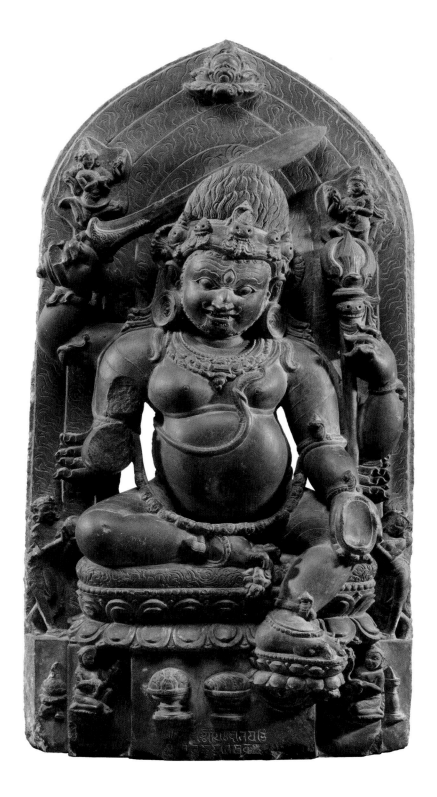

51
Mahakala
India, Bihar, Pala period, 11th–12th century.
Black stone

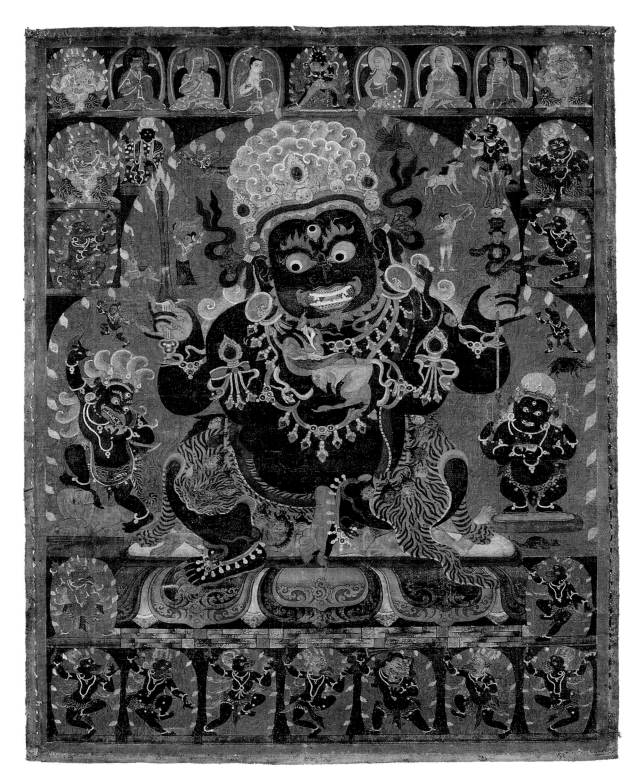

52
Mahakala
Tibet, 14th century. Mineral pigments
on cotton

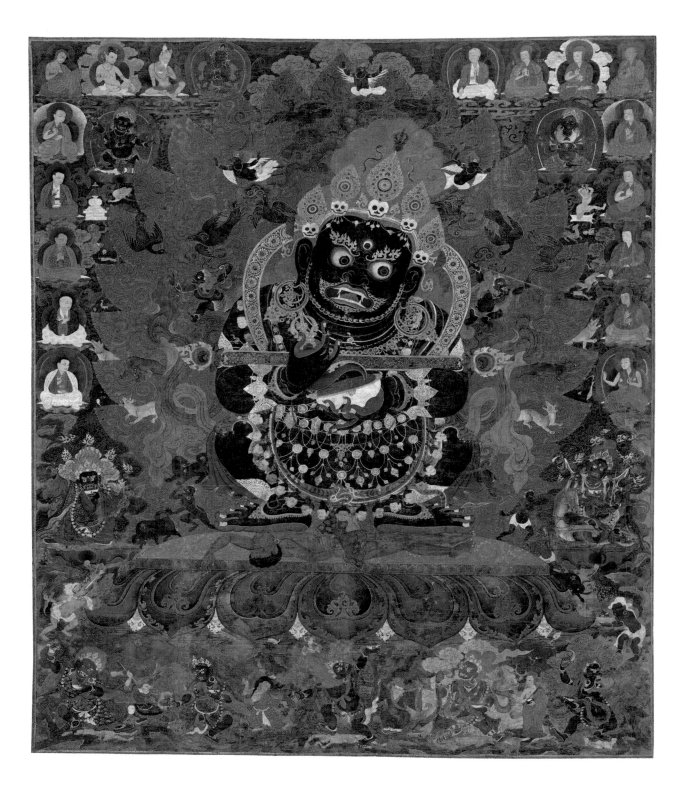

53
Mahakala, Protector of the Tent
Central Tibet, ca. 1500. Distemper on cloth

54
Rahula
Tibet, 15th century. Gilt copper
alloy with turquoise and coral

55
**Chest with Scenes of Tantric
Offerings**
Tibet, late 19th century. Polychrome wood
with iron brackets

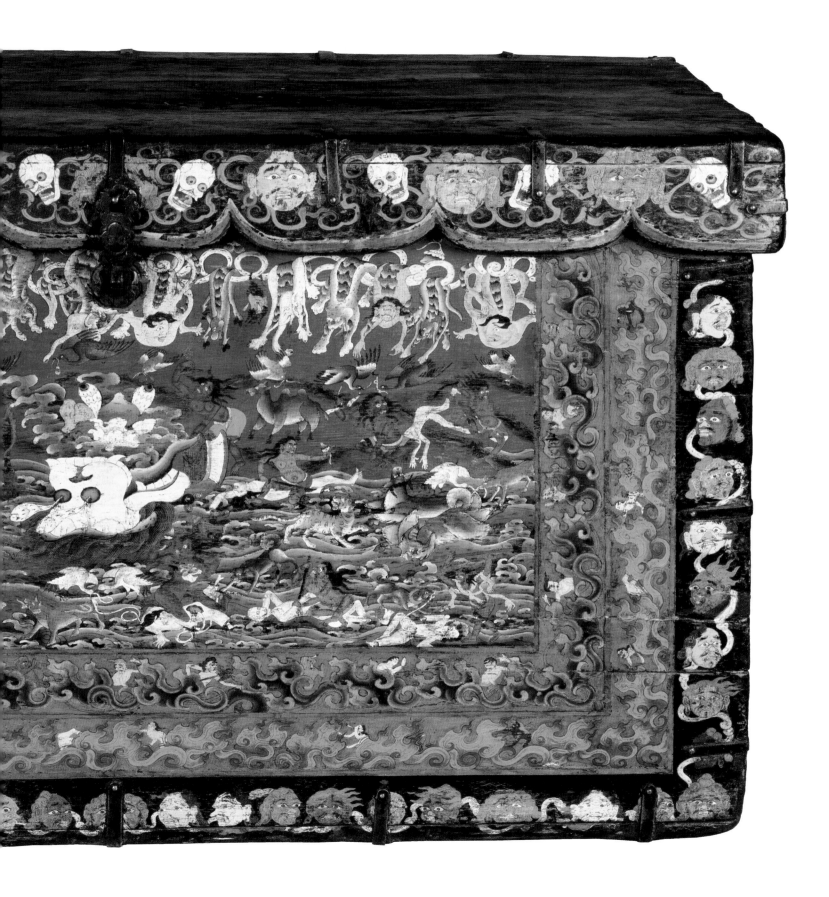

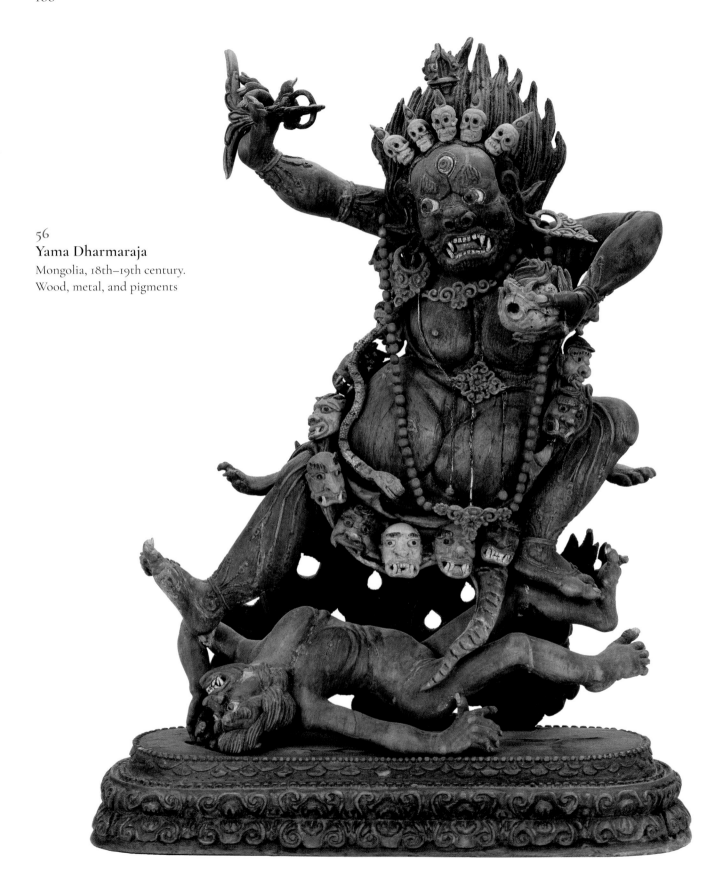

56
Yama Dharmaraja
Mongolia, 18th–19th century.
Wood, metal, and pigments

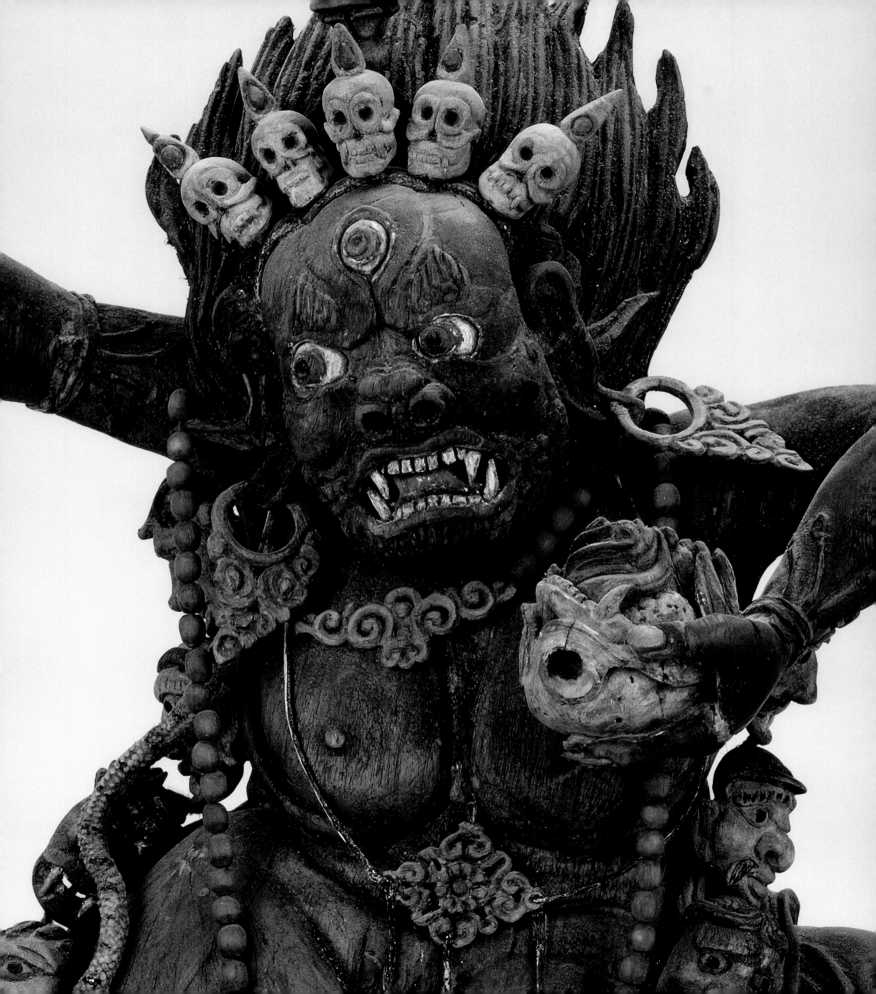

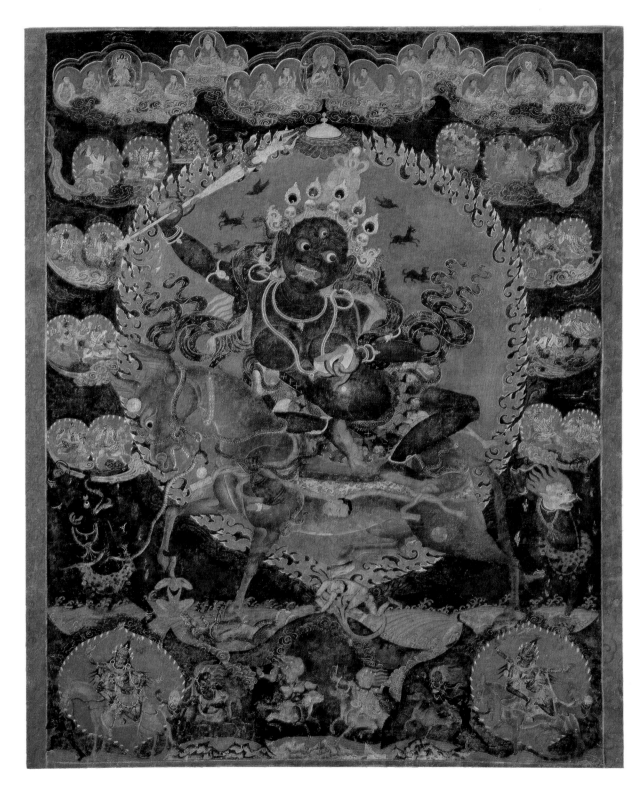

57
Palden Lhamo
Tibet, 15th century. Mineral pigments on
cotton

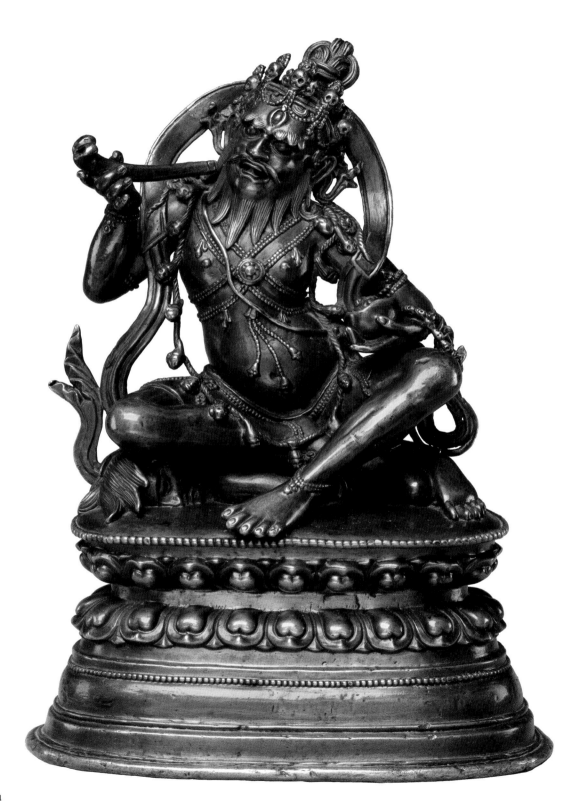

58
Brahmarupa Mahakala
Tibet, 17th century. Brass

59
Phurba Emanation of
Padmasambhava
Tibet, ca. 17th century. Polychromed wood

60
Base from a Purification Brazier
Tibet, probably Derge, 15th–17th century.
Iron inlaid with gold and silver

61
Vajra with Angry Heads and
Makara Prongs
China, Tang dynasty (618–907). Gilt
bronze

62
Ritual Staff (*Khatvanga*)
China, Ming dynasty (1368–1644),
Yongle mark and period (1403–24). Iron
damascened with gold and silver

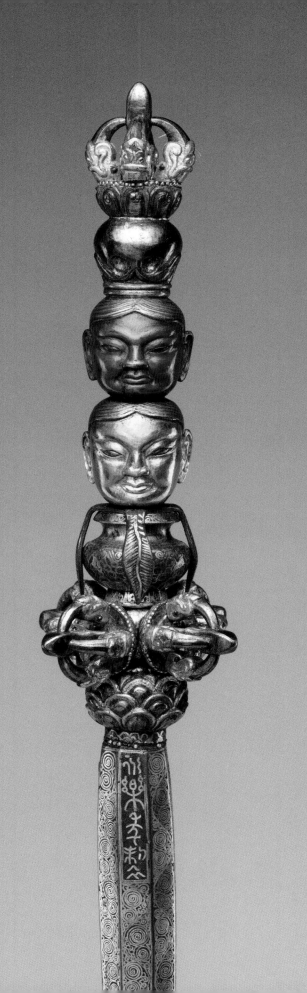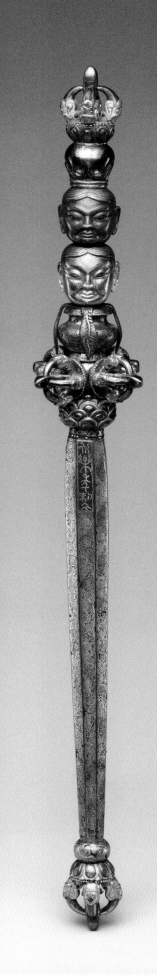

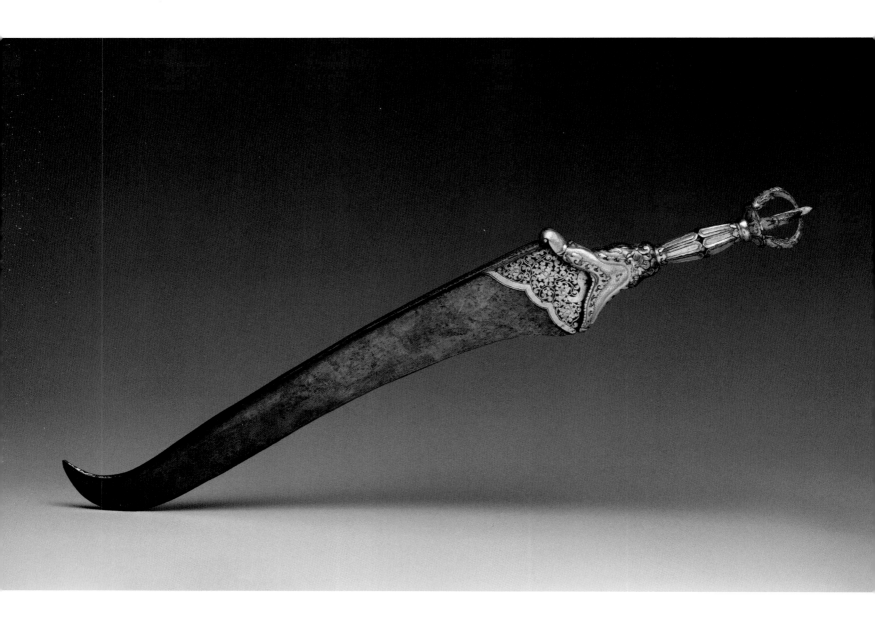

63
Vajra Flaying Knife
Eastern Tibet, Derge, ca. 15th century.
Steel inlaid with gold and silver

64
Skull Cup (*Kapala*)
Tibet, 19th century. Stone

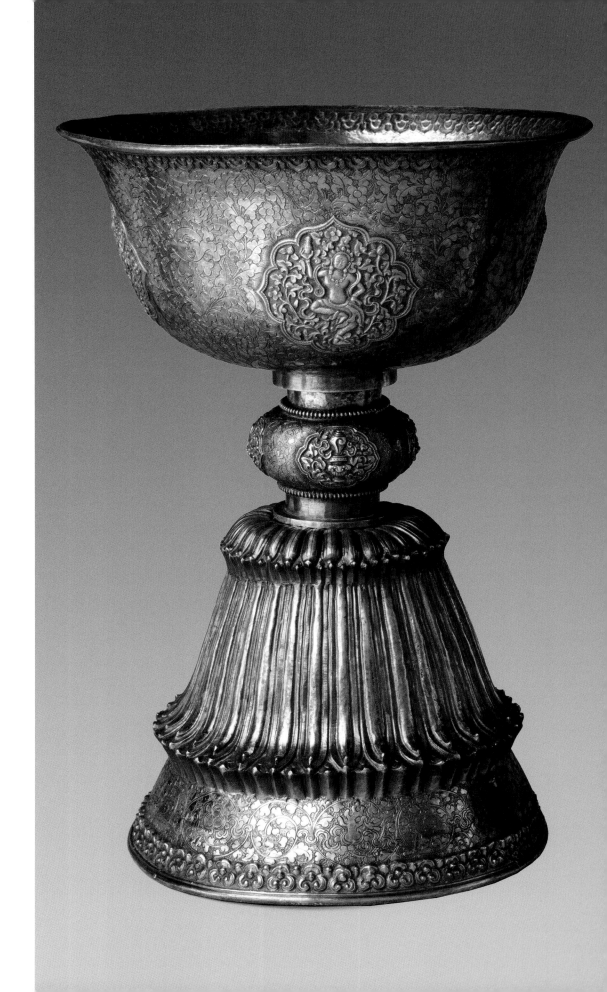

65
Pair of Butter Lamps
Central Tibet, 19th century.
Gilt silver with repoussé and
engraving

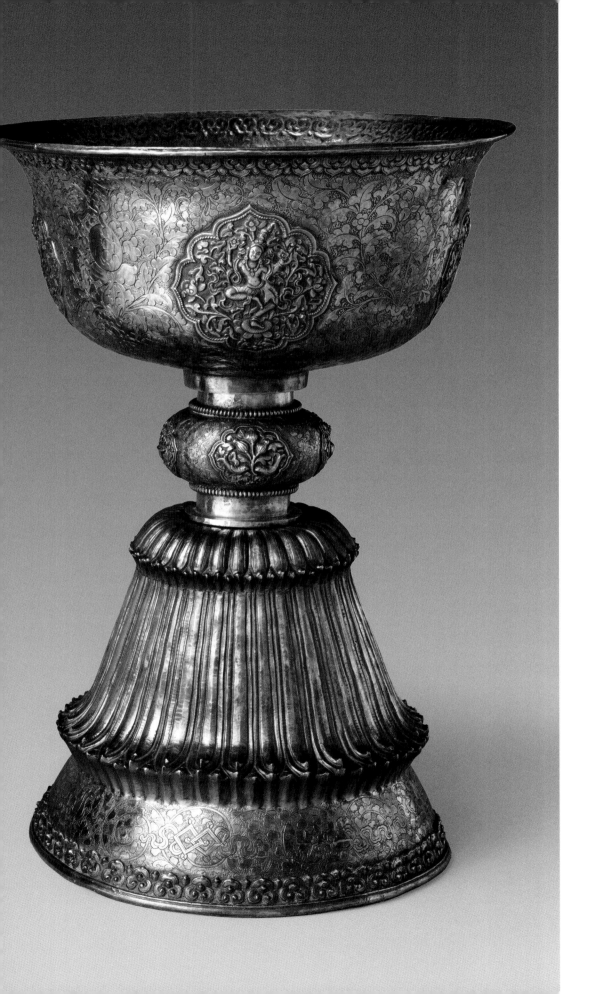

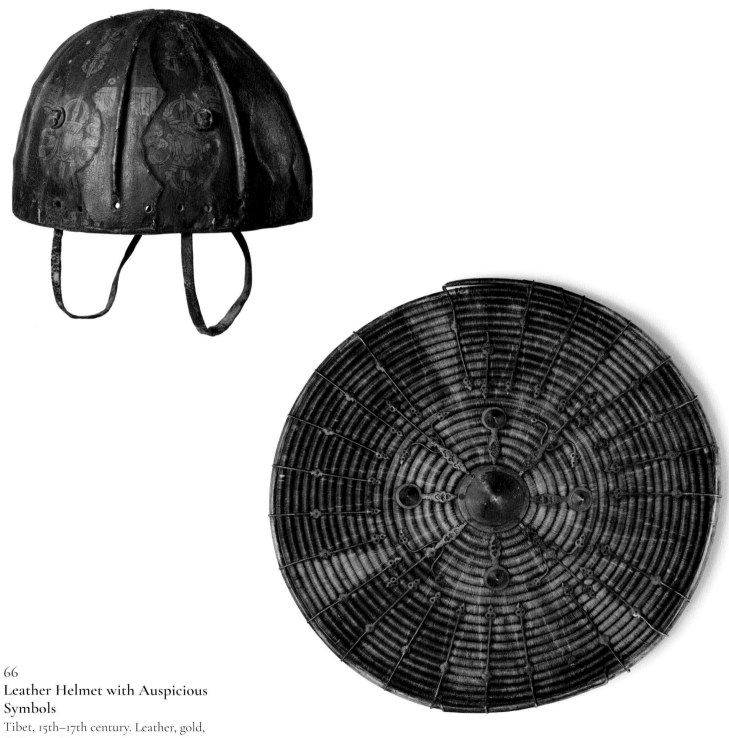

66
Leather Helmet with Auspicious Symbols
Tibet, 15th–17th century. Leather, gold, shellac, and pigments

67
Shield (*Phub*)
Tibet, ca. 14th–16th century. Cane, iron, and brass

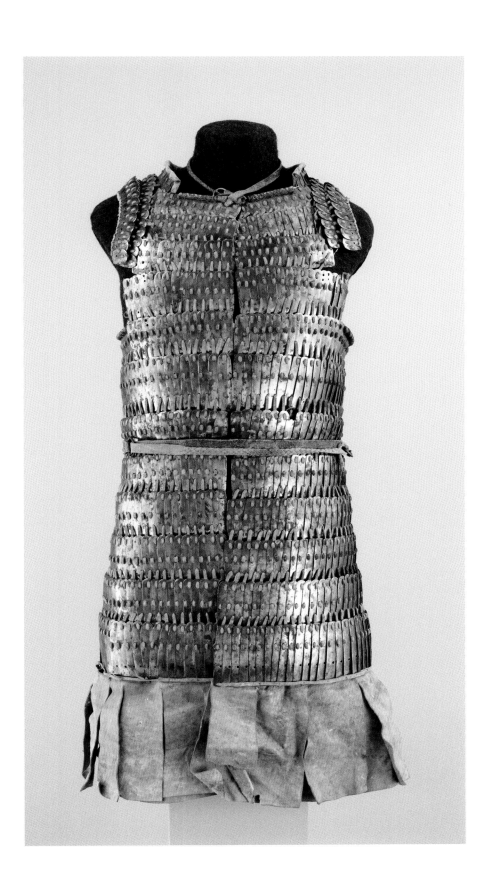

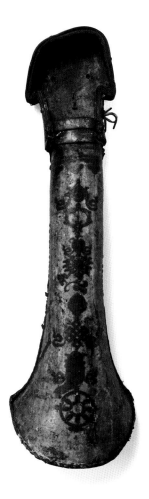

68
Lamellar Armor (*Byang bu'i khrab*)
Tibet, ca. 16th–17th century. Iron and leather

69
Quiver
Tibet or Mongolia, 14th–16th century. Leather, shellac, and pigment

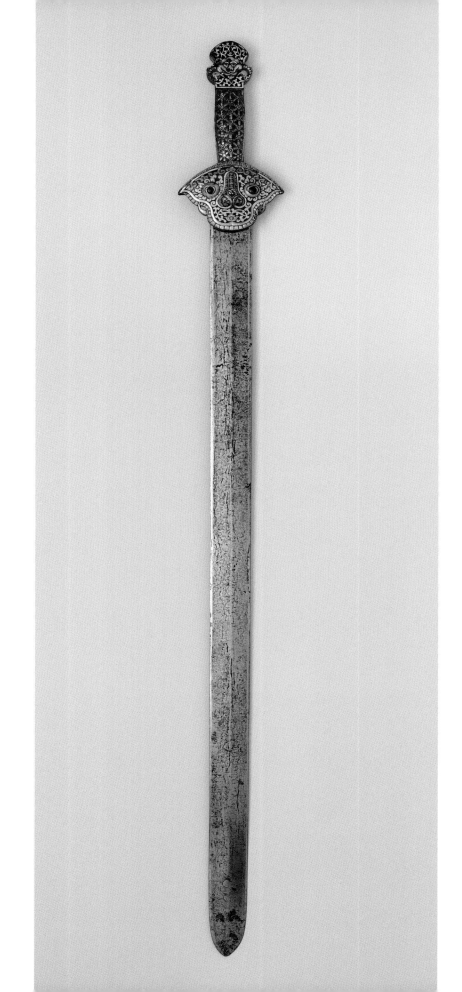

70
Sword (*Ral gri*)
Tibet or China, 14th–16th century. Iron, steel, gold, and silver

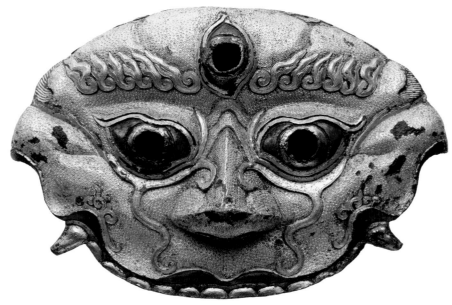

71
Sword Guard
Tibet or China, 14th–15th century. Iron, gold, silver, and copper

72
Hilt of a Ritual or Votive Sword
Tibetan, possibly 15th–16th century. Copper alloy and gold

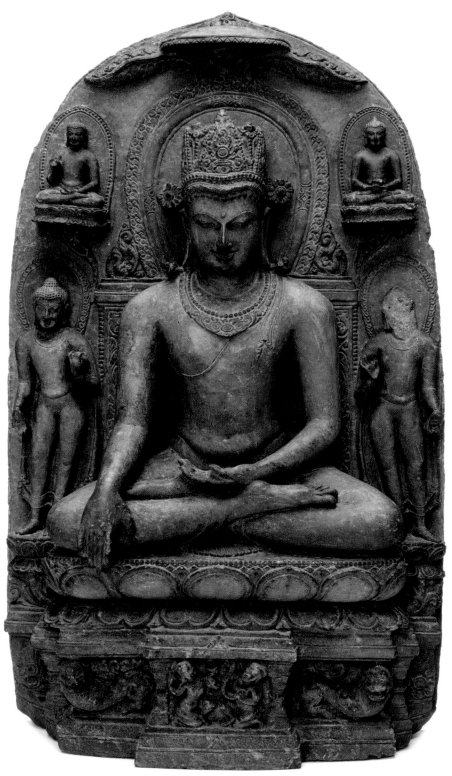

73
Crowned Buddha Shakyamuni
India, Bihar or West Bengal, 11th century.
Schist

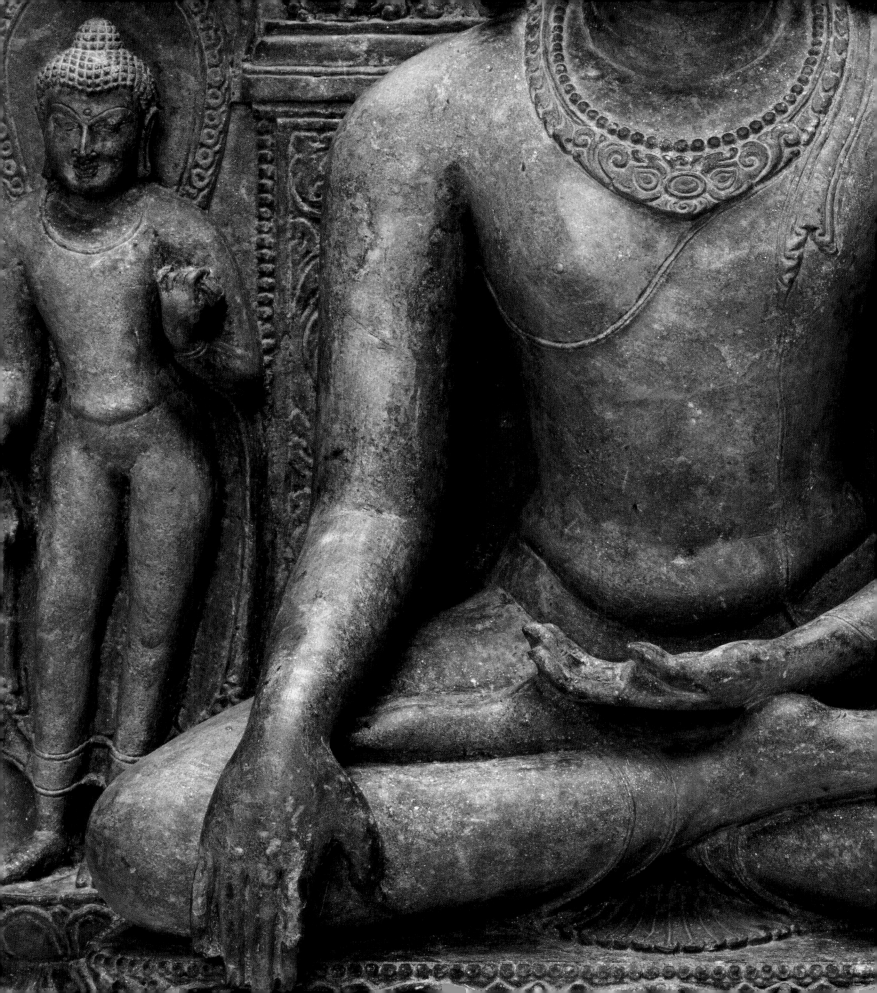

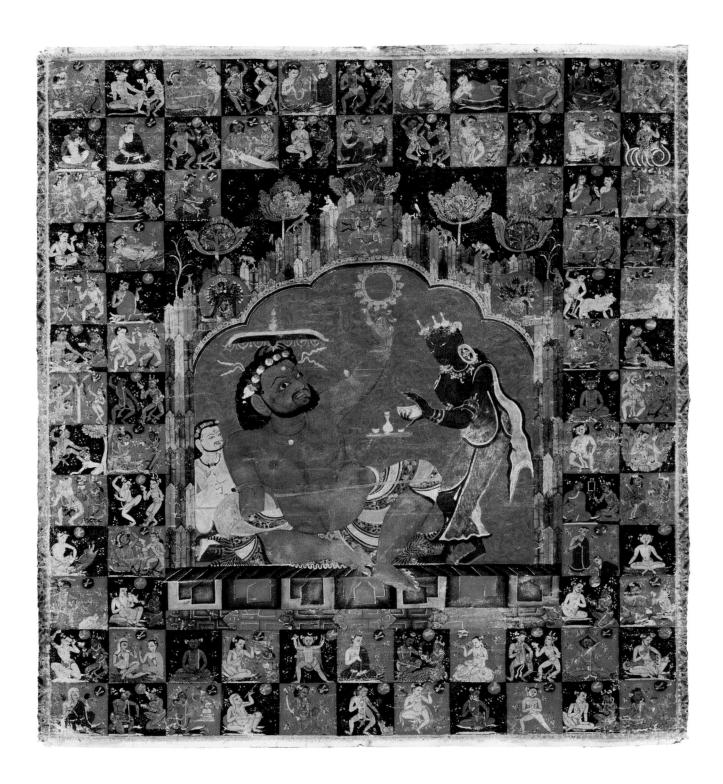

74
Mahasiddha Virupa
Central Tibet, second quarter 13th century.
Distemper and gold on cloth

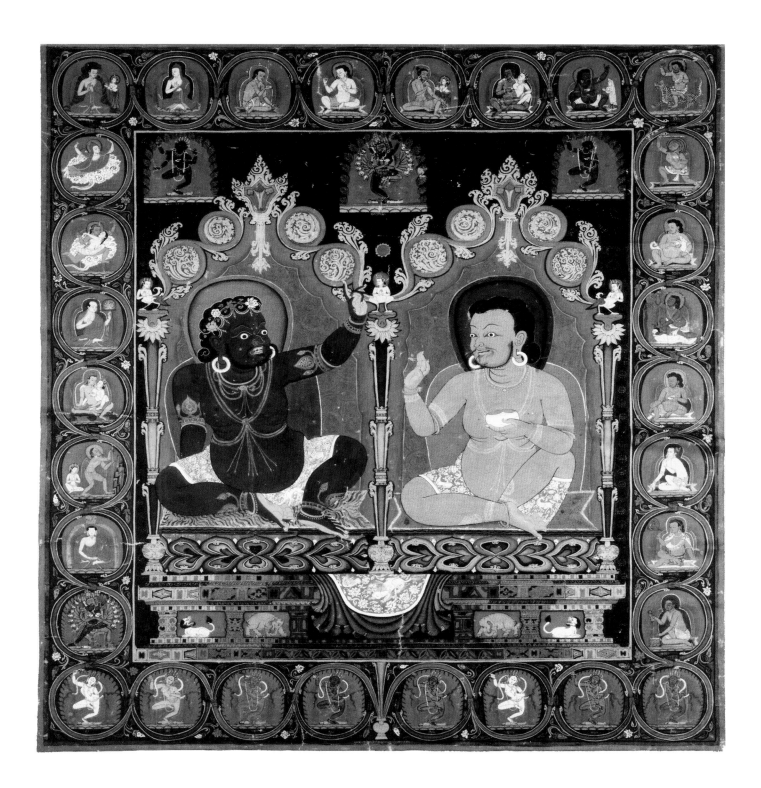

75
Mahasiddhas Virupa and Krishnapa
Tibet, 1429–56. Distemper on cloth

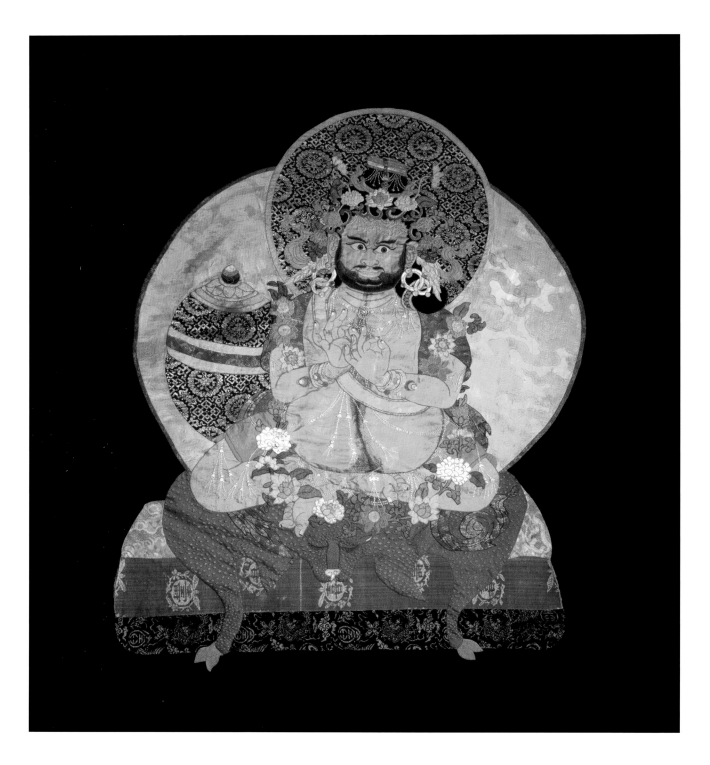

76
Mahasiddha Virupa
Tibet, 18th century. Appliqué silk damask
and velvets with cording and embroidery

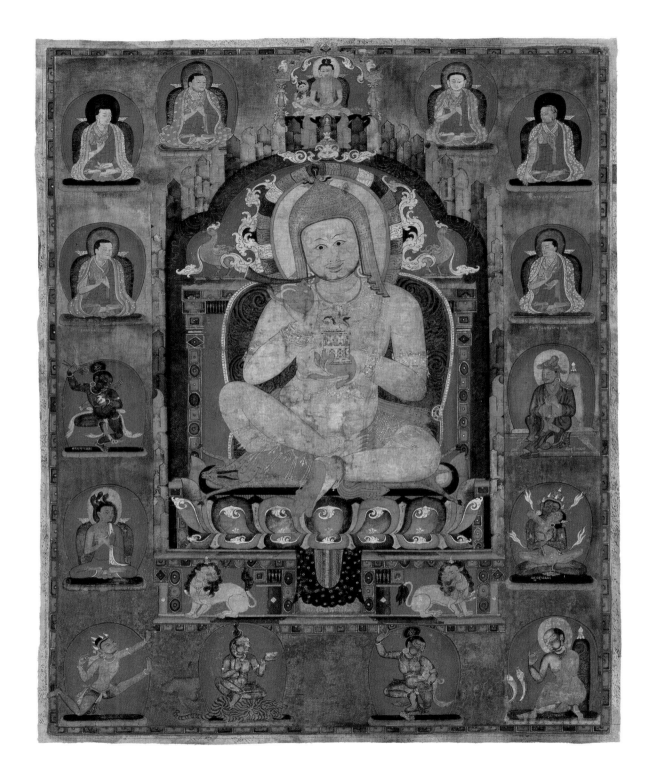

77
Mahasiddha Jnanatapa
Eastern Tibet, Kham, Riwoche monastery,
ca. 1350. Distemper on cloth

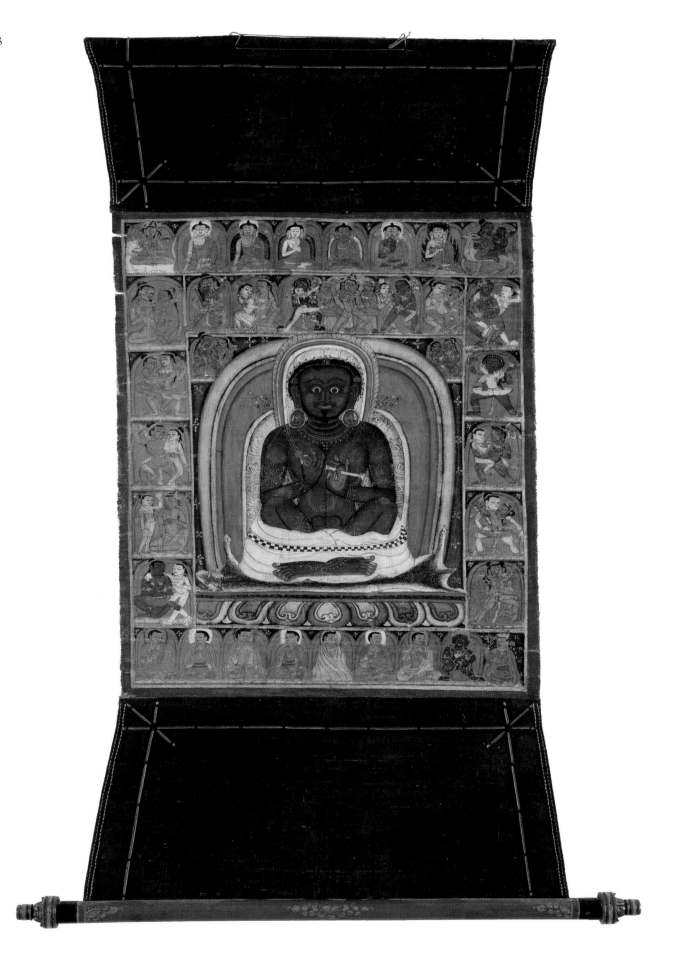

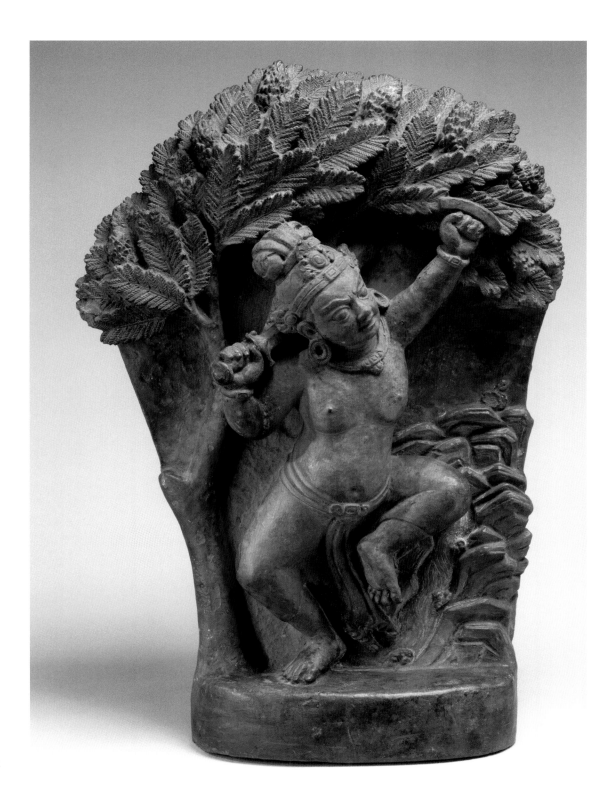

78
Mahasiddha Padampa Sangye
Tibet, 14th century.
Distemper on cotton

79
Mahasiddha Kirapalapa
Nepal, Kathmandu Valley,
ca. 14th century. Terracotta

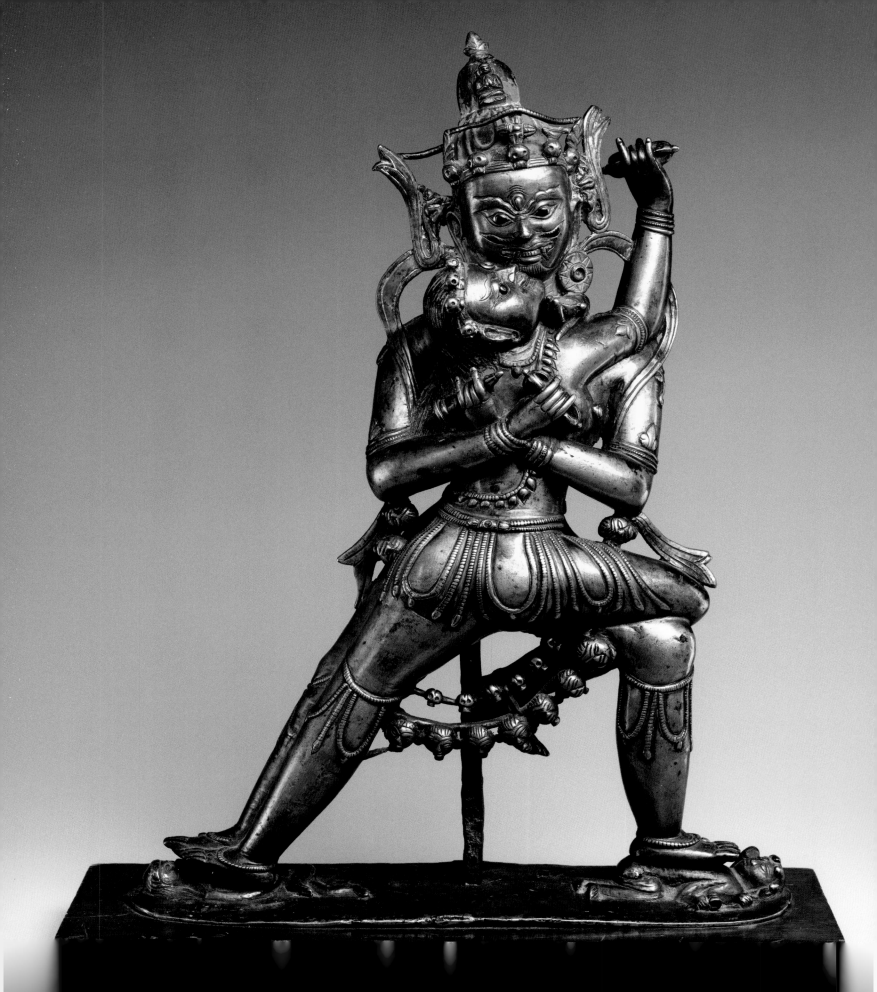

80

Hevajra and Nairatmya
Tibet, late 12th century. Brass
with silver and pigment

81

**Hevajra with the Footprints
of the Kagyu Patriarch
Tashipel**
Tibet, Taklung, 1180–1210.
Mineral pigments and gold on
silk and cotton

82
Raktayamari with His Consort Vajravetali
Central Tibet, 14th century. Distemper and gold on cloth

83
Guhyasamaja
Western Tibet, late 15th century. Distemper, gold, and ink on cloth

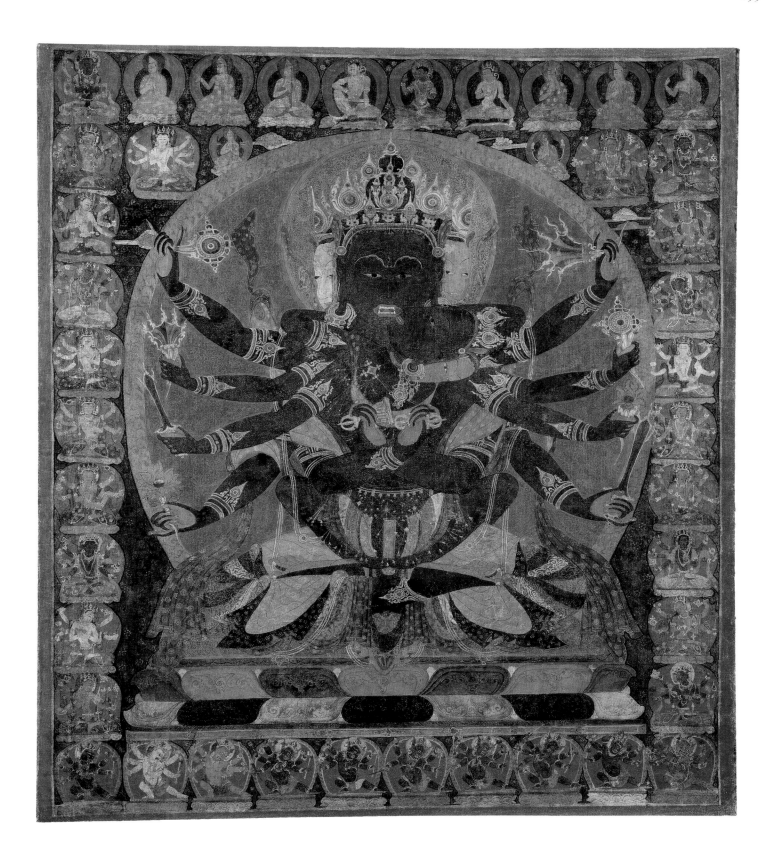

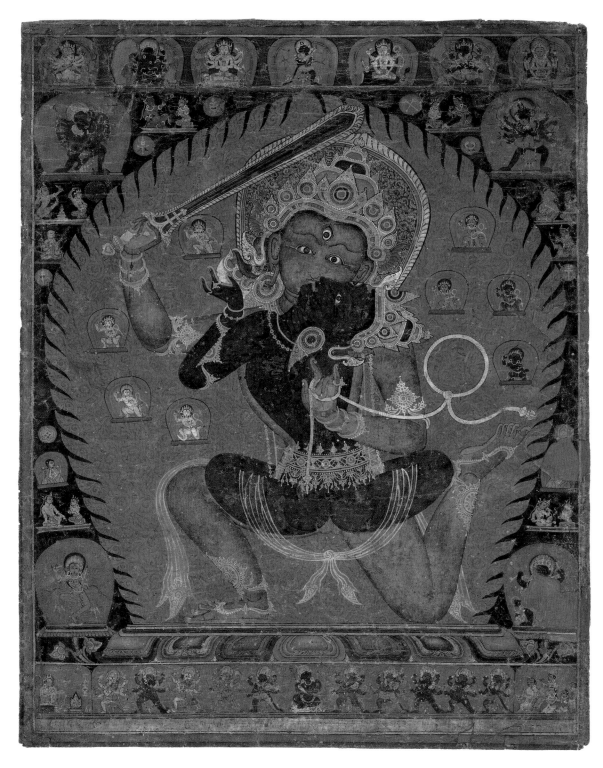

84
Achala with His Consort
Vishvavajri
Nepal, Kathmandu Valley, Malla period,
1525–50. Distemper on cloth

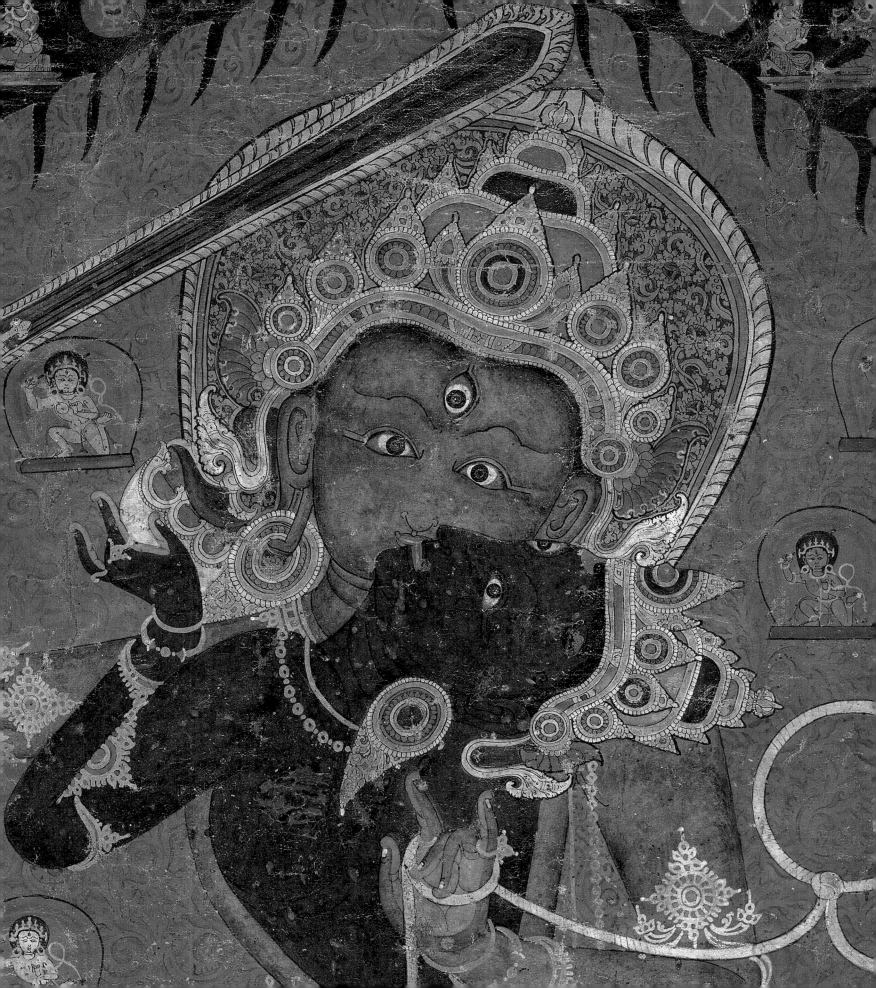

85
Tantric Rug with Two Flayed Male Figures
Tibet, 18th–19th century. Wool, cotton, and dye

86
Ekajata Attribute Mandala
Central Tibet, ca. 1800. Distemper on cotton

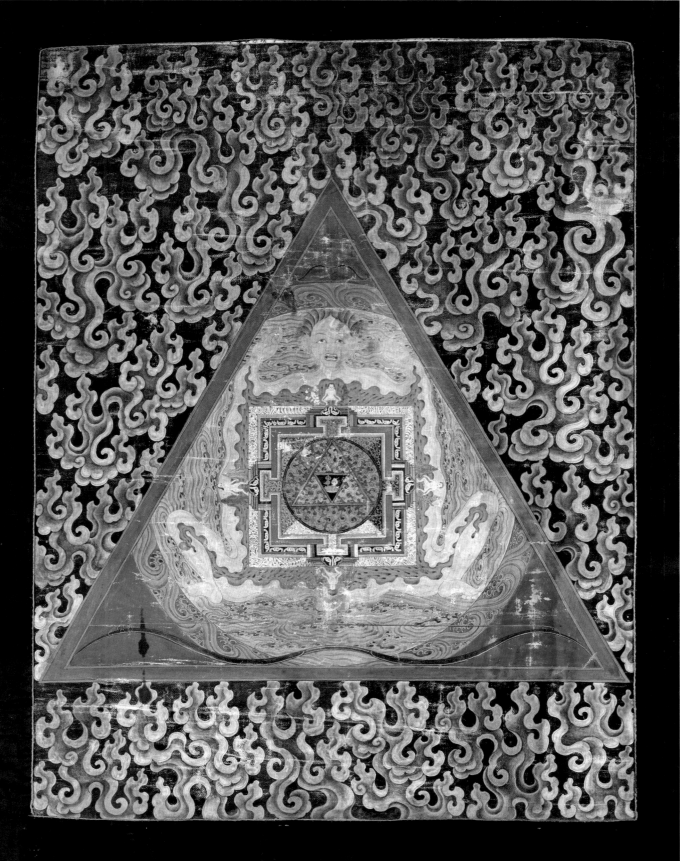

87
Ritual Dagger (*Phurba*) and Stand
Tibet, late 14th–early 15th century. Ebony with polychrome

88
Twelve-Armed Chakrasamvara with His Consort Vajravarahi
India (West Bengal) or Bangladesh, ca. 12th century. Phyllite

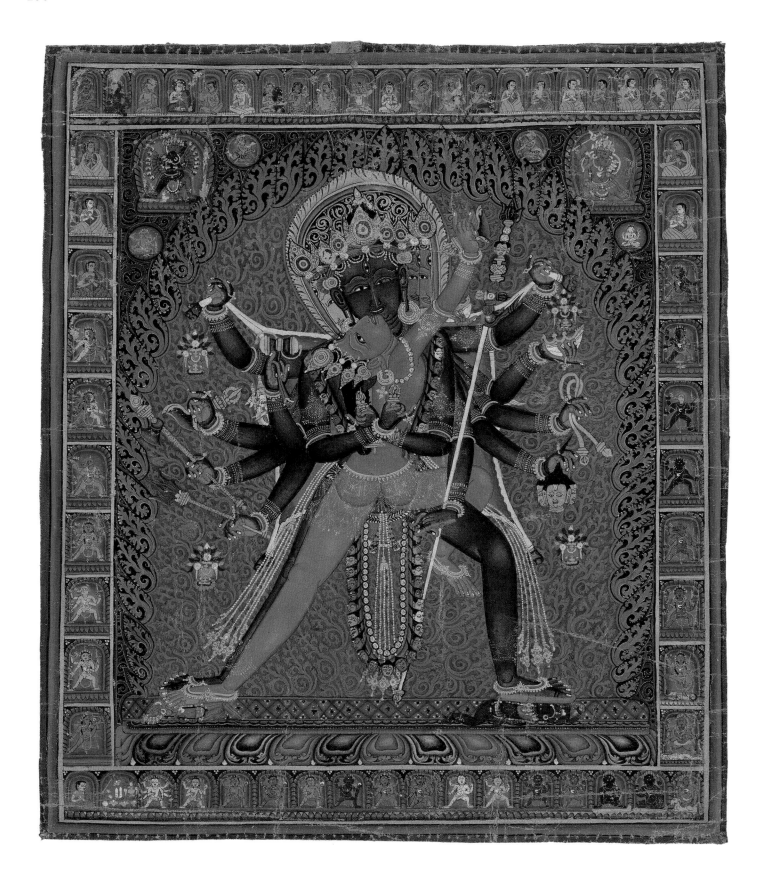

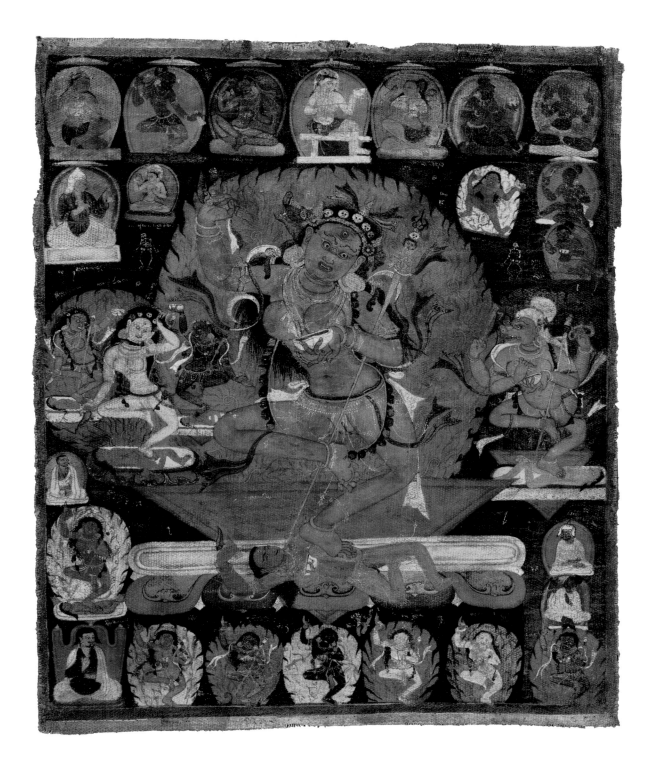

89
Chakrasamvara with His Consort
Vajravarahi
Central Tibet, Sakya school, 1450–1500.
Distemper on cotton

90
The Fivefold Form of Vajravarahi
Tibet, late 12th century. Distemper on
cloth

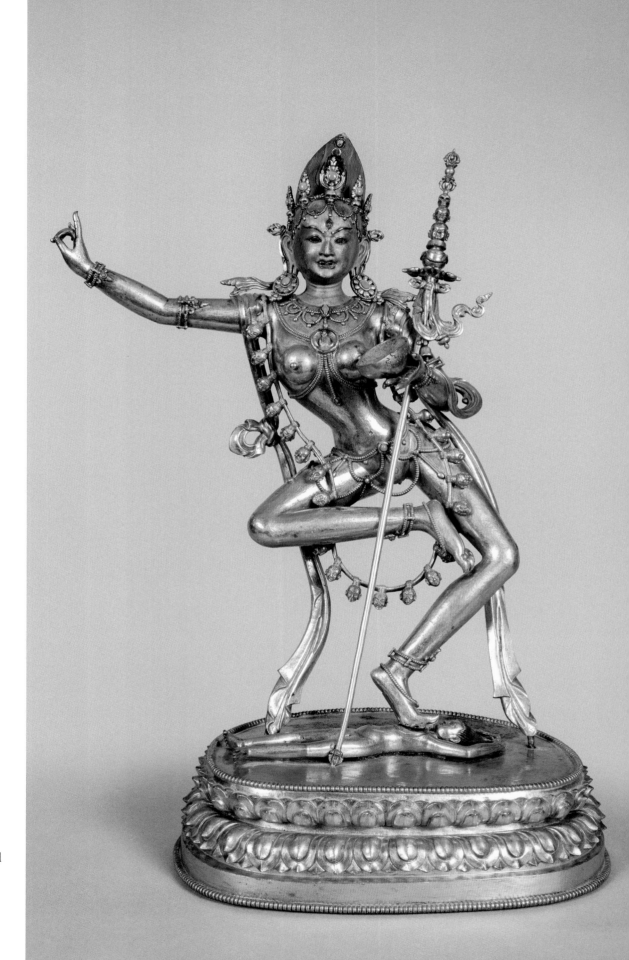

91
Vajravarahi
Tibet, ca. 18th century.
Copper alloy, gilding, and
paint with inset turquoise

92
Kurukulla
Tibet, 19th century. Appliquéd
satin, brocade, damask,
embroidered silk, and painted
details

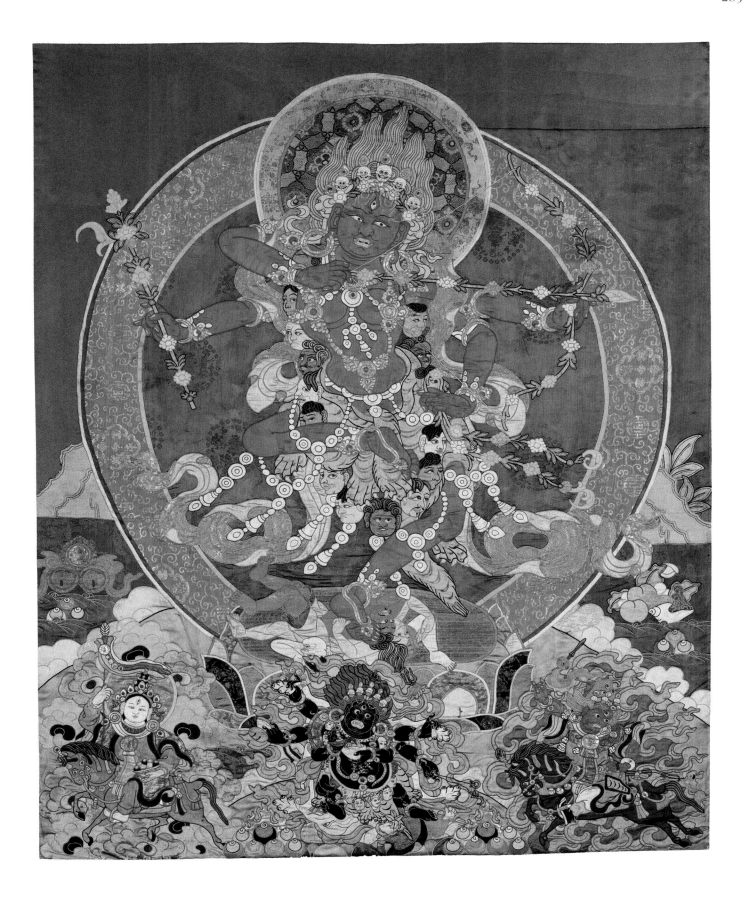

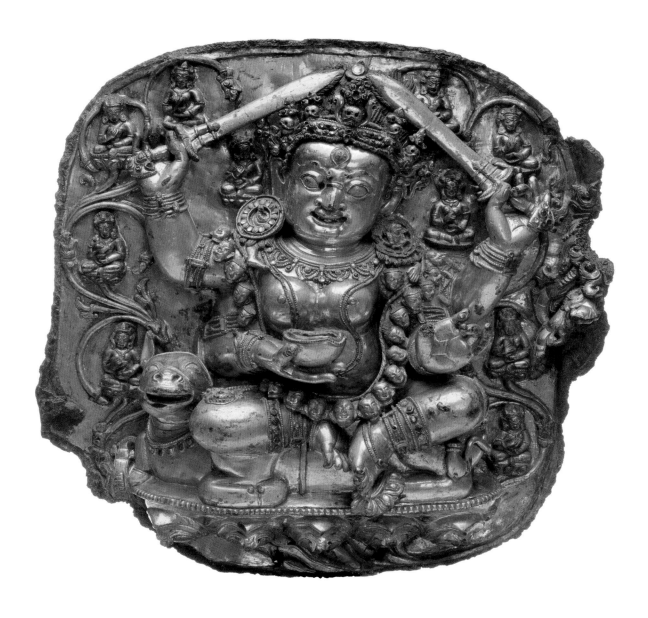

93
Dhumavati Sri Devi
Central Tibet, Densatil monastery, early
15th century. Gilt copper alloy with inlays
of semiprecious stones

94
Initiation Cards (*Tsakalis*)
Tibet, early 15th century. Opaque
watercolor on paper

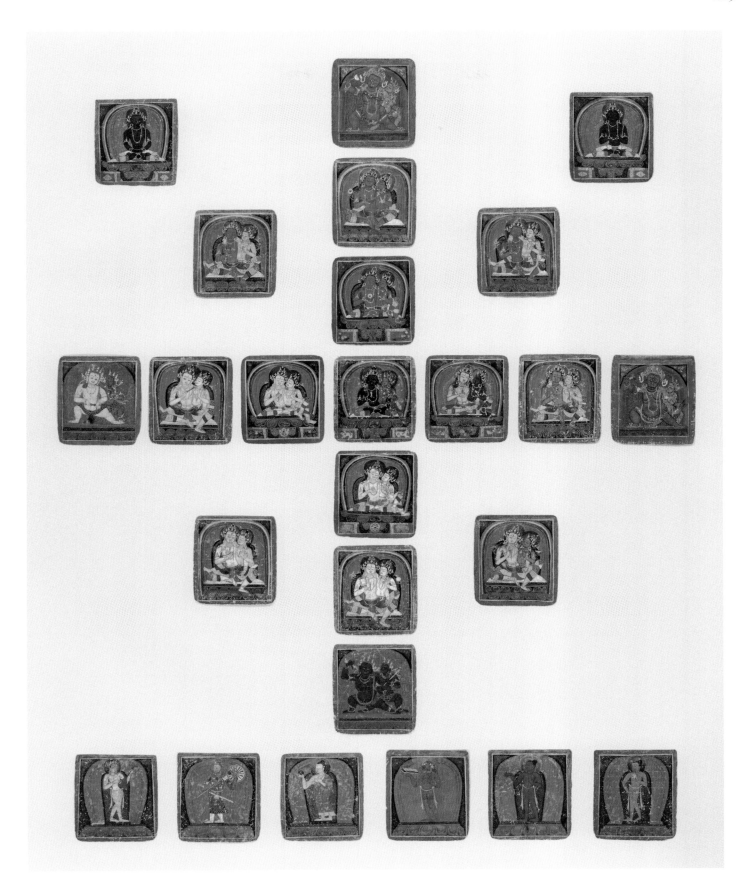

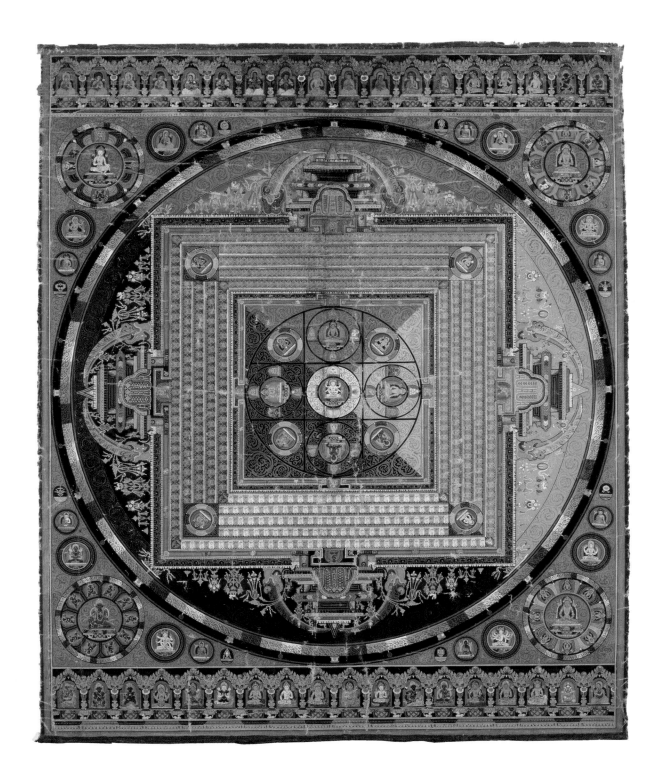

95
Vajradhatu (Diamond Realm)
Mandala
Central Tibet, 14th century. Distemper and
gold on cloth

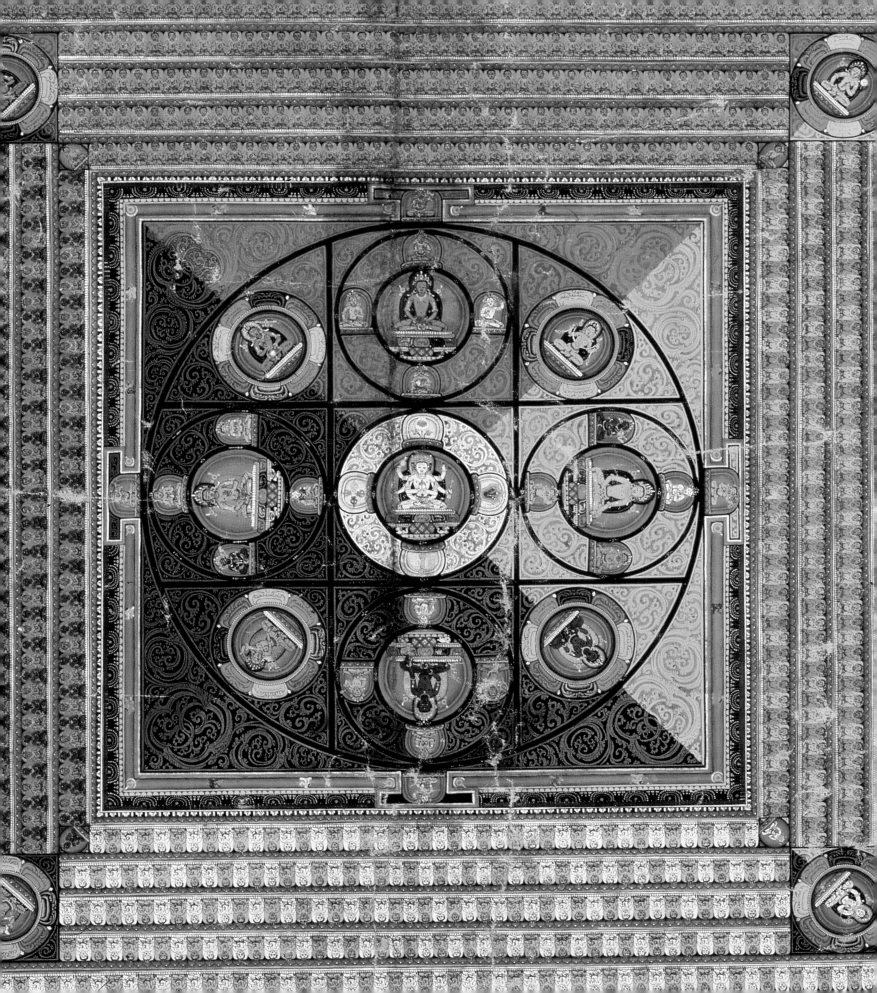

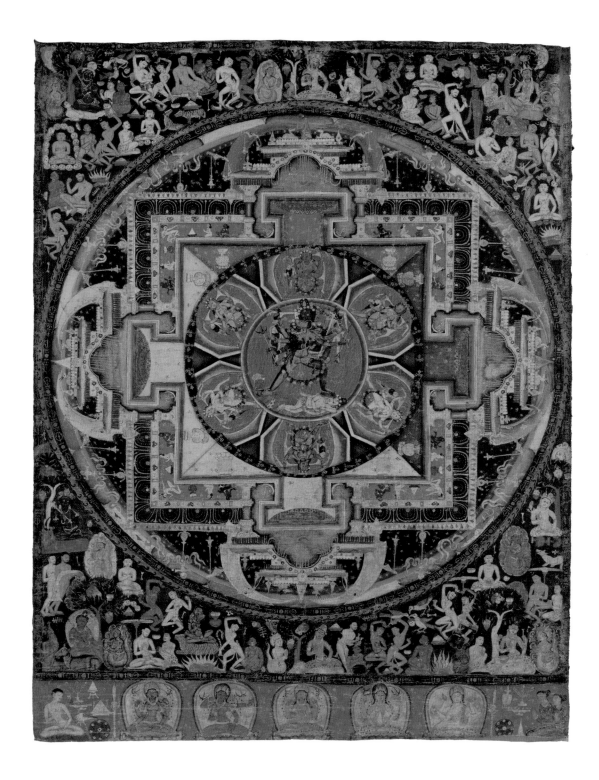

96
Chakrasamvara Mandala
Nepal, Thakuri–early Malla period,
ca. 1100. Distemper on cloth

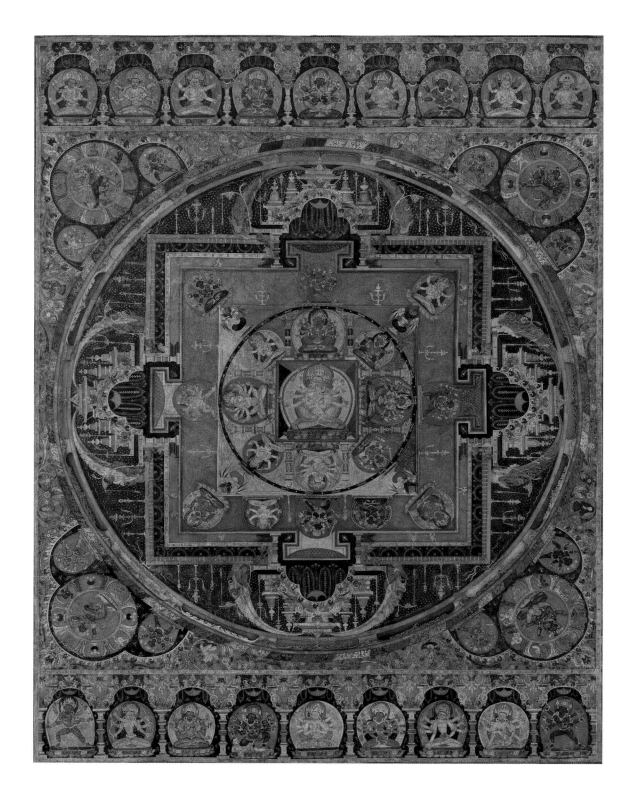

97
Manjuvajra Mandala
Tibet, late 12th century. Distemper and
gold on cotton

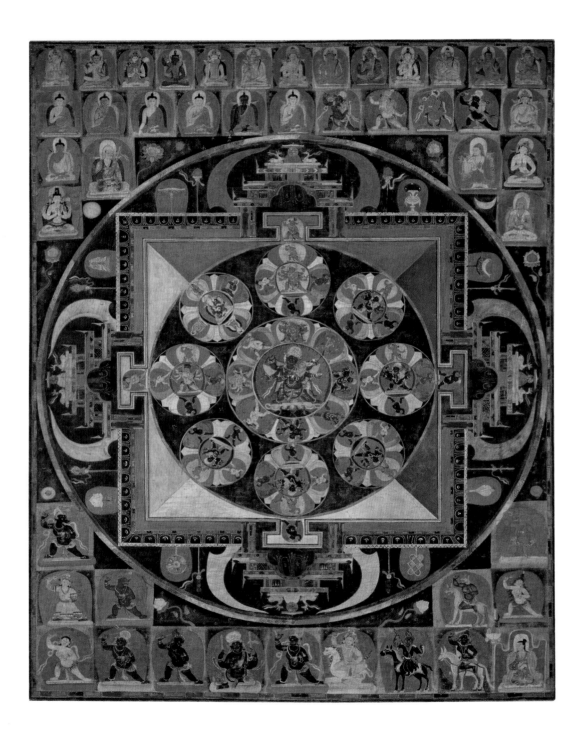

98
Chemchok Heruka Mandala
Tibet, second half 12th century. Mineral
pigments on cotton

99
Vajrabhairava Mandala
China, Yuan dynasty (1271–1368),
ca. 1330–32. Silk tapestry (*kesi*)

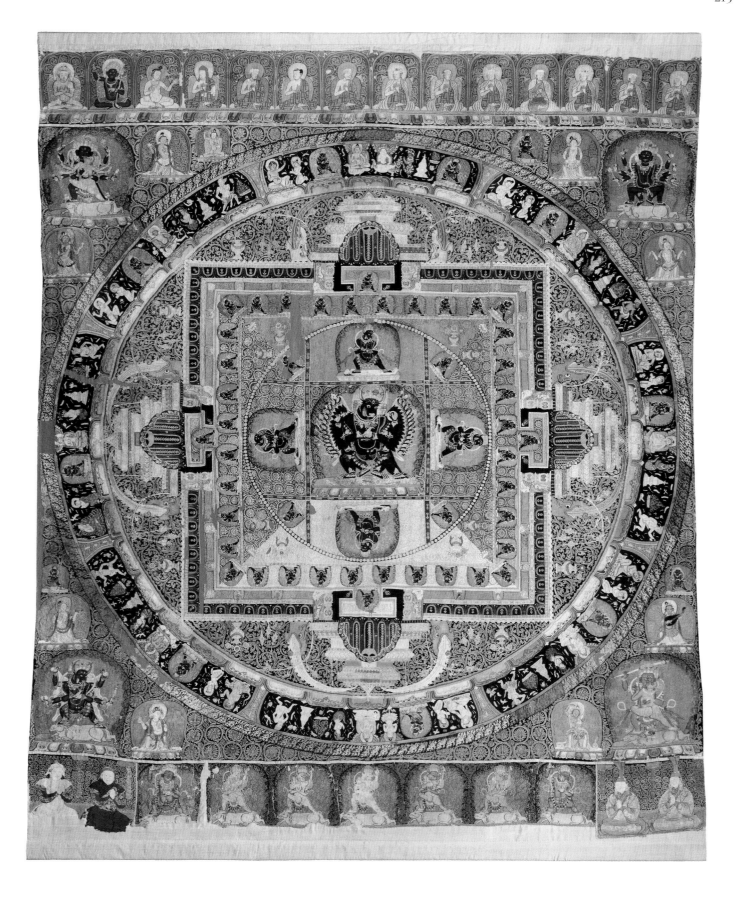

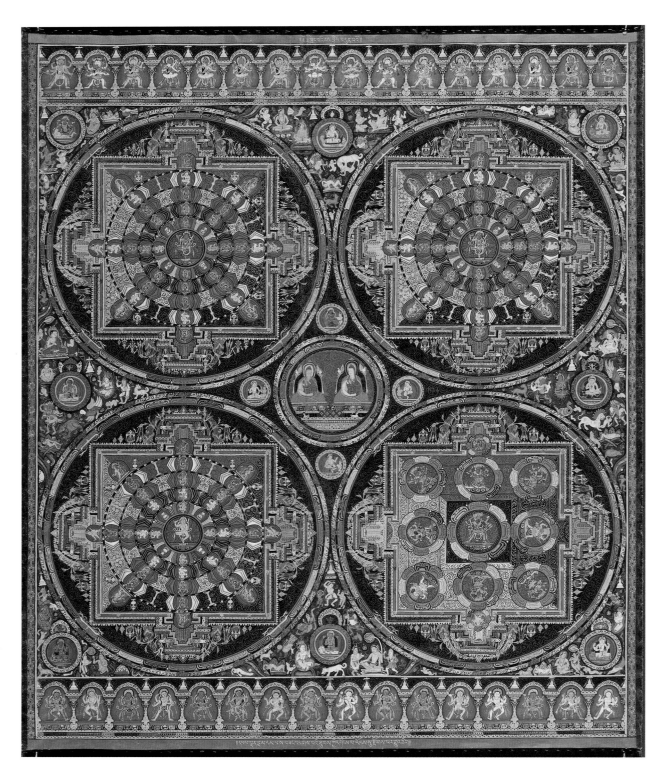

100
Four Mandalas of the Vajravali
Series
Central Tibet, ca. 1429–56. Distemper on
cotton

101
Mandala of Jnanadakini
Tibet, late 14th century. Distemper on
cloth

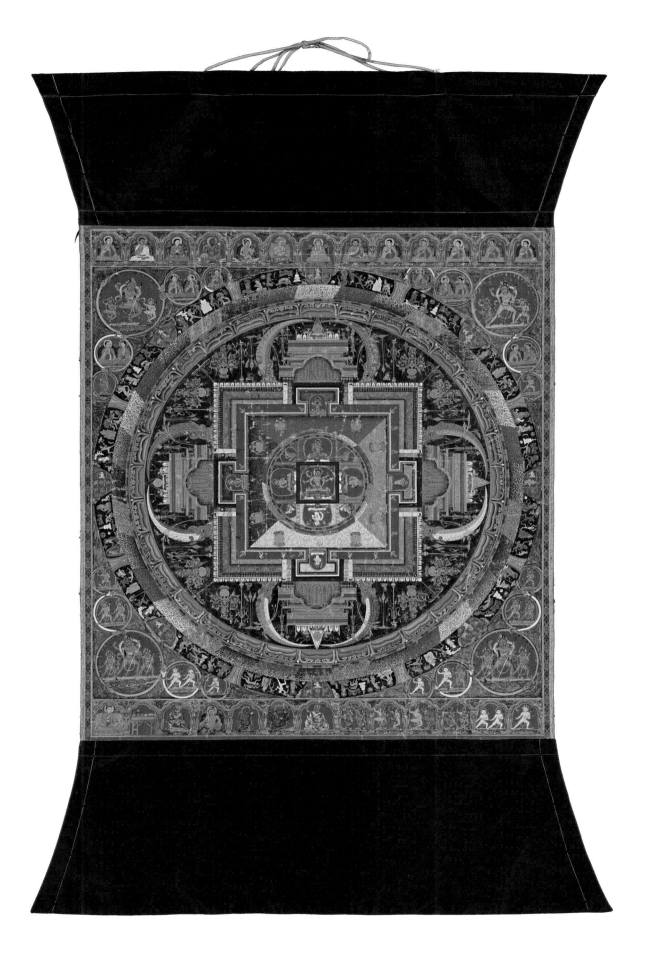

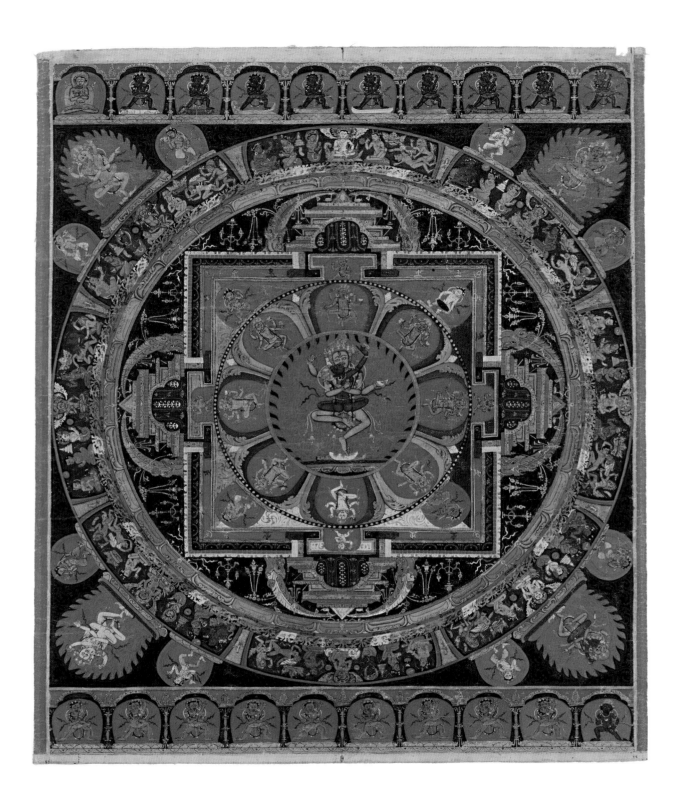

102
Hevajra Mandala
Tibet, 15th century. Distemper on cloth

103
Mandala of Raktayamari
Artist: Mikyo Dorje, Central Tibet,
late 14th century. Distemper on cloth

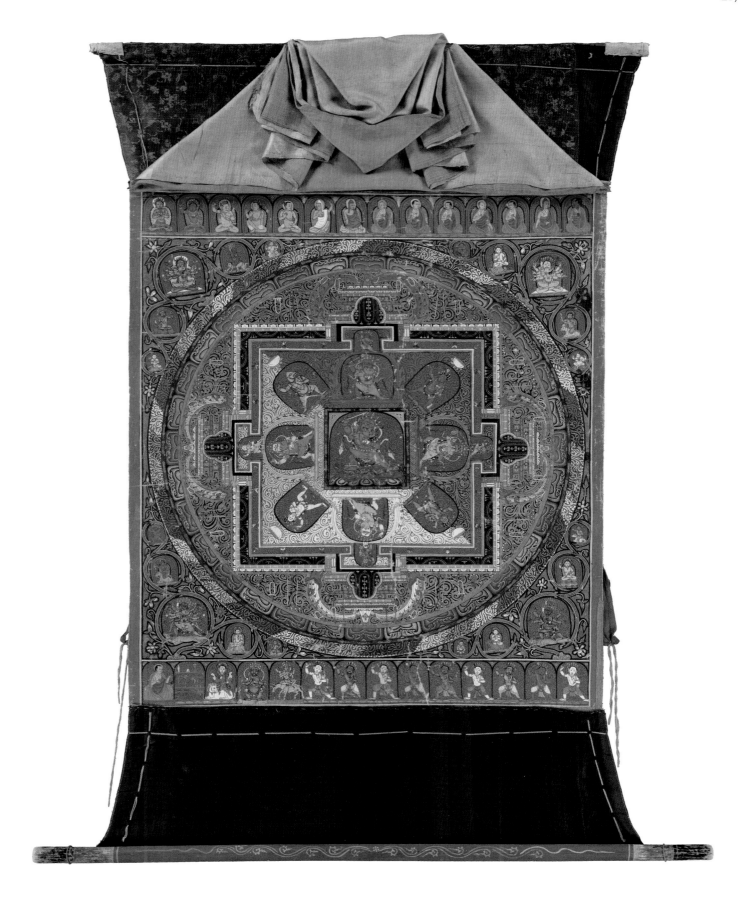

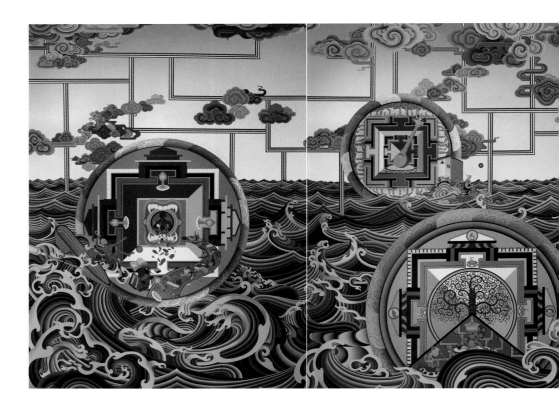

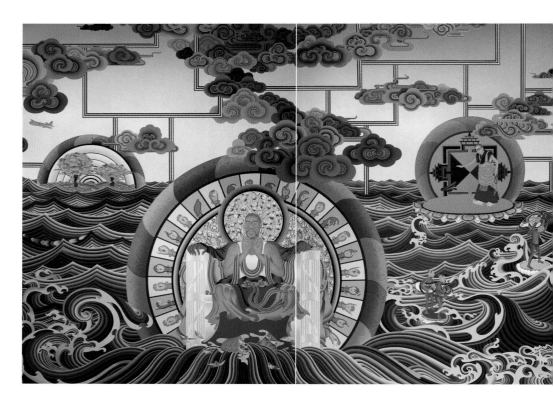

104
Biography of a Thought
Artist: Tenzing Rigdol (b. Kathmandu, 1982), Nepal, 2024. Acrylic on stretched canvas and woven carpet

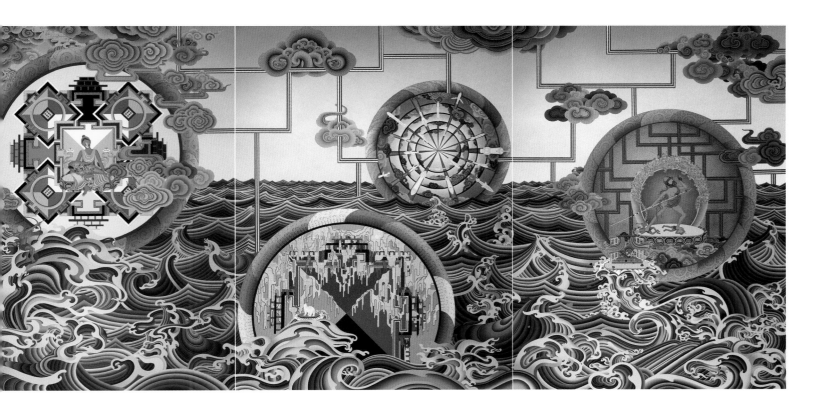

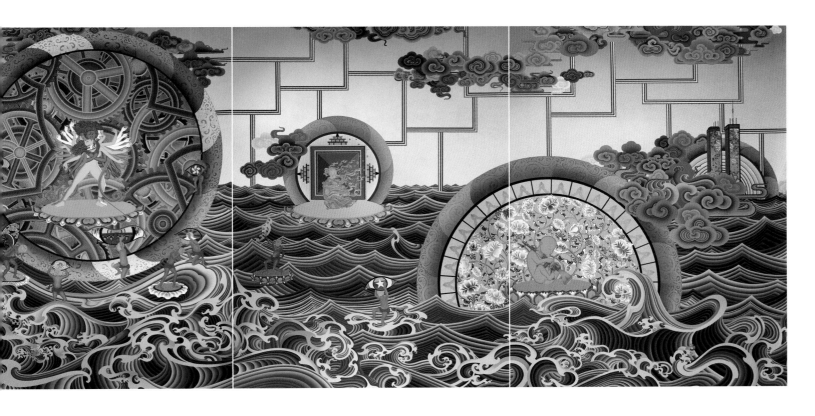

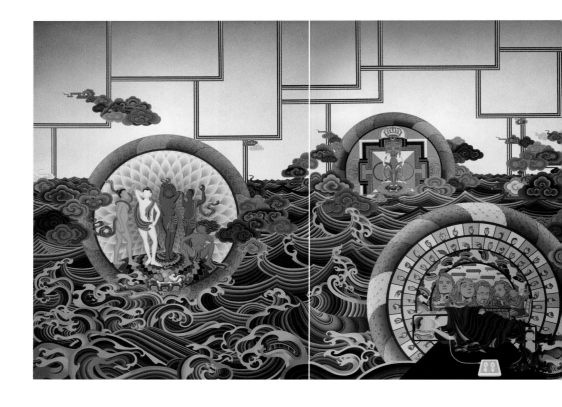

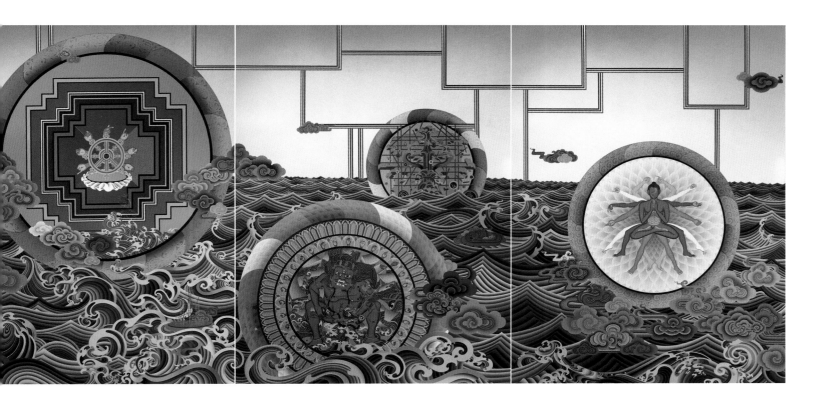

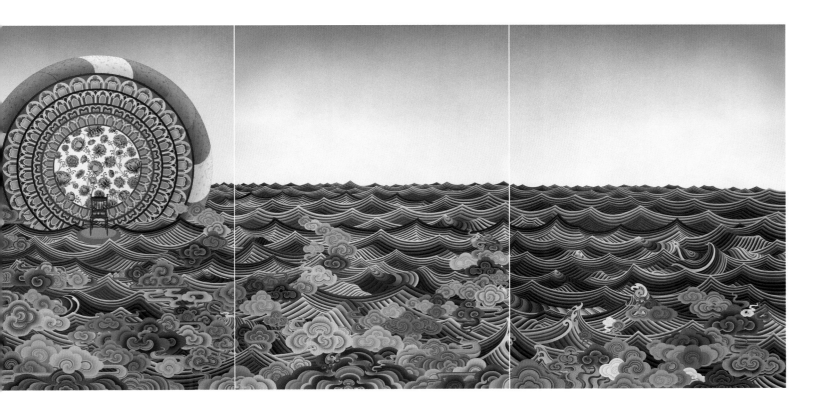

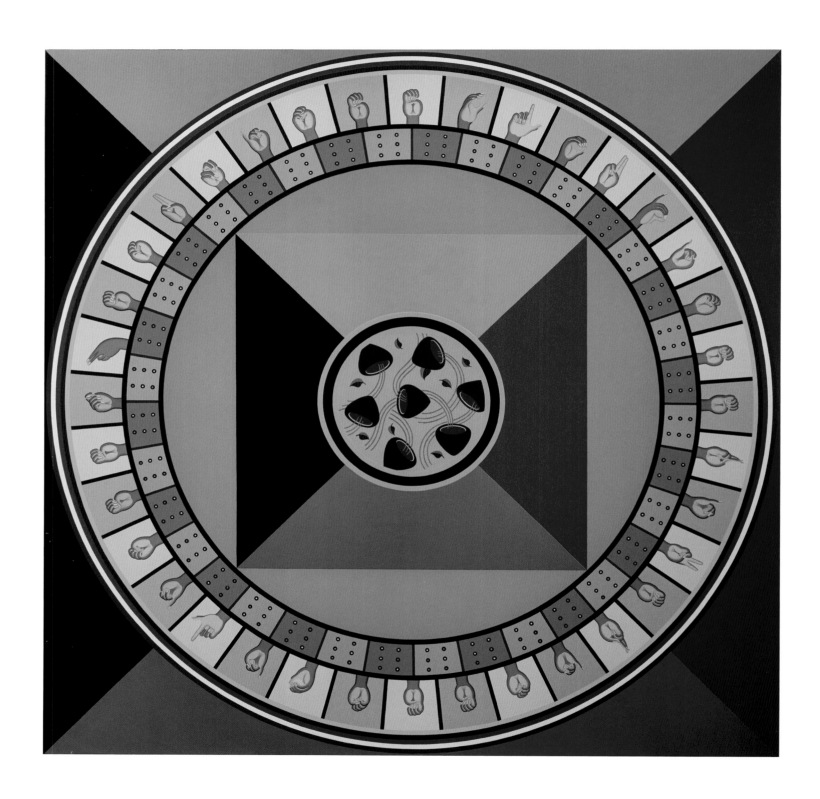

Checklist of Plates

1. Portrait of a Kadam Master with Buddhas and His Lineage

Central Tibet, ca. 1180–1220
Distemper on cloth, 45 × 30 in. (114.4 × 76.3 cm)
Michael J. and Beata McCormick Collection
Provenance: purchased from Rasa Gallery, Portland, Oregon, 1996

This massive monastic portrait is a sophisticated early example of the Tibetan format that emphasizes the enlightened status of this teacher. The youthful lama holds his hands in the teaching gesture and, like the Buddha, has a halo and sits on a lotus atop a lion throne. Further emphasizing his status are the seven medicine Buddhas across the topmost register, with Bhaishajyaguru at center, and, along either vertical edge, the celestial Buddhas of the ten directions. The lineage above his head, flanking Shadakshari Avalokiteshvara, includes the Indian monk Atisha in his peaked hat of a *pandita* (learned one) and two lay teachers with long hair that sit below his knees. While the identity of the lama is unknown, such a lineage suggests that this master is of the Kadam order. KB

2. Portrait of the Indian Monk Atisha

Tibet, early–mid-12th century
Distemper and gold on cloth, 19 ½ × 13 ¹⁵⁄₁₆ in. (49.5 × 35.4 cm)
The Metropolitan Museum of Art, New York, Gift of Steven M. Kossak, The Kronos Collections, 1993 (1993.479)
Provenance: Steven M. Kossak, New York, until 1993; his gift to The Met

The monk Atisha presided over the north Indian monastery of Vikramashila. In 1042 he traveled to Tibet at the invitation of the western Tibetan king Yeshe-Ö to help purify Buddhist practices. Done after his death, this portrait shows him as an enlightened being with a halo, seated on an elaborate jeweled throne. His right hand is held in a gesture of discourse or teaching, while in his left hand he holds what appears to be a palm-leaf manuscript. The *thangka* can be dated securely from an inscription on the reverse naming known historical figures. KB

3. Portrait of Shakyashribhadra with His Life Episodes and Lineage

Tibet, early–mid-14th century
Distemper on cloth, 33 × 25 ⁵⁄₁₆ in. (83.8 × 64.3 cm)
The Metropolitan Museum of Art, New York, Florence and Herbert Irving Acquisitions Fund for Asian Art, 2021 (2021.289)
Provenance: Giuseppe Tucci, Rome, acquired ca. 1928–48 in Tibet; Wildenstein Gallery, New York, 1955; sale, to Nasli and Alice Heeramaneck, New York, 1974; sale, to Christian Humann (Pan-Asian Collection), New York, until 1982; sale, to R. H. Ellsworth Ltd., New York, until 1993; sale, to a private collection, London, until 2021; sale, to Carlton Rochell LLC, New York; sale, purchased by The Met

This portrait combines a penetrating study of the famed practitioner of esoteric Buddhism, the Kashmiri monk Shakyashribhadra (1127–1225), with a beautiful depiction of the holiest of Buddhist sites, the Mahabodhi temple at Bodhgaya, where the Bodhi ("wisdom") tree marks the location of the historical Buddha's spiritual awakening. Shakyashribhadra served as the last abbot of the famed Nalanda monastery until its ruination by hostile forces in 1192. As the last Indian *pandita* to propagate the teachings of Vajrayana Buddhism in Tibet, he was of enduring importance to the development of Tibetan Buddhism. This portrait honors that legacy. JG

4. Portrait of the Last Indian Pandit, Vanaratna

Central Tibet, first half 15th century
Distemper on cloth, 40 ¼ × 34 ½ in. (102.2 × 87.6 cm)
The Kronos Collections
Provenance: purchased from Masurier Ltd., 1990

Vanaratna (1384–1468), born in the eastern port city of Chittagong (in modern Bangladesh), went in search of Buddhist teachings long after the great Buddhist centers of India had fallen into ruin. After visiting south India and Sri Lanka, he settled in Nepal and made three trips to Tibet, where he enjoyed great status, taught students, and helped establish Kalachakra Tantrism. He wears the hat of a north Indian *pandita* (learned one), holds a Sanskrit text in his left hand, and is surrounded by a Vajravali lineage of Tibetan teachers. Artisans from Nepal established the style of this portrait, which relates directly to the wall paintings of Gyantse, especially in terms of its color palette. KB

5. The Founding Masters of Taklung Monastery

Tibet, Taklung, last quarter 13th century
Ground mineral pigment on cotton, 19 ½ × 14 in. (49.5 × 35.6 cm)
Stephen and Sharon Davies Collection
Provenance: private collection, London, 1996–2020; Carlton Rochell LLC, New York, 2020; Stephen and Sharon Davies Collection

Tashipel (1142–1210), founder of Taklung monastery, sits at center with his successors, Kuyalwa (1191–1236), to the left, and Sangye Yarjon (1203–1272), to the right. Long consecratory inscriptions on the reverse of the painting take the shape of three stupas, corresponding to each monk; these dharma relics purify and give power to the work (Casey 2023, vol. 1, pp. 327–30). Mirroring the central figures above is a complex lineage organized in triads that traces back to the historical Buddha himself, seen at upper left. At the base of the painting are two registers, the upper one showing a monk conducting a ritual to consecrate the image in perpetuity together with a group of protectors and a bodhisattva. Unusually, the second, lower register is populated by tantric deities and their consorts, which speaks to the deep knowledge of the three monks being aggrandized in this painting. KB

6. Portrait of the Third Kagyu Taklung Abbot, Sangye Yarjon

Central Tibet, ca. 1262–63
Distemper and gold on cloth, 12 ¾ × 10 in. (32.4 × 25.4 cm)
The Kronos Collections
Provenance: purchased from Great Here Ltd., 1990

A distinct painting style emerged at the Taklung monastery, where small, highly detailed monastic portraits were produced. In this refined example, the facial features and neck folds of the Taklung abbot Sangye Yarjon (1203–1272) relate to early Tibetan wall painting from the end of the twelfth century. His hands and feet are colored red with henna like those of a deity; his right hand makes the earth-touching gesture of enlightenment, attesting to his status as the third patriarch of Taklung. An inscription in gold above the bottom register by his student Lama Rinpoche Wonpo (1251–1296), who was forced out of Taklung and founded the Riwoche monastery in 1276, helps contextualize the portrait within this period of monastic transition. KB

7. Portrait of the Monk Ngorchen and His Successor München

Central Tibet, 1450–1500
Distemper and gold on cotton, 34 ½ × 31 ½ in. (87.6 × 80 cm)
Stephen and Sharon Davies Collection
Provenance: Zimmerman Family Collection, New York; Carlton Rochell LLC, New York, 2006; Stephen and Sharon Davies Collection

Shown together on a common lotus base, these two monks make eye contact and hold their hands in gestures of discourse. The student (left), having fully mastered the subtle lessons of the teacher (right), is rendered nearly identically to the latter—a perfect expression of the transmission of doctrine from master to pupil. The painting was executed by an elite workshop, and no expense was spared in its creation, from the extensive use of gold in their clothing to the vibrant pigments. Observers knew that both successor and predecessor were enlightened, as confirmed by their halos, the surrounding auspicious symbols (*mangala*), and a lengthy lineage wrapping around three sides, as well as the tantric deities and protectors along the base. KB

8. Four Leaves from an *Ashtasahasrika Prajnaparamita Sutra*

India, Bihar, Nalanda monastery, Pala period, third quarter 11th century
Ink and opaque watercolor on palm leaf, each: approx. 2 ⅞ × 22 ⅜ in. (7.3 × 56.8 cm)

Asia Society, New York, Mr. and Mrs. John D. Rockefeller 3rd Acquisitions Fund (1987.1)
Provenance: acquired by the Asia Society from David Tremayne, Ltd., London, August 7, 1987

Illuminated manuscripts of this text, believed to epitomize the totality of Mahayana Buddhist teachings, were widely commissioned and donated to accrue religious merit. Central illustrations on the first two leaves depict the goddess Prajnaparamita and bodhisattva Manjushri, who personify the transcendent wisdom of the text. On the next two, the bodhisattvas Avalokiteshvara and Tara embody salvific compassion. Portrayed to either side of these four deities are the eight great events in the life of the historical Buddha Shakyamuni (see p. 41). A fifth folio from this manuscript preserves Sanskrit epigraphs that record the book's donation by a patron, transcription by the scribe Ananda at Nalanda monastery, and subsequent reconsecration. The Tibetan inscriptions chronicle its history of ownership after arriving in Tibet. RLB

9. Four Leaves from an *Ashtasahasrika Prajnaparamita* Sutra

Artist: Mahavihara Master
India (West Bengal) or Bangladesh, Pala period, early 12th century
Opaque watercolor on palm leaf, each: 2 ¾ × 16 ⁷⁄₁₆ in. (7 × 41.8 cm)
The Metropolitan Museum of Art, New York, Purchase, Lila Acheson Wallace Gift, 2001 (2001.445a, .445j, .445c, .445b)
Provenance: T. T. Gallery, Kathmandu, until 2001; sale, purchased by The Met

Illuminated manuscripts of the *Ashtasahasrika Prajnaparamita Sutra*, were widely commissioned and donated to accrue religious merit. The text is written in a black, carbon-based ink, while the illustrations were executed in mineral- and vegetable-based pigments. KB

a. Shadakshari Avalokiteshvara
Shadakshari Avalokiteshvara, a four-armed manifestation of the bodhisattva, appears at center, his primary hands pressed together in the gesture of veneration (*anjali mudra*). His right hand holds a *mala* (prayer beads) and his left hand holds a lotus and a book. He sits in a yogic posture, drawing legitimacy from ascetic

practice as a means to harness the power of meditation.

b. Six-Armed Avalokiteshvara Sitting in a Posture of Royal Ease
On this leaf, the placement of Avalokiteshvara does not relate to the content of the text. Rather, the bodhisattva appears to be marking a chapter heading, in addition to rendering the book an object of veneration.

c. Green Tara
Like the other illuminations in this sutra, which are among the greatest palm-leaf manuscript illustrations from the Indian subcontinent to survive, this tiny painting of the goddess Tara was executed by an artist of great skill.

d. Kurukulla Dancing in Her Mountain Grotto
The goddess Kurukulla, destroyer of corruption, is surrounded by a halo of flames, dancing on a corpse. Like many esoteric deities, Kurukulla is understood to be an aggressive emanation of one of the five cosmic Buddhas, or Tathagatas—in this case, the Buddha Amitabha, who presides over the western Pure Land. Such dualistic female-male or aggressive-pacific relationships typify how the emerging Vajrayana Buddhist pantheon gave visual form to the often arcane tenets of tantric Buddhism.

10. Four Leaves from a *Gandavyuha* Manuscript

Nepal, Transitional period (880–1200), late 11th–12th century
Ink and opaque watercolor on palm leaf, each: approx. 2 × 21 ½ in. (5.1 × 54.6 cm)
Asia Society, New York, Mr. and Mrs. John D. Rockefeller 3rd Collection of Asian Art (1979.54.1–.4)
Provenance: John D. Rockefeller 3rd, New York, acquired from Heeramaneck Galleries, New York, October 1970; his bequest to the Asia Society, 1979

This Mahayana text recounts Sudhana's quest to find a teacher. In the process, he meets numerous bodhisattvas, including Maitreya, who resides in a multifaceted tower symbolizing infinite realms of existence. In the second of four episodes seen here, Sudhana is shown with a halo,

suggesting attainment, in discourse with Avalokiteshvara, identifiable by the adjacent floating stupa. Although closely related to that of north Indian palm-leaf manuscripts, the style is distinctly Nepalese, especially in the simple place-ment of a single figure against a saturated, solid background and the omission of sec-ondary details. The holes for the string to bind the manuscript lack wear, suggesting that it was not read but instead created to generate merit and to be venerated as an object imbued with doctrinal power. KB

11. Three Fragmentary Leaves from an *Ashtasahasrika Prajnaparamita Sutra*

Kashmir or western Tibet, 12th century
Colors and black ink on paper, a) 3 ⅜ × 2 ¹⁵⁄₁₆ in. (8.5 × 7.5 cm); b) 8 ¹⁄₁₆ × 6 ½ in. (20.5 × 16.5 cm); c) 6 ¹¹⁄₁₆ × 14 ¹⁵⁄₁₆ in. (17 × 38 cm)
The Metropolitan Museum of Art, New York, Gift of Chino Franco Roncoroni, in celebration of the Museum's 150th Anniversary, 2020 (2020.74.1, .2, .4)
Provenance: private collection, Hong Kong, ca. 1990s; sale, to Chino Franco Roncoroni, Bali, until 2020; his gift to The Met

The introduction of plant-fiber papers as supports for illustrated manuscripts allowed for larger and more flexible dimensions than traditional palm-leaf folios and, when properly sized, for a new refinement of execution. In the eleventh and twelfth centuries, Kashmiri artists, or Tibetans working in the Kashmiri style, harnessed this new material to produce manuscripts of unprecedented radiance. These three folios originally belonged to large-format editions of the *Ashtasahasrika Prajnaparamita Sutra*, which teaches the importance of the perfections (*paramitas*), mastery of which leads to higher knowledge. The sutra was closely linked to the rise in popularity of Vajrayana practices in the early medieval period and was widely reproduced as an act of merit, its recitation understood to bring protection and benefit to all. JG

a. A Royal Worshipper

This exquisite miniature painting exempli-fies the unprecedented quality achieved by Kashmiri-trained artists in western Tibet working on larger-format paper folios. It depicts a worshipper seated cross-legged in the posture of royal ease (*lalitasana*), his hands raised in veneration. He wears a diadem and jewelry appropriate to his status and is framed by a rainbow aureole, normally reserved for a deity. He may rea-sonably be assumed to be the donor of the manuscript. The verso features seven lines of archaic Tibetan script in black ink cit-ing passages from the *Prajnaparamita* text.

b. The Goddess Prajnaparamita

Prajnaparamita sits on a golden lotus, encircled by a rainbow nimbus. She assumes her six-armed form, the central hands held over the heart in a variation of the *dharmachakra mudra*, the imparting of the Buddha's teachings, while her upper hands display the sacred book (*pustaka*) and thunderbolt scepter (*vajra*). In her lower hands she holds a rosary (*mala*) and gestures boon bestowing. The tonal model-ing of her body is noteworthy, and the full breasts and constricted waist are hallmarks of the Kashmiri style. The recto features, in an archaic Tibetan script, eight lines from the *Ashtasahasrika Prajnaparamita Sutra*, as well as, in a smaller, red script, the open-ing stanza of the "Ye dharma" prayer.

c. Buddha, Probably Amoghasiddhi

Radiant colors with subtle tonal gradations add luminosity to the green figure of a Buddha, seated in the lotus pose (*padma-sana*) on a lotus cushion with rainbow-colored petals. As he is shown without crown or jewels, dressed only in the patch-work robe of the renunciant Shakyamuni, his precise identity remains uncertain. He may be Amoghasiddhi, the Buddha of the North, or one of the One Thousand Buddhas of the Present Age (Bhadra Kalpa). Remarkable are the speckling of his body color and the spiky treatment of his hair and *ushnisha*. Energy lines radiate from his body, and he is enveloped in a brilliant rainbow aureole.

12. Cover for an *Ashtasahasrika Prajnaparamita Sutra*

Nepal, Kathmandu Valley, Thakuri–Malla period, 10th–11th century
Ink and color on wood with metal insets, 2 ¼ × 22 ⅜ in. (5.7 × 56.8 cm)
The Metropolitan Museum of Art, New York, Gift of John and Evelyn Kossak, The Kronos Collections, and Mr. and Mrs. Peter Findlay, 1979 (1979.511)
Provenance: jointly owned by Mr. and Mrs. John Kossak, New York, and Mr. and Mrs. Peter Findlay, New York, by 1979; their gift to The Met

This painted manuscript cover protected a palm-leaf edition of the *Ashtasahasrika Prajnaparamita Sutra*. The painting style belongs to the medieval Indian Pala-Nepalese tradition. Seated at center is Prajnaparamita, the goddess of transcen-dent wisdom and the personification of the text she holds in a raised hand, attended by two bodhisattvas, Padmapani Lokeshvara and Vajrasattva. Illustrated at left are two miraculous events from the life of the historical Buddha: his birth in the Lumbini grove and his subduing of the enraged elephant Nalagiri at Rajgir. Depicted at right is the Buddha's first sermon at Sarnath and the miracle at Shravasti, where he caused a multiplicity of Buddhas to appear. Such auspicious scenes added efficacy to the protective role of the manuscript cover. JG

13. Pair of Manuscript Covers Illustrating Sadaprarudita's Self-Sacrifice

Nepal, Kathmandu Valley, 12th century
Distemper on wood, each: 2 ¼ × 12 ¹⁵⁄₁₆ in. (5.7 × 32.9 cm)
The Metropolitan Museum of Art, New York, Gift of Mr. and Mrs. Walter Eisenberg, 1984 (1984.479.1a, b)
Provenance: Mr. and Mrs. Walter Eisenberg, Boca Raton, Florida, until 1984; their gift to The Met

The story of Sadaprarudita is embedded in the *Prajnaparamita Sutra*; it opens with him in a forest, hoping to learn the content of this very text (top, center left scene). He travels to the city of Gandhavati to find the bodhisattva Dharmodgata, who he hopes will preach the sutra to him. He is tested by the god Indra and makes offerings of his heart, blood, and bone marrow (center right scene). As the paint-ings appear on the interior of the covers, they would only have been seen when the text—likely a *Prajnaparamita Sutra*—was being read, thus placing devotees in the

position of our protagonist. The distinctive figural type and mode of depiction characterize early Nepalese painting and offer a departure from earlier styles popular in north India. KB

14. Pair of Manuscript Covers with Buddhist Deities

Nepal, Thakuri period, 11th–12th century
Ink and color on wood, 2 ¼ × 21 ³⁄₁₆ in. (5.7 × 53.8 cm)
The Metropolitan Museum of Art, New York, Anonymous Gift, 1983 (1983.555.2, .3)
Provenance: private collection, until 1983; donated to The Met

The top cover shows tantric emanations of the five cosmic Buddhas, or Tathagatas, flanked on the left by the bodhisattvas Vajrapani and Maitreya and, on the right, by Avalokiteshvara and, possibly, Manjushri. At the center of the bottom cover is the goddess Prajnaparamita, flanked on each side by fierce multiarmed goddesses. Joining a green protective deity at left is Vasudhara who, as an emanation of the Buddha Ratnasambhava, confers abundance. At right are a blue protector and Green Tara, an important manifestation of the Buddha Amoghasiddhi, who is identifiable by her color and the blue lotus. KB

15. Pair of Manuscript Covers, Each with Five Deities

Tibet, end of the 11th century
Distemper and gold on wood, each: 4 ¼ × 22 in. (10.8 × 55.9 cm)
The Metropolitan Museum of Art, New York, Gift of Jeffrey Kossak, The Kronos Collections, 2020 (2020.290a, b)
Provenance: Nawang Paljor, until ca. 2000; sale, to Jeffrey Kossak, New York, until 2020; his gift to The Met

The upper cover shows the most important Mahayana Buddhist deities: at center is the Buddha, attaining enlightenment; to his right are the bodhisattvas Manjushri and Vajrapani; and to his left sit Shadakshari Avalokiteshvara and Tara. Together, these deities represent enlightenment, compassion, correct method and practice, and protection from worldly harm. The lower cover, by contrast, illustrates fierce protective deities flanking a

central bodhisattva: Achala and Marichi at right, and Mahapratisara and Mahakala at left. Although these esoteric deities appear in north Indian sculptures and manuscript illustrations, only in Tibet are they grouped in a set as here. KB

16. Interior of a Manuscript Cover: Manjuvajra Embracing His Consort, with Attendant Lamas

Tibet, late 13th century
Distemper on wood, 5 ⅝ × 16 ¾ in. (14.3 × 42.5 cm)
The Metropolitan Museum of Art, New York, Harris Brisbane Dick Fund and Louis V. Bell Fund, 1998 (1998.75)
Provenance: Arnold H. Lieberman, New York, until 1998; sale, purchased by The Met

Paintings on the interiors of book covers consecrated and protected the ideologically pure space of the text. The lamas shown here no doubt refer to an unbroken chain of teacher-student relationships and the guidance required to understand the subtle meaning of the text. Manjuvajra, at center, is an esoteric manifestation of Manjushri, a bodhisattva who cuts through ignorance. Here, he offers greater access to the difficult ideas contained within the text. The refined and sensitive treatment of the figures, foliate patterns, and variety of motifs speak to a Nepalese stylistic idiom. KB

17. Manuscript Cover with Prajnaparamita Flanked by Ten Buddhas

Tibet, late 12th century
Wood with gilding and polychrome, 8 ¼ × 27 ⅛ in. (21 × 68.9 cm)
Michael J. and Beata McCormick Collection
Provenance: acquired from the Nami Ronge' collection, Bonn, Germany, 2005

The goddess Prajnaparamita, seated at the center of this manuscript cover, embodies the transcendent Mahayana Buddhist doctrine expounded by the book she grasps in her upper left hand. The upper right hand wields a *vajra* to invoke the power of enlightenment. At the apex of the arch above her is a *khyung*, a horned avian assimilated into Buddhist contexts from Tibet's indigenous Bon religion. The Buddhas of the ten directions—cardinal, ordinal, zenith, and nadir—are

arranged symmetrically on either side of Prajnaparamita, implying the universality of the Buddhist teachings protected by book covers such as this one. RLB

18. The Transcendent Buddha Akshobhya

Central Tibet, 13th or early 14th century
Distemper on cloth, 30 ¹⁄₁₆ × 24 ¾ in. (76.4 × 62.8 cm)
The Metropolitan Museum of Art, New York, Purchase, Gift of Florence and Herbert Irving, by exchange, 2021 (2021.288)
Provenance: Giuseppe Tucci, Rome, acquired ca. 1928–48 in Tibet; Wildenstein Gallery, New York, 1955; sale, to Nasli and Alice Heeramaneck, New York, until 1974; sale, to Christian Humann (Pan-Asian Collection), New York, until 1982; sale, to R. H. Ellsworth Ltd., New York, until 1993; sale, to a private collection, London, until 2021; sale, to Carlton Rochell LLC, New York; sale, purchased by The Met

Akshobhya, the "Immovable One," is one of the five transcendent Buddhas, the so-called Tathagatas, "those who have entered into [the truth of] highest perfection" and preside over Vajrayana Buddhism. He embodies the pure mind that distinguishes (higher) reality from (material) illusion, symbolized by the *vajra* scepter he displays before his throne. He is the highest expression of the power to pacify aggression and transmute it into wisdom. This painting was one of a set of five, typically venerated in a mandala configuration, each assuming a specific iconographic form distinguished by directional orientation, body color, and attributes. Akshobhya, protector of the east, is blue in complexion and wields the *vajra*. JG

19. Crown Ornaments for a Deity

Newari for the Tibetan market, 17th–19th century
Gilt silver, emeralds, sapphires, rubies, garnets, pearls, lapis lazuli, coral, shell, and turquoise, each: 6 ¾ × 4 in. (17.1 × 10.2 cm)
The Metropolitan Museum of Art, New York, John Stewart Kennedy Fund, 1915 (15.95.81, .82)
Provenance: Lockwood de Forest, New York, until 1915; sale, purchased by The Met

Pious donors often donated elaborate jewelry to important devotional sculptures. These pronged crown elements likely were part of a set of five that referenced

the Tathagatas, or cosmic Buddhas, as indicated by the *vajra* (thunderbolt) and *purnaghata* (foliate forms). KB

20. Ear Ornaments for a Deity
Nepal, 17th–19th century
Mercury, gilt silver, rubies, emeralds, sapphires, lapis lazuli, coral, pearls, and turquoise, each: 9 ½ × 4 in. (24.1 × 10.2 cm)
The Metropolitan Museum of Art, New York, John Stewart Kennedy Fund, 1915 (15.95.83, .84)
Provenance: Lockwood de Forest, New York, until 1915; sale, purchased by The Met

The eight auspicious symbols (*ashtamangala*) embedded in these pendant ear ornaments served to consecrate the image to which they were attached. KB

21. Ear Ornaments for a Deity
Nepal, 17th–19th century
Gold with coral and turquoise, 8 × 2 ⅝ in. (20.3 × 6.7 cm)
The Metropolitan Museum of Art, New York, John Stewart Kennedy Fund, 1915 (15.95.85, .86)
Provenance: Lockwood de Forest, New York, until 1915; sale, purchased by The Met

22. Forehead Ornament for a Deity
Newari for the Nepalese or Tibetan market, 17th–19th century
Gold, diamonds, rubies, emeralds, sapphires, garnet, lapis lazuli, coral, and turquoise, 2 ¾ × 8 ½ in. (7 × 21.6 cm)
The Metropolitan Museum of Art, New York, John Stewart Kennedy Fund, 1915 (15.95.161)
Provenance: Lockwood de Forest, New York, until 1915; sale, purchased by The Met

Marking the cosmic axis at the center of this ornament is a pronged lightning bolt (*vajra*), which stands in for the Buddha Vairochana. It also references the diamond throne (*vajrasana*) where the historical Buddha Shakyamuni reached enlightenment, under the Bodhi tree. Flanking the *vajra* are the celestial Buddhas Amitabha, Amoghasiddhi, Akshobhya, and Ratnasambhava, who together with Vairochana comprise the Tathagatas, or five cosmic Buddhas. KB

23. Forehead Ornament for a Deity
Newari for the Nepalese or Tibetan market, 17th–19th century
Gilt silver, brass, diamonds, emeralds, rubies, sapphires, pearls, coral, shell, turquoise, and semiprecious stones, 2 ¾ × 10 in. (7 × 25.4 cm)
The Metropolitan Museum of Art, New York, John Stewart Kennedy Fund, 1915 (15.95.174)
Provenance: Lockwood de Forest, New York, until 1915; sale, purchased by The Met

24. Armlet for an Image with Crossed *Vajra*s
Nepal, 17th–19th century
Mercury, gilt silver, diamonds, rubies, emeralds, sapphires, pearls, lapis lazuli, coral, shell, and turquoise, 2 ⅝ × 7 ¼ in. (6.7 × 18.4 cm)
The Metropolitan Museum of Art, New York, John Stewart Kennedy Fund, 1915 (15.95.175)
Provenance: Lockwood de Forest, New York, until 1915; sale, purchased by The Met

The crossed *vajra*s at the center of this arm ornament indicate the cardinal directions and the universe's axis—a place of ultimate stability where the Buddha reached enlightenment, which is marked here with a diamond. The gems, semiprecious stones, and coral convey ideas of purity and together form a mosaic that evokes the heavens. On either side of the armlet in reddish coral are *kirtimukha*s, fierce faces that symbolize the relentless passage of time. KB

25. Amulet Box of a Noblewoman
Tibet, late 19th–early 20th century
Gold, beryl, rubies, emeralds, sapphires, and turquoise, 4 × 4 in. (10.2 × 10.2 cm)
The Metropolitan Museum of Art, New York, John Stewart Kennedy Fund, 1915 (15.95.97)
Provenance: Lockwood de Forest, New York, until 1915; sale, purchased by The Met

26. Dish for Ritual Offerings
Nepal, 17th–19th century
Gilt silver, rock crystal, emeralds, rubies, sapphires, yellow quartz, garnets, spinels, coral, shell, lapis lazuli, and semiprecious stones, Diam. 8 ½ in. (21.6 cm)
The Metropolitan Museum of Art, New York, John Stewart Kennedy Fund, 1915 (15.95.168)
Provenance: Lockwood de Forest, New York, until 1915; sale, purchased by The Met

27. The Bodhisattva Maitreya, Buddha of the Future
Tibet, 11th or early 12th century
Distemper on cloth, 54 ½ × 41 ¾ in. (138.4 × 106.1 cm)
The Metropolitan Museum of Art, New York, Rogers Fund, 1989 (1989.284)
Provenance: David Newman, London, until 1989; sale, purchased by The Met

One of the largest early Tibetan *thangka*s, this painting presents the bodhisattva Maitreya, who sits in meditation holding a *kamandalu* (waterpot), a reference to his ascetic nature. He wears a jeweled crown with fluttering ribbons, and his many necklaces, bracelets, and luxurious textiles emphasize his radiant yellow body. The shimmering surface was not part of the original composition, developing over time as arsenic crystals formed from the orpiment pigments used for the bold yellow color. The figures at the top wearing robes and flat hats seem to be lay followers; at the lower right, a monk sits before a table of offerings and consecratory implements. KB

28. The Bodhisattva Maitreya, Buddha of the Future
Mongolia, school of Zanabazar (1635–1723), second half 17th century
Gilt bronze with blue pigment and traces of other pigments, 24 ⁹⁄₁₆ × 8 ⁷⁄₁₆ × 7 ⅝ in. (62.4 × 21.5 × 19.4 cm)
Harvard Art Museums/Arthur M. Sackler Museum, Gift of John West, 1963 (1963.5)
Provenance: John West, by 1963; his gift to the Fogg Art Museum

This elegant bronze depicts Maitreya as a bodhisattva residing in Tushita heaven until he is reborn as the future Buddha. He bears the trappings of an ascetic—matted hair piled high, a *kamandalu* (waterpot), an antelope hide draped over his shoulder—harbingers of his impending retreat to the forest to perform austerities in his final rebirth prior to enlightenment. The sculpture is ascribed to the school of the Buddhist master and Mongolian artist Zanabazar, who was identified by the fifth Dalai Lama as an incarnation of the Tibetan scholar Taranatha (1575–1634) and ordained as the head lama of the Gelug sect in Mongolia. Zanabazar's fabled artistry is apparent in the rendering of Maitreya's lissome torso and clinging garment. The round lotus pedestal supporting the figure is a signature trait of the Zanabazar school. RLB

29. Manjushri, the Bodhisattva of Transcendent Wisdom

Western Tibet, late 10th–early 11th century
Brass with inlays of copper and silver, 27 ¼ × 11 ½ × 4 ½ in. (69.2 × 29.2 × 11.4 cm)
Asia Society, New York, Mr. and Mrs. John D. Rockefeller 3rd Collection (1979.45)
Provenance: John D. Rockefeller 3rd, New York, acquired from Sandra Neubardt, New Rochelle, New York, April 1971; his bequest to the Asia Society, 1979

Manjushri is among the most important deities in Tibetan Buddhism. In this exquisite bronze, the tiger-claw necklace and youthful countenance confirm Manjushri's identity, even though he lacks other attributes that may have once been supported by the lotus stalk rising from his left hand. Especially accomplished are the finely detailed floral and foliate patterns of his garment and the flower garland draped around his body. Stylistic affinities with Kashmiri metalwork are evident in the sharp contours of the face, the muscular pectorals, and the articulation of the flesh around the navel, attesting to the circulation of artists and objects between Kashmir and western Tibet. RLB

30. Manjushri, the Bodhisattva of Transcendent Wisdom

China, Qing dynasty (1644–1911), 17th–18th century
Silk appliqué with damask, satin, brocade, and leather substrate with silver finish and embroidery with silk cord (raw silk wrapped in fine silk floss), 104 ⅝ × 67 ¾ in. (265.7 × 172.1 cm)
The Metropolitan Museum of Art, New York, John Stewart Kennedy Fund, 1915 (15.95.154)
Provenance: Lockwood de Forest, New York, until 1915; sale, purchased by The Met

In the eighteenth century, the bodhisattva Manjushri was revered by the Manchu rulers, especially Emperor Qianlong (r. 1736–95). This monumental appliqué, which shows Manjushri on a blue lion, holding a sword and a book and attended by Sudhana (see pl. 10), was likely fabricated in the Suzhou imperial workshop and gifted to a Tibetan monastery. A variety of silks were stitched together to render this iconic figure within an idyllic landscape. To render volume, artists utilized strips of silk to create the folds of Manjushri's garment and couched silk cords to delineate the lion's mane and tail. The blue Akshobhya Buddha above Manjushri suggests a strong familiarity with Tibetan conventions. CM

31. The Bodhisattva Manjushri as a Ferocious Destroyer of Ignorance

Nepal, Kathmandu Valley, Thakuri period, 10th century
Gilt copper alloy with color and gold paint, overall with base: 14 ¼ × 6 ¼ × 3 ¼ in. (36.2 × 15.9 × 8.3 cm)
The Metropolitan Museum of Art, New York, Purchase, Harris Brisbane Dick, Dodge and Fletcher Funds, and Joseph Pulitzer Bequest, 1982 (1982.220.13)
Provenance: Ben Heller, Inc., New York, by 1968 until ca. 1970; sale, to Christian Humann, New York, until (d.) 1981; his estate; sale, to R. H. Ellsworth Ltd., New York, until 1982; sale, purchased by The Met

With his knitted brow, fearsome face, and aggressive stance, the usually pacific bodhisattva Manjushri takes on a more aggressive manifestation associated with his role as a bearer of tantric knowledge. He originally held a sword in his right hand; with his left, he makes the gesture of discourse and teaching (*vitarka mudra*). Elaborate jewels in his headdress and on his belt relate to motifs associated with the nomadic Sogdian people of Central Asia, while the gold textile patterns of his dhoti (loincloth) likely derive from north India. KB

32. Vajracharya Priest's Crown

Nepal, early Malla period, 13th–early 14th century
Gilt copper alloy inlaid with semiprecious stones, lapis lazuli, and turquoise, 12 × 9 × 8 ¼ in. (30.5 × 22.9 × 21 cm)
The Metropolitan Museum of Art, New York, Gift of Barbara and David Kipper, 2016 (2016.408)
Provenance: Zimmerman Family Collection, before 1991–2007; Carlton Rochell LLC, New York, 2007; sale, to David and Barbara L. Kipper, Chicago, until 2016; their gift to The Met

This ritual crown was worn by Newari Buddhist priests during the enactment of rituals in which the wearer entered into the persona of a bodhisattva, becoming in that moment a transcendent Buddha. This practice is unique to Newari Buddhism, preserving older, now lost Indian esoteric practices associated with Vajrayana. This crown is exceptional in its complexity: it is dominated by a series of diadem plaques representing emanations of Manjushri in both benign and wrathful forms, accompanied by eight smaller plaques depicting the gift-granting goddesses. A five-pronged thunderbolt (*vajra*) scepter surmounts the crown. This rare iconography indicates that the crown was designed for rites that invoke Manjushri, the bodhisattva of wisdom. JG

33. Shadakshari Avalokiteshvara, the Bodhisattva of Compassion

Tibet, 1300–1350
Distemper on cloth, 15 ¼ × 13 ¼ in. (38.7 × 33.7 cm)
The Kronos Collections
Provenance: purchased from Carlo Cristi, 2011

Avalokiteshvara sits with his primary hands in the *mudra* of veneration and holds a *mala* and a lotus in his upraised secondary arms. Here, he resides on Mount Potalaka, depicted as a rocky landscape populated by animals, birds, and a host of Buddhas and *mahasiddha*s. The bodhisattva descends from the mountain and makes himself available to devotees, which perfectly corresponds to the group of lay donors and monks shown at the lower left, venerating him. The mantra "Om mani padme hum" is recited to invoke this deity; in fact, the epithet "Shadakshari" in Sanskrit translates to "six syllables." Above Avalokiteshvara is the Buddha Amitabha, who presides over the western paradise of Sukhavati, where the devout hope to be reborn. Amitabha's presence emphasizes Avalokiteshvara's role as an emanation and intermediary of this Buddha. KB

34. Thousand-Armed Chenresi, a Cosmic Form of the Bodhisattva Avalokiteshvara

Artist: Sonam Gyaltsen (active 15th century)
Central Tibet, Shigatse, 1430
Copper alloy with gilding, H. 26 ⅝ in. (67.7 cm)
Robert H. Blumenfield Collection (HAR 61516)
Provenance: Oriental Antiques Ltd., London, by 1968; sale, Sotheby's, London, May 9, 1977, lot 167; private English collection, 1977–2014; sale, Bonhams, New York, March 19, 2018, lot 3033; the Robert H. Blumenfield Collection

With his eleven heads and "one thousand" arms, Avalokiteshvara helps countless masses realize their false perceptions and escape the cycle of rebirth. While Avalokiteshvara is central to Tibetan Buddhism, this form of the deity first emerged across East Asia in the seventh century. An inscription along the lotus base tells us that it was "made by the hands of Sonam Gyaltsen," a shift from the anonymity that otherwise characterizes Tibetan production. This artist or head of a workshop must have held great status, as reflected in the execution of this large, exquisite sculpture. The royal donors named in the inscription allow us to date the work, for we know they controlled the area of Gyantse, meaning that this image was created in the same period as the Kumbum (see fig. 4). Hence, this sculpture was done by a prominent artist who would have been aware of, and maybe even involved in, the extensive wall painting of that major devotional structure. KB

35. Thousand-Armed Chenresi, a Cosmic Form of the Bodhisattva Avalokiteshvara

Tibet, 14th century
Distemper and gold on cloth, 28 ¾ × 24 in. (73 × 61 cm)
The Metropolitan Museum of Art, New York, Purchase, Lita Annenberg Hazen Charitable Trust Gift, 1989 (1989.18)
Provenance: A.R.C.O. Antiques Ltd., London, until 1989; sale, purchased by The Met

In this rare early painting of Chenresi, a cosmic form of the bodhisattva Avalokiteshvara, he is represented with eleven heads and one thousand arms that fan out to form a golden aureole. Each of the Buddhist savior's palms has an eye, emblematic of his power to radiate wisdom in every quarter of the universe. He stands elevated on a lotus pedestal and is surrounded by cavelike niches, each occupied by either a lineage lama or a protective deity. At lower left is an offering table with attendant monks. Two inscriptions appear on the reverse: one in Sanskrit (the "Ye dharma" charm-verse) and one in Tibetan that praises one of the perfections, patience, "the most holy ascetic practice." JG

36. The Bodhisattva Vajrapani

Eastern India, Bihar, probably Nalanda monastery, 7th–early 8th century
Sandstone, 30 ⅞ × 23 ¹³⁄₁₆ × 6 in. (78.4 × 60.5 × 15.2 cm)
The Metropolitan Museum of Art, New York, Gift of Florence and Herbert Irving, 2015 (2015.500.4.9)
Provenance: Alice Boney, New York, by 1983; sale, to Florence and Herbert Irving, New York, until 2015; their gift to The Met

The Buddhist savior Vajrapani, the "holder of a thunderbolt (vajra)," shares his origins with the Vedic deity Indra, god of storms. Early in Buddhist iconography, the vajra assumed an independent meaning associated with clarity of pure thought leading to enlightenment. In this early and rare Pala-dynasty representation of Vajrapani, he stands flexed, holding the vajra in his raised hand, the other resting on a dwarf attendant. He has long, unkempt dreadlocks that imply asceticism, evocative of Shiva; the large, asymmetrical ear ornaments further strengthen this association, as does the presence of the gana-type dwarf guardian. A Sanskrit inscription in proto-Bengali script frames the youthful Vajrapani. JG

37. The Bodhisattva Vajrapani

Western Tibet, Guge, early 12th century
Distemper on cotton, 29 ½ × 21 ¼ in. (75 × 54 cm)
Stephen and Sharon Davies Collection
Provenance: International Handicrafts, Zurich, 2006 (Chino Roncoroni); Carlton Rochell LLC, New York, 2007; Stephen and Sharon Davies Collection

Vajrapani, whose name in Sanskrit means "holder of the vajra", is a deity who embodies the very power of enlightenment. He first appeared in the second century as a protector of the Buddha; then, as a bodhisattva; and, ultimately, as the Buddha Vajradhara. Here, the Buddha Akshobhya, who presides over the vajrakula (vajra realm or family), appears above his head, meaning that Vajrapani can be understood as his emanation. Vajrapani, here shown as a protector of the kingdom of Guge, in western Tibet, stands assertively in a posture associated with the tantric deity Achala. The lotus pond below and the overall bold, graphic style relate to north Indian Pala

idioms, while motifs like his spiked crown link this work to late twelfth-century Tibetan wall painting. KB

38. Ashtamahabhaya Tara, Savior from the Eight Perils

Tibet, Reting monastery, late 12th century
Mineral and organic pigments on cloth, 48 × 31 ½ in. (121.9 × 80 cm)
The John and Berthe Ford Collection at the Walters Art Museum, Baltimore (F.112)
Provenance: Eleanor Olsen; purchased by Alice Heeramaneck, New Haven, 1967; purchased by John and Berthe Ford, Baltimore, January 1984

The goddess Tara sits on a lotus throne within a stylized mountain grotto in the magical Khadira grove, as suggested by the foliage across the top of this thangka. With her hand in the boon-bestowing gesture (varada mudra), she offers devotees salvation while protecting them from harm, as indicated by the eight perils, illustrated in episodes to either side of the central figure. The Indian monk Atisha (likely one of the two monks seated above her shoulders) venerated Tara, who appeared in his dreams and encouraged him to travel to Tibet to spread Buddhist teachings. Flanking Tara are protective goddesses, and in the top register are the five celestial Buddhas, or Tathagatas. Typical of Tibetan thangkas, a monk with ritual implements is shown at the base, followed by a row of six-armed protective deities. KB

39. Tara, the Buddhist Savior

Nepal, Kathmandu Valley, Malla period, 14th century
Gilt copper alloy with color, inlaid with semiprecious stones, 23 ¼ × 10 ½ × 5 in. (59.1 × 26.7 × 12.7 cm)
The Metropolitan Museum of Art, New York, Louis V. Bell Fund, 1966 (66.179)
Provenance: William H. Wolff, New York, until 1966; sale, purchased by The Met

The protective goddess Tara holds a flower bud in her lowered right hand and supports with her left shoulder a lotus, in direct reference to the bodhisattva Avalokiteshvara. This particular manifestation of Tara was one of the most important Buddhist deities across the Himalayas, where she is often mentioned in terms of her appearance in dreams. Tara protects devotees from harm and provides them

access to the intellectual dimensions of Buddhist ideology. KB

40. Mahapratisara, the Buddhist Protectress
India, Bihar, Pala period, 10th century
Black stone, 23 × 15 ½ × 7 in. (58.4 × 39.4 × 17.8 cm)
The Metropolitan Museum of Art, New York, Purchase, Florence and Herbert Irving Gift, 1991 (1991.108)
Provenance: sale, Sotheby's, New York, 1991, purchased by The Met

Mahapratisara, a ferocious emanation of the Buddha Ratnasambhava, is one of the five female protectors of Vajrayana Buddhism. She holds an axe, sword, trident, and discus—weapons that cut through illusion to reveal the true nature of the world or, in the case of her noose, to catch ignorant souls. As an expression of power, she holds a *vajra* (lightning bolt) in one of her lowered hands and a palm-leaf manuscript in another, indicating her conceptual embodiment of complex ideologies and, more broadly, of wisdom. Ultimately, this image plays on ideas of dualism: her active role as a protector and bestower of rebirth is juxtaposed with her calm yogic posture, which suggests deep meditation. KB

41. Ushnishavijaya
Central Tibet, ca. 1300
Distemper on silk, 9 × 7 in. (22.9 × 17.8 cm)
The Kronos Collections
Provenance: purchased from Great Here Ltd., 1990

This representation of Ushnishavijaya is a rare example of a consecrated underdrawing enhanced with red wash. Commissioned to bestow longevity, images of Ushnishavijaya typically depict her with eight arms and three heads. Here, the goddess is ensconced within the drum and dome of a stupa, a structure central to her conception and ceremonial invocation. Another standard attribute is the tiny image of the cosmic Buddha Amitabha supported by a lotus in her upper right hand. Also venerated for longevity, Amitabha is associated with the blissful realm of Sukhavati, reminding patrons that supplicating Ushnishavijaya may help them attain salvation. RLB

42. Skeleton Mask (*Chitipati*)
Bhutan, 20th century
Papier-mâché, 12 ½ × 9 × 6 ⅜ in. (31.8 × 22.9 × 16.2 cm)
Rubin Museum of Art, New York (C2002.5.3)
Provenance: Pace Primitive, New York, 2001; the Shelley and Donald Rubin Cultural Trust (Rubin Museum of Art)

This *chitipati* mask was worn, together with the skeleton dance costume, and usually by a monk, in *cham* dance performances (see pl. 43, below). Fundamentally, the skeleton iconography speaks to the transient nature of life, the cycle of rebirth, and the need to actively pursue enlightenment while there is still time to do so. For the lay community, it was auspicious to see these performances, one of the few times when Vajrayana ritual entered the public sphere. KB

43. Skeleton Dance Costume
Tibet, late 19th or early 20th century
Silk and flannel, 70 × 60 in. (177.8 × 152.4 cm)
The Metropolitan Museum of Art, New York, Gift of Mrs. Edward A. Nis, 1934 (34.80.3a–h)
Provenance: Mrs. Edward A. Nis, New York, until 1934; her gift to The Met

Skeleton dances are performances that evoke the impermanence of life and, by extension, of all things—a central tenet of Buddhism. In Tibet, these dances might be performed publicly to remind the populace of such transience. Alternatively, a monk seeking a deeper understanding of this truth might leave his monastery to meditate in the charnel grounds, a place where the dead were left to decompose. Upon his departure, a skeleton dance was performed in a secretive monastic context, to prepare him for his journey. Whether public or private, these performances were heightened by dramatic costumes such as this one, with white bones set dramatically against red fabric, symbolizing flesh. KB

44. Stag Mask
Tibet, late 19th–early 20th century
Papier-mâché, polychrome, gilding, leather, and silk, 14 × 15 ¼ in. (35.6 × 38.7 cm)
The Metropolitan Museum of Art, New York, Gift of Mrs. Edward Nis, 1934 (34.80.3i)
Provenance: Mrs. Edward A. Nis, New York, until 1934; her gift to The Met

Dances accompanied by music have always been an important part of Tibetan Buddhist ritual. Stag dances are especially popular during the end-of-year Gu Tor Festival. These performances, dedicated to fierce deities, siphon malignant forces into a *torma* (a sculpted offering made of butter and flour). A monk dressed as a stag cuts the *torma* offerings into pieces, scattering them as he dances to rid the community of negative forces. Because these dances are attended by large audiences, stag costumes are deliberately dramatic, allowing them to be seen from afar. The large eyes and antlers give the dancer greater stature. KB

45. Monastic Dance Robe
China, Qing dynasty (1644–1911), early 19th century
Plain-weave silk brocaded with silk and metallic thread, overall: 60 ¼ × 66 in. (153 × 167.6 cm)
The Metropolitan Museum of Art, New York, Gift of Mrs. Edward A. Nis, 1934 (34.80.1)
Provenance: Mrs. Edward A. Nis, New York, until 1934; her gift to The Met

Ritual dances (*cham*) are performed in Tibet for both lay and monastic communities to banish evil forces and bring prosperity. In Qing-dynasty China, with the support of the Manchu rulers, *cham* took place regularly in the Forbidden City and at Buddhist sites such as Wutaishan. A robe such as this one would have been worn by a *cham* dancer, usually paired with a stag mask. Made of Chinese silk, it is tailored in Tibetan style. Its front opening and back, with a dragon cavorting among clouds and waves, are sewn from a blue brocade. Its triangular sleeves, pleated skirt, and striping are assembled with brocade woven with auspicious emblems, such as lotuses, peaches, and coins that bear Chinese characters reading "peace under heaven." Lavish Chinese textiles were common donations to Tibetan Buddhist monasteries. CM

46. Frame Drum (*Rnga* or *Lag-rnga*)
Tibet, 18th century
Wood, paint, lacquer, and hide, drum: 53 ¾ × 24 ⅛ × 8 ½ in. (136.5 × 61.3 × 21.6 cm); beater: 21 ½ × 1 × 7 in. (54.6 × 2.5 × 17.8 cm)
The Metropolitan Museum of Art, New York,

Purchase, Gift of Herbert J. Harris, by exchange, 1997 (1997.365a, b)

This double-headed drum, played with a crooked beater and supported by a handle, is part of the temple orchestra that accompanies Buddhist ceremonies and processions, ritual dances, and theater. During chants, the drum may simply accompany, or it may add contrast by joining with other instruments in an interlude that punctuates the recitation. The handle, carved with lotus and lozenge motifs, is usually held in the left hand but may be inserted into a stand during long ceremonies. A suspension ring located at the top of the drum provides the option of hanging it for storage. BSS

47. Lute (*Sgra-snyan*)
Tibet, late 19th century
Wood, hide, wire, and polychrome, 9 ½ × 3 ⁵⁄₁₆ × 31 in. (24.1 × 8.4 × 78.7 cm)
The Metropolitan Museum of Art, New York, Purchase, Gift of Robert Alonzo Lehman, by exchange, and Gift of Mr. and Mrs. Gregory Mandeville, by exchange, 2001 (2001.391)

The *sgra-snyan* is a folk lute of the Himalayas found throughout Tibet and Bhutan. It features in Drukpa Buddhist culture and is often played during religious festivals, as well as in accompaniment to folk stories and dancing. Painted lotus flowers and a soundhole carved in the form of an endless knot decorate this example. Both motifs number among the eight auspicious emblems of Buddhism. BSS

48. Trumpet (*Dung chen*)
Tibet, late 18th–early 19th century
Metal, L. 68 in. (172.7 cm)
The Metropolitan Museum of Art, New York, The Crosby Brown Collection of Musical Instruments, 1889 (89.4.2563)

Dung chen, perhaps the most visually striking instruments associated with Buddhism, are found throughout Tibetan cultural areas. They are played by monks during preludes, processions, and calls to prayer, which are often sounded from monastery rooftops. Usually heard in pairs or ensembles, *dung chen* are played on their own or in alternation with *rgya-glings* (shawms). Each trumpet produces only two or three notes, but performers achieve tonal variety by wavering the pitch, fluc-

tuating volume and intensity, and through different ways of starting and finishing the note. Their collapsible, telescopic design makes these large trumpets easy to transport. BSS

49. Pair of Trumpets (*Rkangling*)
Tibet, 19th century
Copper, brass, glass, turquoise, and coral, each: L. 17 ⅛ in. (43.3 cm)
The Metropolitan Museum of Art, New York, Rogers Fund, 1908 (08.184.24, .25)

The *rkangling* is a short trumpet typically played in pairs, like other wind instruments in the Tibetan monastery band. They are used to signal the entry of dancers and often feature in rites connected with fierce deities. As can be seen on these examples, a *chu-srin* or *makara*, a mythical aquatic monster associated with water and rain, often adorns the bell of *rkangling*. While now most commonly made of metal, as here, *rkangling* were once fashioned from human leg bones. These bone instruments were often portrayed in sacred paintings and are used in the Tibetan Buddhist practice of *chöd* (cutting). BSS

50. Vaishravana, the Guardian of Buddhism and Protector of Riches
Tibet, 15th century
Distemper on cloth, 32 × 29 ⅛ in. (81.3 × 73.9 cm)
The Metropolitan Museum of Art, New York, Purchase, Gift of Florence and Herbert Irving, by exchange, 2021 (2021.290)
Provenance: Giuseppe Tucci, Rome, acquired ca. 1928–48 in Tibet; Wildenstein Gallery, New York, 1955; sale, to Nasli and Alice Heeramaneck, New York, until 1974; sale, to Christian Humann (Pan-Asian Collection), New York, until 1982; sale, to R. H. Ellsworth Ltd., New York, until 1993; sale, to a private collection, London, until 2021; sale, to Carlton Rochell LLC, New York; sale, purchased by The Met

Vaishravana is a complex deity who embodies many strands of Buddhist thought and belief. Tibetans understand him foremost as the premier guardian of the cardinal directions (*lokapalas*) and associate him with the north. In this role he serves as a protector (*dharmapala*) of Buddhist law. Here, he sits on his snow-

lion mount in a stormy sky, accompanied by his generals, the eight lords of the horses (*ashvapati*). Dressed as a warrior-king in full armor, he wears high boots, which point to his Central Asian connections. Vaishravana is principally represented in Tibet in mural programs, such as those preserved at Shalu and Gyantse monasteries from the fourteenth and fifteenth centuries. Versions on cloth of this scale and pictorial sophistication are extremely rare. JG

51. Mahakala
India, Bihar, Pala period, 11th–12th century
Black stone, 23 ⅛ × 11 ¾ × 5 in. (58.7 × 29.8 × 12.7 cm)
The Metropolitan Museum of Art, New York, Gift of Samuel Eilenberg, in memory of Anthony Gardner, 1996 (1996.465)
Provenance: Samuel Eilenberg, New York, until 1996; his gift to The Met

Here, the fierce protector deity Mahakala holds, in his upper hands, a sword and a *vajra*-tipped staff and, somewhat more terrifyingly, a skull cup full of blood in his lower left hand. His lower right hand, now severed, likely held a flaying knife. Mahakala's terrible nature was actually reassuring to the faithful, as he was understood to destroy evil and corruption. A fierce manifestation of the compassionate bodhisattva Avalokiteshvara, Mahakala is responsible above all with guarding the dharma, or Buddhist teachings. KB

52. Mahakala
Tibet, 14th century
Mineral pigments on cotton, 25 × 20 in. (63.5 × 50.8 cm)
Michael J. and Beata McCormick Collection
Provenance: purchased from Art Orient Company, Hong Kong, 1999

A favorite protector of Buddhist monasteries and teachings in Tibet, Mahakala is here represented with sublime intensity. He wears a splendid tiger-skin skirt, brandishes a sword and *khatvanga* staff in his upper two arms, and holds a flaying knife and a skull cup in his bottom two. Stylistic features of the painting such as the lotus pedestal's rinceaux, the translucent polychrome rock motifs beneath them, the lama portraits in the upper register, and the studded flaming nimbi surrounding

deities recall the painting traditions of the Taklung lineage of the Kagyu Tibetan Buddhist order. On the painting's verso Tibetan inscriptions glorifying Mahakala are arranged within the golden outline of a stupa. RLB

53. Mahakala, Protector of the Tent

Central Tibet, ca. 1500
Distemper on cloth, 64 × 53 in. (162.6 × 134.6 cm)
The Metropolitan Museum of Art, New York, Zimmerman Family Collection, Gift of the Zimmerman Family, 2012 (2012.444.4)
Provenance: private collection, England, early 1960s–ca. 1980; sale, to Zimmerman Family Collection, New York, until 2012; their gift to The Met

Mahakala is a fierce form of the bodhisattva Avalokiteshvara and one of the most popular guardians in the Tibetan Buddhist pantheon. Here, he tramples a corpse while wielding a flaying knife and a blood-filled skull cup, signifying the destruction of impediments to enlightenment. In the crooks of his elbows, he supports a gong (*gandi*), used to summon monks to assemblies and a symbol of his vow to protect their community (*sangha*). His principal companions, Palden Remati and Palden Lhamo, appear to his left; Legden Nagpo and Bhutadamara, to his right. At lower left is Brahmarupa blowing a thighbone trumpet. The presence of *mahasiddha*s and Sakya lineage teachers makes clear that this *thangka* was commissioned for a monastery of the Sakya order. It relates closely to murals in the fifteenth-century Kumbum mandala-stupa at Gyantse monastery, in central Tibet, likely painted under Newari direction. JG

54. Rahula

Tibet, 15th century
Gilt copper alloy with turquoise and coral, 12 ⅜ × 6 × 10 in. (31.4 × 15.2 × 25.4 cm)
Rubin Museum of Art, New York (C2003.7.2)
Provenance: sale, Christie's, New York, March 27, 2003, lot 91, purchased through Navin Kumar, Inc., for the Shelley and Donald Rubin Cultural Trust (Rubin Museum of Art)

Rahula is a fearsome god in Tibetan cosmology. Like his Indian antecedent, Rahu, he causes eclipses by devouring the sun and moon. In this evocative bronze,

the meticulously rendered scales and eyes of Rahula's ophidian bottom half conflate iconographic features of the Indic deities Indra, whose body is covered with a thousand eyes, and Ketu, the comet divinity endowed with a serpent's tail. The menacing face in Rahula's second tier of heads indicates his malevolent aspect. Just above is his distinguishing raven's head and a miniature bodhisattva Vajrapani, who, according to one myth, becomes a bird to restrain Rahula. Vajrapani's ability to control his ruthlessness for beneficent purposes may explain Rahula's role as a protector favored by the Nyingma order of Tibetan Buddhism. RLB

55. Chest with Scenes of Tantric Offerings

Tibet, late 19th century
Polychrome wood with iron brackets, 30 × 51 ½ × 24 ⅜ in. (76.2 × 130.8 × 61.9 cm)
The Metropolitan Museum of Art, New York, Gift of Steven M. Kossak, The Kronos Collections, in celebration of the Museum's 150th Anniversary, 2022 (2022.431.1)
Provenance: Gérard Labre, probably by 2002; Steven M. Kossak, New York, 2004–22; his gift to The Met

This chest likely doubled as an altar, placed before a wrathful deity in a protective shrine (*gonkhang*). Ceremonial utensils, stored inside the chest when not in use, were laid out on the lid during rituals. Set within a sea of blood, the scene on the chest features some demons bearing gory offerings and others dismembering the dead, while dogs and vultures tear at the corpses. Attended by a tiger, a camel, elephants, and mules, the demons approach the central offering: a large decaying head. The head supports objects related to the five senses (equated with the five desires)—eyes for sight, a *damaru* drum for sound, a nose for smell, a tongue for taste, and a heart for touch. KB

56. Yama Dharmaraja

Mongolia, 18th–19th century
Wood, metal, and pigments, H. approx. 10 in. (25.4 cm)
The Kronos Collections
Provenance: purchased from Great Here Ltd., 1990

Terrifying in appearance, Yama Dharmaraja conquers death and offers devotees an escape from the cycle of rebirth. He is considered the inner protector of the Vajrabhairava tantras, which are especially important for the Gelug sect that flourished in Mongolia. This polychromed sculpture triumphantly captures Yama Dharmaraja's ferocity; like Mahakala, he holds a skull cup and *vajra*-tipped chopper while trampling a prone demoness under the weight of his corpulent body. The distinctive rendering of his armbands, skull coronet, tiger hide, and the garland of individuated severed heads that hangs below his belly typifies the later Buddhist sculptural traditions of Mongolia. RLB

57. Palden Lhamo

Tibet, 15th century
Mineral pigments on cotton, 45 × 30 in. (114.3 × 76.2 cm)
Michael J. and Beata McCormick Collection
Provenance: purchased from Rossi & Rossi Ltd., London, October 1, 2002

Palden Lhamo, which in Tibetan translates to "glorious goddess," is a fierce defender of Buddhism in Tibet. Here, her blue complexion contrasts strikingly with her fiery aureole, to dramatic effect. She traverses a roiling sea of blood upon a mule, using her son's flayed skin as a saddle blanket. Instruments of her power, attached at the mule's neck, include white dice for cleromancy and a bag of maladies fastened by a serpent harness, which she employs to effectuate divine will. Palden Lhamo's function as guardian of Tibet is supplemented by her more specific role as the tutelary goddess of Lhasa and the Dalai Lama, the spiritual head of the Gelug sect of Tibetan Buddhism. Lamas of this sect, identifiable by their distinctive pointed yellow hats, assume hieratic positions among monastic acolytes in the clouds above the goddess. RLB

58. Brahmarupa Mahakala

Tibet, 17th century
Brass, 6 ⅝ × 4 ¾ × 3 ⅜ in. (16.8 × 12.1 × 8.6 cm)
The Metropolitan Museum of Art, New York, Purchase, Friends of Asian Art Gifts, 2007 (2007.1)
Provenance: Carlton Rochell LLC, New York, until 2007; sale, purchased by The Met

Brahmarupa Mahakala, a wrathful protector of the dharma (Buddhist teachings), is seen here sitting on a corpse. As befitting his fearsome mien, he wears a bone apron and holds a thighbone trumpet and a skull cup. In this respect, he looks like one of the many itinerant Buddhist practitioners of the Tibetan Plateau who brought Buddhist teachings to nomadic communities, conducted rituals, and went on pilgrimages. Brahmarupa is credited with introducing the *Hevajra Tantra*, an important Vajrayana text of the Sakya school. KB

59. *Phurba* Emanation of Padmasambhava

Tibet, ca. 17th century
Polychromed wood, H. 6 in. (15.2 cm)
The Kronos Collections
Provenance: purchased from Arnold Lieberman, 1990

Padmasambhava, the Indian tantric master credited with transmitting Buddhism to Tibet in the eighth century, here assumes the form of a deified *phurba*, a ritual dagger utilized in tantric rites to subdue baleful forces. Certain exorcistic rituals entail binding antagonistic spirits to a triangular iron platform via mantra recitation and piercing them with the three-sided blade of a *phurba*, as depicted in this sculpture, just underneath Padmasambhava. His menacing countenance and the scorpion he holds in his left hand are consistent with his protective Guru Dragpo manifestation, which was invoked by the Nyingma sect of Tibetan Buddhism that regards Padmasambhava as their founder. RLB

60. Base from a Purification Brazier

Tibet, probably Derge, 15th–17th century
Iron inlaid with gold and silver, H. 3 5/16 in. (8.4 cm); W. 4 9/16 in. (11.6 cm); Diam. 4 3/4 in. (12.1 cm)
The Metropolitan Museum of Art, New York, Gift of Shirley Day, in memory of Anthony Gardner, 1992 (1992.257.2)
Provenance: Shirley Day, New York, until 1992; her gift to The Met

This brazier was used for burning sacrificial offerings during purification rites. The circle-on-a-square configuration is echoed in the fire-offering ladles, which form part of sets of such ritual utensils. The base

and drum display a meandering lotus-flower decoration; the drum features four cast flaying knives with gilt *vajra* handles guarding the four directions. A band of gold- and silver-damascened *vajras* decorates the exterior rim and repeats on the interior. At the heart of the brazier's bowl is an engraved lotus. JG

61. *Vajra* with Angry Heads and *Makara* Prongs

China, Tang dynasty (618–907)
Gilt bronze, 1 1/4 × 1 3/4 × 8 1/2 in. (3.2 × 4.4 × 21.6 cm)
The Metropolitan Museum of Art, New York, Charlotte C. and John C. Weber Collection, Gift of Charlotte C. and John C. Weber, 1994 (1994.605.43)
Provenance: Charlotte C. and John C. Weber, New York, until 1994; their gift to The Met

Symbolizing the energy associated with enlightenment, the *vajra* is often described as a bolt of lightning with the indestructible, luminescent quality of a diamond. *Vajras* like this example are used in esoteric Buddhist rituals in conjunction with mantras and hand gestures. At each end, the four prongs, representing the cardinal directions, surround a central spike marking the cosmic axis of the universe. KB

62. Ritual Staff (*Khatvanga*)

China, Ming dynasty (1368–1644), Yongle mark and period (1403–24)
Iron damascened with gold and silver, 17 × 3 × 3 in. (43.2 × 7.6 × 7.6 cm)
The Metropolitan Museum of Art, New York, Gift of Florence and Herbert Irving, 2015 (2015.500.6.28)
Provenance: Susan B. Levinson & Donald J. Wineman Fine Asian Antiques and Antiquities, New York, until 1987; sale, to Florence and Herbert Irving, New York, until 2015; their gift to The Met

The *khatvanga*, or ritual staff, is an important tool in Tibetan tantric Buddhism. Its origins lie in India, where the Hindu god Shiva Bhairava is frequently portrayed brandishing a skull-capped staff. This *khatvanga* would have been used in Vajrayana ritual, probably by a learned monk who practiced at the Chinese court during the Yongle era. This imperial connection explains the presence of lavish, elaborate metalwork. KB

63. *Vajra* Flaying Knife

Eastern Tibet, Derge, ca. 15th century
Steel inlaid with gold and silver, L. 22 11/16 in. (57.7 cm)
The Metropolitan Museum of Art, New York, Gift of Alexander Polsky, 1985 (1985.397)
Provenance: Alexander Polsky, New York, until 1985; his gift to The Met

This ritual knife is styled in the Indian manner—that is, with a long, hooked blade for butchering and flaying. The handle takes the form of a *vajra* (thunderbolt) that metamorphoses into a wide-jawed aquatic monster (*makara*), from which the steel blade emerges. Workshops in the eastern Tibetan region of Derge, in Kham province, excelled in such fine chiseled and damascened metalworking techniques and may be responsible for this elaborate knife. KB

64. Skull Cup (*Kapala*)

Tibet, 19th century
Stone, 2 7/8 × 4 3/4 × 5 3/4 in. (7.3 × 12.1 × 14.6 cm)
The Kronos Collections
Provenance: purchased from John Eskenazi Ltd., 1995

Skull cups, or *kapala*, were among the basic ritual paraphernalia employed by Buddhist *yogins* and itinerant ascetics, and they played an important role in monastic practice as well. Such implements also appear as motifs in paintings and as offerings presented to fierce deities. True to their name, skull cups originally were cut from skeletons of the deceased. This example, though made of stone rather than human bone, still speaks to the visceral power inherent in these objects and their ability to evoke the transience of earthly existence. KB

65. Pair of Butter Lamps

Central Tibet, 19th century
Gilt silver with repoussé and engraving, each: H. 12 1/2 in. (31.8 cm)
The Metropolitan Museum of Art, New York, Purchase, funds from various donors, by exchange, and bequest of Mary Strong Shattuck, by exchange, 2019 (2019.303.1a–c, .2a–c)
Provenance: sale, Christie's, New York, September 12–19, 2019, lot 42, purchased by The Met

This pair of votive lamps would have stood before a sculpture or painting, ready to receive offerings of butter from devotees.

The dancing goddesses set within lobed frames, some of whom play instruments, reference the celestial realms. Additional auspicious Buddhist symbols (*mangala*) are set into frames at the neck and foot of each lamp. The engraved floral pattern that fills the background spaces elicits abundance and prosperity. The style of the repoussé (hammered metalwork) and engraving is typical of central Tibet. KB

66. Leather Helmet with Auspicious Symbols

Tibet, 15th–17th century
Leather, gold, shellac, and pigments, H. 6 ¼ in. (15.9 cm); Diam. 8 ⅞ in. (22.5 cm)
The Metropolitan Museum of Art, New York, Purchase, Bequest of George Blumenthal and Bashford Dean Memorial Collection, funds from various donors, by exchange; Steve and Madeline Condella Gift; and Rogers Fund, 1998 (1998.1)

One of the few surviving examples of its kind, this helmet, made of two halves of molded leather, imitates an iconic form of Tibetan helmet comprising eight overlapping iron plates joined by leather laces. Its red surface is decorated with *vajra*s and sixteen seed syllables forming the repeating mantra "Om ah hum." Red leather armor is an attribute of several deities, including the *dharmapala* Chos skyong bse khrab pa, whose name literally means "leather-armored dharma protector." While its *vajra*s and mantra imbue this helmet with potent spiritual protection, it is also a practical piece of defensive equipment. The use of hardened-leather armor is documented in regions that were culturally Tibetan for at least one thousand years, from the eighth or ninth century into the nineteenth. DLR

67. Shield (*Phub*)

Tibet, ca. 14th–16th century
Cane, iron, and brass, Diam. 29 ⅞ in. (75.9 cm)
The Metropolitan Museum of Art, New York, Purchase, Arthur Ochs Sulzberger Gift, 2001 (2001.55)
Provenance: art market, London, until 2001; sale, purchased by The Met

This shield belongs to a rare group, examples of which have been recorded at Tsaparang, at one time the capital of the kingdom of Guge, in western Tibet,

and as a votive offering in the *gonkhang* of Phyang monastery, in the adjacent Ladakh region of India. Domed cane or wicker shields were common in China and Tibet, but this type of flat cane shield with iron struts is known only from works of art and a few extant examples, all of which appear to be connected to western Tibet and nearby areas that were conquered by Ladakh in the seventeenth century. The iron fittings are extremely similar to the iron mounts on other Tibetan objects, specifically leather armguards, horse shaffrons (head defenses), and furniture such as chests and boxes. DLR

68. Lamellar Armor (*Byang bu'i khrab*)

Tibet, ca. 16th–17th century
Iron and leather, H. 38 in. (96.5 cm); W. 29 in. (73.7 cm)
The Metropolitan Museum of Art, New York, Purchase, Arthur Ochs Sulzberger Gift, 2001 (2001.318)

Featured prominently in imagery of dharma protectors and legendary heroes, and often included among votive offerings to wrathful deities, Tibetan lamellar armor has several distinct features. The body forms a sleeveless robe made from twelve or more rows of iron lamellae joined by an intricate pattern of leather laces. Its distinct waist results from the lamellae of that row being bent in a subtle curve. Some armors have shoulder defenses, and a few have full sleeves. The coat opens down the front, and the back of the skirt is split vertically by a seam at either side. Sometimes trimmed with silk brocade, the majority have a simple border at the base of the skirt consisting of narrow flaps of thick leather. DLR

69. Quiver

Tibet or Mongolia, 14th–16th century
Leather, shellac, and pigment, 31 ¼ × 8 ¾ in. (80.6 × 22.2 cm)
The Metropolitan Museum of Art, New York, Purchase, Arthur Ochs Sulzberger Bequest, and Rogers Fund, by exchange, 2014 (2014.71)
Provenance: art market, by 2013–14; sale, purchased by The Met

Made to hold arrows, a quiver was suspended from the right side of an archer's belt and usually balanced by a matching bow case on the left. Sets of bow cases

and quivers were practical accessories for the style of horseback archery practiced in Tibet, Mongolia, and Central Asia. All-leather quivers in this form from such an early date are extremely rare. Typically, they are embellished with a background of dense repeating patterns surrounding large designs in cartouches. This example, however, is decorated in a bold, painterly style with the eight auspicious symbols of Buddhism: a parasol, a pair of golden fishes, a treasure vase, a lotus, a right-turning conch shell, an endless knot, a victory banner, and the wheel of the dharma. DLR

70. Sword (*Ral gri*)

Tibet or China, 14th–16th century
Iron, steel, gold, and silver, overall: L. 34 ⅞ in. (88.6 cm); W. 3 ⅞ in. (9.8 cm)
The Metropolitan Museum of Art, New York, Purchase, Rogers Fund and Fletcher Fund, by exchange, 1995 (1995.136)
Provenance: art market, Europe, until 1995; sale, purchased by The Met

This exceptional weapon belongs to a rare group of early straight-bladed, double-edged swords from Tibet. The hilt is made entirely of iron that has been chiseled and damascened in gold and silver. The guard is in the form of a stylized mask with teeth and fangs, evoking a protector or guardian deity. The pommel features an auspicious *kirtimukha* mask, a popular secular and religious ornament throughout Tibet, India, and Southeast Asia. The workmanship and details of the decoration, particularly the fine damascening in silver wire, echo styles found on imperial ironwork, particularly Buddhist ritual objects made during the Hongwu and Yongle eras, including ritual staffs (*khatvanga*), flaying knives, choppers, and bells. DLR

71. Sword Guard

Tibet or China, 14th–15th century
Iron, gold, silver, and copper, 3 ¼ × 4 ¾ in. (8.3 × 12.1 cm)
The Metropolitan Museum of Art, New York, Gift of Steven M. Kossak, The Kronos Collections, 2014 (2014.533)
Provenance: Rossi & Rossi Ltd., London, until 1994; sale, to Steven M. Kossak, New York, until 2014; his gift to The Met

Featuring a fierce expression accentuated by bared teeth, fangs, and fiery eyebrows flanking a third eye, this extremely rare sword guard depicts a *dharmapala*, or wrathful guardian deity. It was originally the centerpiece of a high-quality sword, to be mounted between the hilt and the blade. It exemplifies the peak of Tibetan and Sino-Tibetan ironwork, coinciding with the rule of the Phagmodrupa kings in central Tibet and the Hongwu and Yongle periods in China. It is exceptional for the precision of its chiseling, punchwork, and damascening, all further animated by the height of its raised decoration. The excellence of its design and execution makes this sword guard one the finest existing examples of secular Tibetan ironwork. DLR

72. Hilt of a Ritual or Votive Sword

Tibet, possibly 15th–16th century
Copper alloy and gold, L. 8 ½ in. (21.6 cm)
The Metropolitan Museum of Art, New York, Purchase, Richard Gradkowski Gift, 2016 (2016.702)
Provenance: Peter Finer, Warwickshire, England (said to have previously been in a private collection, France), until 2016; sale, purchased by The Met

Designed for a ritual or votive sword, this hilt is remarkable in both its proportions and iconography. The *kirtimukha* mask at the bottom is a typical motif made highly unusual by being rendered fully in the round. Possibly unique in terms of sword ornament are the engraved images known as wet skulls (*thod rlon*) and dry skulls (*thod skam*), associated with wrathful guardian deities. The large human head surrounded by swirls on both sides of the grip represents a wet skull (still having flesh and hair) and entrails, while the pommel is engraved on both sides with dry skulls flanked by scrolls. A resinous material filling many of the lines and recesses may be the remains of substances applied to the hilt during ritual or ceremonial practices. DLR

73. Crowned Buddha Shakyamuni

India, Bihar or West Bengal, 11th century
Schist, 27 ¾ × 16 ¼ × 6 ½ in. (70.5 × 41.3 × 16.5 cm)
Asia Society, New York, Mr. and Mrs. John D. Rockefeller 3rd Collection (1979.36)

Provenance: sale, Christie, Manson & Woods, Ltd., London, July 2, 1962, lot 158, to John D. Rockefeller 3rd, New York; his bequest to the Asia Society, 1979

This lithely carved image represents the historical Buddha Shakyamuni in earth-touching gesture, invoking the moment of his enlightenment to which the earth bears witness. Despite renouncing his royal life, he is shown crowned and bejeweled. In the Mahayana tradition, such imagery signifies the Buddha's status as universal sovereign and denotes his *sambhogakaya* (enjoyment body). The plinth is inscribed with the "Ye dharma" stanza, a statement of Buddhist teachings uttered by Ashvajit, one of the Buddha's five disciples present at the first sermon he delivered after enlightenment. Subsequently used in consecration rites, the verse was transliterated into different languages and incorporated onto innumerable Buddhist stupas, images, stamps, and manuscripts. RLB

74. Mahasiddha Virupa

Central Tibet, second quarter 13th century
Distemper and gold on cloth, 22 × 19 ⅝ in. (55.9 × 49.9 cm)
The Kronos Collections
Provenance: private collection, Switzerland; purchased from Köller, Zurich, 1992

This painting illustrates a famous tale wherein Virupa, one of eighty-four *mahasiddhas* (great adepts), insatiably consumes alcohol at a tavern. Rather than settle his tab by the stipulated time, Virupa deploys tantric powers to halt the sun in its path, continuing to imbibe until the local ruler pays his bill. Here, Virupa's left hand touches the gold-ringed disk of the sun, while drinking vessels are displayed to his left. This *thangka* is remarkable for its inclusion of eighty-two vignettes depicting additional *mahasiddhas*, who are referenced along with Virupa in a consecratory Tibetan inscription on the verso (Casey 1994, p. 119). Pronounced Newari elements include the red-and-blue checkered background, the polychrome outcrops rendered as blocks and staves, and the textured foliation of the red space behind the central figures. RLB

75. Mahasiddhas Virupa and Krishnapa

Tibet, 1429–56
Distemper on cloth, 34 × 31 ½ in. (86.4 × 80 cm)
Mr. and Mrs. Gilbert H. Kinney Collection
Provenance: purchased from Köller, Zurich, 1993

The Indian *mahasiddhas* Virupa (left) and Krishnapa (right) are regarded as progenitors of the prominent Sakya school, which espoused the *lamdre* ("path and fruit") tantric method for spiritual attainment. Central to this sect's teachings is meditation on the tantric deity Hevajra, who appears here in his sixteen-armed form embracing his companion Nairatmya above Virupa and Krishnapa. Bordering roundels contain additional *mahasiddhas* and tantric deities. This painting is part of a set depicting gurus from the Sakya *lamdre* lineage that was commissioned by Ngorchen (1382–1456), who founded a monastery in 1429 near the city of Shigatse (Jackson 2010, pp. 184–85). RLB

76. Mahasiddha Virupa

Tibet, 18th century
Appliqué silk damask and velvets with cording and embroidery, 50 ⅝ × 38 ⅞ in. (128.6 × 98.7 cm)
The Newark Museum of Art, Purchase, Wallace M. Scudder Bequest Fund and The Members' Fund, 1976 (76.188)
Provenance: purchased from Gerald Pine, Oriental Art, 1976

Mahasiddhas like Virupa were Indian yogic practitioners who performed miraculous feats and participated in nonconformist behavior. Virupa's own transgressive nature is encapsulated in this arresting portrait by two extremes. On the one hand, his enormous paunch implies intemperance; on the other, the spotted deerskin, yoga strap, and ritual bone apron signal austerity. The book bound in his hair evokes his role in the protection and transmission of esoteric teachings. This appliquéd and embroidered textile was manufactured in Tibet with Chinese fabrics, as evidenced by the designs and Chinese characters on Virupa's seat cushion. The large banner was probably displayed during public festivals. RLB

77. Mahasiddha Jnanatapa
Eastern Tibet, Riwoche monastery, ca. 1350
Distemper on cloth, 27 × 21 ½ in. (68.6 × 54.6 cm)
The Metropolitan Museum of Art, New York, Purchase, Friends of Asian Art Gifts, 1987 (1987.144)
Provenance: Arnold H. Lieberman, New York, by 1987; sale, purchased by The Met

This portrait was created for Riwoche monastery, in eastern Tibet, a branch of Taklung monastery. Although the central figure and the assembled abbots are not named, two inscriptions allow a lineage identification: on the painting's veil, the epithet Jnanatapa ("heat of wisdom") denotes a famous Indian *mahasiddha* (one of the spiritual fathers of tantric Buddhism), and above the central figure, the presiding deity is named as Avagarbha. Both clues appear in the official history of Taklung monastery, which tells that the first abbot of Riwoche was an incarnation of "the peerless *mahasiddha* Jnanatapa" and that his teacher was Avagarbha, a Bengal *siddha*, thus invoking the spiritual lineage of the two monasteries. JG

78. Mahasiddha Padampa Sangye
Tibet, 14th century
Distemper on cotton, 14 × 11 ¼ in. (35.5 × 28.5 cm)
Somylo Family Collection
Provenance: Axel Ball, Majorca, Spain; European private collection; Carlton Rochell LLC, New York; Carlo Cristi, Milan; Somylo Family Collection, since 2010

Padampa Sangye (d. 1117) was a tantric adept whose south Indian origins are reflected in his dark complexion. He visited and taught in Tibet multiple times, primarily in the Tingri region, and traveled as far east as Wutaishan, China. This painting shows him naked but for a wool blanket wrapped around his legs. He uses an animal hide as a mat and holds a bone trumpet and a *vajra*. The palette and configuration of this artwork and its pendant portraying Padampa Sangye's famous female pupil Machik Labdrön are indebted to Nepalese traditions (Heller 1999, p. 86), which constituted a salient stylistic source for Tibetan *thangka*s in the thirteenth to sixteenth century. RLB

79. Mahasiddha Kirapalapa
Nepal, Kathmandu Valley, ca. 14th century
Terracotta, 11 ⁷⁄₁₆ × 7 ⅞ × 3 ¼ in. (29.1 × 20 × 8.3 cm)
The Metropolitan Museum of Art, New York, Purchase, Seymour Fund, and Bernice Richard and Anonymous Gifts, 1983 (1983.503)
Provenance: Moonsail Ltd., Vezia, Switzerland, until 1983; sale, purchased by The Met

Operating outside monastic precincts, *mahasiddha*s were advanced tantric practitioners whose ranks were filled by all walks of society. The warrior-king Kirapalapa was one such individual, shown here holding a sword and a shield. Though he dons fine garments and jewels, he is portrayed in the wilderness under a tree, in the manner of an ascetic. Renouncing violence and his royal lifestyle, Kirapalapa was initiated to the deity Chakrasamvara and, after twelve years of meditation under his yogi's guidance, achieved a *siddhi* (attainment or knowledge). *Mahasiddha*s were revered by both lay and monastic devotees, exemplifying the possibility of mastering tantric knowledge in a single lifetime. KB

80. Hevajra and Nairatmya
Tibet, late 12th century
Brass with silver and pigment, 12 ½ × 9 ¼ × 2 ¾ in. (31.8 × 23.5 × 7 cm)
The Metropolitan Museum of Art, New York, Promised Gift of Mr. and Mrs. Richard L. Chilton Jr., in celebration of the Museum's 150th Anniversary (L.2020.3)
Provenance: Zimmerman Family Collection, New York, until 2017; sale, to Mr. and Mrs. Richard L. Chilton Jr., New York, 2017

This sculpture is an early and rare Tibetan representation of the esoteric Buddhist deity Hevajra, who was well known from eastern Indian medieval Tantrism and preserved in Tibetan Vajrayana practice. It was produced during the second wave of Buddhism in Tibet, which was propagated in part by the renowned Bengali monk Atisha, a trained master of the *Hevajra Tantra* who had studied at both Rajgir and Vikramashila monasteries in Bihar before being invited to teach in Tibet in the second quarter of the eleventh century. This sculpture dates to the end of the twelfth century, an emerging moment for Tibetan devotional art coinciding with the

historical collapse of monastic Buddhism in India. JG

81. Hevajra with the Footprints of the Kagyu Patriarch Tashipel
Tibet, Taklung, 1180–1210
Mineral pigments and gold on silk and cotton, 25 × 18 ½ in. (63.5 × 47 cm)
Michael J. and Beata McCormick Collection
Provenance: private collection, United States, 1993; purchased through L. C. Art Advisory, New York, 2019

Following a long relic tradition going back to traces of the Buddha's footprints, the master Tashipel (1142–1210) impressed his own footprints onto a piece of silk that, in turn, was affixed to this painting, giving it great power. A student would have requested the footprints that are juxtaposed here with the tantric deity Hevajra in a practice called *guruyoga*, whereby teacher and deity are seen as an interchangeable focus for tantric practice. Surviving north Indian Pala motifs, such as the jewelry and stance of Hevajra, support an early date for this work, as does the fact that Tashipel would have been alive, serving as the abbot of Taklung monastery, when the footprints were taken (Casey 2023, vol. 1, p. 186). KB

82. Raktayamari with His Consort Vajravetali
Central Tibet, 14th century
Distemper and gold on cloth, 23 ¾ × 21 ½ in. (60.3 × 54.6 cm)
The Kronos Collections
Provenance: purchased from Great Here Ltd., 1990

Raktayamari is one of several forms of Yamantaka, a deity who subdues Yama, the god of death, to pave a devotee's path to achieving enlightenment and ending the cycle of rebirth. Raktayamari and his consort Vajravetali, both rendered in an orange-red hue, trample on a fallen blue Yama astride his water-buffalo mount. Two other forms of Yamantaka appear in the upper corners of the central frame, including the buffalo-headed Vajrabhairava at right. Like Raktayamari, they are wrathful emanations of the bodhisattva Manjushri. The painting's dynamic figures, lively flourishes, and

yellow borders suggest the involvement of Nepalese artists. Stylized flame tips surrounding the mandorla persisted as a motif in the fifteenth-century murals of Gyantse. RLB

83. Guhyasamaja

Western Tibet, late 15th century
Distemper, gold, and ink on cloth, 33 × 30 in. (83.8 × 76.2 cm)
Michael J. and Beata McCormick Collection
Provenance: purchased from Rossi & Rossi Ltd., London, 2004

Guhyasamaja is the primary deity of his eponymous tantra, a foundational text in the unsurpassed class of yoga tantras. This blue deity is an emanation of the cosmic Buddha Akshobhya, whose *vajra* (thunderbolt) and *ghanta* (bell) attributes he holds in his hands crossed behind his consort Sparshavajra. The artist's decision to render the esoteric pair in the same azurite hue emphasizes their physical and conceptual union—a powerful visualization for realizing the state of blissful nonduality that is the goal of praxis prescribed by the *Guhyasamaja Tantra*. Features such as the droplet-shaped tines on the crowns of the central deities and subsidiary beings are characteristic of painting from the western Tibetan prefecture of Ngari, while the comportment of the figures invites comparisons with the murals of Tholing monastery in the region (Kerin 2014, pp. 172–74). RLB

84. Achala with His Consort Vishvavajri

Nepal, Kathmandu Valley, Malla period, 1525–50
Distemper on cloth, 34 ⅛ × 25 ⅞ in. (86.7 × 65.7 cm)
The Metropolitan Museum of Art, New York, Zimmerman Family Collection, Purchase, Lila Acheson Wallace Gift, 2012 (2012.456)
Provenance: Zimmerman Family Collection, New York, until 2012; sale, purchased by The Met

Achala (literally, "immovable") is a wrathful manifestation of Manjushri, the bodhisattva of wisdom and, in Nepalese Buddhism, a manifestation of Chakrasamvara. This painting is a visualization of the *Chandamaharoshana Tantra*, the text devoted to Achala. With

its intense colors, dynamic postures, and imposing scale, it ranks among the most powerful examples of early sixteenth-century Nepalese painting. Crowned, jeweled, and wielding his sword, Achala cuts through the veil of ignorance. In his left hand he holds a *vajra*-tipped noose, to catch the ignorant. He is seen in sexual embrace with his consort Vishvavajri, so expressing the bliss of enlightenment achieved through the union of wisdom and compassion. JG

85. Tantric Rug with Two Flayed Male Figures

Tibet, 18th–19th century
Wool, cotton, and dye, 65 ½ × 32 in. (166.4 × 81.3 cm)
The Metropolitan Museum of Art, New York, Gift of Steven M. Kossak, The Kronos Collections, 2022 (2022.431.2)
Provenance: Rossi & Rossi Ltd., London, ca. 1990s; sale, to Steven M. Kossak, New York, until 2022; his gift to The Met

Wool rugs are an important element of Tibetan material culture, serving as coverings for beaten-earth floors and as saddle blankets. They also provide the setting for some of the most dramatic imagery in Tibetan art. Here, the flayed male figures framed by severed heads and skulls invoke the protective deities (*dharmapalas*) and form part of the paraphernalia displayed in the *gonkhang*, a chapel reserved for tantric initiation rites within a Tibetan monastery. Such rugs also feature in the annual New Year's Eve exorcism dance (Tse Gutor, *rtse dgu gtor*), performed by masked dancers to cleanse past sins in preparation for the new year. JG

86. Ekajata Attribute Mandala

Central Tibet, ca. 1800
Distemper on cotton, 24 × 18 ½ in. (61 × 47 cm)
Zimmerman Family Collection
Provenance: acquired in the 1970s based on photographs

Floating amid a smoky abyss is an unusual mandalic configuration dedicated to Ekajata. The inverted triangle at its core resembles the *yantra* (geometric diagram) associated with this tantric goddess and contains two of her attributes—a human heart and a trident (Bühnemann 1996, p. 478; J. Huntington and Bangdel 2003,

p. 407). Triangular and circular infernos surround the innermost zone and are themselves inscribed within square walls comprising human entrails and bones, and whose four gates are marked by impaled human and animal corpses. The mandala is enveloped by a flayed cadaver and oceans of blood. These grisly visuals reflect Ekajata's status as a fearsome protector of teachings and secret mantras for the Nyingma sect of Tibetan Buddhism. RLB

87. Ritual Dagger (*Phurba*) and Stand

Tibet, late 14th–early 15th century
Ebony with polychrome, 16 ¾ × 3 ½ in. (42.5 × 8.9 cm)
The Metropolitan Museum of Art, New York, Purchase, Friends of Asian Art and Mr. and Mrs. Richard L. Chilton Jr. Gifts, 2019 (2019.122a, b)
Provenance: Rossi & Rossi Ltd., London, by 1999; sale, to Florence and Herbert Irving, New York, by 2010 until 2019; on loan to The Met; sale, Christie's, New York, March 20, 2019, lot 816, purchased by The Met

Ritual utensils are the essential tools of Vajrayana Buddhism, used to drive away the delusions that impede enlightenment. The *phurba* (Sanskrit: *kila*) dagger consumes the three poisons of ignorance, greed, and delusion. Its triple-edged blade equates to the three-fold realization that accompanies the negation of these poisons and the awakening that follows. The *phurba* embodies Vajrakilaya Buddha, who suppresses the world's evils. Its ritual use was first described in the *Vajrakilaya Tantra*, a Vajrayana text dating to the eighth century or earlier. The Vajrakilaya ritual is closely associated with the Sakya monastic order and to Padmasambhava, who is credited with introducing the text and ritual practice to Samye, the foundational monastery of Buddhist Tibet. JG

88. Twelve-Armed Chakrasamvara with His Consort Vajravarahi

India (West Bengal) or Bangladesh, ca. 12th century
Phyllite, 5 × 3 ⅛ × 1 ½ in. (12.7 × 7.9 × 3.8 cm)
The Metropolitan Museum of Art, New York, Gift of Mr. and Mrs. Perry J. Lewis, 1988 (1988.392)
Provenance: Mr. and Mrs. Perry J. Lewis, Ridgefield, Connecticut, until 1988; their gift to The Met

A popular Vajrayana deity in Bengal and Bangladesh, Chakrasamvara here holds a range of weapons and stands in sexual embrace with his consort Vajravarahi. The prone bodies of two demons lie underfoot. The sacred tantric text devoted to Chakrasamvara allowed a learned practitioner to invoke this fierce protector in times of need, which perhaps explains the many early depictions of this deity in Nepal and Tibet. KB

89. Chakrasamvara with His Consort Vajravarahi

Central Tibet, Sakya school, 1450–1500
Distemper on cotton, 16 × 13 ¼ in. (40.6 × 33.7 cm)
The Metropolitan Museum of Art, New York, Zimmerman Family Collection, Purchase, The Vincent Astor Foundation and the Zimmerman Family Gifts, 2017 (2017.371)
Provenance: Jack and Muriel Zimmerman, New York, by the 1970s; Zimmerman Family Collection, LLC, New York, until 2017; sale, purchased by The Met

This depiction of Chakrasamvara embracing his consort Vajravarahi is a highly energized visualization, such as would have been experienced by an advanced tantric master. It depicts key deities in the Vajrayana system, uniting two of the most powerful ideas in esoteric Buddhism—wisdom, embodied in Vajravarahi, and compassion, the essence of Chakrasamvara. Their sexual union expresses the principle that right knowledge and right method together provide a secure path to spiritual awakening. Chakrasamvara's name translates as "circle of bliss," thus embodying the union of these two fundamental tenets of Buddhism. The couple is encircled in a flaming aureole, understood in Tibetan sources as "the blazing fire of pristine awareness." JG

90. The Fivefold Form of Vajravarahi

Tibet, late 12th century
Distemper on cloth, 14 ¾ × 12 in. (37.5 × 30.5 cm)
The Kronos Collections
Provenance: purchased from Great Here Ltd., 2011

In this unusual painting, Vajravarahi, identifiable by the boar's head emerging from her neck, appears five times, corre-sponding in color to the center and the cardinal directions. As the consort of Chakrasamvara, the subject of a tantra emphasized at the time of this painting's creation, Vajravarahi personifies the concept and power of this Vajrayana practice. Across the top sit *mahasiddha*s, replacing a monastic lineage, and at the base is a row of dancing *dakini*s, who mirror the pose of Vajravarahi. In the lower left is a monastic practitioner who may be the patron, and several other monks appear among the surrounding figures. The volumetric figural type and saturated color palette suggest that this early work was carried out by a Nepali artisan. KB

91. Vajravarahi

Tibet, ca. 18th century
Copper alloy, gilding, and paint with inset turquoise, H. 15 ⅛ in. (38.4 cm)
Somylo Family Collection
Provenance: Spink & Son, London; Bodhicitta Gallery, London; Somylo Family Collection, since 1995

Vajravarahi dances wildly atop a corpse, holding a skull cup and supporting a *khatvanga* staff in the crook of her arm. She wears elaborate jewelry highlighted with inlaid turquoise, as well as a garland of severed heads. Placed out of sight behind the central diadem of her crown is her defining iconography, a boar's head, drawn from the Hindu deity Varahi, consort of Vishnu, who appears as one of the seven mother goddesses (*saptamatrika*s). Given the importance of Chakrasamvara within Tibetan tantric practice, it is significant that it is his consort who is here given emphasis as a goddess for veneration. This late sculpture is a true masterpiece of eighteenth-century Tibetan bronze casting. KB

92. Kurukulla

Tibet, 19th century
Appliquéd satin, brocade, damask, embroidered silk, and painted details, 56 × 47 in. (142.2 × 119.4 cm)
The Metropolitan Museum of Art, New York, Zimmerman Family Collection, Gift of the Zimmerman Family, 2014 (2014.720.1)
Provenance: Zimmerman Family Collection, New York; until 2014; their gift to The Met

This large appliquéd *thangka* depicts the beautiful, bewitching goddess Kurukulla.

She is four-armed and red in complexion, corresponding to her status as an emanation of Amitabha Buddha. Kurukulla is evoked during tantric rituals; reciting her mantra is believed to allow practitioners to bewitch men of all ranks, even kings. Here, as is typical of late images of this deity, she shoots a flower-tipped arrow, invoking Kamadeva, god of love. Like many ferocious female protectors, she wears a skull headdress and bone ornaments while dancing on a pile of corpses. Below her is a row of fierce protectors, including a six-armed Mahakala at center. JG

93. Dhumavati Sri Devi

Central Tibet, Densatil monastery, early 15th century
Gilt copper alloy with inlays of semiprecious stones, 18 × 19 × 7 in. (45.7 × 48.3 × 17.8 cm)
Asia Society, New York, Gift of Mr. and Mrs. Gilbert H. Kinney in honor of Vishakha Desai (2012.4)
Provenance: Gilbert and Ann Kinney, New York, acquired from Chino F. Roncoroni, Zurich, May 1993; their gift to the Asia Society, 2012

Sri Devi ("glorious goddess") is the chief protectress of Tibet, where she is known as Palden Lhamo. Identifiable by her mule conveyance, Sri Devi's skull diadem, bared fangs, garland of heads, and skull cup indicate her wrathful, if ultimately beneficent, nature as one who neutralizes obstacles on the path to liberation. This image once adorned the bottom tier of a *tashi gomang* stupa (memorial reliquary) at Densatil monastery, southeast of Lhasa. Eight of these gilded structures—where corporeal remains of eminent abbots were interred—were built in Densatil's main hall between the thirteenth and fifteenth centuries. Pairs of Sri Devi and her male counterpart, Mahakala, were positioned in the cardinal directions of the *tashi gomang* stupa, while *nagaraja*s (serpent kings) occupied the intercardinal points (Czaja and Proser 2014, p. 42). Ascending tiers of the stupa displayed deities of correspondingly higher status. RLB

94. Initiation Cards (*Tsakalis*)

Tibet, early 15th century
Opaque watercolor on paper, each: 6 ¼ × 5 ¾ in. (16 × 14.5 cm)

The Metropolitan Museum of Art, New York, Rogers Fund, 2000 (2000.282.1–.25)
Provenance: Sam Fogg Rare Books Ltd., London, 2000; sale, purchased by The Met

When laid on the ground in the form of a mandala, *tsakali* cards create a fixed sacred space, akin to a temple. They were used by itinerant teachers, moving from one monastery to another, to evoke Vajrayana Buddhist deities. The imagery on these cards includes the celestial Buddhas, various bodhisattvas, protectors, and, across the bottom, the six possible realms of rebirth. They probably were made by a Nepali artist for a Tibetan patron of the Nyingma school of Tibetan Buddhism. *Tsakali* cards were used to align a disciple with a deity from the vast tantric pantheon. First, the disciple sought permission from the deity, either through a dream or under the guidance of a teacher. The associated ritual involved visualizing the deity as described in recited mantras and with an image—in this case, the image represented on the individual *tsakali*. KB

95. Vajradhatu (Diamond Realm) Mandala

Central Tibet, 14th century
Distemper and gold on cloth, 36 × 29 ½ in. (91.4 × 74.9 cm)
The Kronos Collections
Provenance: purchased from David Tremayne, London, 1993

The Buddha Vairochana, sitting at the center of this mandalic diagram of the heavens, is framed by the four directional Buddhas, each with its own distinctive color. Amitabha presides over the most important of the heavens, the western Pure Land (at top), where devotees hope to be reborn. The square section takes the form of a multitiered palace, inhabited by one thousand bodhisattvas; it encloses the five celestial Buddhas, set within circles. Gateways in the form of pronged *vajra*s stand at the four directions and, as they cross under the central image of Vairochana, mark a point of perfect stability. Along the top register are Buddhist deities, *mahasiddha*s, and monastic patriarchs, and along the base are powerful protectors and auspicious gods. At bottom left, a monk sits before an altar, eternally consecrating the mandala. KB

96. Chakrasamvara Mandala

Nepal, Thakuri–early Malla period, ca. 1100
Distemper on cloth, 26 ½ × 19 ¾ in. (67.3 × 50.2 cm)
The Metropolitan Museum of Art, New York, Rogers Fund, 1995 (1995.233)
Provenance: Bodhicitta Gallery, London, until 1995; sale, purchased by The Met

This mandala evokes the palace of Chakrasamvara and his consort Vajravarahi, seen together at center. They are important deities in Tibet and Nepal, embodying the esoteric knowledge of the *Yoga Tantra*. Six goddesses on stylized lotus petals that form a *vajra* surround the divinities—an atypical feature that suggests an early date. Indeed, this is one of the earliest large-scale paintings from Nepal that survives. Stylistic features relate it to Nepalese manuscript covers and to eastern Indian manuscript illustrations of the twelfth century. Framing the mandala are the eight great charnel grounds, which were considered appropriate places to meditate on the wrathful Chakrasamvara and the realms of existence. KB

97. Manjuvajra Mandala

Tibet, late 12th century
Distemper and gold on cotton, 40 × 30 in. (101.6 × 76.2 cm)
The Kronos Collections
Provenance: ex-coll. Sandy Chandra; Spink & Son, London, 1980s; purchased from Great Here Ltd., 2018

Manjuvajra is a tantric form of the bodhisattva Manjushri and is evoked to better understand subtle aspects of Buddhist texts and practice. Here, he sits with his consort Prajna in iconographic accordance with the *Nishpanna Yogavali* (Garland of Perfection Yoga), a text that relates his three heads to the three great mantra families and the three ways of escape, and his arms to the six supranormal cognitions and remembrances. There is a row of goddesses at the base, and replacing a monastic lineage at the top are multiple forms of Manjushri, emphasizing the mandala's function of providing access to Buddhist knowledge. The refined, intricate details and volumetric treatment of the figures, as well as numerous motifs, indicate a Nepali artisan working for a Tibetan patron. Some of these motifs relate to late

twelfth-century manuscript covers from Nepal, suggesting that this work was also produced in this period (Kossak 2019). KB

98. Chemchok Heruka Mandala

Tibet, second half 12th century
Mineral pigments on cotton, 38 × 32 in. (96.5 × 81.3 cm)
Michael J. and Beata McCormick Collection
Provenance: purchased from Alpha Charter Ltd., Hong Kong, 1996

The tantric deity Chemchok Heruka stands at center with one arm around his consort, following an early convention for showing the pair. Surrounding "sub-mandalas" contain deities such as Yamantaka and Hayagriva, all fearsome, tantric manifestations of the major bodhisattvas. There is also a monk, who could be Atisha, among the group. The iconography is based on two eighth-century tantric texts that a Nyingma monk rediscovered as "revealed treasure." After its creation, this mandala made its way to Taklung monastery, where a consecratory inscription was added by the abbot Tashipel before his death in 1210 (Casey 2023, vol. 1, pp. 139–42). This early date corresponds stylistically to the use of bold, saturated color fields and motifs such as the unadorned *vajra* prongs in the four directions. KB

99. Vajrabhairava Mandala

China, Yuan dynasty (1271–1368), ca. 1330–32
Silk tapestry (*kesi*), 96 ⅝ × 82 ⁵⁄₁₆ in. (245.5 × 209 cm)
The Metropolitan Museum of Art, New York, Purchase, Lila Acheson Wallace Gift, 1992 (1992.54)
Provenance: Francesca Galloway Ltd., London, until 1992; sale, purchased by The Met

In the fourteenth century, China was ruled by the Mongol Yuan dynasty, established by Khubilai Khan (1215–1294), grandson of Genghis Khan (1162–1227). The Mongol rulers were adherents of Tibetan Buddhism, and they were also lavish patrons of luxury arts, including sumptuous woven silk textiles. This mandala exemplifies the fanciest type of textile, *kesi*, in which each colored thread is woven individually to form an image. The central focal point is the fierce deity Vajrabhairava, the buffalo-headed, blue-

skinned conqueror of death, a focus of devotion for the Yuan emperors. At the bottom, from left to right, are portraits of the patrons: Tugh Temür, the great-grandson of Khubilai Khan, who briefly served as Yuan emperor; his older brother; and their wives. JSD

100. Four Mandalas of the Vajravali Series

Central Tibet, ca. 1429–56
Distemper on cotton, 36 × 29 in. (91.4 × 73.7 cm)
Stephen and Sharon Davies Collection
Provenance: Zimmerman Family Collection, New York; Carlton Rochell LLC, New York, 2006; Stephen and Sharon Davies Collection

This painting is seventh in a series of *thangka*s commissioned by the abbot Ngorchen (1382–1456) and dedicated by inscription to his late teacher Sazang Phagpa. Executed by Newari artists, the cycle illustrates mandalas described in the *Vajravali* treatise on tantric Buddhist iconography. This *thangka* is organized as a quincunx—four mandalas surround a circular panel featuring two preceptors of the Sakya school. Three of the mandalas are nearly identical except for the color of the tantric deity at their center, Vajravarahi, whose emanations radiate outward in concentric rings; the fourth portrays Humkara with his consort (J. Huntington and Bangdel 2003, p. 318). The spandrels lining the perimeter display intriguing representations of the eight charnel grounds inhabited by *mahasiddha*s and wild animals. Medallions centered within each spandrel contain the eight guardians of the cardinal and intermediary directions. RLB

101. Mandala of Jnanadakini

Tibet, late 14th century
Distemper on cloth, overall with mount: 54 ⅛ × 36 ¼ in. (137.5 × 92.1 cm)
The Metropolitan Museum of Art, New York, Purchase, Lita Annenberg Hazen Charitable Trust Gift, 1987 (1987.16)
Provenance: Dale Crawford Gallery Ltd., London, until 1987; sale, purchased by The Met

The six-armed goddess (*devi*) Jnanadakini appears at center, surrounded by eight emanations—representations of the *devi* that correspond to the colors of the

mandala's four directional quadrants. Four additional protective goddesses (*dakini*s) sit within the gateways. Surrounding the mandala are concentric circles that contain lotus petals, *vajra*s, flames, and the eight charnel grounds. Additional *dakini*s and lamas occupy roundels in the corners. The upper register depicts lamas and *mahasiddha*s representing the Sakya school's spiritual lineage. The lower register depicts protective deities and a monk who performs a consecration ritual. This *thangka* was likely part of a set of forty-two mandalas relating to ritual texts collectively known as the *Vajravali* or *Vajramala* (Garland of Vajras). The refined detailing suggests that an itinerant Newari artist painted it in Tibet. JG

102. Hevajra Mandala

Tibet, 15th century
Distemper on cloth, 21 ½ × 17 ½ in. (54.6 × 44.5 cm)
The Metropolitan Museum of Art, New York, Gift of Stephen and Sharon Davies Collection, 2015 (2015.551)
Provenance: Axel Ball, early 1990s until ca. 2009; Stephen and Sharon Davies, Pacific Grove, California, until 2015; their gift to The Met

Hevajra is a tantric manifestation of Akshobhya Buddha, whose blue color he shares. This mandala allowed the practitioner to visualize and self-identify with the deity's three-headed, four-armed form, as drawn from the text of the *Hevajra Tantra*. He dances in sexual union with his consort Nairatmya at the center of the cosmos. This concept of dualism is echoed in his name, with the male *he* (compassion) fused with the female *vajra* (wisdom). Surrounding the couple is a ring of ferocious yet beautiful dancing *dakini*s, powerful female deities credited with obtaining secret doctrines. KB

103. Mandala of Raktayamari

Artist: Mikyo Dorje
Central Tibet, late 14th century
Distemper on cloth, 37 ½ × 30 in. (95.3 × 76.2 cm)
The Metropolitan Museum of Art, New York, Zimmerman Family Collection, Gift of the Zimmerman Family, 2012 (2012.444.3)
Provenance: Zimmerman Family Collection, New York, until 2012; their gift to The Met

At the center of this mandala, Raktayamari (Red Yamari) appears in sexual union with his consort, an emanation of himself. Together they trample on their enemy Yama, god of death. Radiating from the central square are four distinctly colored manifestations of Yamari, also depicted in *yab-yum* union. The strong colors and precise, animated line work suggest a master painter, perhaps Mikyo Dorje, who is known to have been active at the time this mandala was made. An inscription identifies the work as a meditation *thangka* belonging to Kunga Lekpa, likely depicted at lower left, one of the teachers of the great Tibetan theologian Tsongkhapa (1357–1419). JG

104. *Biography of a Thought*

Artist: Tenzing Rigdol (b. Kathmandu, 1982)
Nepal, 2024
Acrylic on stretched canvas and woven carpet, 20 wall paintings, each: 8 ft. 6 in. × 6 ft. (259.1 × 182.9 cm); center painting: 6 × 6 ft. (182.9 × 182.9 cm); carpet: 40 × 40 ft. (1,219.5 × 1,219.5 cm)
Collection of the artist

Glossary

Achala: "Immovable One"; an esoteric wrathful manifestation of the bodhisattva Manjushri who holds a sword and a noose.

Atisha (982–1054): Monk from Bengal who brought Mahayana and Vajrayana teachings to Tibet; one of the great teachers within the Tibetan monastic lineages.

Avalokiteshvara: The bodhisattva of compassion and protection; an emanation of the Buddha Amitabha, who often appears in Avalokiteshvara's headdress.

Bhaishajyaguru: The Medicine Buddha with healing abilities; especially popular in East Asia and Tibet and expounded in the *Bhaishajyaguru Sutra*.

Bodhgaya: The place in present-day Bihar, India, where the Buddha Shakyamuni reached enlightenment under the Bodhi tree. The Mahabodhi temple complex at the site is one of the eight pilgrimage places associated with the Buddha.

Bodhisattva: One who vows to pursue the path to becoming a Buddha. Prior to enlightenment, Shakyamuni was a bodhisattva, as is the future Buddha Maitreya. In Mahayana Buddhism, a devotee can take the bodhisattva vow; Mahayana bodhisattvas are deities who have all but reached enlightenment.

Buddha: "Enlightened One"; capable of teaching others the dharma. Shakyamuni is the historical Buddha and Maitreya is the future Buddha. In the Mahayana and Vajrayana traditions, there are many Buddhas living in heavens, such as Amitabha and Vairochana.

Chakrasamvara: Major Vajrayana deity and the focus of the *Chakrasamvara Tantra*; often depicted in *yab-yum* with his consort Vajravarahi.

Cham: Tibetan ritual dance accompanied by instrumental music, often staged in monastic settings. Performers don elaborate masks and costumes during these religious and social occasions.

Chitipati: Lords of the charnel grounds; dancing pair of male and female skeletal deities who function as enlightened protectors. Also, performers dressed as skeletons during *cham* dances.

Dakini: Multivalent term that frequently denotes different classes of enlightened, fearsome female deities who are credited with conveying hidden knowledge; examples include Jnanadakini and Vajrayogini.

Dalai Lama: Title of a distinguished religious official in the Gelug sect of Tibetan Buddhism; considered a living incarnation of Avalokiteshvara.

Dharma: In Buddhist contexts, the "teachings" or "doctrine" revealed by the historical Buddha Shakyamuni.

Gandavyuha Sutra: Mahayana Buddhist text recounting the pilgrim Sudhana's journey through various spiritual stages with multiple teachers on the path to enlightenment.

Gelug sect: Major school of Tibetan Buddhism founded by Tsongkhapa (1357–1419), and the most prominent one today. The Dalai Lamas belong to this order, whose monks wear yellow hats.

Ghanta: Bell utilized in tantric rituals and symbolizing the feminine essence of wisdom. It is often paired with its counterpart, the *vajra*, to signify enlightenment.

Gonkhang: Shrine dedicated to protector deities within a monastery or temple.

Guhyasamaja: Tantric deity regarded as an emanation of Akshobhya; the focus of the *Guhyasamaja Tantra*.

Heruka: Generic epithet applied to wrathful enlightened deities of the unsurpassed class of yoga tantras; denotes Hevajra and especially Chakrasamvara in their respective tantras.

Hevajra: Major Vajrayana deity and the focus of the *Hevajra Tantra*; often depicted in *yab-yum* with his consort Nairatmya.

Kadam sect: Important order of Tibetan Buddhism established in the eleventh century but eventually superseded by other sects. Its origins trace back to Atisha's disciple Dromton, founder of Reting monastery.

Kagyu sect: Major school of Tibetan Buddhism linked to the teachings transmitted via the Indian *mahasiddha*s Tilopa and Naropa to the Tibetan translator Marpa in the eleventh century.

Kanjur (Kangyur): Classification of texts in the Tibetan Buddhist canon denoting discourses attributed to the Buddha.

Kurukulla: A red-skinned form of Tara who can appear either peaceful or fearsome; venerated for favorable outcomes in worldly affairs.

Lama: Title for a spiritual preceptor in Tibetan Buddhism.

Mahakala: "Great Black One"; a wrathful emanation of the bodhisattva Avalokiteshvara who protects the monastic community and the dharma.

Mahasiddha: A quasi-mythical figure from India who reached enlightenment through Vajrayana tantric practices. *Mahasiddha*s are important as founders of monastic lineages in Tibet.

Mahayana: "Greater Vehicle"; a major Buddhist school that became important across Asia after the fifth century CE, although some of its founding texts date to as early as the second century BCE. Imagery related to this school emphasizes living Buddhas residing in heavens and a diverse group of bodhisattvas.

Maitreya: The bodhisattva and future Buddha who is currently waiting in Tushita heaven for his final rebirth. Like Shakyamuni, he will also reach enlightenment and teach the dharma.

Mandala: "Circle"; a ritual map of the universe. Best known for their use in tantric Vajrayana practice, mandalas, which have a focal deity at the center of a palace-like structure, aid practitioners in visualization. Many Buddhist architectural monuments

are three-dimensional conceptions of mandalas.

Manjushri: An important bodhisattva of wisdom; often holds a sword to cut through ignorance in one hand and a lotus stem supporting a *Prajnaparamita Sutra* manuscript in the other.

Mantra: A sacred utterance consisting of a verse, series of syllables, or a single seed syllable; often recited for meditational aid, ritual invocation, and spiritual efficacy.

Mount Meru: In Buddhist cosmology, the axial mountain at the center of the universe.

Mudra: Hand gesture assumed by a deity or religious practitioner. Mudras frequently observed in Buddhist iconography include *abhaya mudra, bhumisparsha mudra, dharmachakra mudra, dhyana mudra, varada mudra,* and *vitarka mudra.*

Nalanda: A major monastic center and Buddhist university in Bihar, India. It was here that many texts were copied and translated so they could be brought to Tibet.

Nyingma sect: The oldest of the major schools of Tibetan Buddhism. Padmasambhava propagated its teachings in the eighth century.

Padmasambhava: Indian tantric master credited with transmitting Buddhism to Tibet in the eighth century; known in Tibet as Guru Rinpoche ("Precious Guru"), and especially associated with the Nyingma sect.

Palden Lhamo (Sri Devi): Fierce protectress of Vajrayana Buddhism and Tibet; associated especially with the Gelug sect, the sacred lake Lhamo Latso, Lhasa, and the Dalai Lama.

Parinirvana: "Complete cessation"; denotes the final passing of the Buddha. Artistic representations of Shakyamuni's *parinirvana* portray him in a recumbent posture.

Prajnaparamita: "Perfection of Wisdom"; name of the quintessential Mahayana sutras generally understood to be the totality of this doctrine. It also designates the goddess who embodies the doctrine.

Raktayamari: "Red Foe of Death"; one of three common forms of Yamantaka.

Sakya sect: Major order of Tibetan Buddhism known for its *lamdre* ("path and fruit") method; the *mahasiddha* Virupa is regarded as its progenitor. The eponymous Sakya monastery was founded in 1073.

Samsara: The cycle of rebirth dictated by one's karma (actions).

Sarnath: Site in present-day Uttar Pradesh, India, where the Buddha Shakyamuni preached the First Sermon in Deer Park and revealed the dharma to his first five followers; now one of the eight pilgrimage places associated with the Buddha.

Shakyamuni: "Sage of the Shakya Clan"; a name given to the historical Buddha, who lived in north India during the sixth to fifth century BCE.

Stupa: A solid hemispherical structure typically crowned with parasols used to house relics of the Buddha.

Tanjur (Tengyur): Classification of texts in the Tibetan Buddhist canon denoting expository treatises and commentaries.

Tantra: A Vajrayana ritual text that often describes how to venerate a major esoteric deity, such as Chakrasamvara or Hevajra.

Tantric Buddhism: Esoteric form of Mahayana Buddhism that draws on tantras and presents an expedited path to enlightenment; synonymous with Vajrayana Buddhism. It was transmitted from India to Tibet and influenced by tantric Hinduism.

Tara: A female bodhisattva. She has peaceful (e.g., Green Tara, White Tara) and wrathful (e.g., Ekajata, Kurukulla) manifestations.

Tathagata: "One who has thus come/gone"; an epithet for the Buddha in general, but specifically for the set of five cosmic Buddhas: Vairochana, Akshobhya, Amitabha, Ratnasambhava, and Amoghasiddhi. Each of the five is associated with their own Buddha family and directional realm.

Tushita: The heaven where bodhisattvas such as Maitreya are born prior to their final incarnation on earth.

Ushnishavijaya: Buddhist goddess of longevity; typically depicted with a white complexion, three faces, and eight arms.

Vajra: "Thunderbolt" or "diamond"; a multipronged implement utilized in tantric rituals and symbolizing the masculine concept of method. It is a common attribute of esoteric deities and often paired with its counterpart, the *ghanta*, to signify enlightenment.

Vajrabhairava: Buffalo-headed meditational deity and wrathful emanation of the bodhisattva Manjushri; one of three common forms of Yamantaka.

Vajrapani: "Holder of the *Vajra*"; a protector of the Buddha and later an esoteric bodhisattva associated with the power of enlightenment.

Vajravarahi: Form of Vajrayogini with a sow's head appendage; consort of Chakrasamvara.

Vajrayana: "Thunderbolt Vehicle" of Buddhism, also known as tantric or esoteric Buddhism; a tradition that advocates complex rituals involving the use of mandalas, repetition of mantras, and the visualization of tantric deities. Invoking such powerful deities requires initiation by a teacher and offers the possibility of enlightenment in this lifetime.

Vajrayogini: Foremost *dakini* and female meditational deity in Vajrayana Buddhism; consort of Chakrasamvara.

Yab-yum: "Father-mother"; posture of physical union between a male and female deity, especially those of the unsurpassed class of yoga tantras. It is often understood to signify the coalescence of masculine compassion and feminine wisdom essential for enlightenment.

Yamantaka: "Destroyer of Death"; a wrathful but enlightened manifestation of the bodhisattva Manjushri and one of the principal meditational deities of the Gelug sect.

Yogin/yogini: Male/female practitioner of yoga, a discipline for spiritual attainment achieved through techniques employed to control the body and mind. In tantric Buddhism "yogini" became synonymous with *dakini*.

Notes

Mandalas: Mapping the Buddhist Art of Tibet pp. 15–29

1. See Meister 2003.
2. Snellgrove 1982, pp. 74–75.
3. Flood 2009, pp. 107–19; Verardi 2011, pp. 359–69.
4. Davidson 2005, p. 108.
5. Leidy 2010, p. 103.
6. Bhattacharyya 1924, p. 122.
7. La Rocca 2006, pp. 12–15.
8. Kapstein 1995, p. 246.
9. Kapstein 1995, pp. 244–60; Wallis 2002, pp. 91–102.
10. Kossak 2019, pp. 63–65.

Teachers and Texts pp. 31–45

1. Jackson 2011, pp. 74–75.
2. Davidson 2005, p. 108.
3. Behrendt 2014, pp. 21–23.
4. Chattopadhyaya 1967, pp. 84–95.
5. Apple 2019, p. 4.
6. Gonkatsang and Willis 2021; Van Schaik 2021, p. 65.
7. Wallis 2002, p. 127.
8. Jackson 1990, pp. 1, 18.
9. Jackson 2011, pp. 94–98.
10. Jackson 2011, p. 95.
11. Damron 2021.
12. Kossak and Casey 1998, p. 190.
13. Snellgrove 1987, vol. 1, p. 130.
14. Dowman 1986, pp. 339–40; Linrothe 2006, pp. 281–83, cat. 44.
15. S. Huntington and J. Huntington 1990, p. 186; Kim 2013, p. 44.
16. Kim 2013, p. 226; Leidy, Proser, and Yun 2016, pp. 81–83; Weinstein 2024.
17. Kim 2013, pp. 38–40.
18. Casey, Ahuja, and Weldon 2003, pp. 124–25.
19. Brown 2012, p. 9.
20. Wallis 2002, p. 67.
21. Pal and Meech-Pekarik 1988, pp. 45–46.
22. Kim 2009, pp. 259–60, 264–66.
23. Luczanits 2014, p. 124.
24. Heller and Eng 2017, p. 176.
25. Heller 2002, pp. 47–48.

Visualizing the Taboo in Esoteric Buddhism pp. 47–67

1. See Dalton 2005 for an outline of this development.
2. Here, I am grossly oversimplifying the analysis of Isaacson and Sferra 2015. They present the classifications of tantric teachings in great detail.
3. On the Kalachakra mandala's relation to earlier Buddhist concepts, see in particular Tanaka 2018, pp. 229–59.
4. Introductory information on the cosmos can be found in Brauen 1997, pp. 18–51; Brauen 2009, pp. 43–77. Depictions of the cosmos in Himalayan art are discussed in detail in E. Huntington 2019.
5. See in particular the pioneering studies by Martin Brauen on the subject, cited in the previous note.
6. For example, see *Oxford Dictionary of English*, s.v. "mandala," accessed December 14, 2023, via the Dictionary app of macOS Sonoma.
7. The different versions of the *Sarvadurgatiparishodhana Tantra* (Tantra for the Purification of All Bad Transmigrations) represent the most prominent early corpus relating the mandala to the cosmos. Both of its primary mandalas include cosmic aspects, but they do not appear to have resulted in the mandala being round, as the earliest representations related to this cycle in Dunhuang show. See, for example, the Sarvavid Vairochana mandala (ca. 10th century), from Dunhuang (now Bibliothèque Nationale de France, Paris, P4518.33).
8. For the Japanese context, see Sharf 2001.
9. For another example of this set in The Met (1977.340) and the historical background of its making, see Jackson and Luczanits 2023. See also Heller 2004; Jackson 2010, pp. 131–35; Watt 2016.
10. The respective directions of Amitabha and Akshobhya reference those of their respective Buddha fields, Sukhavati and Abhirati, which emerge as early as the first or second century CE.
11. See, for example, Davidson 1991. On the interchange of tantric Buddhism and Shaiva Tantrism, see in particular the seminal study Sanderson 2009 and the contributions recently collected in Goodall et al. 2020.
12. Pl. 84 represents the kneeling form of this deity, which is without a vehicle.
13. The Indian scholar Atisha (Dipankara Srijana, 982–1054), who had a great influence on Tibetan monasticism, had an interesting take on this subject; see Gray 2020.
14. On the history and importance of this group of deities, see Wessels-Mevissen 2001.
15. For more on this subject, see Fuentes 2020.
16. Davidson 2002.

Compassion as Essence: Bodhisattvas as Spiritual Guides pp. 69–87

1. In Sanskrit, the accurate transliterated spelling of the term *being* is "satva," as noted in Bhattacharya 2010, p. 35. However, the more common spelling in English is "bodhisattva," which is used in this essay.
2. This discussion is based on Snellgrove 1982; Skorupski 2001; Snellgrove 2011; Rinpoche 2023.
3. Williams 2009, p. 45.
4. Jackson 2010, pp. 110–12, cat. 6.19.
5. See Mallmann 1975, p. 109. Accompanying a stone sculpture from Sarnath, a description of the same ritual is translated in Bhattacharyya 1924, p. 34, and the sculpture is illustrated as pl. XVIIIa.
6. Both S. K. Saraswati and Pratapaditya Pal call attention to Manjushri's association with the ancient Indian god Kumara, of the Brahmanical pantheon, who also takes the form of a young boy. See Saraswati 1977, pp. 18–19; Pal 2003, p. 31.
7. I thank Pratapaditya Pal for the identification of this seed as that of the myrobalan plant; email message to the author, August 2023.
8. de Bary 1967, vol. 1, p. 11.
9. Watt 2013.
10. Shaw 2006, p. 306.
11. Pratapaditya Pal also illustrates the four-armed Dhanada Tara (Tara, Giver of Wealth) with the Buddha Amoghasiddhi in her crown; see Pal 1975, pp. 182–83, cat. 68.
12. See Mallmann 1975, p. 369.
13. Translation from Watt and Gellek 2017.
14. Kossak and Casey 1998, p. 66.
15. Samuel and David 2016, p. 8.
16. See Pommaret 2004.

Biography of a Thought: A Discussion with Tenzing Rigdol pp. 89–97

1. Tenzing Rigdol, interview with Kurt Behrendt, fall 2023.
2. For more on Tenzing Rigdol and other contemporary artists from Nepal and Tibet, see Harris 1999; Magnatta 2019.
3. Becker and Scoggin 2007.
4. See Magnatta 2022. The documentary film *Bringing Tibet Home* (2013) explores the making of this important work.
5. Tenzing Rigdol, interview with Kurt Behrendt, fall 2023.
6. Tenzing Rigdol, interview with Kurt Behrendt, fall 2023.
7. The artist would like to thank the following individuals for their studio assistance in the creation of *Biography of a Thought*: Tenpa Sither, Sonam Phinjo Lama, Sonam Chhiring Lama, Phurpa Gyalbo Tamang, Wangjen Lama, Pema Lama, Samana Tamang, Shusmita Tamang, Lhasang Lama, and Ang Babu. Additional thanks are owed to Sarasvati, Nyima, Sarita Bhujal, and Maile Tamang.

Bibliography

Apple 2019
Apple, James B. *Atiśa Dīpaṃkara: Illuminator of the Awakened Mind*. Boulder, Colorado: Shambhala, 2019.

Bailey 2015
Bailey, Cameron. "The Demon Seer: Rāhula and the Inverted Mythology of Indo-Tibetan Buddhism." *Journal of the International Association of Buddhist Studies* 38 (2015), pp. 33–72.

Becker and Scoggin 2007
Becker, Lisa Tamiris, and Tamar Scoggin. *Waves on the Turquoise Lake: Contemporary Expressions of Tibetan Art*. Exh. cat. Boulder: University of Colorado Art Museum, 2007.

Behrendt 2014
Behrendt, Kurt. "Tibet and India: Buddhist Traditions and Transformations." *The Metropolitan Museum of Art Bulletin* 71, no. 3 (Winter 2014), pp. 5–48.

Behrendt 2016
Behrendt, Kurt. "Tantric Buddhist Art of Tibet." *Arts of Asia* 46, no. 2 (March–April 2016), pp. 79–89.

Behrendt 2020
Behrendt, Kurt. "The Iconographic Distribution of Ninth- to Twelfth-Century Buddhist Imagery from Bihar and Odisha." In *Across the South of Asia: A Volume in Honor of Professor Robert L. Brown*, edited by Robert DeCaroli and Paul A. Lavy, pp. 73–90. New Delhi: DK Printworld, 2020.

Behrendt 2021
Behrendt, Kurt. "Manjushri, Avalokiteshvara, and Vajrapani: Lords of the Three Worlds." *Arts of Asia* 51, no. 1 (Spring 2021), pp. 94–103.

Berger and Bartholomew 1995
Berger, Patricia, and Terese Tse Bartholomew, eds. *Mongolia: The Legacy of Chinggis Khan*. Exh. cat. San Francisco: Asian Art Museum of San Francisco, 1995.

Bhattacharya 2010
Bhattacharya, Gouriswar. "How to Justify the Spelling of the Buddhist Hybrid Sanskrit Term 'Bodhisatva'?" In *From Turfan to Ajanta: Festschrift for Dieter Schlingloff on the Occasion of His Eightieth Birthday*, edited by Eli Franco and Monika Zin, vol. 1, pp. 35–49. Lumbini: Lumbini International Research Institute, 2010.

Bhattacharyya 1924
Bhattacharyya, Benoytosh. *The Indian Buddhist Iconography: Mainly Based on the Sādhanamālā and Other Cognate Tāntric Texts of Rituals*. London: Oxford University Press, 1924.

Brauen 1997
Brauen, Martin. *The Mandala: Sacred Circle in Tibetan Buddhism*. Translated by Martin Willson. Exh. cat. London: Serindia Publications, 1997.

Brauen 2009
Brauen, Martin. *Mandala: Sacred Circle in Tibetan Buddhism*. Updated and expanded edition. Exh. cat. Stuttgart: Arnoldsche Art Publishers; New York: Rubin Museum of Art, 2009.

Brown 2012
Brown, Kathryn H. Selig. *Protecting Wisdom: Tibetan Book Covers from the MacLean Collection*. Chicago: MacLean Collection; Munich: Prestel Verlag, 2012.

Bühnemann 1996
Bühnemann, Gudrun. "The Goddess Mahācīnakrama-Tārā (Ugra-Tārā) in Buddhist and Hindu Tantrism." *Bulletin of the School of Oriental and African Studies* 59, no. 3 (1996), pp. 472–93.

Buswell and Lopez 2013
Buswell, Robert E., Jr., and Donald S. Lopez Jr. *The Princeton Dictionary of Buddhism*. Princeton: Princeton University Press, 2013.

Casey 1994
Casey [Singer], Jane. "Painting in Central Tibet, ca. 950–1400." *Artibus Asiae* 54, no. 1–2 (1994), pp. 87–136.

Casey 2023
Casey, Jane. *Taklung Painting: A Study in Chronology*. 2 vols. Chicago: Serindia Publications, 2023.

Casey and Denwood 1997
Casey [Singer], Jane, and Philip Denwood, eds. *Tibetan Art: Towards a Definition of Style*. London: Laurence King, 1997.

Casey, Ahuja, and Weldon 2003
Casey [Singer], Jane, Naman Parmeshwar Ahuja, and David Weldon. *Divine Presence: Arts of India and the Himalayas*. Exh. cat. Barcelona: Casa Asia; Milan: 5 Continents, 2003.

Chattopadhyaya 1967
Chattopadhyaya, Alaka. *Atiśa and Tibet: Life and Works of Dīpaṃkara Śrījñāna in Relation to the History and Religion of Tibet*. Calcutta: Alaka Chattopadhyaya, 1967.

Czaja 2013
Czaja, Olaf. *Medieval Rule in Tibet: The Rlangs Clan and the Political and Religious History of the Ruling House of Phag mo gru pa; With a Study of the Monastic Art of Gdan sa mthil.*
2 vols. Vienna: Österreichische Akademie der Wissenschaften, 2013.

Czaja and Proser 2014
Czaja, Olaf, and Adriana Proser, eds. *Golden Visions of Densatil: A Tibetan Buddhist Monastery*. Exh. cat. New York: Asia Society Museum, 2014.

Dalton 2005
Dalton, Jacob. "A Crisis of Doxography: How Tibetans Organized Tantra during the 8th–12th Centuries." *Journal of the International Association of Buddhist Studies* 28, no. 1 (2005), pp. 115–81.

Damron 2021
Damron, Ryan C. "Deyadharma—A Gift of the Dharma: The Life and Works of Vanaratna (1384–1468)." PhD diss., University of California, Berkeley, 2021.

Davidson 1991
Davidson, Ronald M. "Reflections on the Maheśvara Subjugation Myth: Indic Materials, Sa-skya-pa Apologetics, and the Birth of Heruka." *Journal of the International Association of Buddhist Studies* 14, no. 2 (1991), pp. 197–235.

Davidson 2002
Davidson, Ronald M. *Indian Esoteric Buddhism: A Social History of the Tantric Movement*. New York: Columbia University Press, 2002.

Davidson 2005
Davidson, Ronald M. *Tibetan Renaissance: Tantric Buddhism in the Rebirth of Tibetan Culture*. New York: Columbia University Press, 2005.

de Bary 1967
de Bary, William Theodore, ed. *Sources of Indian Tradition*. 2 vols. Reprint, New York: Columbia University Press, 1967.

Dowman 1986
Dowman, Keith, ed. and trans. *Masters of Mahamudra: Songs and Histories of the Eighty-Four Buddhist Siddhas*. Albany: State University of New York Press, 1986.

Flood 2009
Flood, Finbarr B. *Objects of Translation: Material Culture and Medieval "Hindu-Muslim" Encounter*. Princeton: Princeton University Press, 2009.

Fuentes 2020
Fuentes, Ayesha. "On the Use of Human Remains in Tibetan Ritual Objects." PhD diss., School of Oriental and African Studies, University of London, 2020.

Gonkatsang and Willis 2021
Gonkatsang, Tsering, and Michael Willis. "Tibetan Inscriptions in the British Museum

Archive." In *Precious Treasures from the Diamond Throne: Finds from the Site of the Buddha's Enlightenment*, edited by Sam van Schaik, Daniela De Simone, Gergely Hidas, and Michael Willis, pp. 71–75. London: British Museum, 2021.

Goodall et al. 2020
Goodall, Dominic, Shaman Hatley, Harunaga Isaacson, and Srilata Raman, eds. *Śaivism and the Tantric Traditions: Essays in Honour of Alexis G. J. S. Sanderson*. Leiden: Brill, 2020.

Gray 2020
Gray, David B. "The Visualization of the Secret: Atiśa's Contribution to the Internalization of Tantric Sexual Practices." In "The Society for Tantric Studies Proceedings (2019)," special issue, *Religions* 11, no. 3 (March 2020), p. 136. https://doi.org/10.3390/rel11030136.

Guy 2011
Guy, John. "Mahavihara Master." In *Masters of Indian Painting*, edited by Milo Cleveland Beach, Eberhard Fischer, and B. N. Goswamy, vol. 1, pp. 29–40. Exh. cat. Zurich: Artibus Asiae Publishers, 2011.

Guy 2012
Guy, John. "Defining the Narrative in Pāla Dynasty *Prajñāpāramitā* Palm-Leaf Manuscript Painting." In *Buddhist Narrative in Asia and Beyond: In Honor of HRH Princess Maha Chakri Sirindhorn on Her Fifty-Fifth Birth Anniversary*, edited by Peter Skilling and Justin McDaniel, vol. 2, pp. 83–94. Bangkok: Institute of Thai Studies, Chulalongkorn University, 2012.

Guy 2015
Guy, John. "Saviours and Protectors in Esoteric Buddhism: The Irving Gifts." In "The Florence and Herbert Irving Collection of East and South Asian Art," special issue, *Arts of Asia* 45, no. 6 (November–December 2015), pp. 116–27.

Guy 2018
Guy, John. "Crowns of the Vajra Masters: Tracing Nepalese Buddhist Ritual." *Orientations* 49, no. 2 (March–April 2018), pp. 2–13.

Guy 2024
Guy, John. "The Transcendent Buddha, the Revered Teacher, and the Dharma Guardian: Three Tibetan Paintings from the Tucci Expeditions." *Orientations* 55, no. 2 (March–April 2024), pp. 62–75.

Halkias 2013
Halkias, Georgios T. *Luminous Bliss: A Religious History of Pure Land Literature in Tibet*. Honolulu: University of Hawai'i Press, 2013.

Harris 1999
Harris, Clare. *In the Image of Tibet: Tibetan Painting after 1959*. London: Reaktion Books, 1999.

Heller 1999
Heller, Amy. *Tibetan Art: Tracing the Development of Spiritual Ideals and Art in Tibet, 600–2000 A.D.* Milan: Jaca Book, 1999.

Heller 2002
Heller, Amy. "The Paintings of Gra thang: History and Iconography of an 11th Century Tibetan Temple." In "Contributions to the History of Tibetan Art," special issue, *Tibet Journal* 27, nos. 1–2 (Spring–Summer 2002), pp. 37–70.

Heller 2004
Heller, Amy. "The Vajravali Mandala of Shalu and Sakya: The Legacy of Buton (1290–1364)." *Orientations* 35, no. 4 (May 2004), pp. 69–73.

Heller and Eng 2017
Heller, Amy, and Charlotte Eng. "Three Ancient Manuscripts from Tholing in the Tucci Collection, IsIAO, Roma, Part II: Manuscript 1329 O." In *Interaction in the Himalayas and Central Asia: Processes of Transfer, Translation and Transformation in Art, Archaeology, Religion and Polity*, edited by Eva Allinger, Frantz Grenet, Christian Jahoda, Maria-Katharina Lang, and Anne Vergati, pp. 173–90. Vienna: Österreichische Akademie der Wissenschaften, 2017.

E. Huntington 2019
Huntington, Eric. *Creating the Universe: Depictions of the Cosmos in Himalayan Buddhism*. Seattle: University of Washington Press, 2019.

J. Huntington 1975
Huntington, John C. *The Phur-pa: Tibetan Ritual Daggers*. Ascona: Artibus Asiae Publishers, 1975.

J. Huntington and Bangdel 2003
Huntington, John C., and Dina Bangdel. *The Circle of Bliss: Buddhist Meditational Art*. Exh. cat. Chicago: Serindia Publications; Columbus, Ohio: Columbus Museum of Art, 2003.

S. Huntington and J. Huntington 1990
Huntington, Susan L., and John C. Huntington. *Leaves from the Bodhi Tree: The Art of Pāla India (8th–12th Centuries) and Its International Legacy*. Exh. cat. Dayton, Ohio: Dayton Art Institute, 1990.

Isaacson and Sferra 2015
Isaacson, Harunaga, and Francesco Sferra. "Tantric Literature: Overview South Asia." In *Brill's Encyclopedia of Buddhism*. Vol. 1,

Literature and Languages, edited by Jonathan A. Silk, Oskar von Hinüber, and Vincent Eltschinger, pp. 307–19. Leiden: Brill, 2015.

Jackson 1990
Jackson, David P., ed. *Two Biographies of Śākyaśrībhadra: The Eulogy by Khro-phu lo-tsā-ba and Its "Commentary" by Bsod-nams-dpal-bzang-po; Texts and Variants from Two Rare Exemplars Preserved in the Bihar Research Society, Patna*. Stuttgart: Franz Steiner Verlag, 1990.

Jackson 1996
Jackson, David P. *A History of Tibetan Painting: The Great Tibetan Painters and Their Traditions*. Vienna: Österreichische Akademie der Wissenschaften, 1996.

Jackson 2010
Jackson, David P. *The Nepalese Legacy in Tibetan Painting*. Exh. cat. New York: Rubin Museum of Art, 2010.

Jackson 2011
Jackson, David P. *Mirror of the Buddha: Early Portraits from Tibet*. Exh. cat. New York: Rubin Museum of Art, 2011.

Jackson and Luczanits 2023
Jackson, David P., and Christian Luczanits. "An Example of Court Patronage to Honor a Religious Master: Mandala of Manjuvajra of the Vajravali Set Commissioned in Memory of Lama Dampa Central Tibet, 1375–1380." In *Himalayan Art in 108 Objects*, edited by Karl Debreczeny and Elena Pakhoutova, pp. 224–27. New York: Rubin Museum of Art, 2023.

Kapstein 1995
Kapstein, Matthew. "Weaving the World: The Ritual Art of the 'Paṭa' in Pala Buddhism and Its Legacy in Tibet." *History of Religions* 34, no. 3 (February 1995), pp. 241–62.

Kerin 2014
Kerin, Melissa R. "From Emulation to Interpretation: Trends in the Late-Medieval Ngari Painting Tradition of the Guge Kingdom and Beyond." In *Collecting Paradise: Buddhist Art of Kashmir and Its Legacies*, by Rob Linrothe, with essays by Melissa R. Kerin and Christian Luczanits, pp. 151–95. Exh. cat. New York: Rubin Museum of Art, 2014.

Kim 2009
Kim, Jinah. "Iconography and Text: The Visual Narrative of the Buddhist Book-Cult in the Manuscript of the Ashṭasāhasrikā Prajñāpāramitā Sūtra." In *Kalādarpaṇa, The Mirror of Indian Art: Essays in Memory of Shri Krishna Deva*, edited by Devangana Desai and Arundhati Banerji, pp. 255–72. New Delhi: Aryan Books International, 2009.

Kim 2013
Kim, Jinah. *Receptacle of the Sacred: Illustrated Manuscripts and the Buddhist Book Cult in South Asia*. Berkeley: University of California Press, 2013.

Klimburg-Salter 1982
Klimburg-Salter, Deborah E., ed. *The Silk Route and the Diamond Path: Esoteric Buddhist Art on the Trans-Himalayan Trade Routes*. Exh. cat. Los Angeles: UCLA Art Council, 1982.

Kossak 2010
Kossak, Steven M. *Painted Images of Enlightenment: Early Tibetan Thankas, 1050–1450*. Mumbai: Marg Publications, 2010.

Kossak 2019
Kossak, Steven M. "Late 12th Century Thangkas by Newari Artists for Tibetan Patrons." *Arts of Asia* 49, no. 4 (July–August 2019), pp. 60–68.

Kossak and Casey 1998
Kossak, Steven M., and Jane Casey [Singer]. *Sacred Visions: Early Paintings from Central Tibet*. Exh. cat. New York: The Metropolitan Museum of Art, 1998.

La Rocca 2006
La Rocca, Donald J. *Warriors of the Himalayas: Rediscovering the Arms and Armor of Tibet*. Exh. cat. New York: The Metropolitan Museum of Art, 2006.

Leidy 2010
Leidy, Denise Patry. "Buddhism and Other 'Foreign' Practices in Yuan China." In *The World of Khubilai Khan: Chinese Art in the Yuan Dynasty*, edited by James C. Y. Watt, pp. 87–127. Exh. cat. New York: The Metropolitan Museum of Art, 2010.

Leidy and Thurman 1997
Leidy, Denise Patry, and Robert A. F. Thurman. *Mandala: Architecture of Enlightenment*. Exh. cat. Boston: Shambhala, 1997.

Leidy, Proser, and Yun 2016
Leidy, Denise Patry, Adriana Proser, and Michelle Yun. *Treasures of Asian Art: The Asia Society Museum Collection*. Revised and expanded edition. Exh. cat. New York: Asia Society Museum, 2016.

Linrothe 2006
Linrothe, Rob, ed. *Holy Madness: Portraits of Tantric Siddhas*. Exh. cat. New York: Rubin Museum of Art, 2006.

Luczanits 2014
Luczanits, Christian. "From Kashmir to Western Tibet: The Many Faces of a Regional Style." In *Collecting Paradise: Buddhist Art of Kashmir and Its Legacies*, by Rob Linrothe, with essays by Melissa R. Kerin and

Christian Luczanits, pp. 109–49. Exh. cat. New York: Rubin Museum of Art, 2014.

Magnatta 2019
Magnatta, Sarah. *Tenzing Rigdol: My World Is in Your Blind Spot*. Exh. cat. Denver: University Press of Colorado, 2019.

Magnatta 2022
Magnatta, Sarah. "*Our Land, Our People*: Reconsidering Site-Specificity in Exile." *Journal of Aesthetics and Culture* 14, no. 1 (2022), pp. 1–14.

Mallmann 1975
Mallmann, Marie-Thérèse de. *Introduction à l'iconographie du tántrisme bouddhique*. Paris: Centre de recherches sur l'Asie centrale et la Haute Asie, 1975.

Martin 2006
Martin, Dan. "Padampa Sangye: A History of Representation of a South Indian Siddha in Tibet." In *Holy Madness: Portraits of Tantric Siddhas*, edited by Rob Linrothe, pp. 108–23. Exh. cat. New York: Rubin Museum of Art, 2006.

Meinert 2011
Meinert, Carmen, ed. *Buddha in the Yurt: Buddhist Art from Mongolia*. 2 vols. Munich: Hirmer, 2011.

Meister 2003
Meister, Michael W. "Vāstupuruṣamaṇḍalas: Planning in the Image of Man." In *Maṇḍalas and Yantras in the Hindu Traditions*, edited by Gudrun Bühnemann, pp. 251–70. Leiden: Brill, 2003.

Pal 1969
Pal, Pratapaditya. *The Art of Tibet*. Exh. cat. New York: Asia Society, 1969.

Pal 1975
Pal, Pratapaditya. *Bronzes of Kashmir*. Graz: Akademische Druck- und Verlagsanstalt, 1975.

Pal 1991
Pal, Pratapaditya. *Art of the Himalayas: Treasures from Nepal and Tibet*. Exh. cat. New York: Hudson Hills Press and American Federation of Arts, 1991.

Pal 1997
Pal, Pratapaditya. *Tibet: Tradition and Change*. Exh. cat. Albuquerque: Albuquerque Museum, 1997.

Pal 2003
Pal, Pratapaditya. *Himalayas: An Aesthetic Adventure*. Exh. cat. Chicago: Art Institute of Chicago, 2003.

Pal and Meech-Pekarik 1988
Pal, Pratapaditya, and Julia Meech-Pekarik.

Buddhist Book Illuminations. New York: Ravi Kumar, 1988.

Pommaret 2004
Pommaret, Françoise. "L'énigme du sourire." In *La danse des morts: Citipati de l'Himalaya, danses macabres et vanités de l'Occident*, edited by Gilles Béguin, pp. 44–46. Exh. cat. Paris: Éditions Findakly, 2004.

Proser 2020
Proser, Adriana. *Buddha and Shiva, Lotus and Dragon: Masterworks from the Mr. and Mrs. John D. Rockefeller 3rd Collection at Asia Society*. Exh. cat. Munich: Hirmer; New York: American Federation of Arts, 2020.

Reynolds 1999
Reynolds, Valrae, ed. *From the Sacred Realm: Treasures of Tibetan Art from the Newark Museum*. Munich: Prestel Verlag, 1999.

Rhie and Thurman 1996
Rhie, Marylin M., and Robert A. F. Thurman. *Wisdom and Compassion: The Sacred Art of Tibet*. First expanded edition. New York: Harry N. Abrams, 1996.

Rice and Durham 2019
Rice, John Henry, and Jeffrey S. Durham. *Awaken: A Tibetan Buddhist Journal Toward Enlightenment*. Exh. cat. Richmond: Virginia Museum of Fine Arts, 2019.

Rinpoche 2023
Rinpoche, Lama Kunga. "May All Beings Know Supreme Happiness." Teaching presented at the weekly Zoom meeting of Ewam Choden Tibetan Buddhist Center, Kensington, California, summer 2023.

Samuel and David 2016
Samuel, Geoffrey, and Ann R. David. "The Multiple Meanings and Uses of Tibetan Ritual Dance: *Cham* in Context." In "Transformations in Contemporary South Asian Ritual: From Sacred Action to Public Performance," special issue, *Journal of Ritual Studies* 30, no. 1 (2016), pp. 7–24.

Sanderson 2009
Sanderson, Alexis. "The Śaiva Age: The Rise and Dominance of Śaivism during the Early Medieval Period." In *Genesis and Development of Tantrism*, edited by Shingo Einoo, pp. 41–350. Tokyo: Institute of Oriental Culture, University of Tokyo, 2009.

Saraswati 1977
Saraswati, S. K. *Tantrayāna Art: An Album*. Calcutta: Asiatic Society, 1977.

Sharf 2001
Sharf, Robert H. "Visualization and Mandala in Shingon Buddhism." In *Living Images: Japanese Buddhist Icons in Context*, edited by

Robert H. Sharf and Elizabeth Horton Sharf, pp. 151–97. Stanford, California: Stanford University Press, 2001.

Shaw 2006
Shaw, Miranda. *Buddhist Goddesses of India.* Princeton: Princeton University Press, 2006.

Skorupski 2001
Skorupski, Tadeusz. "The Historical Spectrum of the Bodhisattva Ideal." *Buddhist Forum 6* (2001), pp. 1–14.

Snellgrove 1982
Snellgrove, David L. "Buddhism in North India and the Western Himalayas: Seventh to Thirteenth Centuries." In *The Silk Route and the Diamond Path: Esoteric Buddhist Art on the Trans-Himalayan Trade Routes*, edited by Deborah E. Klimburg-Salter, pp. 64–80. Exh. cat. Los Angeles: UCLA Art Council, 1982.

Snellgrove 1987
Snellgrove, David L. *Indo-Tibetan Buddhism: Indian Buddhists and Their Tibetan Successors.* 2 vols. Boston: Shambhala, 1987.

Snellgrove 2011
Snellgrove, David L., ed. and trans. "Philosophy and Religion: Popular Conceptions of a Buddha and a Would-Be Buddha." In *Four Lamas of Dolpo: Autobiographies of Four Tibetan Lamas*, vol. 1, pp. 17–34. 3rd ed. Bangkok: Orchid Press, 2011.

Tanaka 2018
Tanaka, Kimiaki. *An Illustrated History of the Mandala: From Its Genesis to the Kālacakratantra.* Somerville, Massachusetts: Wisdom Publications, 2018.

Van Schaik 2021
Van Schaik, Sam. "The Internalisation of the Vajrāsana." In *Precious Treasures from the Diamond Throne: Finds from the Site of the Buddha's Enlightenment*, edited by Sam van Schaik, Daniela De Simone, Gergely Hidas, and Michael Willis, pp. 65–70. London: British Museum, 2021.

Verardi 2011
Verardi, Giovanni. *Hardships and Downfall of Buddhism in India.* New Delhi: Manohar, 2011.

Wallis 2002
Wallis, Glenn. *Mediating the Power of Buddhas: Ritual in the "Mañjuśrīmūlakalpa."* Albany: State University of New York Press, 2002.

Watt 2013
Watt, Jeff. "Tara (Buddhist Deity)—Green." Himalayan Art Resources. January 2013. https://www.himalayanart.org/items/59224.

Watt 2016
Watt, Jeff. "Painting Set: Vajravali (Lama Dampa Set)." Himalayan Art Resources. Updated September 2016. https://www.himalayanart.org/search/set.cfm?setID=2083.

Watt and Gellek 2017
Watt, Jeff, and Karma Gellek. "Tara (Buddhist Deity)—White." Himalayan Art Resources. January 2017. https://www.himalayanart.org/items/2126.

Weinstein 2024
Weinstein, Laura A. "Manuscript Pages—Illuminated Pages." Himalayan Art Resources. Updated January 2024. https://www.himalayanart.org/items/88677.

Wessels-Mevissen 2001
Wessels-Mevissen, Corinna. *The Gods of the Directions in Ancient India: Origin and Early Development in Art and Literature (until c. 1000 A.D.).* Berlin: Dietrich Reimer Verlag, 2001.

Williams 2009
Williams, Paul. *Mahāyāna Buddhism: The Doctrinal Foundations.* 2nd ed. London: Routledge, 2009.

Index

Page references in *italics* refer to illustrations.

A

Abhayakaragupta, 51

Abhidharmakosha, 51

Achala, 24, 44, 56, 57 (fig. 25), *194–95* (pl. 84), 227, 230, 238, 244n12 (Visualizing the Taboo)

Achala trampling on Ganesha, Tibet, 13th century (fig. 25), *56*, 57

Achala with His Consort Vishvavajri, Nepal, Kathmandu Valley, Malla period, 1525–50 (pl. 84), *194–95*, 238, 244n12 (Visualizing the Taboo)

Afghanistan, 19, 43

agriculture, Buddhist texts' role in, 42

Akshobhya, 53, 54, 55, 76–77, 79, 80, *126–27* (pl. 18), 227, 228, 229, 230, 238, 241, 244n10 (Visualizing the Taboo)

Akshobhyavajra, 59

Alchi monastery, Ladakh, India:
 prayer wheel at, *21* (fig. 5)
 wall paintings at, 29, *29* (fig. 10), *58* (fig. 26)

Amitabha, 53, 54, 75, 81, 85, 225, 228, 229, 231, 239, 240, 244n10 (Visualizing the Taboo)

Amoghasiddhi, 54, 81, 82, *82*, *114–15* (fig. 11c), 226, 227, 228

Amulet Box of a Noblewoman, Tibet, late 19th–early 20th century (pl. 25), *132*, 228

Aniko, 20

Armlet for an Image with Crossed *Vajras*, Nepal, 17th–19th century (pl. 24), *131*, 228

Ashtamahabhaya Tara, Savior from the Eight Perils, Tibet, Reting monastery, late 12th century (pl. 38), 80, 81, 82, *146–47*, 230

Ashtasahasrika Prajnaparamita Sutra:
 Artist: Mahavihara Master, India (West Bengal) or Bangladesh, Pala period, early 12th century (pl. 9), *110–11*, 225
 cover for, 42–43, *116–17* (pl. 12), 226
 India, Bihar, Nalanda monastery, Pala period, third quarter 11th century (pl. 8), 17, 41, 42, 43, 44, 77, 78, 80–81, *108–9*, 225
 India, West Bengal or Bangladesh, Pala period, early 12th century (fig. 42), 81, *83*
 Kashmir or western Tibet, 12th century (pl. 11), 43–44, *45*, 81, *114–15*, 226

Atisha, 19, 31–34, *34* (fig. 12), 35, 37, 76, *101* (pl. 2), 224, 230, 237, 240

Avalokiteshvara, 21, *21* (fig. 5), 22, 24, 43, 53, 54, 63, 69, 73, *74* (fig. 36), 85, 225, 226, 227, 229–30

 cosmic form of, known as Chenresi, 68, *142–43* (pls. 34, 35), 229–30
 fierce manifestation of. *See* Mahakala
 four-armed aspect of, known as Shadakshari Avalokiteshvara, 31, 44, 74–76, *75*, 110 (pl. 9a), *140–41* (pl. 33), 224, 225, 227, 229
 "Lotus-in-Hand" aspect of, known as Padmapani, 76, *76* (fig. 38), 79, 226
 Six-Armed Avalokiteshvara Sitting in a Posture of Royal Ease (pl. 9b), *110*, 225
 Tara's close association with, 81, 231

B

Base from a Purification Brazier, Tibet, probably Derge, 15th–17th century (pl. 60), *171*, 234

Bhairava, 56

Bhaishajyaguru, 224

Bhutan, 232
 chitipati mask from, *152* (pl. 42), 231
 masked dances in, 85, *86* (figs. 44–46)

Bihar, India:
 Mahabodhi temple in, 35, *35* (fig. 13), 224
 manuscript illuminations from, 17, 41, 42, 43, 44, 77, 80–81, *108–9* (pl. 8), 225
 sculptures from, 16–17, *17* (fig. 1), *144* (pl. 36), *149* (pl. 39), *160* (pl. 51), *182–83* (pl. 73), 230, 231, 232, 236
 see also Nalanda monastery, Bihar, India

Biography of a Thought, Tenzing Rigdol, Nepal, 2024 (pl. 104; figs. 48–52), *14*, 15, 29, 88, 89–96, *90*, 218–23, 241
 American Sign Language (ASL) and braille elements integrated into, 91, *222–23*
 Picasso's *Les Demoiselles d'Avignon* referenced in, 94 (fig. 50), 95
 preliminary drawings for, *92* (fig. 48), 96
 tantric ideas in, 89, 91, 92–95

Bodhgaya, Bihar, India, 33, 35, *35* (fig. 13), 224

The Bodhisattva Maitreya, Buddha of the Future, Mongolia, school of Zanabazar (1635–1723), second half 17th century (pl. 28), 22, 71–72, *72*, *135*, 228

The Bodhisattva Maitreya, Buddha of the Future, Tibet, 11th or early 12th century (pl. 27), 73–74, *74*, *134*, 228

The Bodhisattva Manjushri as a Ferocious Destroyer of Ignorance, Nepal, Kathmandu Valley, Thakuri period, 10th century (pl. 31), 79, *138*, 229

Bodhisattva Manjushri as a youth, Nepal, Kathmandu Valley, Licchavi–Thakuri period, 10th century (fig. 40), *78*, 79

bodhisattvas, 15, 19, 21–22, 24, 27, 41, 69–80, 81, 87,

 crown worn in Newari ritual for entering persona of, 57, 60, *139* (pl. 32), 229
 ideal of, 71
 jewelry or other luxury items for adornment of, 71, 73, 79, 80, *128–33* (pls. 19–26), 227–28
 in triads of divine beings, 73–74
 visual depictions of, 73–80, *134–45* (pls. 27–37), 228–30
 see also goddesses and female bodhisattvas; *specific bodhisattvas*

The Bodhisattva Vajrapani, Eastern India, Bihar, probably Nalanda monastery, 7th–early 8th century (pl. 36), 79–80, *144*, 230

The Bodhisattva Vajrapani, Western Tibet, Guge, early 12th century (pl. 37), 80, *145*, 230

Bodhi tree, 35, *35* (fig. 13), 228

book covers. *See* manuscript covers

Brahmarupa Mahakala, Tibet, 17th century (pl. 58), 64, *169*, 233–34

Buddha Amoghasiddhi with eight bodhisattvas, Central Tibet, ca. 1200–1250 (fig. 41), 81, *82*

Buddha-family deities, 53–54, 59

Buddha Maitreya. *See* Maitreya

Buddhas, 19, 24, 27, 33, 69, 85
 cosmic, or Tathagatas, 75, 225, 227, 228, 230
 female, 80–81
 five esoteric, 53, 54–55, 56, 57
 see also specific Buddhas

Buddha Shakyamuni, 16–17, *17*, 22, 33, 35 (fig. 13), 37, 69–71, *71*, 73, 80, 95, *182–83* (pl. 73), 225, 226, 228, 236
 bodhisattvas and teachings of, 71–72
 depictions from life of, 41, 42–43, *42* (fig. 17)
 enlightenment of, 16, 33, 35 (fig. 13), 41, *42* (fig. 17), 69, *70* (fig. 34), 83, 95, 228
 founding and development of Buddhist religion and, 69–72
 jewelry for adornment of representations of, 16, 71, *128–31* (pls. 19–24), 227–28

Buddha Shakyamuni, Central Tibet, 12th century (fig. 34), 69, *70*

Buddha Vairochana. *See* Vairochana

Buddha with the bodhisattvas Padmapani and Vajrapani. Tibet, ca. 10th century (fig. 38), 76, *76*

Buton Rinchen Drub, 41

butter lamps, 26, *176–77* (pl. 65), 234–35

Byang bu'i khrab (Lamellar Armor), Tibet, ca. 16th–17th century (pl. 68), *179*, 235

C

Central Asia, 43, 85, 229, 232, 235

Chakrasamvara, 24, 36, 38, 46, 56, 59, 60, *199* (pl. 88), *200* (pl. 89), *208–9* (pl. 96), 237, 238, 239, 240

Chakrasamvara Mandala, Nepal, Thakuri–early Malla period, ca. 1100 (pl. 96), 27, 60, *208–9*, 240

Chakrasamvara Tantra, 16, 39

Chakrasamvara with His Consort Vajravarahi, Central Tibet, Sakya school, 1450–1500 (pl. 89), *200*, 239

cham festivals, 67 (fig. 33), 85–87, *86* (figs. 44–46)

charnel grounds, 60, 65, 67, 67 (fig. 33)
 attributes and paraphernalia of protective deities derived from, 64, 65 (fig. 31)
 Chakrasamvara mandala set within, 60, *208–9* (pl. 96), 240
 furnishings decorated with motifs related to, 52, 65, 67, *164–65* (pl. 55), *196* (pl. 85), 233, 238
 as ideal places of esoteric practice, 60, 64
 lords of, as dance costumes and masks, 65, 67, 67 (fig. 33), *152* (pls. 42, 43), 231
 Mahakala depictions and, 64
 represented in mandalas, 50, 52, *197* (pl. 86), *208–9* (pl. 96), 238, 240, 241

Chemchok Heruka Mandala, Tibet, second half 12th century (pl. 98), 19, 27, 55, *212*, 240

Chenresi, 68, *142–43* (pls. 34, 35), 229–30

Chest with Scenes of Tantric Offerings, Tibet, late 19th century (pl. 55), *164–65*, 233

China, 20, 41, 44, 77
 Ming dynasty (1368–1644), *173* (pl. 62), 234
 Qing dynasty (1644–1911), 22, 23, *137* (pl. 30), *153* (pl. 45), 229, 231–32
 Tang dynasty (618–907), 123, *172* (pl. 61)
 Yuan dynasty (1271–1368), *18*, 19, 20, 27, 55, 60–61, *213* (pl. 99), 240–41

chitipati dancers, 87, *152* (pls. 42, 43), 231

cosmos, Buddhist understanding of, reflected in mandala, 50, 51

Cover for an *Ashtasahasrika Prajnaparamita Sutra*, Nepal, Kathmandu Valley, Thakuri–Malla period, 10th–11th century (pl. 12), 42–43, *116–17*, 226

covers for illustrated manuscripts. *See* manuscript covers

crown, ritual, for tantric priest, 57, 60, *139* (pl. 32), 229

Crowned Buddha Shakyamuni, India, Bihar or West Bengal, 11th century (pl. 73), 16, 17, *182–83*, 236

Crown Ornaments for a Deity, Newari for the Tibetan market, 17th–19th century (pl. 19), *128*, 227–28

D

Dalai Lama, 74, 233

dance, 65, 67, 67 (fig. 33), 85–87, *86* (figs. 44–46)
 drums, cymbals, and horns for, 87, *154–57* (pls. 46–49), 232
 masks and robes for, 85, 87, *152–53* (pls. 42–45), 231

death:
 deities connected to overcoming (Yamantaka deities), 59, 60, 237–38, 240
 depictions of, 47. *See also* charnel grounds

deer and stag masks, 85, *153* (pl. 44), 231

deities:
 connected to overcoming death (Yamantaka deities), 59, 60, 237–38, 240
 families of, 52–55
 initiation to align disciple with, 54, 60, 66, *205* (pl. 94), 240
 local, 65
 shown in sexual embrace, 28–29, 42, 55, 56, 57–59, 238, 239
 visualization practice and, 16, 36, 60, 63, 240, 241
 wrathful manifestations of, 55–56, 233, 234, 235, 236, 238, 239, 240
 see also protector deities; *specific deities*

Les Demoiselles d'Avignon, Pablo Picasso (fig. 50), 94, 95

Densatil monastery, Tibet, 239

dharma, 17, 22, 61, 76, 80
 protectors of, 22–24, 29, 69. *See also* protector deities

dharmachakra mudra, 43, 45, 85, 226

dharma relics, 41–42

Dhumavati Sri Devi, Central Tibet, Densatil monastery, early 15th century (pl. 93), 65, *204*, 239–40

Dish for Ritual Offerings, Nepal, 17th–19th century (pl. 26), *133*, 228

donor figures, 27

drums, 87, *154* (pl. 46), 232
 hand (*damaru*), made of skulls, 64, 64 (fig. 30)

Dunhuang mandalas, 50, *50* (fig. 22), 51, 244n7 (Visualizing the Taboo)

E

Ear Ornaments for a Deity, Nepal, 17th–19th century (pls. 20, 21), *129*, 228

eight perils, 81, 230

Ekajata Attribute Mandala, Central Tibet, ca. 1800 (pl. 86), 47, 52, *197*, 238

enlightenment, 22, 33, 37–39, 80
 bodhisattvas and, 71
 of Buddha Shakyamuni, 16, 33, *35* (fig. 13), 41, *42* (fig. 17), 69, *70* (fig. 34), 83, 95, 228
 images and symbols indicative of, 39, 69, 77
 progressing toward, 37–39, 73, 237

esoteric Buddhism, 16, 19, 47–67, 85
 development of, in Tibet, 47–49
 entire spectrum of human emotion utilized in, 55
 families of deities in, 52–55
 five esoteric Buddhas in, 53, 54–55, 56, 57
 gender symbolism in, 28–29, 56–57
 initiation to align disciple with deity in, 54, 60, 66, *205* (pl. 94), 240
 protector deities in, 22–24, 27, 55, 63–66
 ritual practice in, 59–63. *See also* mandalas
 wrathful images in, 55–56
 see also charnel grounds

F

families of deities, 52–55

five esoteric Buddhas, 53, 54–55, 56, 57

The Fivefold Form of Vajravarahi, Tibet, late 12th century (pl. 90), *201*, 239

Forehead Ornament for a Deity, Newari for the Nepalese or Tibetan market, 17th–19th century (pls. 22, 23), *130*, 228

The Founding Masters of Taklung Monastery, Tibet, Taklung, last quarter 13th century (pl. 5), *104*, 224

Four Leaves from a *Gandavyuha* Manuscript, Nepal, Transitional period (880–1200), late 11th–12th century (pl. 10), 43, *112–13*, 225–26

Four Leaves from an *Ashtasahasrika Prajnaparamita Sutra*, Mahavihara Master, India (West Bengal) or Bangladesh, Pala period, early 12th century (pl. 9), *110–11*, 225

Four Leaves from an *Ashtasahasrika Prajnaparamita Sutra*, India, Bihar, Nalanda monastery, Pala period, third quarter 11th century (pl. 8), 17, 41, *42*, 43, 44, 77, 80–81, *108–9*, 225

Four Mandalas of the Vajravali Series, Central Tibet, ca. 1429–56 (pl. 100), 27, 29, 37, 51, *214*, 241

Four Noble Truths, 22

Frame Drum (*Rnga* or *Lag-rnga*), Tibet, 18th century (pl. 46), *154*, 231–32

G

Gandavyuha Manuscript (pl. 10), 43, *112–13*, 225–26

Ganesha, 56, *57* (fig. 25)

Gelug sect, 39, 229, 233

gender symbolism, 28–29, 56–57

Ghurid conquest (1192–1206), 18

Gigantic effigy of Vajrabhairava in the *gonkhang* of Thiksey monastery, Ladakh, 2023 (fig. 32), 65, 66

goddesses and female bodhisattvas, 22, 24, 69, 80–85, 87

visual depictions of (pls. 38–41), 80–85, *146–51*, 230–31

see also bodhisattvas; Tara

gonkhang, 24, 65, *66* (fig. 32), 233, 235, 238

"Green Tara Dispensing Boons to Ecstatic Devotees," detail of a leaf from an *Ashtasahasrika Prajnaparamita Sutra*, India, West Bengal or Bangladesh, Pala period, early 12th century (fig. 42), 81, *83*

Guge kingdom, western Tibet, 23, 43, 79, 80, 230

Guhyasamaja, 24, 59, *193* (pl. 83), 238

Guhyasamaja, Western Tibet, late 15th century (pl. 83), *193*, 238

Guhyasamaja Tantra, 16, 57, 59, 238

guruyoga, 63, 237

Gu Tor Festival, 231

Gyantse, Tibet, *20* (fig. 4), 224, 230, 232, 233, 238

H

hand drum (*damaru*), 64, *64* (fig. 30)

Healing ritual with mandala, Dunhuang, Library cave, 10th century (fig. 22), *50*

helmet, leather, with auspicious symbols, 24, 66, *178* (pl. 66), 235

Heruka, 24, *212* (pl. 98), 240

Hevajra, 24, 59, 63, 73, *190* (pl. 80), *191* (pl. 81), *216* (pl. 102), 236, 237, 241

Hevajra and Nairatmya, Tibet, late 12th century (pl. 80), 73, 80, *190*, 237

Hevajra Mandala, Tibet, 15th century (pl. 102), 27, *216*, 241

Hevajra Tantra, 16, 234, 237, 241

Hevajra with the Footprints of the Kagyu Patriarch Tashipel, Tibet, Taklung, 1180–1210 (pl. 81), *191*, 237

Hilt of a Ritual or Votive Sword, Tibetan, possibly 15th–16th century (pl. 72), 24, *181*, 236

hilts. *See* sword hilts

Hinduism, 15, 18, 51, 56, 79, 85, 234, 239

I

illustrated manuscripts, 22, 40–44, *42*, 73, 77 (fig. 39), *108–9* (pls. 8–11), 225

India:

Buddhist teaching transmitted to Tibet from, 16, 18–21, 25–26, 33, 40–42, 45, 234

complexities of travel between Tibet and, 19–20

decline of Buddhism in, 17–18, 224

development of Buddhist religion in, 69–73

illustrated manuscripts from, 40–41, 42, *42* (fig. 17), 43, 44, *108–11* (pls. 8, 9), 225

oral traditions in, 40

Pala period, 19, 42, 43, 44, 73–74, 78, 80–81, *83* (fig. 42), 85, 226, 230, 237

repositories of Buddhist knowledge in, 40–41, 42

sculptures from, 16–17, *17* (fig. 1), 44, *144* (pl. 36), *149* (pl. 40), *160* (pl. 51), *182–83* (pl. 73), *199* (pl. 88), 230, 231, 232, 236, 239

tantric movement and esoteric Buddhism in, 47

see also Bihar, India

Indra, 60, 79, 226, 230, 233

Initiation Cards (*Tsakalis*), Tibet, early 15th century (pl. 94), *205*, 239–40

Interior of a Manuscript Cover: Manjuvajra Embracing His Consort, with Attendant Lamas, Tibet, late 13th century (pl. 16), 77, *122–23*, 227

J

Jambhala, 80

Japan, mandalas from, 50

jewelry and other luxury items, 16, 71, 79, 80, 81, 85, *128–33* (pls.19–26), *139* (pl. 32), 226, 227–28, 229

Jnanadakini, 24, 51–52, *215* (pl. 101), 241

K

Kadam sect, 19, 31

portrait of master of, 31–33, *32*, *100* (pl. 1), 224

Kagyu sect, 19, 39, 59, 63, 233

see also Taklung Monastery, Tibet

Kalachakra, 92–95

Kalachakra mandala, 47, *48* (fig. 20), 50, 51

three-dimensional model of, *52* (fig. 24)

Kalachakra Tantra, 95

Kalachakra Tantrism, 37, 95, 224

Kalaratri, 56

Kanjur (or Kangyur), 41

karma, 69, 85, 87

Kashmir, 15, 16, 34, 79, 229

illustrated manuscripts from, 43–44, *45*, *114–15* (pl. 11), 226

Kathmandu Valley, Nepal, 19–20

manuscript covers, 44, *116–19* (pls. 12, 13), 226–27

paintings from, *193–94* (pl. 84), 238

sculptures, *38* (fig. 15), *78* (pl. 31), *138* (pl. 39), *148* (pl. 79), 189, 229, 230–31, 237

Swayambhunath stupa in, *25* (fig. 7), 26

Khatvanga (Ritual Staff), China, Ming dynasty (1368–1644), Yongle mark and period (1403–24) (pl. 61), *173*, 234

Khubilai Khan, 19, 241

Kirapalapa, 37–39, *38*, *189* (pl. 79), 237

kirtimukhas, 228, 235, 236

knife, curved, 64, *174* (pl. 63), 234

Kumbum three-dimensional mandala in Gyantse, Tibet, founded 1427, *20* (fig. 4), 230, 233

Kunga Lekpa, 241

Kurukulla, 24, *111* (pl. 9d), *203* (pl. 92), 225, 239

Kurukulla, Tibet, 19th century (pl. 92), *203*, 239

Kuyalwa, 224

L

Lag-rnga or *Rnga* (Frame Drum), Tibet, 18th century (pl. 46), *154*, 231–32

lamas, portrayal of. *See* monastic portraits

Lamellar Armor (*Byang bu'i khrab*), Tibet, ca. 16th–17th century (pl. 68), *179*, 235

laypeople, 39, 71, 85–87

access to esoteric practice for, 85

festivals of masked dances (*cham*) for, 65, *67* (fig. 33), 85–87, *86* (figs. 44–46)

Lay Translator Marpa, Tibet, 17th century (fig. 2), *18*

Leather Helmet with Auspicious Symbols, Tibet, 15th–17th century (pl. 66), 24, 66, *178*, 235

lotus-family deities, 53–54

lotus mandalas, *50* (fig. 23), 51

Lute (*Sgra-snyan*), Tibet, late 19th century (pl. 47), *155*, 232

luxury items. *See* jewelry and other luxury items

M

Mahabodhi temple, Bodhgaya, Bihar, India, 35, *35* (fig. 13), 224

Mahakala, 22–23, 33, 44, 63–64, *160–62* (pls. 51–53), 227, 232–33

in form of brahmin (Brahmarupa Mahakala), 64, *169* (pl. 58) 233, 233–34

Mahakala, India, Bihar, Pala period, 11th–12th century (pl. 51), 22–23, *160*, 232

Mahakala, Protector of the Tent, Central Tibet, ca. 1500 (pl. 53), 64, *162*, 233, 239

Mahakala, Tibet, 14th century (pl. 52), *161*, 232–33

Mahapratisara, 44, *149* (pl. 40), 227, 231

Mahapratisara, the Buddhist Protectress, India, Bihar, Pala period, 10th century (pl. 40), *149*, 231

Mahasiddha Jnanatapa, Eastern Tibet, Kham, Riwoche monastery, ca. 1350 (pl. 77), *187*, 237

Mahasiddha Kirapalapa, Nepal, Kathmandu Valley, ca. 14th century (pl. 79), 37–39, *38*, *189*, 237

Mahasiddha Padampa Sangye, Tibet, 14th century (pl. 78), *188*, 237

mahasiddhas, 18–19, 25–26, 27, 37–39, 45, 66, *184–89* (pls. 74–79), 229, 233, 236–37, 239, 240, 241

Mahasiddhas Virupa and Krishnapa, Tibet, 1429–56 (pl. 75), *185*, 236

Mahasiddha Virupa, Central Tibet, second quarter 13th century (pl. 74), *184*, 236

Mahasiddha Virupa, Tibet, 18th century (pl. 76), *186*, 236–37

Mahavihara Master: Four Leaves from an *Ashtasahasrika Prajnaparamita Sutra,* India (West Bengal) or Bangladesh, Pala period, early 12th century (pl. 9), *110–11*, 225

Mahayana Buddhist tradition, 33, 35, 236

manuscript covers, 227
 texts of, 41–43, 225

Maitreya, 22, 24, 35, 43, 69, 71–72, *72* (fig. 35), 73–74, *74* (fig. 36), 92, *134* (pl. 27), *135* (pl. 28), 225–26, 227, 228

Mandala of Jnanadakini, Tibet, late 14th century (pl. 101), 51–52, *215*, 241

Mandala of Raktayamari, Mikyo Dorje, Central Tibet, late 14th century (pl. 103), 27, 60–61, *217*, 241

mandalas, 15, 16, *18* (fig. 3), *20* (fig. 4), 25, 26–29, *27–29*, 37, 47, *48* (fig. 20), 49–55, 67, 73, 89–96, *206–23* (pls. 95–104), 240–41, 244n7 (Visualizing the Taboo)
 central circle of deities in, 50–55
 color schemes related to five esoteric Buddhas in, 55
 common features of (fig. 8), 26–28, *27*, 49–50
 gender symbolism in, 56–57
 groups or sets of, 29, 51–52
 lotus (fig. 23), 50, 51
 meaning of term *mandala*, 50

objects associated with charnel grounds represented in (pls. 86, 96), 50, 52, *197*, *208–9*, 238, 240, 241
 as portable scroll painting or *thangka*, 16, 29, *48* (fig. 20), 51, *206–12* (pls. 95–98), *214–17* (pls. 100–103), 240–41
 ritual ground and assembly of deities in, 50–51
 as ritual tool, 49, 50 (fig. 22), 51–52, 59–63
 sand, 26, 49, *49* (fig. 21), 51
 three-dimensional, *20* (fig. 4), 51, *52* (fig. 24)
 tsakali cards and, *205* (pl. 94), 239–40
 visualization practice and, 60, 61–63
 wall paintings, 29 (fig. 10), 51
 see also specific mandalas

Manjushri, 21–22, *23*, 26, 29, 44, 53, 59, 69, 73, 74, *74* (fig. 40), 76–79, *77*, 81, *136–38* (pls. 29–31), 225, 227, 229, 238, 240
 represented as Siddhaikavira, or "Perfect Hero," 78–79
 sand mandala of, 49, *49* (fig. 21)

Manjushri, the Bodhisattva of Transcendent Wisdom, China, Qing dynasty (1644–1911), 17th–18th century (pl. 30), 22, 23, 30, 76–77, *137*, 229

Manjushri, the Bodhisattva of Transcendent Wisdom, Western Tibet, late 10th–early 11th century (pl. 29), 59, 78–79, *136*, 229

Manjushrimulakalpa, 26

Manjuvajra, 24, 28, *28–29*, 59, *122–23* (pl. 16), *210–11* (pl. 97), 227, 240

Manjuvajra Mandala, Tibet, late 12th century (pl. 97), 16, 24, 27, 28, *28–29*, 59, *210–11*, 240

mantras, 16, 21, *21* (fig. 5), 25, 37, 66, 73, 74, 229, 234, 235, 238, 239, 240

manuscript covers, 22, 42–44, *44* (fig. 18), 57, 59, 80, *116–25* (pls. 12–17), 226–27, 240

Manuscript Cover with Prajnaparamita Flanked by Ten Buddhas, Tibet, late 12th century (pl. 17), 22, 44, 59, 80, *124–25*, 227

Marichi, 44, 227

Marpa, *18* (fig. 2), 19, 39

masks:
 for dancers, *67* (fig. 33), 85, *86* (figs. 44–46), *152* (pl. 42), *153* (pl. 44), 231
 on sword hilts (pls. 70–72), 24, 66, *180–81*, 235–36

Maya, 41

meditation, 51, 71, 73, 77, 82, 225, 228, 231, 236, 241
 of Shakyamuni, 69

Mikyo Dorje: Mandala of Raktayamari, Central Tibet, late 14th century (pl. 103), 27, 60–61, *217*, 241

Milarepa, 39

mindfulness, 89

Ming-dynasty China (1368–1644), *173* (pl. 62), 234

Monastic Dance Robe, China, Qing dynasty (1644–1911), early 19th century (pl. 45), *153*, 231–32

monastic libraries, 40–42
 see also illustrated manuscripts; manuscript covers

monastic portraits, 31–40, 66, *100–107* (pls. 1–7), 224–25

monastic teacher-student lineages, 19, 26, 33, 37, 39, 45, 55, 66

Mongolia, 22
 quiver from, *179* (pl. 69), 235
 sculptures from, 22, 71–72, *72* (fig. 35), *135* (pl. 28), *166–67* (pl. 56), 228–29, 233

Mongols, 19, 241
 see also Yuan-dynasty China

monks, portrayal of. *See* monastic portraits

Mount Meru, 16

Mount Potalaka, 229

München, 39–40, *40* (fig. 16), *106–7* (pl. 7), 225

musical instruments, 87, *154–57* (pls. 46–49), 232
 with attributes of charnel grounds, 64, *64* (figs. 29, 30)

N

Nalanda monastery, Bihar, India, 33, 34, 40, 41, *42* (fig. 17), *77* (fig. 39), *108–9* (pl. 8), *144* (pl. 36), 224, 225.230

Naropa, 19, 39

Neljo Gurung, 96

Nepal, 15, 16, 17, 20, 36, 37–39, 45, 57, 77, 81, 82, 85
 early Malla period, *139* (pl. 32), 229
 illustrated manuscripts and their covers, 40–41, 42–43, 44, *44* (fig. 18), 57, *112–13* (pl. 10), *116–21* (pls. 12–14), 225–27, 240
 jewelry and other luxury items, *129–31* (pls. 20–24), *133* (pl. 26), *139* (pl. 32), 228, 229
 Malla period, *148* (pl. 39), *194–95* (pl. 84), 230, 238
 paintings, 37, 60, *194–95* (pl. 84), *208–9* (pl. 96), 224, 237, 238–39, 240
 sculpture, 37–38, *38* (fig. 15), *78* (fig. 40), 79, *138* (pl. 31), *148* (pl. 39), *189* (pl. 79), 229, 230–31, 237
 Swayambhunath stupa in Kathmandu Valley, *25* (fig. 7), 26
 Thakuri–early Malla period, *208–9* (pl. 96), 240

Thakuri-Malla period, *116–17* (pl. 12), 226

Thakuri period, *120* (pl. 14), *138* (pl. 31), 227, 229

Transitional period (880–1200), *112–13* (pl. 10), 225–26

Newari, 57, 233, 236, 241

jewelry and luxury items produced by, *128* (pl. 19), *130* (pls. (pls. 22, 23), 227–28

ritual crown for tantric priest, 57, 60, *139* (pl. 32), 229

Ngorchen, 39–40, *40* (fig. 16), *48* (fig. 20), *106–7* (pl. 7), 225, 236, 241

Nishpanna Yogavali, 29, 240

Nyingma sect, 39, 65, 233, 234, 238, 240

O

Our Land, Our People, Tenzing Rigdol, Dharamshala, India, 2011, 89

P

Padmapani, 76, *76* (fig. 38), 79, 226

Padmasambhava, 65, *171* (pl. 59), 234, 238

painting:

underdrawing in, 26, 85, 91, 231

see also illustrated manuscripts; manuscript covers; *thangkas*; wall paintings

Pair of Butter Lamps, Central Tibet, 19th century (pl. 65), *176–77*, 234–35

Pair of Manuscript Covers, Each with Five Deities, Tibet, end of the 11th century (pl. 15), 44, 77, *121*, 227

Pair of Manuscript Covers Illustrating Sadaprarudita's Self-Sacrifice, Nepal, Kathmandu Valley, 12th century (pl. 13), 43, *44*, *118–19*, 226–27

Pair of Manuscript Covers with Buddhist Deities, Nepal, Thakuri period, 11th–12th century (pl. 14), 47, 57, *120*, 227

Pair of Trumpets (*Rkangling*), Tibet, 19th century (pl. 49), *157*, 232

Pakistan, 19

Pala period, 19, 42, 43, 44, 73–74, 78, 80–81, *83* (fig. 42), 85, 226, 230, 237

Palden Lhamo, or Sri Devi, 23, 65, *168* (pl. 57), *204* (pl. 93), 233, 239–40

Palden Lhamo, Tibet, 15th century (pl. 57), 23, 65, *168*, 233

Panjara Mahakala, 63–64, *162* (pl. 53)

Parvati, 56

Phagpa, 19, 241

Phub (Shield), Tibet, ca. 14th–16th century (pl. 67), *178*, 235

Phurba (Ritual Dagger) and Stand, Tibet, late 14th–early 15th century (pl. 87), *198*, 238

Phurba Emanation of Padmasambhava, Tibet, ca. 17th century (pl. 59), *170*, 234

Picasso, Pablo, *94* (fig. 50), 95

pilgrimage, 17, 41, 43

Portrait of a Kadam Master with Buddhas and His Lineage, Central Tibet, ca. 1180–1220 (pl. 1), 31–32, *32*, 100, 224

Portrait of Shakyashribhadra with His Life Episodes and Lineage, Tibet, early–mid-14th century (pl. 3), 34–35, *102*, 224

Portrait of the Indian Monk Atisha, Tibet, early–mid-12th century (pl. 2), 33, *34*, *101*, 224

Portrait of the Last Indian Pandit, Vanaratna, Central Tibet, first half 15th century (pl. 4), *36*, 36–37, *103*, 224

Portrait of the Monk Ngorchen and His Successor München, Central Tibet, 1450–1500 (pl. 7), 39–40, *40*, *106–7*, 225

Portrait of the Third Kagyu Taklung Abbot, Sangye Yarjon, Central Tibet, ca. 1262–63 (pl. 6), *30*, *105*, 224–25

Prajna, 28–29, 240

Prajnaparamita, 22, 41, 42–43, 44, *44*, 45, 57, 59, 69, 80–81, *115* (pl. 11), *116–17* (pl. 12), *124–25* (pl. 17), 225, 226, 227

Prajnaparamita Sutra, 41, 44, 72, 76, 77, 78, 80, 81, *108–9* (pl. 8), 226–27

see also Ashtasahasrika Prajnaparamita Sutra

prayer wheels, 21, *21* (fig. 5)

protective symbols, 65–66

protector deities, 22–24, 27, 55, 63–66

shrines dedicated to (*gonkhang*), 24, 65, *66* (fig. 32), 233, 235, 238

visual depictions of, 22–24, *158–63* (pls. 50–54), *166–70* (pls. 56–58), 232–34

Q

Qianlong, Emperor, 229

Qing-dynasty China (1644–1911), 22, *23* (fig. 6), *137* (pl. 30), *153* (pl. 45), 229, 231–32

Quiver, Tibet or Mongolia, 14th–16th century (pl. 69), *179*, 235

R

Rahula, Tibet, 15th century (pl. 54), 23–24, *163*, 233

Raktayamari, 24, *192* (pl. 82), 237–38

mandala of, 27, 60–61, *217* (pl. 103), 241

Raktayamari with His Consort Vajravetali, Central Tibet, 14th century (pl. 82), *192*, 237–38

Ral gri (Sword), Tibet or China, 14th–16th century (pl. 70), 24, *180*, 235

Ratnasambhava, 54, 227, 228, 231

rebirth, 21, 22, 31, 53, 228, 230, 231, 233, 237, 240

deer as symbol of, 85

generating merit for, 41, 69, 73, 85–87

Shakyamuni and doctrine of, 69–71

Reting monastery, Tibet. *See* pl. 38

"revealed treasure" doctrine, 24, 240

Ritual Dagger (*Phurba*) and Stand, Tibet, late 14th–early 15th century (pl. 87), *198*, 238

Ritual Staff (*Khatvanga*), China, Ming dynasty (1368–1644), Yongle mark and period (1403–24) (pl. 61), *173*, 234

Riwoche monastery, Kham, Tibet, 225, 237

Rkangling (Trumpets), Tibet, 19th century (pl. 49), *157*, 232

Rnga or *Lag-rnga* (Frame Drum), Tibet, 18th century (pl. 46), *154*, 231–32

rugs, tantric, *196* (pl. 85), 238

S

Sadaprarudita, 43, *44* (fig. 18), *118–19* (pl. 13), 226–27

Sakya school, 19, 39, 41, 63–64, 233, 234, 236, 238, 241

sand mandalas, 26, 49, *49* (fig. 21), 51

Sangye Yarjon, *30*, *104* (pl. 5), *105* (pl. 6), 224–25

Sarvadurgatiparishodhana Tantra, 244n7 (Visualizing the Taboo)

sexual embrace, 28–29, 42, 55, 56, 57–59, 238, 239

Sgra-snyan (Lute), Tibet, late 19th century (pl. 47), *155*, 232

Shadakshari Avalokiteshvara. *See* Avalokiteshvara

Shadakshari Avalokiteshvara, the Bodhisattva of Compassion, Tibet, 1300–1350 (pl. 33), 74–76, *75*, *140–41*, 229

Shaiva Tantrism, 56

Shakyamuni. *See* Buddha Shakyamuni

Shakyashribhadra, 34–36, *102* (pl. 3), 224

Shield (*Phub*), Tibet, ca. 14th–16th century (pl. 67), *178*, 235

Shiva, 56, 60, 79, 230, 234

siddhi, achievement of, 37–39, 237

Silk Road, 19

silk tapestries, *18* (fig. 3), 19, 22, *23* (fig. 6), 27, 55, 60–61, *137* (pl. 30), *153* (pl. 45), *213* (pl. 30), 229, 231–32, 240–41

Skeleton Dance Costume, Tibet, late 19th or early 20th century (pl. 43), 65, *152*, 231

skeleton dancers, or *chitipati*, 65, 87, *152* (pls. 42, 43), 231

Skeleton Mask (*Chitipati*), Bhutan, 20th century (pl. 42), 87, *152*, 231

Skull Cup (*Kapala*), Tibet, 19th century (pl. 64), *175*, 234

skull cups, 23, 56, 64, 67, *175* (pl. 64), 232, 233, 234, 239

Sonam Gyaltsen, Thousand-Armed Chenresi, a Cosmic Form of the Bodhisattva Avalokiteshvara, Central Tibet, Shigatse, 1430 (pl. 34), *68, 142,* 229–30

Southeast Asia, 34, 235

Sri Devi. *See* Palden Lhamo, or Sri Devi

Sri Lanka, 36, 224

Srivijaya, 34

Stag Mask, Tibet, late 19th–early 20th century (pl. 44), *153,* 231

stupas, *25* (fig. 7), 26, 37, 83–84

Sudhana, 43, *112–13* (pl. 10), 225–26, 229

Sukhavati, 229, 231, 244n10 (Visualizing the Taboo)

sutras, 41, 72

Swayambhunath stupa, Kathmandu Valley, Nepal (fig. 7), *25,* 26

Sword (*Ral gri*), Tibet or China, 14th–16th century (pl. 70), 24, *180,* 235

Sword Guard, Tibet or China, 14th–15th century (pl. 71), 24, *181,* 235–36

sword hilts, 24, 66, 72, *180–81* (pls. 70–72), 235–36

T

Taklung Monastery, Tibet, *30, 62* (fig. 28), *104* (pl. 5), *105* (pl. 6), *191* (pl. 81), 224–25, 233, 237, 240

Tang-dynasty China (618–907), 123, *172* (pl. 61)

tantras, 25, 51, 72–73, 233, 238

Tantrasamuccaya mandala set, 51

Tantric Rug with Two Flayed Male Figures, Tibet, 18th–19th century (pl. 85), *196,* 238

Tantrism. *See* Vajrayana

Tara, 22, 35, 41, 44, 63, 69, 80, 81–83, *83* (fig. 41), *84* (fig. 42), *110* (pl. 8c), *146–48* (pls. 38, 39), 225, 227, 230–31, 239–40

 Green Tara manifestation of, 80, 81–82, *83* (fig. 42), *110* (pl. 8c), *146* (pl. 38), 225, 227,

 surrounded by her twenty-one emanations (fig. 43), 83, *84*

 White Tara manifestation of, 82–83

Tara, the Buddhist Savior, Nepal, Kathmandu Valley, Malla period, 14th century (pl. 39), 82, *148,* 239–40

Taranatha, 18, 34, 228

Tashipel, *104* (pl. 5), *191* (pl. 81), 224, 237, 240

Tathagata Buddhas, 75, 225, 227, 228, 230

teachers:

 essential to practice of esoteric Buddhism, 66

 portrayal of. *See* monastic portraits

teacher-student lineages, 19, 26, 33, 37, 39, 45, 55, 66

Tenzing Rigdol, 89–96

 Biography of a Thought, Nepal, 2024 (pl. 104; figs. 48–52), *14, 15,* 29, 88, 89–96, *90, 218–23,* 241

 Our Land, Our People, Dharamshala, India, 2011, 89

 personal history of, 89, 91

terracotta sculpture, 37–38, *38* (pl. 79), 189, 237

textiles:

 Central Asian, motifs from, 43, 229

 Chinese, *18* (fig. 3), 19, 22, 23, 27, 55, 60–61, *137* (pl. 30), *153* (pl. 45), *213* (pl. 99), 229, 231–32, 240–41

 costumes or dance robes (pls. 44, 45), 231–32

*thangka*s:

 bodhisattva and goddess representations (pls. 27, 33, 35, 37, 38, 41), *134, 140–41, 143, 145–47, 150–51,* 228, 229, 230

 deity representations (pls. 52, 53, 57, 81–84, 89, 90), *160, 161, 168, 191–95, 200, 201,* 232–33, 237–38, 239

 mahasiddha portrayals (pls. 74–78), *184–88,* 236, 237

 mandalas, *27* (fig. 8), *48* (fig. 20), 51, *206–17* (pls. 95–103), 240–41

 monastic portraits, 31–40, *100–107* (pls. 1–7), 224–25

 in tantric practice, 26, 29, 51, 73–75

 underdrawing in, 26, 85, 91, 231

Theravada tradition, 36

thighbone trumpet (*rkangling*), 64, *64* (fig. 29), 233, 234

Thousand-Armed Chenresi, a Cosmic Form of the Bodhisattva Avalokiteshvara, Sonam Gyaltsen, Central Tibet, Shigatse, 1430 (pl. 34), *68, 142,* 229–30

Thousand-Armed Chenresi, a Cosmic Form of the Bodhisattva Avalokiteshvara, Tibet, 14th century (pl. 35), *143,* 230

Three Fragmentary Leaves from an *Ashtasahasrika Prajnaparamita Sutra,* Kashmir or western Tibet, 12th century (pl. 11), 43–44, 45, 81, *114–15,* 226

The Transcendent Buddha Akshobhya, Central Tibet, 13th or early 14th century (pl. 18), *126–27,* 227

triads of divine beings, 73–74

Trumpet (*Dung chen*), Tibet, late 18th–early 19th century (pl. 48), *156,* 232

trumpets (pls. 48, 49), *156, 157,* 232

 thighbone (*rkangling*) (fig. 29), 64, *64,* 233, 234

Tugh Temür, *18* (fig. 3), 19, *213* (pl. 99), 241

Twelve-Armed Chakrasamvara with His Consort Vajravarahi, India (West Bengal) or Bangladesh, ca. 12th century (pl. 88), *46, 199,* 238–39

Twenty-one emanations of the goddess Tara, Tibet, 14th century (fig. 43), 83, *84*

U

underdrawing, 26, 85, 91, *150–51* (pl. 41), 231

Ushnishavijaya, 63, 69, 83–84, *150–51,* 231

Ushnishavijaya, Central Tibet, ca. 1300 (pl. 41), 85, *150–51,* 231

V

Vairochana, 16–17, 53, 54, 55, 56–57, *58* (fig. 26), 228, 240

Vaishravana, the Guardian of Buddhism and Protector of Riches, Tibet, 15th century (pl. 50), *158–59,* 232

Vajrabhairava, 18, 19, 24, 27, 55, 59, 60–61, *213* (pl. 99), 240–41

 effigy of, *66* (fig. 32)

Vajrabhairava Mandala, China, Yuan dynasty (1271–1368), ca. 1330–32 (pl. 99), 18, 19, 27, 55, 60–61, *213,* 240–41

Vajrabhairava mandala, oriented toward the south, South Central Tibet, Ngor monastery, 1515–35 (fig. 27), 60, *61*

Vajrabhairava tantras, 233

Vajracharya Priest's Crown, Nepal, early Malla period, 13th– early 14th century (pl. 32), 57, 60, *139,* 229

Vajradhara, 55, 230

Vajradhatu (Diamond Realm) Mandala, Central Tibet, 14th century (pl. 95), 27, 55, 56–57, 59, *206–7,* 240

Vajradhatu mandala cycle, Alchi Dukhang, late 13th century (fig. 26), 56, *58*

vajra-family deities, 53–54, 55

Vajra Flaying Knife, Eastern Tibet, Derge, ca. 15th century (pl. 63), *174,* 234

Vajrakilaya, 65

Vajrapani, 22, 44, 53, 63, 69, 74, *76* (fig. 38), 79–80, 81, 85, *144* (pl. 36), *145* (pl. 37), 227, 230, 233

*vajra*s, 27, 43, 73, 79, 91, *138* (pl. 24), *172* (pl. 61), 227, 228, 234

 being disassembled by divergent languages in Tenzing Rigdol's *Biography of a Thought,* 91, *92* (fig. 48)

Vajravali, 29, 51, 241

Vajravali mandala set, 27, 29, 37, *48* (fig. 20), 51, *214* (pl. 100), 241

Vajravarahi, 24, 46, 59, *62* (fig. 28), 63, *199–202* (pls. 88–91), 239, 240, 241

Vajravarahi, Tibet, ca. 18th century (pl. 91), *202*, 239

Vajravarahi mandala. Central Tibet, Taklung monastery, first half 13th century (fig. 28), *62*, 63

Vajra with Angry Heads and *Makara* Prongs, China, Tang dynasty (618–907) (pl. 61), *172*, 234

Vajrayana (tantric Buddhism):
 antinomian (socially contrarian or taboo) character of, 47, 67
 Buddhist teaching transmitted from India and, 16, 18–21, 25–26, 33, 40–42, 45, 234
 esoteric rituals in. *See* charnel grounds; esoteric Buddhism; mandalas
 external action or ritual differentiated from yoga or internal ritual action in, 47
 see also specific topics

Vanaratna, *36* (fig. 14), 36–37, *103* (pl. 4), 224

Vasudhara, 227

Vikramashila monastery, north India, 33–34, 224

Virupa, 18, *184–86* (pls. 74–76), 236–37

visualization, 16, 24, 25, 29, 36, 37, 60, 61–63, 66, 73, 238, 239, 240, 241

vitarka mudra, 33, 71, 229

W

wall paintings, 29, *29* (fig. 10), 51, *58* (fig. 26), 224, 225, 230
 Biography of a Thought, Tenzing Rigdol, Nepal, 2024 (pl. 104; figs. 48–52), *14*, 15, 29, *88*, 89–96, *90*, *218–23*, 241

weapons and armor that had been used in battle (pls. 66–72), 24, *78–81*, 235–36

wrathful manifestations, 55–56, 233, 234, 235, 236, 238, 239, 240

Y

Yama, 59, 60, 87

Yama Dharmaraja, Mongolia, 18th–19th century (pl. 56), *166–67*, 233

Yamantaka deities, 59, 60, 237–38, 240

yoga, 25, 37, 47, 63

Yoga Tantra, 16, 240

yogini, 60

yogins. See mahasiddhas

Yuan-dynasty China (1271–1368), *18*, 19, 20, 27, 55, 60–61, *213* (pl. 99), 240–41

Z

Zanabazar, school of, *72*, *135* (pl. 28), 228–29

This catalogue is published in conjunction with *Mandalas: Mapping the Buddhist Art of Tibet*, on view at The Metropolitan Museum of Art, New York, from September 19, 2024, to January 12, 2025.

The exhibition is made possible by the Placido Arango Fund and Lilly Endowment Inc.

Lilly Endowment Inc.
A private foundation since 1937

This publication is made possible by the Florence and Herbert Irving Fund for Asian Art Publications.

Published by The Metropolitan Museum of Art, New York
Mark Polizzotti, Publisher and Editor in Chief
Peter Antony, Associate Publisher for Production
Michael Sittenfeld, Associate Publisher for Editorial

Edited by Marcie M. Muscat
Production by Paul Booth
Designed by Gina Rossi
Bibliographic editing by Julia Oswald
Image acquisitions and permissions by Jenn Sherman
Map by Adrian Kitzinger

Typeset in Matrix IIOT and Cormorant Garamond
Printed on Creator Silk 150 gsm
Printing, binding, and color separations Verona Libri, Verona, Italy

MIX
Paper | Supporting responsible forestry
FSC® C119614

Cover: (front) Manjuvajra Mandala, Tibet, late 12th century (pl. 97, detail); (back) Tenzing Rigdol, *Biography of a Thought*, 2024 (pl. 104, detail). Additional illustrations: p. 2: Chemchok Heruka Mandala, Tibet, second half 12th century (pl. 98, detail); p. 4: Tenzing Rigdol, *Biography of a Thought*, 2024 (pl. 104, detail); pp. 98–99: Kurukulla, Tibet, 19th century (pl. 92, detail)

Every effort has been made to track object provenances as thoroughly and accurately as possible based on available scholarship, traceable transactions, and the existing archaeological record. Despite best efforts, there is often an absence of provenance information. Provenances of objects in The Met collection are updated as additional research comes to light. Readers are encouraged to visit metmuseum.org and to search by an object's accession number for its most up-todate information.

The Metropolitan Museum of Art
1000 Fifth Avenue
New York, New York 10028
metmuseum.org

Distributed by Yale University Press, New Haven and London
yalebooks.com/art
yalebooks.co.uk

Cataloguing-in-Publication Data is available from the Library of Congress.
ISBN 978-1-58839-782-9